ABSTRACTION IN ART AND NATURE

Nathan Cabot Hale

ABSTRACTION IN ART AND NATURE

A Program of Study for Artists, Teachers, and Students

WATSON-GUPTILL PUBLICATIONS/NEW YORK

To the memory of Alan D. Gruskin of the Midtown Gallery—my dealer and friend—and to Mary Gruskin, who continues our friendship.

Published 1972 in New York by Watson-Guptill Publications,
a division of Billboard Publications, Inc.,
One Astor Plaza, New York, N.Y. 10036

Manufactured in Japan

ISBN 0-8230-0049-4

Library of Congress Catalog Card Number: 70-180163

First Printing, 1972
Second Printing, 1974

Acknowledgments

The following artists and scientists have influenced the forming of the ideas in this book: Leonardo da Vinci, Albrecht Dürer, Paul Cézanne, Jackson Pollock, D'Arcy Wentworth Thompson, Wilhelm Reich, Louis Sullivan, Theodore Schwenk, Ernest Lehrs, Hermann Poppelbaum, and my friends of many years—Robert McCullough, biologist, and Richard Snibbe, architect.

Those who have helped to bring this book to print are Donald Holden, Editorial Director of Watson-Guptill; Juliana Goldman, editor; Anna Walters, typist; Mrs. Alison B. Hale, my helpmate; and my students.

Photographs by Nathan Cabot Hale

The books referred to in the text are listed in the Bibliography in the back of this book.

Contents

List of Illustrations from the Masters

ABSTRACTION IN ART AND NATURE

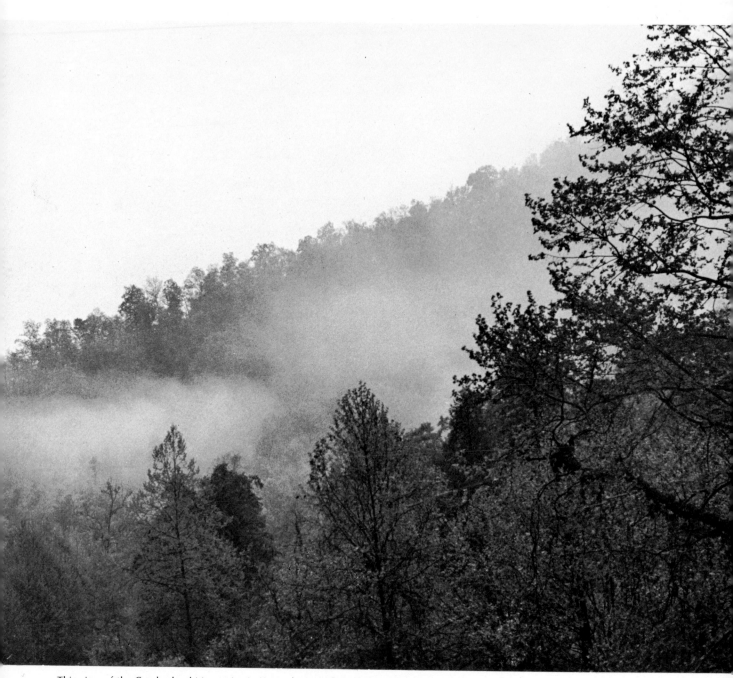

This view of the Cumberland Mountains in Kentucky in early morning would be taken for granted by many people. But to the artist, many things are revealed: the age of the mountains and the direction of the thrust of their strata, the lines of erosion in relation to the plane of gravity, and the lines of levitation in the upward thrust of the trees and plants. In the swirls of the mist of fog, the artist can see the spinning wave movements that animate all nature.

1. The Meaning of Abstraction

The biggest challenge to the artist in the twentieth century is learning the abstract language of art. Long ago it was enough to copy the surface forms of nature, but now it is our task to get to the root of nature's meanings. There is no other way to do this than to learn the kind of reasoning that enables us to look beneath the surface of things. The artists of our time are attempting to learn and develop this kind of insight. Not all of their experiments have been successful; some have led the creators into corridors from which there is no outlet.

In the general confusion of twentieth-century styles, it has been difficult for the average person to understand the art of our time; but it is far more difficult for the artist and art student because their careers demand that they find their own path through the chaos. We are faced with so many different schools of thought and conflicting points of view that we overlook the meaning of the word *abstraction*—which simply means the act of drawing out the essential qualities in a thing, a series of things, or a situation.

EVOLUTION OF ABSTRACTION

This book is intended as a guide to help you through the maze of abstract schools to the simple problems of abstraction. Whether you are an art student or an artist learning on your own, this text will help you to grasp the fundamentals of the abstract language of art. It may seem boastful for me to claim that this book will make the problems of abstraction clear. But the answers to these problems are accessible to anyone who takes the time to do a little detective work and to follow the clues that can be found in nature and in the art of the past.

We must try to step aside from the confusion of schools, movements, and current fads, and attempt to see the whole story of art as a meaningful effort of mankind. This confusion is particularly damaging when it happens in the art schools because the pressure of having to "choose sides" narrows the student's point of view, rather than enlarging it. Being forced to make such a choice prevents the student from exploring and freely selecting the kind of expression that is closest to his heart, his character, or his talents. In this book, I hope to avoid this kind of narrowness. Although, as a working artist, I may follow a certain path—the path that is best for me—I hope this book will encourage you to find the one that is best for you. Art is a product of evolution—not often a result of revolution—a product of the meaningful insights accumulated by artists over thousands of years. Fortunately, these insights cannot be easily erased; they continue to endure and they eventually modify and absorb the useful products of revolution.

The language of the abstract elements of art has developed gradually—as mankind has developed. This language is by no means a product of the twentieth century alone. Over thirty thousand years, each of the seven abstract elements of art in Western civilization has emerged to become part of our cultural treasury. These elements are (1) line, (2) shape-form-mass, (3) pattern, (4) scale-proportion-space, (5) analysis-dissection, (6) lightness-darkness, and (7) color. When we understand the amount of time it has taken to build these seven elements, we can begin to value them as a hard-won heritage.

LEARNING THE ABSTRACT LANGUAGE

My own study of the historical growth of the abstract elements of art—and of the growth of a child's capacity to make pictures—has suggested a natural way to present abstraction to you in this book. Each chapter will carry you one step further along the sequence: from line to shape, to form, to mass, etc. By the time you reach the end of this volume, you will have begun to understand just how artists weave the various strands of art into a sum that is greater than its parts. Equally important, you will have made some firm steps in that direction yourself.

If each artist had to start completely anew—as though he were the first artist in creation—he would be overwhelmed by the magic oneness that exists in nature. Nature hides all meanings in her great, seeming simplicity. All things work together in nature, and it seems almost impossible for the art student to cope with it all in one lifetime or a dozen lifetimes—even if he has the innate capacities of a Leonardo da Vinci. Without the heritage of the abstract elements of art, he would never know where to begin. These elements of art are a refined understanding and reflection of the creative ways of nature. They are the keys to nature's expressions and secrets.

As you learn the abstract elements of art one by one—through study, observation, and drawing—you go through a natural growth process. You extend the logic of nature within yourself. As you develop mastery of these elements, you become a deeper, richer personality with an increasing ability to see beyond the surface of things. This development requires time and patience on your part, and the recognition of your individual needs. One person may require greater study and greater practice in the meaning and use of line; another may have a strong, natural aptitude for line, but the reverse may be true when it comes to color or pattern. It is best to work most intensively on the things in which you are weak; your strong qualities will take care of themselves. The style that you develop eventually will be an expression of your personality, your background, and the amount of learning that you achieve.

I have tried very hard to stress the fact that these abstract elements of art are not isolated from one another,

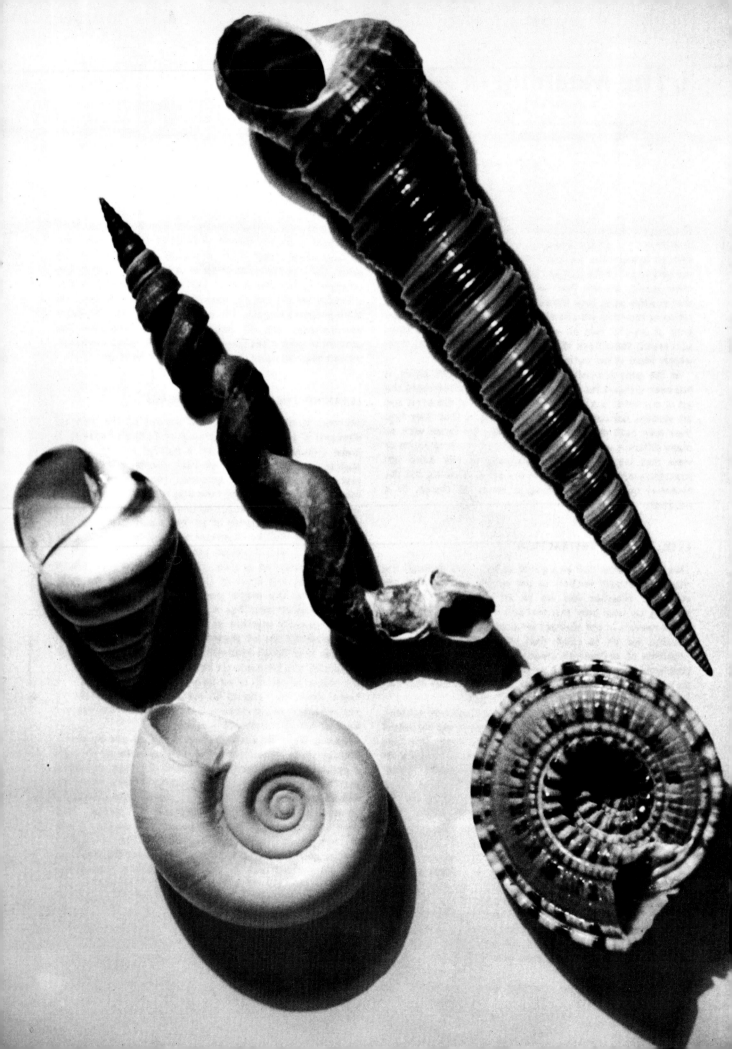

but that there is a natural order and sequence which creates pattern and logic. This logic is the first thing that I want you to understand. It is the skeleton or framework of the learning process you will follow in this book. Each of these chapters is actually a work outline, designed to give you practical experience and familiarity with the elements of art as you find them in nature and in the work of the artists who understood abstraction. The remaining part that completes this book is *you,* of course, and the effort you spend learning by doing the work outlined in each project. You are just as much a part of this book as I am.

WORDS VS. IMAGES

There is one serious drawback to this book, however, and it is in my reaching you through the use of *words*. We, as artists, are not basically concerned with words. For example, when we try to understand the lines that exist in a landscape, we draw these lines, not say them with words. Words are useful to us, as artists, only if we place drawing before the spoken or written word.

When I said earlier that abstraction means the act of drawing out the essential qualities in a thing, a series of things, or a situation, I really meant *draw* with a pencil on a piece of paper. When I talk about your understanding the abstract elements of something, I mean that you are able to *draw* its line, form, patterns, and all of the features that we artists communicate without words. For example, when we try to understand the human figure and express our understanding, we learn to draw the lines of the skeletal structure and the shapes of the bones; we learn to draw the shapes of the muscular masses; we learn to draw the patterns of the mass relationships, the scale of the forms, etc. It is not important to *name* these things or to tell what they do in words; we do all of our telling by *drawing*. This does not mean that knowing the names of things is not useful. It is. But words can be a trap for the artist.

The abstract elements of art are categories—ways of classifying things that exist in nature. These abstract elements enable you to transmit the reality of nature—or the feelings that nature creates inside of you—to the picture surface. Whether your work is faithfully realistic or completely abstract, whether your work reflects nature like a mirror or is an altogether inner vision, the abstract elements of art are the tools that you will use.

A STUDY PROGRAM AND MATERIALS YOU WILL NEED

What I have said has been very solemn and serious. Art has its solemn and serious aspects because it deals with the whole spectrum of human feeling. However, there is much joy, tenderness, pleasure, and freedom in art. The amount of fulfillment you find will be equal to the work you do. If you can set aside an hour each day and do these projects consistently over a period of months—as you do when you study a musical Instrument—you will probably use this book to best advantage. But you may be the kind of person who works in spurts of energy, with periods of waiting between work periods; if this is so, work at your own speed.

The materials you will need for the projects are not expensive: a few pencils, some charcoal, a kneaded rubber eraser, some fixative, a pad of paper, and later on some oil paints or watercolors. If you buy the best, you might spend as much as twenty-five dollars, but you could get by spending ten.

Your place of study is important, and the way that you study goes hand in hand with this. Pick a quiet corner or a room to yourself, where you cannot be distracted. You should have a desk or table on which to put your drawing pad and materials. And it is good to have some shelf space where you can keep the various odds and ends that you will be asked to gather for study from the world around you.

These are examples of different kinds of spiral forms which can be found in shells.

2. Line

The basic ingredient of the language of art is line, and line is something that we all tend to take for granted because paper and pencil have been our constant companions since childhood. In our culture, almost everyone learns to form letters and write words in the first grade, and children begin drawing pictures even before they enter school. Controlling our hands to make lines on paper is so basic to our way of life that it seems that millions of people *should* understand the nature of line in all its intricacies—but the fact is that few people understand it at all.

In our time, we are separated from the deeper meaning of lines by the fact that handwritten documents are not much used and that drawings and handmade illustrations, when used, are used for their effect rather than as a necessity. We generally read pages of mechanically made type and see far more photographs than drawings. To compound the problem, when we do write we use ballpoint pens or other instruments which give very little style or variation to the line of the handwritten signature we place at the end of our typewritten letter.

Of course, before the typewriter and the mechanical printing press came into such common use, and before the photograph and photoengraving came on to the scene, beautiful penmanship and skillful drawing were essential to the world's work and were considered much more important than they are today. The expert penman was employed to copy documents and records; the illustrator made drawings and engravings of important events or people, and pictured any other thing that could not be told adequately with words. The teaching of these skills on a high level was much more widespread than it is today.

It is very important for the artist and the art student to realize that the shift to mechanical type, photographic processes, and photoengraving has led to a decline in the skilled use of line—in art in general and particularly in the teaching of drawing. This decline has progressed for close to seventy years at this writing. At first glance, this might seem a disaster for the artist, as skillful drawing and the understanding of line are the cornerstones of art.

In reality, we may look on this decline in drawing as a disguised blessing because, in former days, good drawing was taken for granted to a very large degree. Until the present time, there has never been a period when it was possible to ask basic questions about drawing and line that have never been asked before. It is now possible for the field of art to develop some deeper self-knowledge about the whole vocabulary of the artist. The Impressionist painters began by asking the first and most important question in this search . . .

1. Cracks in the sidewalk are examples of lines that result from the meeting of two forms. The marks which we put on paper in this case would indicate the spaces between the two solid forms.

DOES LINE EXIST?

The Impressionists made the bold statement that line does not exist in nature. For people whose culture is held together with writings, diagrams, and pictures, this is a very hard fact to accept. We are a reading, writing, mathematical, and picture-making society, and we do all these things by making or using lines without a single thought about the lines themselves. We take line so much for granted that we all think that line is a basic part of the structure of the universe.

Project: This project will help you to explore your ideas about line, because you may have some misconceptions about the subject. It will be better to discover these misconceptions in the beginning than to let them linger through our discussion. All you need for this project is pencil and paper.

I want you to list any object in nature that you regard as an example of pure line. Just write down its name; do not hesitate or worry about being wrong. List *anything* that you have customarily thought of as a pure line.

Now pick two of your best examples from the list and make simple drawings of them. If you can find a model of the example, draw from the model. When your drawings are finished, read the following section to see whether you have the correct ideas about line.

LINES ARE NOT LINES

The Impressionists realized that we use our pencil, pen, or brush to make marks on paper to represent things in our environment, but these marks on paper only *represent* real things or real feelings. For example, we call a crack in the sidewalk a line, but in reality it is only a space between two solid forms even though we may make a solid mark on our paper to represent the crack (Fig. 1). The further the two pieces of concrete are separated, the more apparent this truth becomes.

Other examples of things which *appear* to be lines—such as strands of hair, string (Fig. 2) or wire, a snake, a tree branch (Fig. 3)—all prove to have volume and form on close examination. When lumber is stacked, one board on top of another, we may say that we see lines where the boards meet and draw lines for this on our paper; but in reality, we are drawing the space between the boards where the light does not penetrate (Fig. 4). Or we draw the edge of the board that is bordered by the air around it.

Well, then, what about the seeming border line or contour line around a human figure or a rock? Surely this is a line! But all we have to do is to walk around the figure or the rock to see our line disappear and become a surface or a shape. Even when we make actual marks on paper and call them lines, closer examination with a magnifier proves

2. String is another example of what appears to be a line, though the line actually represents a long, continuous form.

them to be quite solid chunks of lead that cling to quite solid strands of paper fiber.

To those of us who use line a great deal, and who believe in its power and effectiveness, this discovery comes as a shock and a disappointment. But after we face this feeling of discouragement, we realize that we have made the first important step toward learning the *intelligent* use of the marks that we call lines. When you have made this step, you have begun to see nature as it really is instead of what it only appears to be on the surface. You are closer to understanding how to go about making images on paper because you have realized that the important thing in drawing is, first of all, your understanding of the object represented by the lines.

Project: Now you are going to re-examine your drawings from the first project and make new drawings using the concepts that you have just learned. You will need pencil and paper and the models that you originally used.

In your drawing, I want you to pay very close attention to the problems of contour line. Ordinarily, beginners make an even line around an object as though every part of the contour was the same distance from their eye. In reality, some of the contour lines are nearer the front of the form while others are farther away. Notice particularly how, instead of being a continuous line around an object, the contour line will break and a new line will start—either ahead of the old line or behind it.

STICK FIGURES

These marks that you read on this paper as letters, words, and ideas can be traced back to certain activities of our earliest ancestors, just as we can trace back certain drawings on cave walls and on rocks as being their handiwork. As a matter of fact, pictures were the first means of writing. Writing developed very slowly out of the symbols of primitive drawing, just as today the child begins to draw faces and shapes of things before he learns to make letters, numbers, and words.

The ancient drawings on rocks and cave walls begin with a few simple lines that are very much like the stick figures that children draw. A stick figure requires only five or six marks to indicate the two-legged stance that has a very strong likeness to a man. As a matter of fact, this simple little device is so powerful and meaningful that even the artist of modern times begins the construction of his figures with a stick figure that duplicates the skeletal structure and the lines of the action (Fig. 5). Or if he does not actually draw it on the paper, he will develop and hold the image of the stick figure in his mind as he draws.

The stick figure is the beginning of the abstract analysis of the structure of form. The fact that primitive man and most children arrive naturally at this concept shows that the stick figure expresses the logic inherent in the human organism. Stick figures show our innate awareness that the structure of our bodies is endowed with the upward thrust of living energy that counters the downward pull and inertia of gravity.

Thousands of years of development have added many refinements to the basic stick figure. As a matter of fact, all the abstract elements of art discussed in this book were developed as additions to the basic stick figure. The use of line in this structural manner is a central part of our

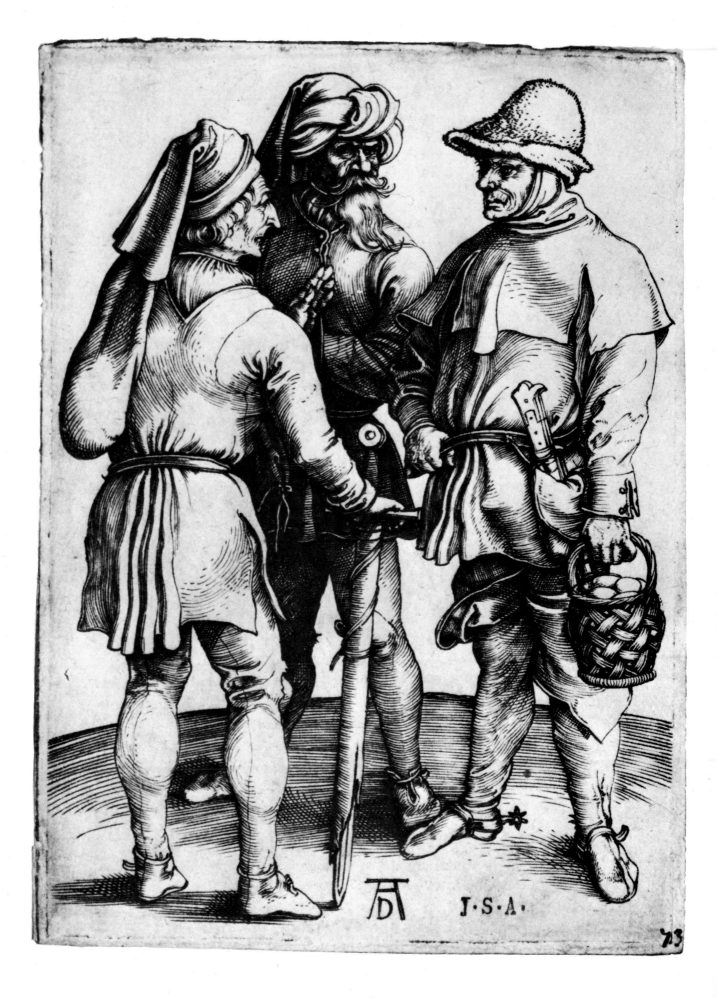

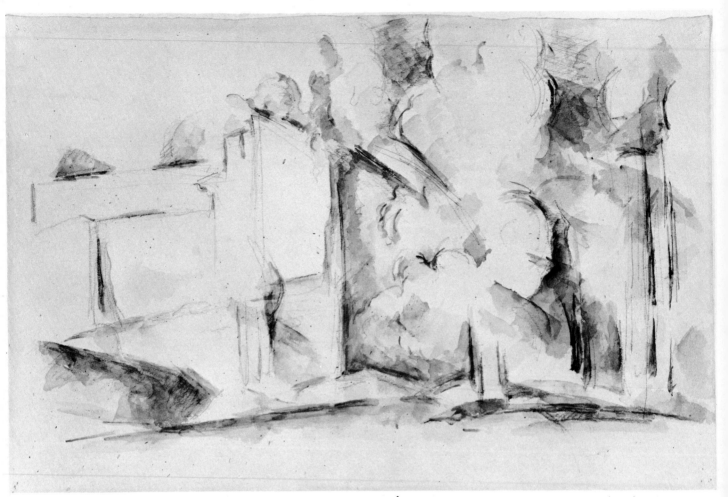

15. *House Among Trees* (Above), Paul Cézanne, watercolor, 11″ x 17 1/8″. Museum of Modern Art, Lillie P. Bliss Collection. Cézanne's line has a nervous and vibrating quality which gives a sense of movement of static forms.

14. *St. Peter and St. John at the Beautiful Gate of the Temple* (Left), Rembrandt van Rijn, pen and wash with bistre, 8 3/8″ x 6 1/2″. The Metropolitan Museum of Art, Rogers Fund. Notice how Rembrandt achieves volume and a sense of weight with his lines.

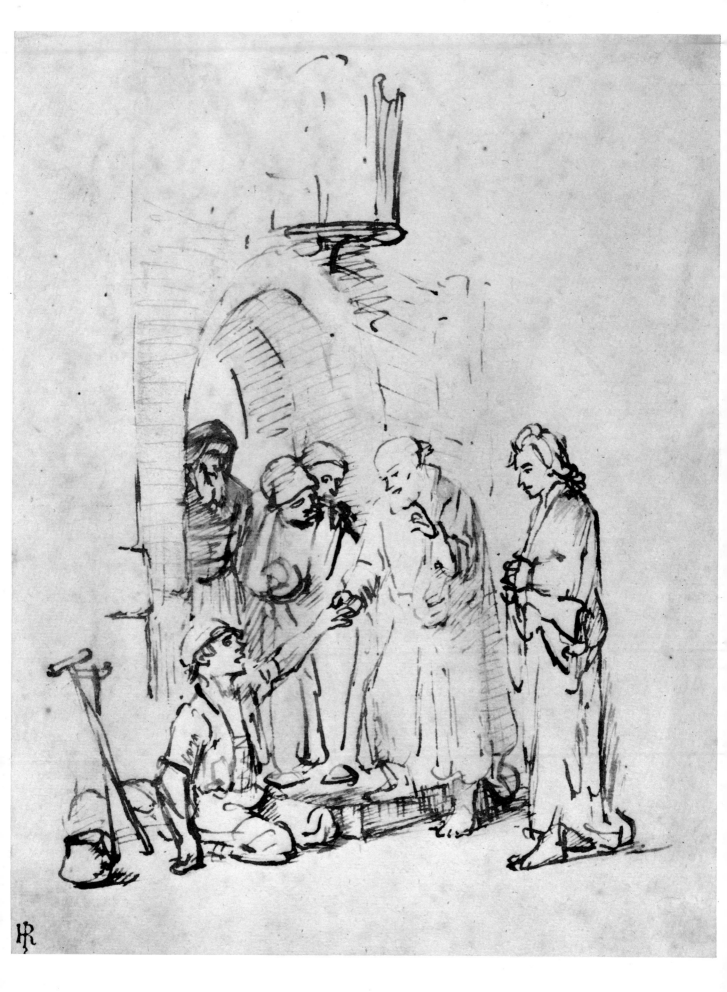

A line is a track for the eye to follow. During the time it takes to scan a line, the viewer responds to the expression of the line's form, speeding ahead or lingering, making jumps or sudden stops, or soaring upward in arcs.

Project: Up to this point, you have been looking at the lines in nature, but this project involves your looking at three master drawings: a Rembrandt, a Cézanne, and a Dürer (Figs. 14, 15, and 16). This project will help you understand how these artists have used line in their drawings to express the lines in nature.

I am not going to tell you what you will see; nor will I interpret these drawings for you. But I am going to tell you how to go about looking at lines. I want you to spend at least fifteen minutes with each of these drawings. Do not concentrate on the subject as you look, but let your eye wander over the lines. As you do this, ask yourself questions about each line in the drawing. Does the line move quickly or slowly? Is it curved or straight? Is it a combination? Is it broken? Is it dark or light? Ask what is the line weight—does it suggest levitation or does it accent gravity? Does the line lead to a point or to a center of interest? Is the line a rhythmic echo of other lines? What is the emotional feeling that the line transmits? Let your eye follow where the artist's line leads, but ask why he has chosen *specific* kinds of lines for specific purposes.

Your drawing task is this: I want you to make a page of totally abstract lines that are something like a road map that starts at one point and wanders all over the paper. You may break this line at times and use any line order or weight. The object is to vary the line and to lead the eye along at different rhythms. You can make junction points and centers, but control these so that the eye will continue to the end of the path. Try to avoid making masses or shapes or confused lines. Perhaps a road map of a state with a variety of terrain will help you.

LINEAR FORMS

As I pointed out in Chapter 1, there is no fine dividing line between the seven elements of art; all the elements interweave with one another. The kinds of line we will deal with now will bring us closer to the subject of our next chapter which deals with three-dimensional forms, as these lines have many of the qualities of solid forms.

As you may have noticed, the spinning wave actually creates a teardrop shape as it recrosses its own path. When a straight line has another line added at an angle, this creates a slight stopping space, a point of attention. Form actually begins in line when space is enclosed or when lines intersect at points and diverge.

Project: Here is a brief project that will illustrate what has just been said. All that you need for this is your pencil and two sheets of paper.

On the first sheet, make a series of continuous spinning wave lines without removing your pencil from the paper. Do only enough to make about ten loops. When you have finished, merely darken the part where the lines move backward to create the teardrop shape, so that the shape stands out as an enclosed form.

On the second sheet of paper, make about eight short horizontal lines that are well separated. Next, on the first of these horizontal lines, draw another line that crosses the

12. Here are some combinations of straight lines. The eye reads each one differently because each causes the eye to make different movements.

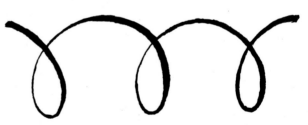

13. The spinning wave line is the basic line of nature.

creatures of the earth is the sun. The sun shines on us from above—a statement that sounds at first like the greatest platitude ever uttered. But natural illumination does come from above and our organs of sight grow and are structured to accommodate this condition. We tend to regard light coming from below as eerie and unnatural, possibly because fire—the great enemy of wild creatures—casts its light upward from below. We have been conditioned from birth by the daily skyward journey of the sun to look to the light from above and to be guided by it. Overhead light is about as fundamental to us as gravity and levitation.

As a matter of fact, light and dark lines are sensed subconsciously by the eye as visible guides to levitation and gravity. The undersides (or earth side) of forms show strong black lines because of the illumination from above; less light gets to the spaces between a form and its resting place on the earth's surface. On the other hand, lines at the top of forms are bordered and surrounded by the luminous atmosphere; these are the light lines. Therefore, light lines intensify our sense of levitation, while dark lines stress the feeling of mass and weight. These line relationships are seen by us each day of our lives and are used as dependable navigation signs; our perception of their meaning becomes subconscious and reflexive.

The weightiest lines of this type are the dark lines parallel with the ground, and weightier yet are those that rest on the ground plane. These dark lines give a great sense of heaviness to a form, a sense of being firmly anchored by weight. But there are also dark lines where any two forms press together: for example, at the juncture of the arm and torso when the arm presses the side, or at a bent elbow or knee (Fig. 11). These lines are generally thinner than the ground lines because they are more exposed to the light and give a lesser sense of weight.

One of the greatest mistakes that beginning draftsmen make is the overuse of heavy black line. This is a mark of particularly bad taste and poor drawing sense when it is done on the upper surfaces or planes that are surrounded with light and atmosphere. This mistake gives drawings a top-heavy, insensitive quality that wounds the eye of an artist. Master draftsmen *do* break this rule occasionally, but they do so only after they have gained control of line and understand its meaning.

Project: This is another project that requires both observation and drawing. Its purpose is to help you discover the nature of light and dark lines. You will need your pencil and paper, a table top, and a work light that can be raised and lowered.

First I want you to make some careful observations of the light and dark lines of sun and earth. The best time for this is noontime, or the hours just before and just after. The sun is overhead and is shining its brightest. Look at the objects that rest on the earth and the objects parallel to the earth's surface. Try to differentiate between the light lines and the dark lines or cast shadows (cast shadows are another problem that we will investigate later). Ask yourself how heavy the objects are—weight that you see and seem to feel. Ask yourself why you feel this weight. Of course, you will find that part of your feeling comes from knowing what the object is; but basically the light and dark lines transmit the sense of weight.

For your drawing project, set some simple objects on your worktable and illuminate them from above with your movable work light. First, draw only the contour lines in just one thickness of line; then stress the dark lines where the objects contact the table or meet each other. Experiment with different line weights and check the effects of them all with your feelings.

LINE AS MOVEMENT AND TIME

Once you have put lines on paper, they may seem at first glance to be static. But the lines of a drawing are far from static; they have a real life of their own that can be read and interpreted.

The element of time enters a drawing first in the time that the artist takes to make all of the lines that he feels will describe the objects that he is drawing. As he draws, the artist is also aware that he must control the viewer's eye and guide it over the forms. He can draw lines that will guide the eye quickly. He can make lines pause by breaking them, so that the eye of the viewer wanders momentarily outside or inside of the form before continuing onward. He can make the viewer's eye concentrate on one area by making several lines lead to one point (or center of attention). These are just a few of the ways that line conveys time. The viewer unconsciously *reads* these lines at the pace and in the sequence that the artist has plotted in his composition.

Any line, or series of lines, that you draw will bring out certain responses in the eye of the viewer—responses that result from the way the eye functions as an organ, as well as from the conditions in the world that make an eye necessary and useful. This is to say that the eye is an organ of light that scans and reads all the data that it comes upon, so that instantaneous decisions can be made about the meaning or value of what is seen. If you have ever seen anyone discover a five dollar bill (without an owner) blowing along a sidewalk, you will understand just how quickly the eye can turn information into action.

Different lines are read in different ways that indicate their order of importance (Fig. 12). Actually the eye does just about what it is told to do by the draftsman. The eye appreciates lines that lead somewhere or say something. Lines that mean nothing are just as quickly interpreted as being empty and monotonous. A long straight line is read very quickly and without much pleasure. If another straight line is projected off one end, the eye will zoom to the junction and jump off along the course of the second line. A series of these lines will give a sense of jagged starts and stops. The eye associates this kind of line with mechanical form, or with an electric kind of discharge, and does not linger over it.

The curved line is the voyager's delight and is a pleasure to the eye. A wavy line can stir the soul. Wind and water both move in curved and wave-formed lines; there is no question about our being drawn to either. These movements are the movements of life and are seen in the purest form in the spinning wave line (Fig. 13). This line curves forward, then loops backward upon its own track, and then curves forward again in a four-beat rhythmic sequence of tension, charge, discharge, and relaxation. Our breathing and heart both move with this rhythm, as do all the pulsating movements of living things. The track of planets revolving through space is a variation of the spinning wave. Our eyes linger on lines of this sort as they have great biological significance.

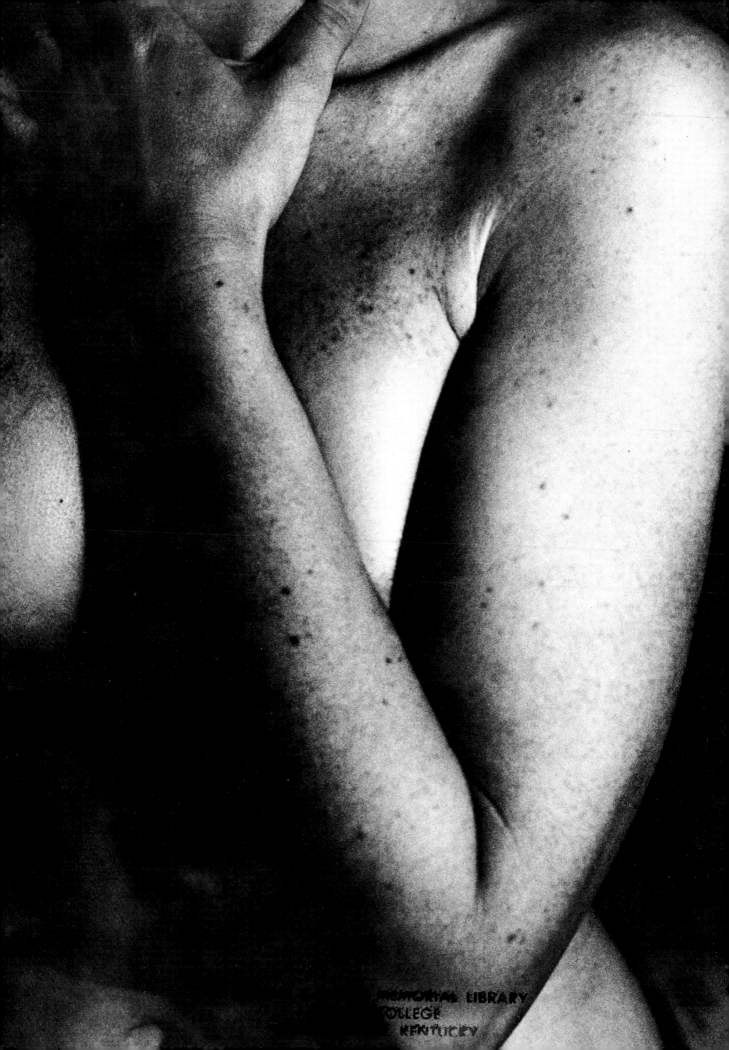

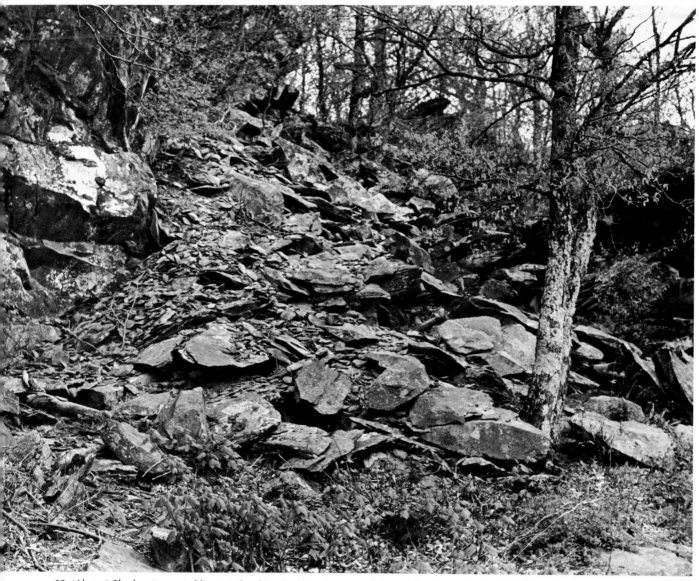

10. (Above) The heavy ground lines under this pile of rocks stress their weight and the force of gravity.

11. (Right) Dark lines occur where forms are pressed together, such as at the juncture of the arm and torso or where the arm bends at the elbow.

for weight and mass. With our sense of this line go the emotional sensations of heaviness and inertia. We search for lines of levitation, on the other hand, which move upward toward the vertical. The emotional sense of leaping, rising, and flying come from this energy as well as spirituality, lightness, and joy. Combinations of these two forces produce countless expressions.

The eye automatically interprets the positions of *all* lines on the page—including diagonals and curves—in the light of these two great forces, these two great opposites of form, these two invisible lines.

Project: This project will help you become aware of the two great linear forces. This is a twofold project that consists of analyzing your inner feelings first and then making some drawing experiments. You need pencil and paper.

You can begin your observation of levitation and gravity in the room that you are in. Examine the objects in the room one at a time; this can include the walls, doors, and windows, as well as furniture and other items. As you examine them one at a time, pay close attention to your own sense of balance and your feeling of body weight. If you are observant, you will notice how you project these inner feelings into the things you see, and from this you conclude facts about *their* weight and balance. (If you have any doubt about this, readjust a picture so that it hangs out of line or place something under a table leg, tilting the top—and see how this makes you feel.) Try this same experiment outdoors as you look at trees and rocks (Fig. 10).

Now I want you to make some experiments on paper, without any references to outside objects. This experiment will show that these inner forces dominate any marks that are made on paper, and thereby become dominant elements of drawing. On your first page, make a horizontal line on the lower third of the paper. On this same paper, make a series of short vertical lines on, and below, the horizontal line. When this is done, ask yourself what feelings come to you from these lines; what associations do you make? Though these lines have no meaning, they will seem to represent things in nature—trees, ground, etc.—because of your innate awareness of gravity and levitation.

Next, make the same vertical lines *without* the horizontal lines, and study their effect. Try another page with vertical and oblique lines placed at random. You will find that some lines will seem to fly while others will seem to fall. Your own inner sense of linear movement—and the directional forces in nature—dominates any lines you see on paper. So drawing depends upon the artist's intentions *and* the inner feelings of the viewer.

SUN AND EARTH: LIGHT LINES AND DARK LINES

The lines of gravity and levitation are invisible lines of force that are really never drawn, but instead affect the lines that *are* drawn on the page. These invisible lines are absolutely basic in all drawings, even drawings done from the bird's- or worm's-eye view. The next lines we will consider are visible lines that have basic characteristics that are as strong as these other two and in many respects relate to them.

The basic source of light for the earth and for the

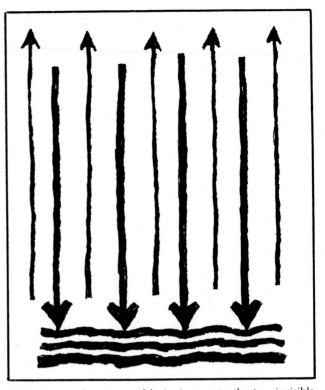

8. The forces of gravity and levitation create the two invisible lines from which we judge all marks made on the page.

9. We see all marks on paper or a picture surface in relation to the invisible lines of levitation and gravity, and these marks take on meaning accordingly.

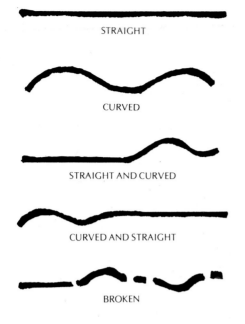

6. There are two basic kinds of line—straight and curved—and their many variations can be seen above.

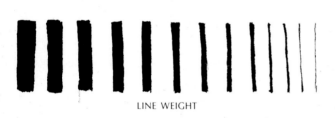

7. Variations in line weight can create a sense of heaviness or lightness.

When you begin to draw, I want you to be aware of two things that cause inaccuracy and vagueness. First, if you do not look closely at the form *before* you begin to draw, you cannot decide the character of the line. Line decisions must be made before the actual line is made. Second, I want you to be aware of the control of your hand and arm in making the line. For even if you see a line correctly, you cannot make it unless your hand and arm can duplicate the linear movement you see. The artist must both *decide* and *control*.

I want you to begin by only *looking* at objects. Pick several models—a person, a plant, a landscape. Spend plenty of time with each, just looking at the lines. Decide what kind of lines they are and where they begin and end.

For drawing practice, I want you to apply what you have seen. Draw the models that you have chosen and make all of your line decisions *before* you draw. Next, feel out the movement of the lines with your pencil held above the paper, not on it, before you draw. When you have the right movement, then make your line on the paper. These drawings will be stiff at first, as it takes time to learn skillful drawing. But in time your drawing will become accurate, knowledgeable, and emotionally clearer.

When we consider them outside of the context of nature, the four orders of line we have just discussed might be looked upon as dryly reasoned and meaningless squiggles. But when you consider that these lines emerge from the hand of man and are directed by the living energy processes, these simple little lines grow greatly in importance. From this understanding it is but a short step to the realization that the four orders of line are very much the same as expressions of pure energy we know and measure in science; the pulsing waves of heartbeats and of oceans, or the explosive discharges of an electrical storm.

LINES OF GRAVITY AND LEVITATION

The eye sees the picture surface, before any lines have been drawn on it, as an infinite space. To the artist, it seems to be as light and as deep as the universe. However, as soon as any marks are put on the paper, two strong forces come into play: the force of gravity and the force of levitation (Fig. 8). The reason for this is a fact about ourselves that is so basic that we are generally unaware of it; this is that our whole lives are spent adjusting to these two primary expressions of energy. From the moment we rise in the morning, the primary thing that we do during all our waking hours is to adjust between the upward thrust of our energy and the downward pull of our mass.

Everything that we do and see is experienced in relation to the thrust of our upright stance and the downward pull of our body's weight toward the earth's surface. Our eyes gauge everything we see in relation to our sense of balance, and our quick response to gravity and levitation is literally a life or death matter, helping us to get the proper bearings, handholds, and footholds that are necessary for us to stand and move with. So when we see a page of paper, a picture surface, a window of space, our eyes immediately look for bearings and landmarks to relate to gravity and levitation (Fig. 9).

When we look at a picture or draw one ourselves, we draw or see all marks in reference to these two built-in invisible lines. Our eye searches for a horizontal line or a horizontal plane as a mark of gravity, as a resting surface

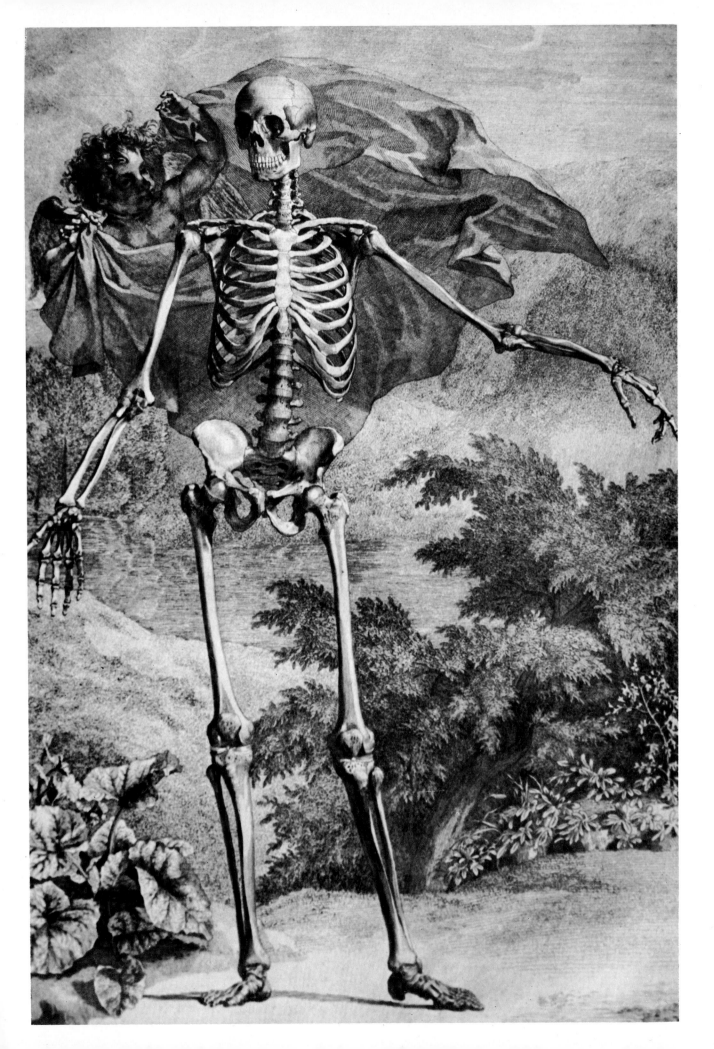

center at an angle of 10° cross the second horizontal line at a 20° angle; and so on, progressing to 90° at the last cross— which should be a horizontal crossed by a vertical. When you have finished, examine all of these crossed lines and determine which is the most eye stopping—and ask why this is so.

LINE FORMS BASED ON THE CURVE

If, instead of allowing the spinning wave line to move across the page, it is held in one place to turn around an axis, it can generate three different line forms (Fig. 17). If it stays on the same track as it moves, it will produce a *circle*. If it coils around its own form closely, but not rejoining itself, it will describe a *spiral*. And when the spinning wave moves around an axis and the open end grows larger uniformly, it creates an *equiangular spiral*. Many organisms in nature are structured with these forms; they are so common that everyone has seen instances of them.

From any one of the above three line forms, the helix can be made by simply stretching the form out in space till it becomes like a screw thread or like a curled wood chip from a lathe. Many plants follow this form, such as circling vines like the bindweed or flowers like the sweet pea. Man's inner ear follows this form.

Project: Your ability to draw the forms just discussed is important to gaining skill as a draftsman. These are primary line forms and drawing them well enables you to understand some of the more complex forms of nature that are built on these same principles. This project is meant to help you gain this skill. Get your pencil and paper and try to do the exercises that I describe.

It is fairly simple to draw a freehand circle with a little practice. The trick is to concentrate on a point which will be the center of your circle. As you move your pencil around this point your object is to keep the pencil always at the same distance from the center. If you are right-handed, you should begin your line at the nine o'clock point and draw the line in a counterclockwise direction. Left-handers should begin at the three o'clock point and draw their line in a clockwise movement. If you make a few practice swings first, without letting your pencil touch the paper, you will get the right feeling of the circle and draw it better.

You can draw spirals that begin at a center point and grow outward in a similar fashion, but with one difference. Touching pencil to paper, you begin the circular movement by moving just your fingers; as you draw larger and larger circles, you transfer the drawing movement gradually to your whole arm. As the spiral progresses, you must be careful to maintain the same distance between the new line and the old.

You also construct the equiangular spiral by beginning the circular motion around an imaginary point. But it is useful to imagine a horizontal and vertical line crossing through the point. As you draw the line around the form, the space between the line you have just drawn and the new line should grow proportionately larger. You control

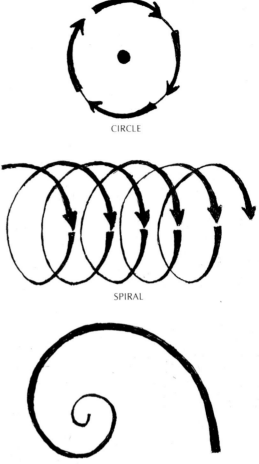

CIRCLE

SPIRAL

EQUIANGULAR SPIRAL

17. Here are line forms generated by the spinning wave.

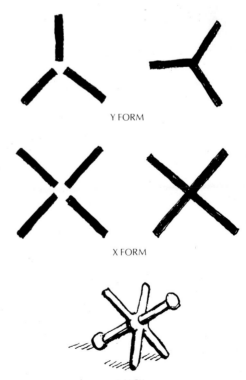

Y FORM

X FORM

A JACK

16. *Three Peasants in Conversation* (Left), Albrecht Dürer, engraving. The Metropolitan Museum of Art, Fletcher Fund. Dürer uses lines within the forms to stress their volume and direction.

18. These examples of line forms are based on the straight line.

this growth from one radius to the next. Drawing this form takes considerable practice, but it is worth doing because it develops great skill.

The spiral and the equiangular spiral can be extended into three-dimensional forms if you will make your circling movements elliptical instead and stretch the forms upward along a straight line.

LINE FORMS BASED ON THE STRAIGHT LINE

The most simple straight line form is the Y form, the meeting of three straight lines (Fig. 18). According to the way this form is constructed, it can be read as two lines branching outward from a single main line or as a starlike junction point. The second simplest straight line form is the cross or X, the intersection and continuation of two lines. This form fixes the eye at the meeting point. If a third line is added to the cross at right angles to the first two, a form is created like a "jack" from the child's game of jacks and ball. In nature, the skeletons of certain radiolarians and some forms of thorn adopt these shapes (Figs. 19 and 20).

By adding more lines to the lines of the cross or the Y where they meet at the center point, you can create various radiating forms that are seen in light radiations, in the vein structure of some leaves (Fig. 21), or in the forms of snowflakes. This form can be on a two-dimensional plane, like the snowflake or the starfish (Fig. 22), or can be of a three-dimensional character, like the century plant or the thistle seed cluster (Fig. 23). This is a very significant form as it describes radiation from an energetic core.

Another form is that of the grid, which is composed of many lines crossing one another at right angles (Fig. 24). This is the pattern followed by the streets of many American cities, as deadly dull and cruel a form of design as we can imagine. It is the ultimate form of rigid structure and a form that the painter Mondrian dealt with exclusively in his later years. It is also a pattern that can be used for precise analysis of other forms—a tremendous tool of logic. It is but a short step from the lines of the grid to the lines of weaving, which are actually wave-formed lines instead of straight.

Project: Radiating lines and junction lines are not at all difficult to draw, but they are important devices in drawing. Such lines are also very significant in nature. This project demonstrates their importance.

I would like you to do some drawings in the landscape of things that possess junction lines and radiating lines. Make quick line drawings of anything you see that has this characteristic of line. When you have done your drawings, try to reason out the meanings that these lines hold before you proceed.

I believe that you will have found some important facts. You will have seen (or sensed) that wherever lines cross or meet at a center point, there is a meeting of energetic forces. This meeting of forces creates a tension at the center point. In living things, these points are often centers of growth or centers of energy. In nonliving things, they are centers of weight, fulcrum points, or points where there is interpenetration.

In drawings, radiating lines are always key points that lead the eye inward or direct it outward. In the drawing of the human figure, they mark the place where the longer lines originate, such as the pit of the neck, the point of the shoulder, or the pubis. In any drawing—whether nonobjective or dealing with the forms of nature—these lines always attract the eye. Because of this, junction lines and radiating lines should always be used with a certain amount of discretion.

COSMIC LINES

One of the most impressive line forms of all is the great line form of galactic superimposition. This is a form based on the spinning wave and consists of two curved arms drawn inward to a mutual center, around which both forms turn. In nature, this form is found in many expressions: in the pattern of the hurricane, in the great ocean currents, in the seed patterns of sunflowers, and most important of all, in the spiraling galactic forms of the universe (Fig. 25). Man has also used this form in many guises, such as the Chinese yin and yang pattern and the child's whirligig; its logic is responsible for the airplane propeller, among other things.

The vortex is a variation of the galactic form in three dimensions, which even the simple morning glory responds to (Fig. 26).

For example, the meeting point of the sexual organs of two mating animals represents the center where the two galactic arms meet. The curving lines of the two bodies represent the two arms of the united system. People who have lived on farms, or who have otherwise cared for animals, will have recognized this form in the mating process of the creatures that they have cared for.

The recognition of these common links of form throughout all of nature is quite staggering. This form principle, in particular, seems to touch at the core of all basic creativity. Particularly so when it is realized that the galactic form is the same form as the coupling sexual union of practically all living creatures.

Project: This project will help you to understand the galactic form as well as to draw it.

First it will be useful for you to observe this form in nature. You can find it in the center of flowers, such as the daisy and the sunflower. This is also the pattern of hair growth at the top and back of the human head. And of course, this form frequently appears in streaming water. Now draw the examples that you find as accurately as you can.

Perhaps it will help if we have a word or two about analyzing this form. Ordinarily people look on this form as originating from the center or core; the tendency is to look upon the center as the creative or generating force. But this form must also be seen as two arms moving inward to focus and concentrate at the center point. When we consider the form visually, there are both inward and outward movements. These movements are very similar to an optical illusion. The form consists of two forces moving inward from opposite directions. The eye follows one arm inward to the center, at which point it follows the opposite arm outward again in a reverse movement. It is therefore easy to see that this form might be a very useful device in drawing, as it not only attracts the eye, but also can change the direction of a rhythmic movement. As a matter of fact, this device is often found in master drawings.

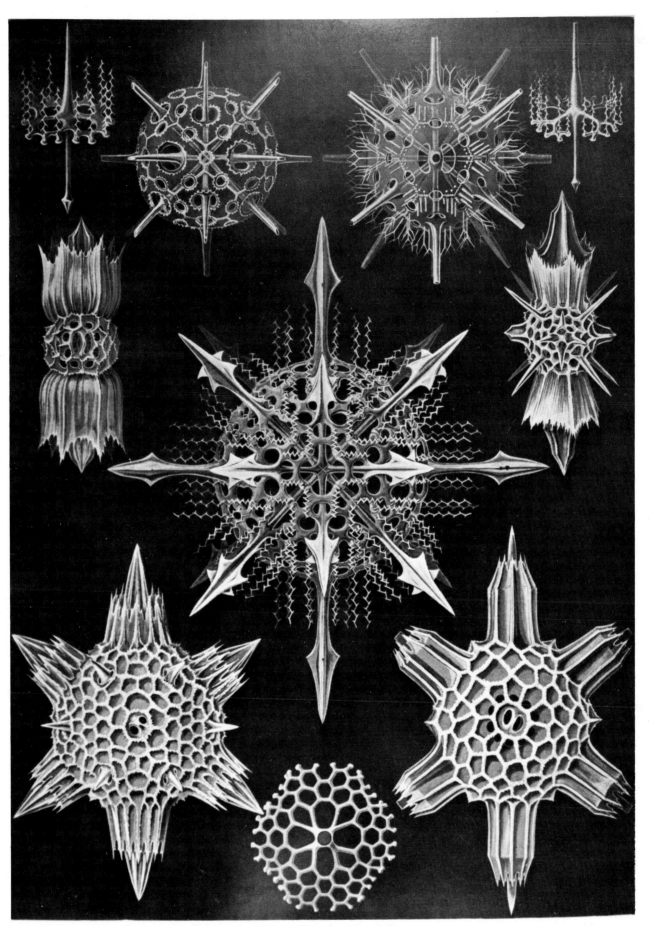

19. Some microscopic marine creatures adopt the axial form. (From Ernst Haeckel)

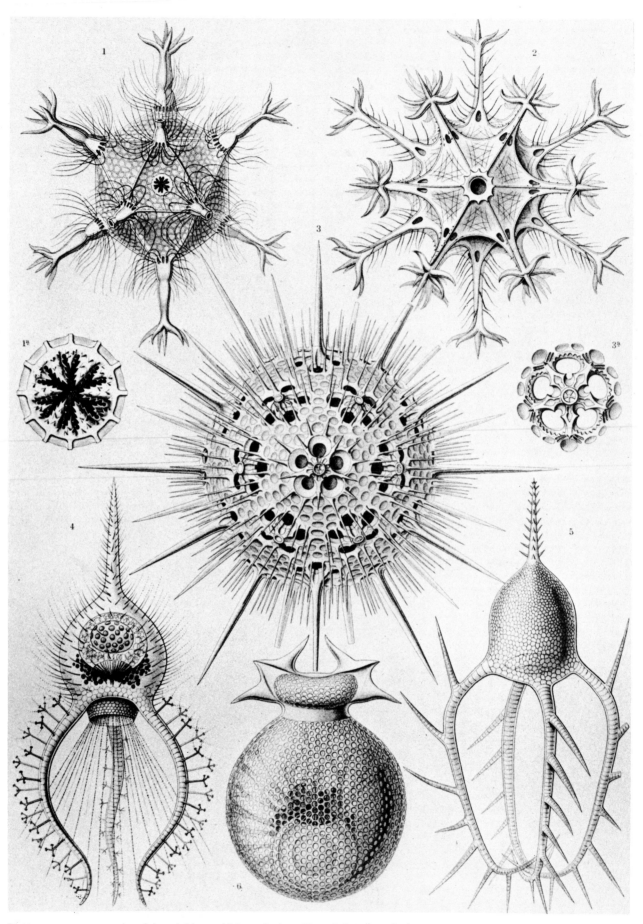

20. Here are more examples of the axial form which can be found in radiolarians and other creatures in nature. (From Ernst Haeckel)

21. (Above) Leaves have intricate radiating lines as well as branching lines.

22. (Left) The starfish shows radiating lines on a two-dimensional plane.

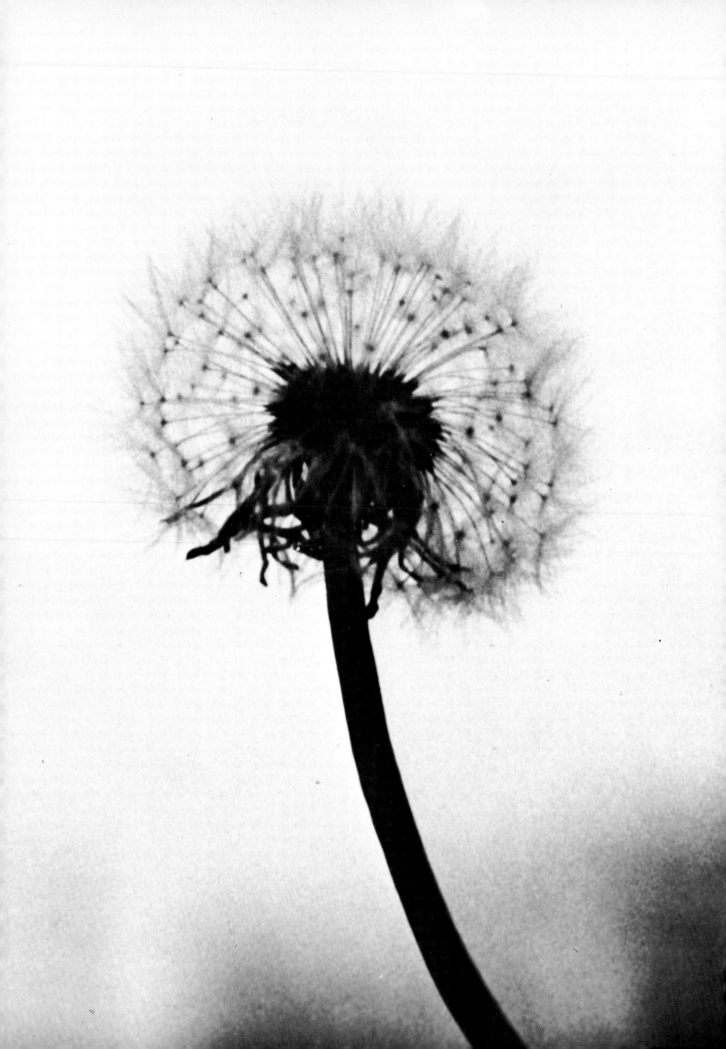

STREAMING LINES

Water, as it flows on its course to the sea, or to the lowest point that it can reach, moves in spinning waves within the mass of the stream (Fig. 27). But the over-all stream mass itself describes a simple meandering wave that might be the size of a brook, a creek, or a river. An aerial view of a whole stream system, on the other hand, will show two very important line forms in addition to the wavy form of the main stream body.

Branching lines are created as water draws into little streamlets after rains (Fig. 28). These streamlets run their wavy course until they meet another streamlet and together they form a larger stream. This continues until many of these small streams meet and form a main river body. This form is almost identical to the tree form, except that the tree form grows in just the reverse order—from the main trunk to the smaller branches (Fig. 29). An example of branching lines in living organisms is the system of bronchial tubes that bring air to the lungs of air breathers (Fig. 31). Of course, the plant world uses many versions of this line form.

A further variation of streaming lines is the network line form or, as they are called in anatomy, the *anastomotic networks*. Examples of this line form are the nerve networks (Fig. 32) and the vein and artery systems (Figs. 33 and 34). These networks grow from large nerves or vessels to smaller channels; but instead of separating into smaller and smaller single units, the whole system will be interwoven the way a branch goes on for a distance and then rejoins with another branch. This might be called an organic kind of weaving, but it differs from the weaving of cloth in that the fibers in cloth are all separate strands.

Project: I think this project will delight you because everyone enjoys playing with water. The purpose of the project is to give you firsthand experience with the formation of branching lines. You need pencil and paper and some other things which I will now describe.

Actually there are two good ways to study this phenomenon: you can find it ready-made in nature or make it yourself. If you have a yard with some unused dirt on a slight slope, simply wet the ground with a garden hose. Use a very wide, diffused stream to simulate rain. Dampen the whole area first until the ground is saturated. Then concentrate your water on the higher ground. As the soil becomes oversaturated, the water will begin to flow downward, cutting channels that join and eventually form a stream. When the stream pattern is clear, shut off the water and make your drawing.

If you do not have your own ground, you can see the same thing at the seashore. As the water recedes at low tide, it will flow back to the sea and form patterns which you can draw.

LINES OF GROWTH AND STRUCTURE FORMATION

There are innumerable examples of growth and structure lines in living and nonliving nature. Fibers of muscle in the animal world are always arranged in a linear manner, as are

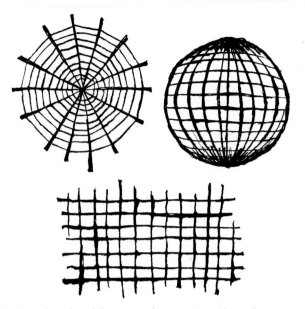

24. Examples of grid forms can be seen in spider webs, in our concept of the globe of the earth with longitudinal and latitudinal lines, and in the weave of cloth.

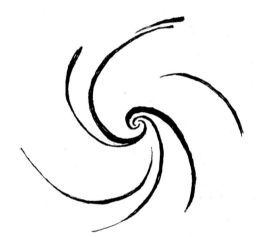

25. The swirling form we see in galaxies can also be seen in hurricanes, ocean currents, and seed clusters.

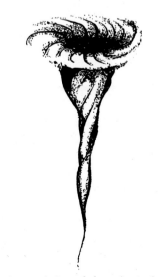

23. (Left) Dandelions show the principle of radiating lines in the seed cluster.

26. The vortex is a variation of the galactic form in which the center point has become an axis of growth, such as that found in spiral sea shells. (After Schwenk)

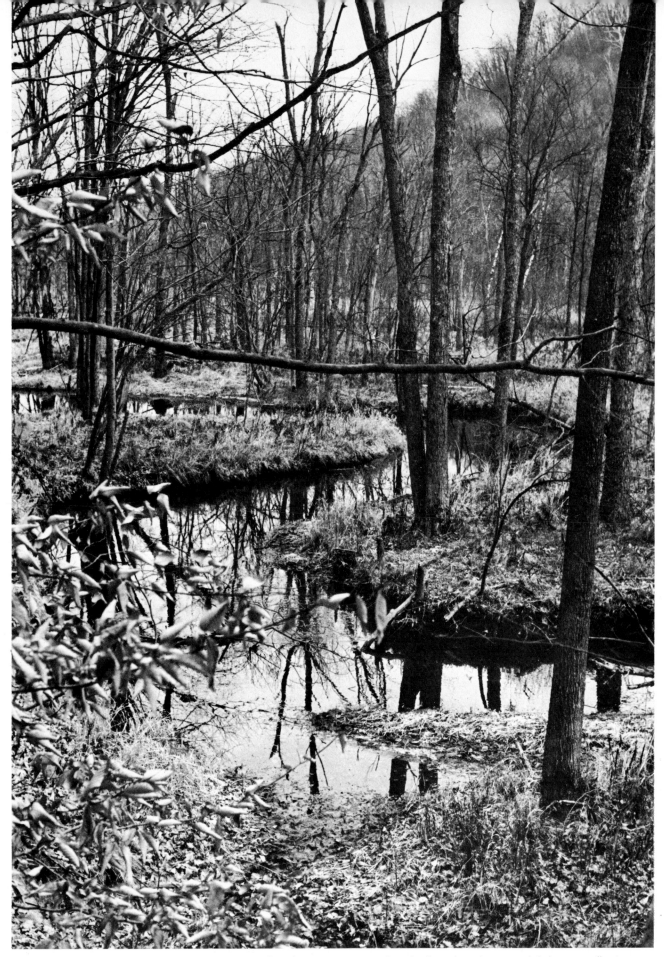

27. (Above) A meandering stream is an example of water following a curved path in nature.

28. (Right) This branching form was left by water flowing over sand; the smaller branches joined the larger ones until finally a main stream was made.

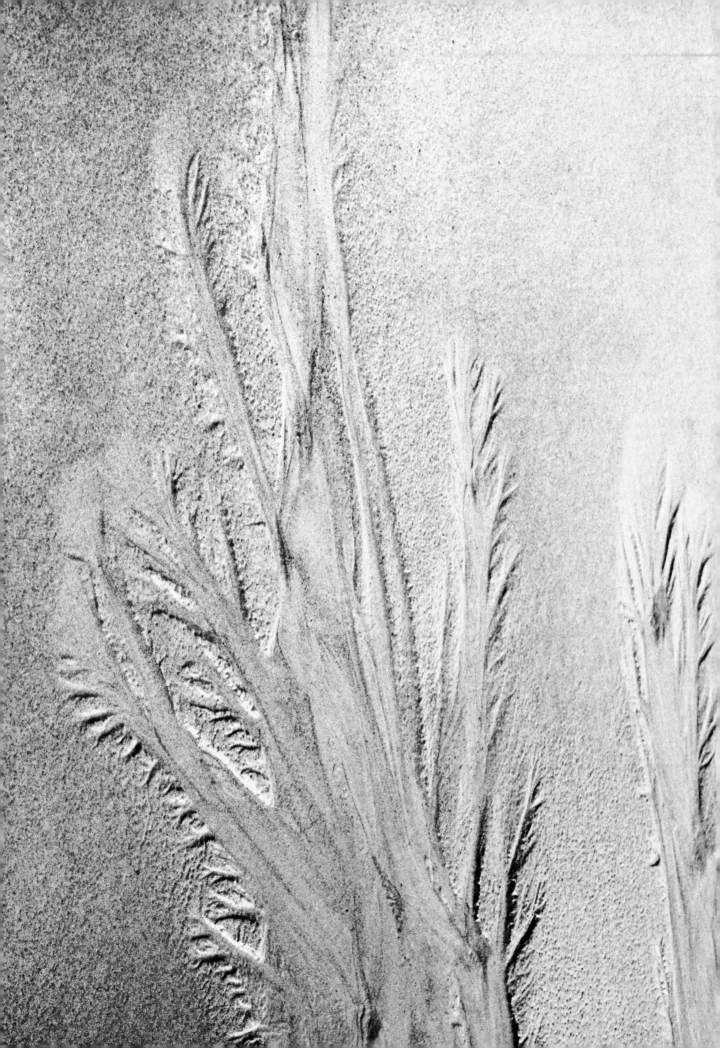

29. (Above) Branches of trees show streaming lines from the larger form—the trunk—to the smaller forms—the branches. This form grows in the reverse direction to the branching of water systems.

30. (Right) Frost crystals on a windowpane show the branching movement from the trunk outward.

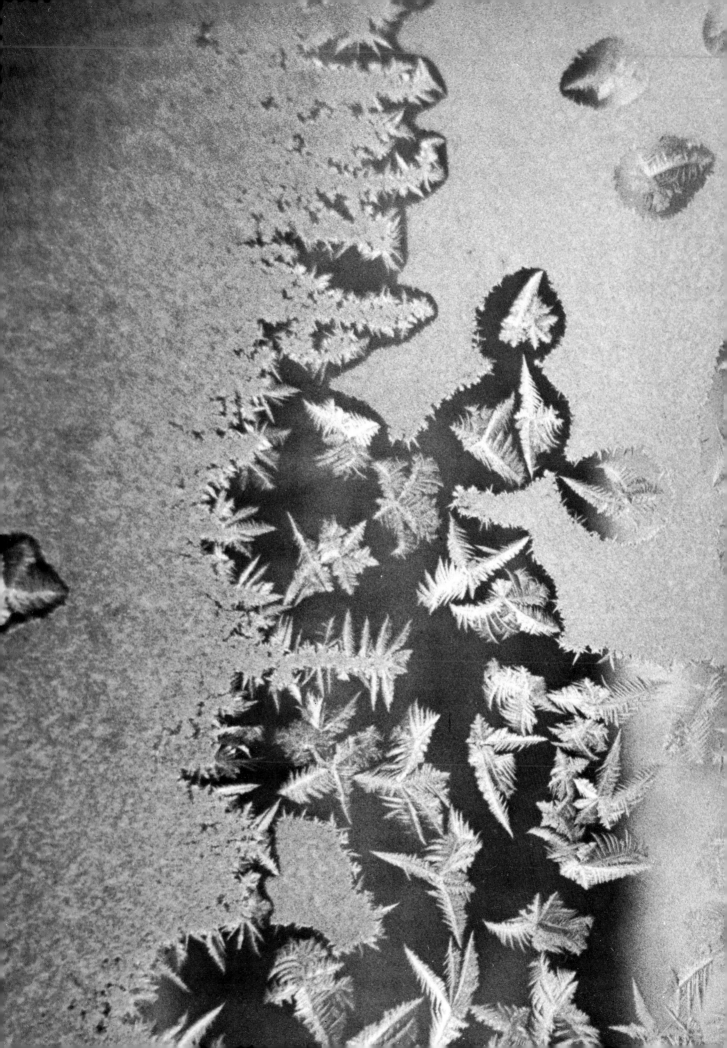

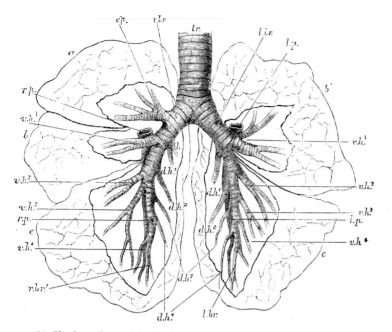
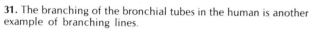

31. The branching of the bronchial tubes in the human is another example of branching lines.

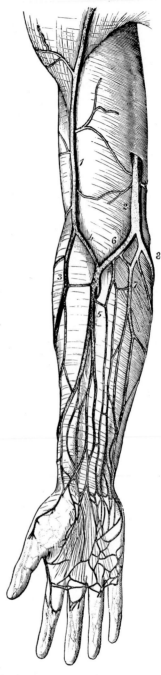

32. The veins in the forearm are another example of anastomotic network.

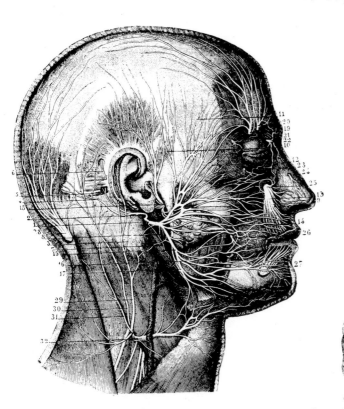

33. Human facial nerves demonstrate the anastomotic network.

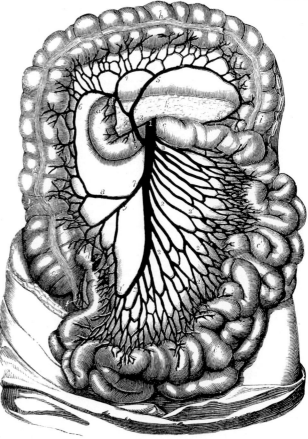

34. The superior mesenteric artery and its branches in the abdomen show a complex anastomotic network.

35. The muscular fiber of the beetle shows a linear arrangement of cells.

36. Human muscle shows directional lines of growth and structure.

the cells of skin or bony substance (Figs. 35 and 36). These lines are always secondary to the main structure lines, but have their importance nevertheless. Think of the grains of woods (Figs. 37, 38, and 39), of fibers in the stems and leaves of plants. These lines are direction lines. In nonliving nature, the molecules of crystals and metals have a grain alignment, too. I have seen old ships' anchors that have rusted in the sea for years and show grains with much the same quality as wood.

Project: This project demonstrates the importance of growth and structure lines in nature and in drawing. You need pencil and paper.

I want you to make several drawings: one of a good-size tree with rough bark; another of a large pile or rocks or boulders; and another of books piled haphazardly at various angles. But instead of using just contour lines, I want you to draw the lines of force as you imagine them within the objects. Try to imagine the lines of growth and balance in the trees and try to make your lines show the direction of the tree's life impulse. In the other objects, try to visualize the lines of structure and weight. Where there is weight pressing down, use lines to show the direction of the weight and the points of weight contact. You might even use little arrows instead of ordinary lines.

This experiment shows you that line is not used for contour alone in drawing, but may also be used to show the forces that move within an object—and sometimes even forces outside an object. If you were to draw a tree with only the contour lines, you would be unable to indicate that the tree is a living thing. So it is necessary to invent ways to show the inner happenings and meanings. With nonliving objects, you must imagine the lines of stress and compression so that you can show the invisible forces that work in and through the object.

Sometimes it is useful to think like an engineer, who must consider the stress, tension, and compression of the materials and structures in his building forms. For example, a heavy stone balanced upon an upright log presses downward along the center of gravity of the two forms; this is *compression*. If a long piece of timber is balanced on two rocks—one at each end, like a footbridge—there is compression on each of the rocks and *tension* within the timber because of the pull created by the sag of its own weight. Both compression and tension create a *stress* within the object.

In drawing the lines of growth, compression, and tension, work with the lines of levitation and gravity to make the contour lines have more meaning. The master draftsmen all show awareness of these forces in their drawings.

LINES OF BREAK, FRACTURE, AND SHEAR

Any form that nature builds can be broken or damaged. *Break* (Fig. 40), *fracture* (Fig. 41), and *shear* (Fig. 42) are ways in which forms are broken. The kind of line that results from the impact is dictated by the structure of the particular material, as well as by the kind of force it meets. There are basically two types of force that cause breaks, fractures, and shears (Fig. 43). These are *compression* (or implosion) which comes from without and *distension* (or explosion) which comes from within. The degree and type

37. (Right) This tree bark shows vertical lines of growth.

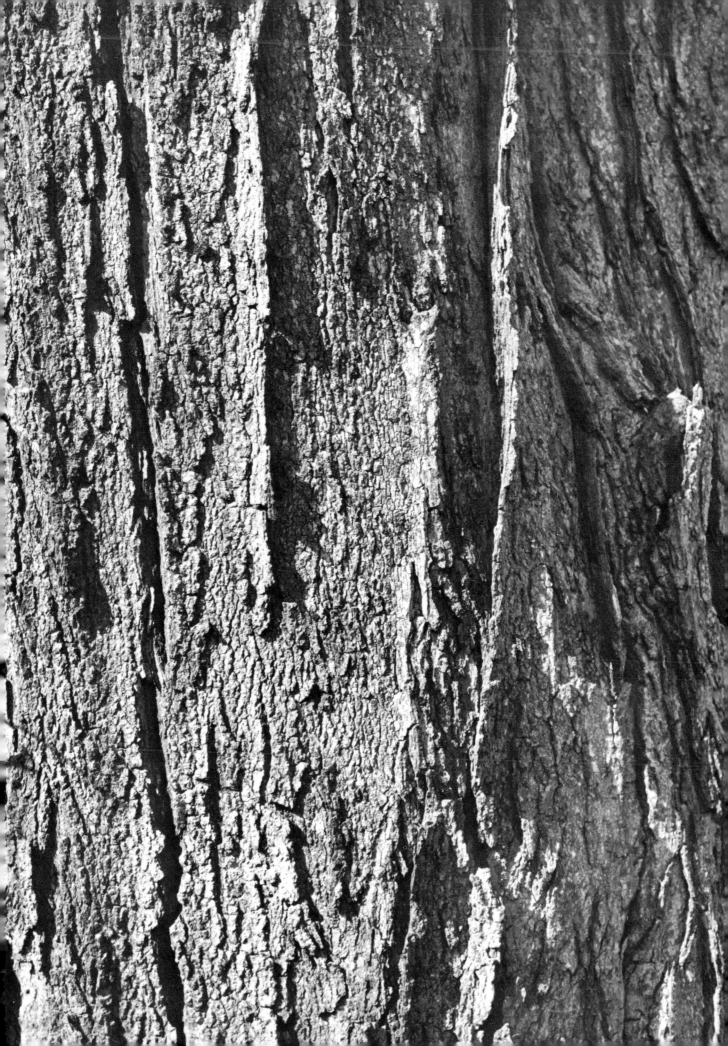

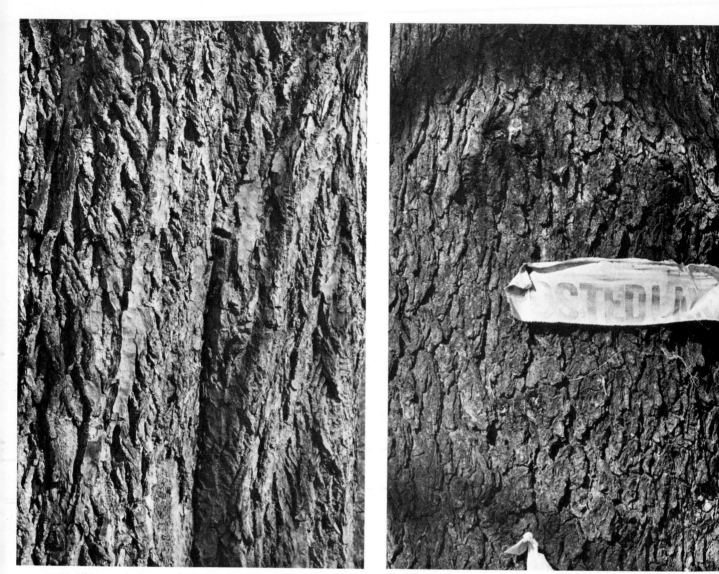

38. This tree bark also shows the expansion of growth in the horizontal breaks.

39. Weight, volume, and position are the clues given by the darkened underlines of this tree bark.

of break will vary a lot depending on the force and the material, but there are certain general patterns that we are all familiar with.

When rock is *crushed,* it is compressed between the force of the blow and the counterforce of the stability of the surface the rock rests upon. When this occurs, the substance loses all form and is reduced to powdery crystals. When a pane of glass is *shattered,* a compressive blow at one point causes the glass to crack outward from the point of impact along radiating lines; safety glass will also show that there is a superimposed pattern of circular waves of shock. When wood is broken along its grain, it shows a *split fracture* that reveals the wood's wavelike growth lines. When rock or mineral is broken along its grain, it shows a *line of cleavage* that smoothly follows the crystalline grain. When glass, obsidian, or gem minerals are chipped, they show a wavelike pattern that is called a *conchoidal fracture.* A cross-grain break in wood, stone, or metal produces a jagged, irregular break that is called a *hackly fracture.* Two forces that pull a material in opposite directions will cause a *tear,* whereas a substance is *sheared* when it is cut between two scissorslike edges.

Project: This project will reacquaint you with the linear patterns of the accidents that fracture forms. You need your pencil and drawing paper and the following tools: a hammer, an old kitchen knife, and a pair of scissors. You will also need a pebble 1″ in diameter, a piece of pine wood (1/2″ x 2″ x 2″), a small piece of plate glass (3″ x 3″), a pane of window glass (8″ x 10″), a piece of iron wire, and some cardboard.

I want you to break these materials in the manner that I describe and then draw the lines of the breaks. First, crush the rock by placing it on pavement and hitting it with the hammer (you should protect your eyes with safety glasses while you do this). Next, place the window glass on an even surface, covered with several sheets of newspaper, and give it a light, but sharp blow in the center with the hammer (here again, protect your eyes). When you are ready to split your board, stand it so that the grain is perpendicular to the floor; then place the sharp edge of the kitchen knife against the top of the upright board—1/2″ in from the edge—and give the blade a smart blow with the hammer, driving it into the grain. If the wood is dry, it should split off a piece the length of the board.

By tapping the edge of the plate glass with the hammer, you can make conchoidal breaks (use gloves and protect your eyes). To observe a hackly fracture, you can break the split-off piece of wood; you can also break the wire by bending it back and forth (examine the ends with a magnifying glass). Tearing and shearing the cardboard is so simple that I need not discuss it.

LINES OF EROSION AND DECLINE

All things come to their end, as all things have their birth and beginning. As you have seen, line can be used to show liveliness as well as immobility; it can be used to show the forms of living nature and the forms of inorganic substance. In the decline toward death of living forms, and in the erosion of nonliving forms, there are certain similarities in the effects on line. In both, there is a loss of substance and submission to the horizontal lines of gravity. This is expressed in the living form by a gradual shrinking of the

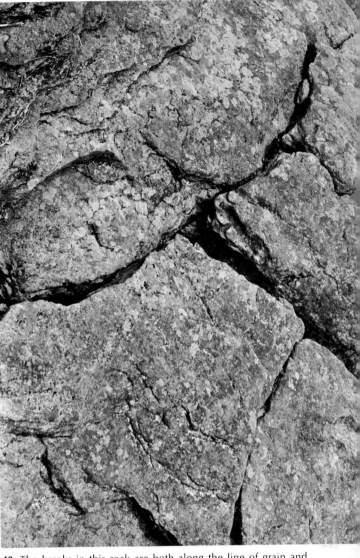

40. The breaks in this rock are both along the line of grain and across the line of grain.

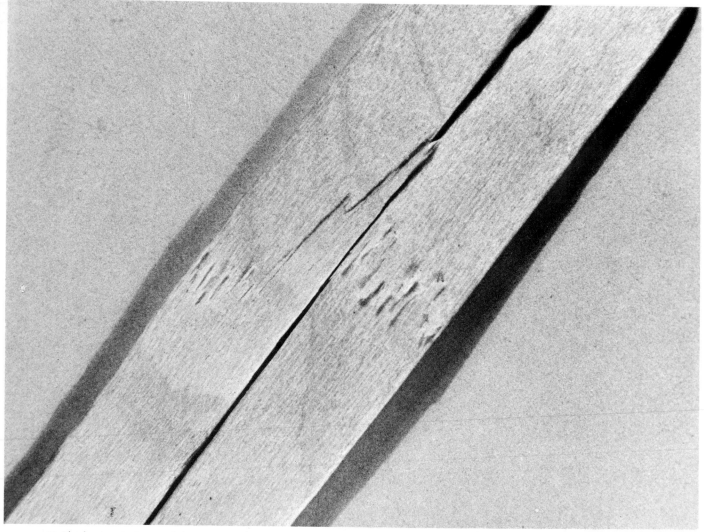

41. The fracture in the wood shows an angular pattern.

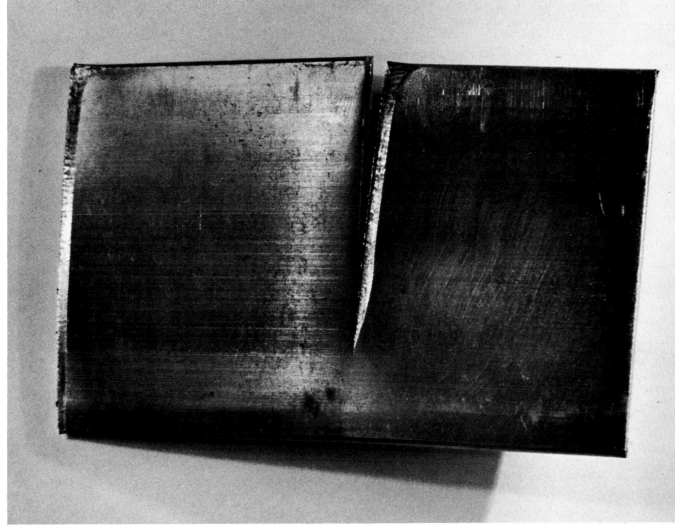

42. The shear in the metal shows crisp, even separation.

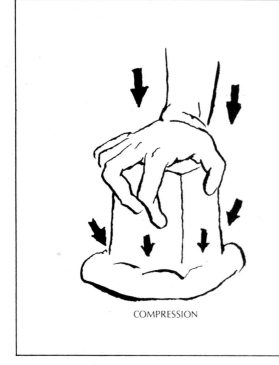

DISTENSION

COMPRESSION

43. Compression of form can be caused by several factors. The weight of an object undergoes a compression as it is pulled by gravity. A form can also be compressed by the weight of a second object as happens when a man carries a burden. Another form of compression is caused by the aging process which might be called life pressure.

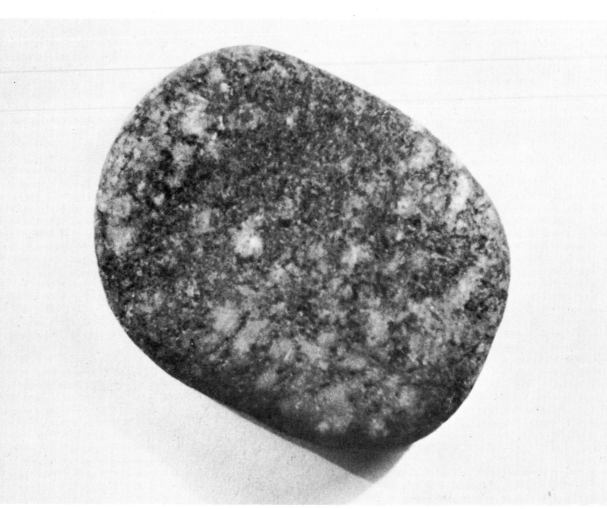

44. (Above) The common pebble is an example of a stream-eroded rock; all angularity is worn away by ages of rolling movement.

45. (Right) This piece of limestone shows cloudlike forms, clusters of crystals from which the softer material has eroded. (Compare these forms with the cloud forms and the cauliflower shown in Figs. 70-74 and 150).

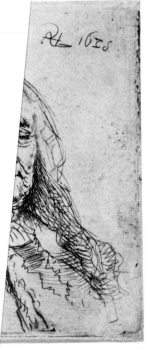

, Rembrandt van Rijn, etching.
, Rogers Fund. The wrinkles in
lasticity of the skin and loss of

decrease in volume and elasticity caused

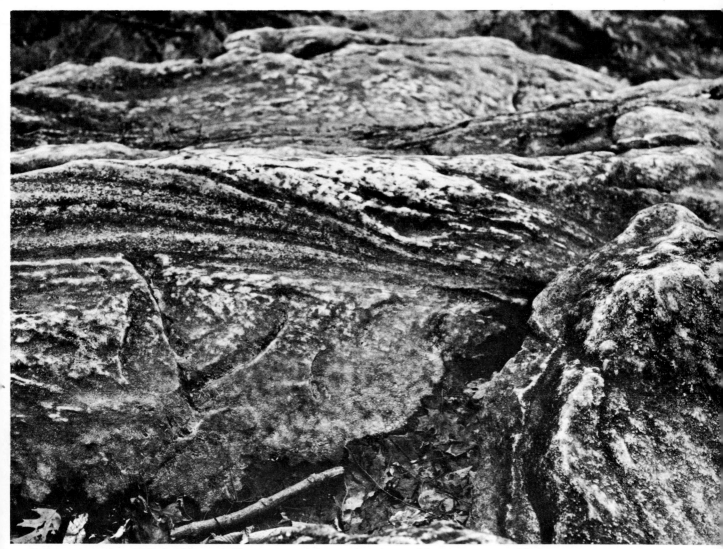

47. The streaming lines in this boulder eroded by water reveal the once liquid state of the stone and its stratified structure.

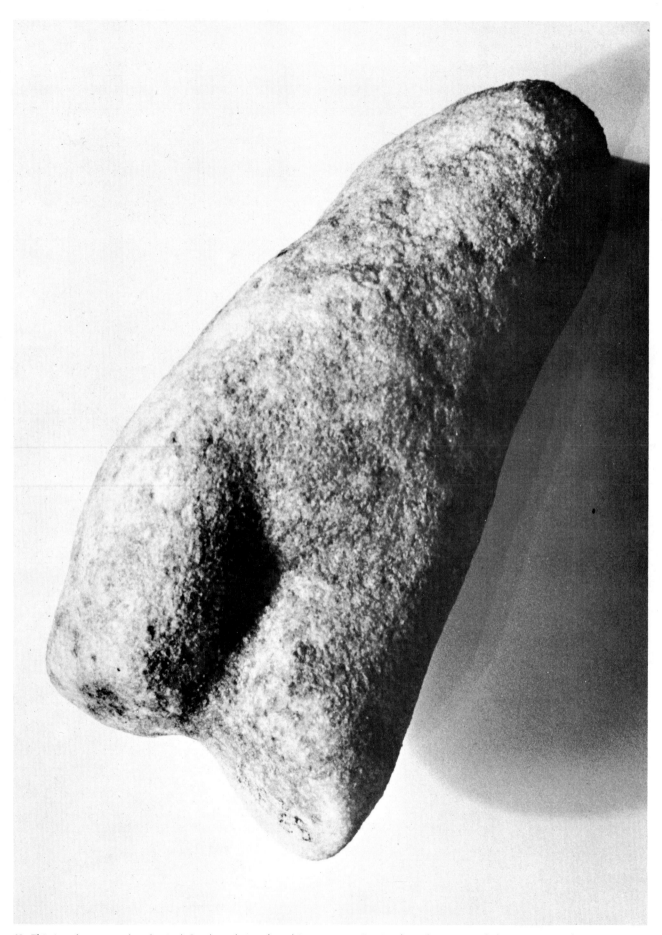

48. This is a fragment of a classical Greek sculpture found in a stream. Erosion has almost erased the carver's work.

3. Form, Shape, and Mass

There are many categories of form in nature and within them there is much variation. There is so much variation in natural forms that it is hard to believe that forms have much in common. So the best way for us to begin to understand form is to discuss the ways that make it possible for artists to classify things into series of relationships. Drawing concepts like form, shape, and mass enable the artist to understand nature's creations. Of course, you have heard these words before, but you have probably heard them used interchangeably, without any clear idea that each of these words has specific meaning in art. So we will begin by discussing the artist's definition of these words and then go on to discuss their practical use.

The word *form* describes an entity that has a meaningful structure, a thing that generally stands by itself, such as a human, a tree, a horse, a fish, or a microorganism—in the case of manmade things, a boat, a building, a book, or a piece of sculpture. A form in nature is a thing that is built on a pattern that is repeatable. In the case of manmade things, it can be a mass-produced object or an original one-of-a-kind creation. In forms of nature such as animal or human forms, the cells, the bones, organs, and fluids all blend together to form a united creature, all of the parts being inseparable from the whole. In manmade forms, though the parts can often be separated—like a carburetor being removed from an engine—there is also a unity and usefulness. In contrast, a lump of clay is only a lump of matter that may be altered by pressure, but it gains form when the sculptor works it into a form that expresses his intentions.

The word *shape* is a much broader term, less definite than form. Think of a group of people; all have the same general form. It is in their shapes that they differ: fatter, leaner, taller, shorter. More closely, the *shape* of a thigh can be altered by being pressed against a chair or by the tension and relaxation of different muscles, but its form will remain the same unless the whole structure is damaged. The clay mentioned before has accidental shape until the sculptor gives it a meaningful form. Or a granite fieldstone may have a round shape caused by weathering and rolling in a stream, but its form resides in its crystalline structure and grain.

To know the form of a thing requires that you know considerably more about its meaning and purpose than just its outer appearance and shape. So you see that there can be a wide range of possibility and difference between one artist's understanding of form and another's. An artist's grasp of form can be either shallow or deep; it is a matter of his patience in the study of nature and his innate intelligence.

Understanding shape is less complex than understanding form, but to understand shape still demands trained skill and intelligence. The artist learns to feel out shapes with his eye and hand and to coordinate both in the act of drawing. Doing this develops his sense of proportion and his sense of geometry. Both senses are natural capacities that are part of the functioning of his organism which can be expanded with training, practice, and intensive study (Fig. 51).

The three words *form, shape,* and *mass* can be easily visualized if you think of a globe of the world with raised mountains which is used in geography classes. The complete globe is a form; the continents are shapes; and the mountains are masses on the shapes (Fig. 52). *Mass* can be looked upon as the swelling or accumulation of substance or, at times, groupings of things. For example, the form of the human figure is composed of individual muscles and series of muscles that possess shapes, but in movement these muscles interact and create temporary bulges or *massings* on the surface of the figure.

In nature, everything overlaps and one thing runs into another; there are not always clearly defined boundaries. This is why it is important to use these three concepts in your drawing. It is also the reason why the three words are generally misused or used interchangeably by almost everyone. The artist must become skilled in the use of these concepts because they make it possible to define what he is drawing, so that he can control his drawing of the forms of nature to make them skillfully clear or even, in some cases, skillfully indefinite.

Project: This is an exercise in seeing. The purpose is to accustom you to think in terms of form, shape, and mass. You must train yourself to look for these three categories as you go about your business during the day. I want you to look at everything and analyze its form, its shape, and its mass.

You will find that certain things are very easy to classify and that others are very confusing. Some forms have very simple shapes, while others will have so many shapes that the over-all form is almost hidden. The tendency for beginners is always to fuss with little details rather than to look for the large important shapes. For example, if you are drawing a chest of drawers, the knobs and the decoration are not as important as the over-all cube or rectangular shape. The over-all shape should be considered first and, following that, the shapes of the drawers, *then* the position of the knobs and decoration. But practice looking first and do not draw. This is important because it is always necessary to think these things out before you even put your pencil to the paper.

51. *Canon of Proportion after Vitruvius* (Left), Leonardo da Vinci, pen and ink, 13 1/2" x 9 5/8". Academy, Venice. The artist uses the innate feeling of geometry which is inherent in all human beings.

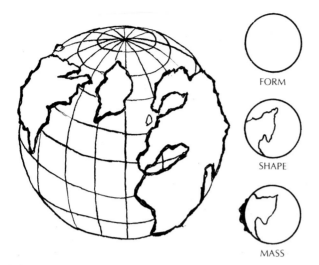

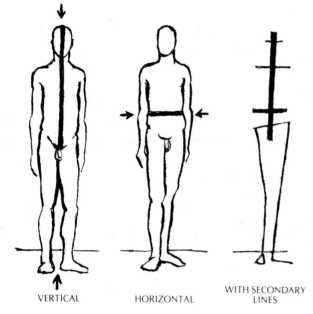

FORM

SHAPE

MASS

52. The globe used in classrooms illustrates the concepts of form, shape, and mass.

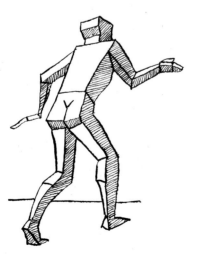

VERTICAL HORIZONTAL WITH SECONDARY LINES

53. This diagram demonstrates the natural coordinate planes which are areas of awareness and feeling of the body.

54. This drawing demonstrates our awareness and feeling of the body's front, back, and sides. (After Cambiaso)

OUR INSTINCTIVE SENSE OF GEOMETRY

We have talked about the way we classify things into form, shape, and mass. Now we must consider some of the basic shapes and what enables us to understand them. The artist is not necessarily a good mathematician, but he develops an instinctive sense and feeling for shapes, angular relationships, and proportion. The artist develops a good sense of geometrical order, he does not force nature into a tight geometrical box, because he knows that if he did he might produce something that is more like an engineering drawing than a work of art. The artist's geometry is not the geometry of drafting board, compass, T-square, and triangle.

The artist uses the basic geometrical functions that are built into the human body. These built-in functions preceded the discovery of formal geometry and are a natural part of all men's reasoning. In Chapter 2, we learned how we see all things from the built-in awareness of the plane of gravity and the line of levitation. It takes no effort to see that gravity and levitation also give us the necessary elements for a natural built-in right angle. In seeing, feeling, and understanding shapes, we have some additional natural endowments. We have a central core—a plane or axis running right down our middle—an anatomical line that divides our two-sided body. Our own core guides us to look for the core, axis, or center plane of anything we see. In addition, we have our own equatorial plane of feeling right at the navel that divides our top half from our lower half (Fig. 53).

In geometry, the concept of a center axis is basic. The concept of coordinate planes is also very important; there are three planes that divide a form at right angles to one another. The globe is divided in this way, with two vertical planes slicing through the north-south axis at right angles to each other, while the third horizontal plane slices through the equator at right angles to the other two. In addition to the natural coordinates, we are aware of front, back, and sides in the trunk of our body; so we are well on the way to a very nice sense of the cube and rectangle (Fig. 54).

The artist relies on the inner feeling of these things to judge his forms. He projects these inner feelings into the objects that he sees and this extension of his feelings helps him to comprehend the shapes in the external world.

Let us go a little further to find more factors in this natural geometry. We see that our arms and legs are joined in such a manner that they can function at any angle from about 180° through 90° and down to about 10° Arms and legs are jointed in such a way that they can be moved in arcs, circles, and globes. Two arms working together can make squares, angles, and embracing circles.

In practical use of this inner geometry, the artist feels the position and shape of the forms he sees. If he is working from a landscape, he uses the basic geometrical shapes to approximate the actual shapes of trees, rocks, and land masses. If he works with human figures, he tries to find simple angles or curves to enclose the shapes along the axis and skeletal framework of the figure. He uses the geometrical shapes as boxes to contain the real forms as he adjusts his composition.

A tree might be considered as an oval on top of the line of its trunk axis; a boulder might be considered as a rectangle or an ellipse. At first, the artist mentally simplifies

forms so that they may be placed in their proper spatial relationships to the plane of gravity and the line of levitation (Fig. 55). Once this is done, he spends more time in analyzing and drawing the *real* forms with their meanings (Fig. 56).

In completely abstract geometrical art that does not refer to nature, these shapes and directional lines are used in their pure sense. This kind of art *does* deal with real things in that the shapes and directions emerge from the artist's inner geometrical sense and the feelings of balance, direction, and weight as in the paintings by Albers and Mondrian (Figs. 57 and 58). This art limits itself to a very narrow area, but it *is* art and it is through the work of the geometrical abstractionists that we achieve our understanding of the inner geometry.

Project: The first half of this project deals with feeling shapes within your own body. In the second half of the project, we will translate these feelings to the drawing page.

First, make angles with your arms and legs, going through the whole range from obtuse to acute. Pay attention to the feeling. Next, by tilting your head to one side or the other, feel the angle you make by pulling out of line with the right-angle line of levitation and plane of gravity. You can get a clearer idea of this feeling by standing in one spot and leaning your entire body.

There are other shapes that you can make. By bending your torso forward, you make a curve with your spine. You can make a square by using both of your arms held out from your body with your elbows bent and hands touching. By relaxing your arms a little, you can make an embracing circle. With your hands and fingers, you can make many shapes including triangles, squares, circles, open-ended cubes, and globes. You can probably invent a few more too.

All of this will make you more aware that our understanding of shape is not gained by the eye alone, but is a product of the entire body. Even though you might be a little unbending at first and think of this as child's play, you will get into the swing and the feel of it if you stop to think that the free and imaginative play of children is a natural way of learning about the world. In experimenting with this kind of feeling and movement, we come to the area where music, dance, and drawing meet.

Now we deal with the special ways that artists translate these feelings and movements to the drawing page.

This is what I want you to do: on separate sheets of paper draw all of the shapes that we have discussed. Make them large enough to fit into a 5" square. Once you have made a circle, square, triangle, rectangle, and some open angles, set them in a pile before you. Now, go over these shapes one by one and duplicate the drawing movement with your arm, the entire arm swinging from the shoulder joint. Observe carefully the way your arm moves when you draw each shape and note the feeling. Once you understand your arm movement, note the feeling in the rest of your body. You will find that there are very definite internal feelings with each of these basic shapes.

Just as you can make these movements with your entire arm, you can also bring these movements to a fine focus by drawing with your hand and fingers alone. It is best to begin with the shape feeling in the entire body and let this move into the arm and on into the hand. Beginners often

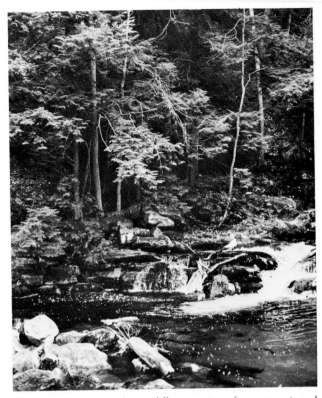

55. This photograph shows different rates of movement and growth—the dynamic elements of landscape.

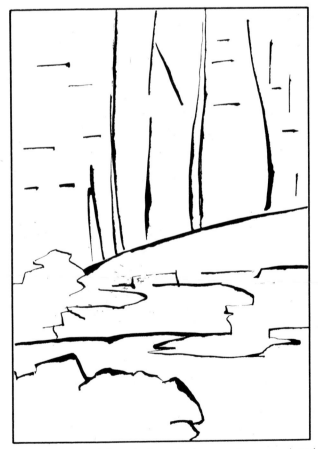

56. The horizontal lines indicate both unmoving ground and moving water, while the vertical lines represent trees of various ages; the diagonal represents the tilt of the land, which can be considered as land in movement toward the plane of gravity.

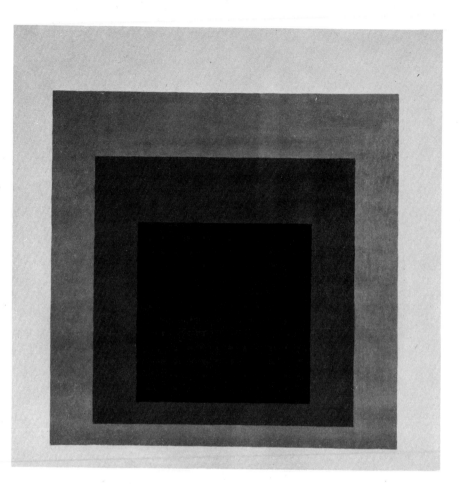

57. *Homage to the Square, Silent Hall,* Josef Albers, oil on composition board, 40″ x 40″. Museum of Modern Art, Dr. and Mrs. Frank Stanton Fund. Albers' painting stresses a geometric volume and a geometric space, which is devoid of life and atmosphere.

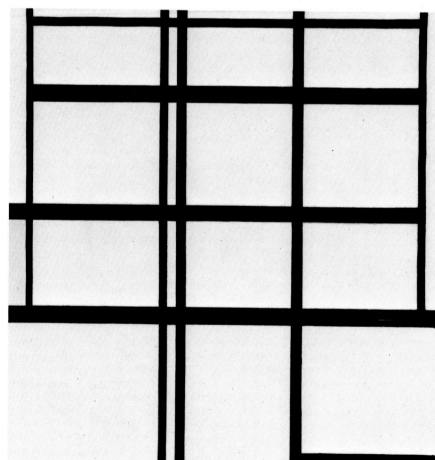

58. *Composition in Yellow, Blue and White, I,* Piet Mondrian, oil on canvas, 22 1/2″ x 21 3/4″. Museum of Modern Art. Sidney and Harriet Janis Collection. Mondrian's work stresses the grid form and linear geometry to the point that curving movements of life and atmosphere are eliminated.

hold back out of fear and shut off the larger feelings of form by trying to squeeze them all out of their fingers. Just as they tend to fuss with the details rather than the large shapes, they tend to make little squiggly movements. So, open up the window and let out some of your inner music!

GOING BEYOND GEOMETRY

Paul Cézanne once made the much-quoted statement that all nature could be reduced to the cylinder, the sphere, and the cube. He was right in the respect that an artist cannot function without a strong internal sense of geometry. However, these geometrical shapes serve only as temporary boxes in the process of realizing the more profound shapes that nature creates. It is interesting to note that Cézanne continually expressed great agony in his struggle to "realize."

Geometrical shapes, when compared to the shapes of nature, are extremely shallow in their range of expressiveness because the forces and functions from which geometry stems do not reflect the deeper vitality and variation of moving and living energy systems—expressions of nature that grow, breathe, and show awareness. But the most meaningful aspects of art are concerned with animation, character, and expressiveness. In order to make geometry come alive, it is necessary to add other factors.

In drawing, once you have decided upon a geometrical shape that estimates the over-all shape, height, width, and position of an object, you have to find the ways that the form deviates from this rigid ideal. In finding the variations of shape, you begin to bring out the true nature of the object. Every single thing in nature is slightly askew, even the crystal forms that are nature's most rigid creations. The tree that you first regarded as having an oval shape resting on the straight line of its trunk will be robbed of life if it is left that way. It is necessary to find the real over-all pattern of form and the smaller shapes and movements within the tree if you are to make a drawing that is vital. The same is true of the boulder that you began by treating as a rectangular geometrical box. In its smaller masses you find the eroded curves, the hollows, and the directional grain that show the rock's origin and history.

Of course, these smaller masses and irregularities also have geometrical shapes and the artist's geometrical sense is used to place them correctly within the larger shapes. But at this time there is something else that comes more strongly into play. You might call it the element of touch. The larger shapes are always defined with simple straight and curved lines at the beginning, and these lines emerge from our bones, our more rigid anatomical structure. But giving character by adjusting shapes, massing, and modeling has a feeling that is softer, more yielding, and tentative. This feeling is soft and fleshy and emerges while you draw in the feeling of patting, fondling, and caressing—or even hitting, pushing, and pulling. These are the tactile sensations that emerge from our own fleshy, muscular structure.

The touch and modeling of the artist's hands represent his human emotional response to the subject. It is in this sense of touching in the process of drawing that the artist's personality is fused with the subject. This, combined with his feeling for the character of the subject, brings life to the drawing.

You must realize that nature constantly touches and caresses or wears upon and assaults objects and creatures. It is only in developing your own sense of touch that you are able to translate the touchings of nature to the drawing page. The weathered surface of a stone, the lined furrows of an aging face, and the radiating roundness of a baby's bottom or a peach cannot be discovered or told by a dry, impersonal geometrical calculation.

Project: First of all, you must forget the admonition that is the curse of small children and young lovers—"Do Not Touch." By all means, touch with your eyes and your hands anything at all that attracts you—with the exception of poisonous snakes, disagreeable people, high tension electrical wires, and radioactive substances. Part of drawing a thing correctly has to do with transmitting the feeling of the thing, and the purpose of this project is to work with your sense of touch. This is a matter of the feeling within your body as you draw and the attempt to transmit this feeling to the lines that you make.

Select a series of objects such as a ball of cotton, a peach, a block of stone, and a stick of wood and try to draw into them the qualities that you feel. Take as much time as you need. I suggest that you think in terms of line weight, using lighter lines to suggest lightness and heavier lines to suggest more mass. Draw with pencil on paper.

Doing this is a matter of practice, and there is no exact advice that can be given to help you develop this sense other than to describe the goal.

CATEGORIES OF FORM IN NATURE

Almost everyone has played the game "animal, vegetable, or mineral" in which one person thinks of an object and the other players try to find out what it is by asking questions which narrow the possibilities. This game is founded on the basic families of form in nature, possessing qualities that make each one tangibly different from the others. If this were not true the game would never work. Both art and science share a similarity to this game.

On the one hand, science is a game played with very exacting rules, the object of which is to weigh and measure the functions of nature. Science has divided the whole universe into realms of study such as astronomy, physics, chemistry, biology, etc. These sciences have uncovered a vast array of facts about nature. The artist, on the other hand, also looks at all of nature, but with a different eye; he seeks feelings and personal affinities as well as facts. In learning to draw, the artist tries to find the common qualities that all things share so that he will be able to draw anything that he encounters. He may even study science to find the keys to these mysteries of form.

Like science, art also separates nature into categories of form. But these categories of art differ from those of science; they are less precise and less measured, or—as the scientists might put it—art is qualitative while science is quantitative. These two fields sometimes overlap and you will occasionally find a scientist who is very intuitive or an artist who has the ability for precise analysis. As a matter of fact, a good deal of what we know of form today is the result of scientific study that has been re-examined with the artist's eye.

In all, artists divide nature into seven realms; five of these realms are very similar to the "animal, vegetable, or mineral" series, but are more comprehensive. They are the

aerial or atmospheric forms, the liquid or water forms, the solid or earth forms, the plant forms, and the forms of living organisms. The two remaining realms relate to all of the others as they are a central part of their nature; these are the creative forms of pure energy and the realm of death, decay, and disintegration. To list these forms in their proper order, they are: (1) energy forms, (2) atmospheric forms, (3) water forms, (4) solid forms, (5) plant forms, (6) organic forms, and (7) disintegration forms.

This order is somewhat different from the order of the realms of science since it is esthetic and emotional, but in this sense it is very exacting and has very deep meaning. As we proceed through these categories the meaning of the order will become clear.

FORMS OF ENERGY FIELDS

When we attempt to draw the forms of living things, trying to encase the great capacities of life that is in them, we become aware of some intangible quality that animates the world of nature. Try as he may, the most difficult thing for the artist to do is to capture the energy of life. Life surrounds us everywhere; it is in the air we breathe and in the rain that falls, yet it is elusive and seemingly invisible. The invisibility of energy has haunted the artist for millennia. But in our time, science has opened the realm of energy and has made many energetic forms visible that were formerly seen only with the artist's intuition.

In earlier times, the most obvious visual expressions of energy were lightning, storm, and fire—all very fearsome and overpowering. But there were also other expressions of energy that were just as powerful but gentler, subtler, and quieter. These were birth and growth, sprouting and blossoming. Feeling some force behind all these things, ancient man developed pagan gods—mythical forces to name and personify what he could not see. Only after centuries of searching have some of the *real* and invisible forces come to light.

Until the discovery of the telescope in 1608—which made visible stellar radiations, cosmic clouds, and the swirling galactic forms—man did not become acquainted with patterns of the great energy forces. It was William Gilbert, the physician to Queen Elizabeth I, who discovered ways of making the earth's magnetic field yield its invisible pattern. When we consider the thousands of years of human development, these are discoveries that are as recent as the space flights that have made visible the earth's vast weather patterns.

Though these forms have seemed to be the special province of the scientist, they are of the utmost importance to the artist as they represent the purest primary expressions of form in nature. The basic forms of energy serve as the patterns—and combinations of pattern—for most of the creations of nature.

Photographs of the swirling galactic forms, cosmic clouds, and the earth's weather patterns bring these gigantic events down to human scale so we can study them, but it is important to keep the vastness of these things in mind. This is always a problem when we study things through the secondhand medium of the photograph. However, an unusual and valuable firsthand study can be made of the magnetic field—the next project. This is an example of a basic energy form that can be made visible and can be felt through simple experiment. As this

is a form that permeates all of nature, the study of it gives us a keener sense of the true nature of those forces that are beyond our immediate perception.

There is a definite relationship between all of these forms that is important to note. We have already seen that the galactic form is a variation of the spinning wave and have examined the linear and circular forms of radiation. The form of the magnetic field has some relationship to both. Seen from the side view (Fig. 59), the magnetic field appears to be constructed of a series of spinning waves, while viewed from either end it bears a striking relationship to the radiation patterns (Fig. 60). Though these may seem at first to be only interesting coincidences, they show the artist how simple and yet inventive the forms of nature can be.

The form of the magnetic field is extremely versatile in that it contains most of the basic forms of geometry: an axis, triangular shapes, cones, circle and ellipse, longitudinal lines, dividing planes, etc. (Fig. 61). In addition, it has some of the basic characteristics of living forms in that it has a head-to-tail directional organization, a fibrous structure, internal loopings, a life span, and a soft, cushiony feeling that is very much like flesh (Fig. 62). Two magnetic fields can superimpose to become one field or can join by segmentation to form a long series (Fig. 63). This form is about the best teaching device because it has so many fascinating, meaningful, and yet mysterious qualities. It is the ultimate in meaningful abstraction.

Project: This project will enable you to see, feel, and draw the magnetic field. It will take a little time because you will have to send away for the proper materials. I recommend sending for these items because the common horseshoe-shape magnets or long bar magnets distort the shape of the field and obscure it in such a way as to make it impossible to see clearly. It is important to use a magnet that will duplicate the shape of the earth's magnetic field.

Purchase from Cenco Scientific Supply (1700 West Irving Park Road, Chicago, Illinois) two No. 78292 bar magnets (1″ x 3/4″ x 1/2″) and a container of No. 78395-2 iron filings. These items should cost about three dollars. In addition, you will need a 12″ x 18″ pane of window or picture glass, which you should have no trouble finding around the house.

To set up the experiment, tape a piece of white paper under your glass and find a couple of books that will support the glass 3/4″ above the table surface. Place one magnet under the center of the glass and sprinkle the iron filings on the glass above it. As the field becomes visible, tap the glass lightly to clear the pattern. When you have drawn the field pattern seen from its side, sweep off the iron filings, position the magnet on its end, and re-sprinkle the filings so that you can examine the pattern of one pole at a time. Once you have drawn this, draw the patterns of the two magnets in various relationships by taping them to the table surface.

To feel the form manually, hold a magnet in each hand and feel the pull of the magnets. Use the field of one

59. (Above right) The magnetic field, seen from the side, shows the spinning wave structure.

60. (Below right) The magnetic field, from one of the polar ends, shows the radiation of energy into and out the other side of the core of the field.

MAGNETIC FIELD

ELLIPTICAL FORMS

RADIAL LINES (POLAR VIEW)

CIRCLE (POLAR VIEW)

TRIANGULAR FORMS
(POLAR VIEW)

AXIAL LINE

CONIC FORMS

BASIC UNIT OF THE
MAGNETIC FIELD

61. These are some geometrical forms created by the magnetic field.

LONGITUDINAL COMPRESSION
OF A SINGLE FIELD

LONGITUDINAL COMPRESSION
AND SEGMENTATION OF SEVERAL FIELDS

POLAR COMPRESSION
RESULTING IN RADIAL FORM

62. These forms demonstrate the relationship of the magnetic field to the structure of organisms.

63. The "arms" of energy of the magnet of the right lock into those of the magnet on the left going in the same direction, and the two are drawn together.

magnet to follow the form of the other. Pay careful attention to the direction of the field and the soft, fleshy quality. I am sure that you will agree with me that this is one of the most interesting forms in nature. As you draw the field, try to interpret these qualities that you have felt.

AERIAL AND ATMOSPHERIC FORMS

The atmosphere of the earth is so much a part of our lives that we walk through it and breathe it without remembering that it is there. The earth's atmosphere is part of the great magnetic field that surrounds and penetrates our planet. Knowing the magnetic field enables us to visualize our atmosphere's form. We have had firsthand experience with the field. You must always keep the shape of the magnetic field and its layers in mind as you try to visualize the atmosphere.

Air moves and you can feel it. If you consider your own breathing and make it conscious for a moment or two, you will be reminded that air does have substance and form. You can observe this form in a number of ways and one is by watching cigarette smoke curl and spiral in dreamy rhythmic waves (one of the dubious pleasures of smoking). Another way is when your whole body feels the atmosphere as you walk and run through it. Children are particularly aware of the feel of the atmosphere. If you think back to your childhood, you will remember puffing your cheeks and blowing your breath at leaves or feathers or the down of the thistle. You will remember twirling and running through space for the sheer pleasure of the feel of the air. Even on days when you were sick in bed, you watched dust motes swirl and dance in a shaft of light. Air has form!

There is another aspect of the atmosphere that is often forgotten and this is sound. We tend to look on sound as something that emerges from a mouth or a radio that jumps directly to our ear without any relationship to the space between. It is only upon reflection that we remember the waves of sound follow the pattern of circular radiation. But drawing, painting, or sculpture does not deal with sound in the ordinary sense. Sound in the visual arts is conspicuous by its absence and is a thing that is suggested rather than produced directly. There are some fine Gothic sculptures of saints at the front of the great cathedral of Toledo, Spain, that not only seem to be listening to the words of Christ but hearing them also.

So the things that are not directly said by art can still be important. If you bend the trees or the grasses in a drawing, the unseen wind is suggested and seems visible.

CLOUD FORMS

Of the visible atmospheric forms, the first that we think of are clouds. In considering the forms of clouds, we have to find ways to understand them that we can memorize because these forms are constantly changing—appearing and disappearing. Clouds are borderline forms between the invisible forms of energy and the visible forms of matter.

First, we consider the structure of the *place* in the atmosphere where clouds form. In this, the shape of the magnetic field is very useful to us as *it is* the shape of the earth's layered atmospheric field; it shows the layering that parallels the earth's surface just like the "ceiling" height of cloud formations. Depending on the weather and the season, clouds can form very close to the ground or at a few hundred, or a thousand, feet above the surface, and on up to several miles. There are, on occasion, clouds that form as high as thirty miles in the stratosphere (Fig. 64). But to the artist, the evenness of the layering is most important. Anyone who has done much flying has noticed that the undersides of cloud formations are often as flat as the ocean's surface on a calm day. The tops of clouds rise and swirl upward with a lot of variation, but in most cases the upper border of the whole formation is surprisingly even also.

Another way that the magnetic field is useful to the artist studying cloud masses has to do with the fibrous lines that go from pole to pole. We can often observe that cloud formations show a linear direction that strongly repeats this north-south line (Fig. 65). Sometimes this series of north-south lines is very clear and straight; other formations show wavy north-south lines that very much resemble water waves. As weather moves from the west toward the east, the cloud formations cross the north-south lines of the magnetic field at right angles so there is actually an invisible gridwork of forces in the atmosphere that governs cloud formation (Fig. 66). Although clouds do occasionally show this pattern clearly, they travel more frequently in scattered clumps and constantly changing wisps. Even these shapes can only be organized if we use the concept of the grid and of atmospheric layering.

There is another weather pattern that has been photographed by the astronauts of Apollo 8 on the return from the moon. This is the great cyclonic pattern of cloud formations that occurs in both the Southern and Northern hemispheres. In form, this vast weather pattern is an exact duplication of the two-armed, spinning galactic form. This form is a natural outgrowth of the energy stream of the planet's orbit which moves from west to east and crosses the north-south structure of the magnetic field at right angles. The orbital force moves the atmosphere along, while the longitudinal structure of the magnetic field tends to hold it in one place, which helps create a spinning movement toward the poles. This explanation is simplified, for there are other complex forces at work. This great weather form is useful to the artist since it is the secret of making the invisible wind becomes visible. Even small gusts of wind move in this swirling fashion.

Wind patterns and cloud patterns have a direct relationship to one another as cloud patterns are accumulations within the moving atmosphere that are modeled both by forces within and by the winds surrounding them. Watching patterns of smoke (Figs. 67, 68, and 69) and steam is an extremely useful way for the artist to study the creation and disintegration of atmospheric forms. Because these forms change so rapidly, photographs can be used to study the movement for a beginning analysis. You will find that these forms move in spinning waves which invaginate—or turn in—upon themselves. If you begin by tracing these patterns from the photos and committing the movements to memory, you will find that it is much easier to observe the actual event.

It is simple to apply the same procedure to cloud formations. You will find that the cloud forms change at a different time rate. The forms move and change in the same patterns as smoke and steam, but as though the change were being shown in a slow-motion movie. Time-lapse motion pictures show that the movement of clouds is very much like the movement of smoke, except that clouds move into their own form while smoke swirls in spinning

64. The great weather patterns of our planet swirl in the same huge movements as the galaxies.
(Courtesy of the National Aeronautics and Space Administration)

SEEN FROM SPACE

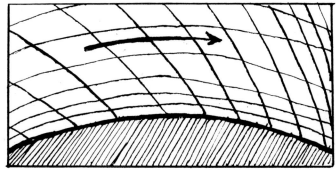

SEEN FROM THE EARTH'S SURFACE LOOKING UPWARD

66. Two views of the invisible forces that create the atmospheric grid form.

65. (Left) These clouds over New York show the north-south direction as well as a flattening of the undersides.

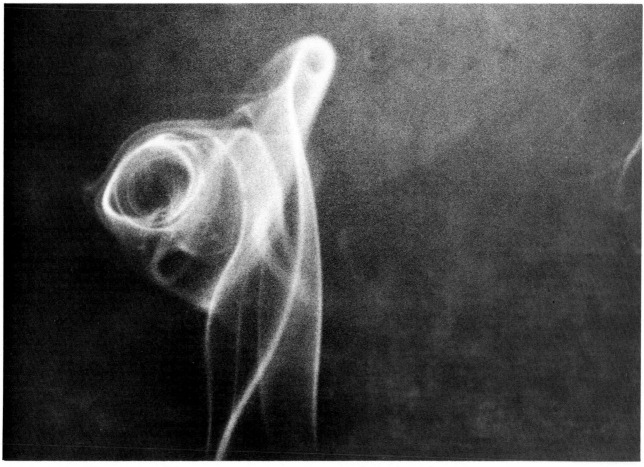

67. Watching smoke patterns or studying their movements in photographs is a good way to understand the creation and disintegration of atmospheric forms.

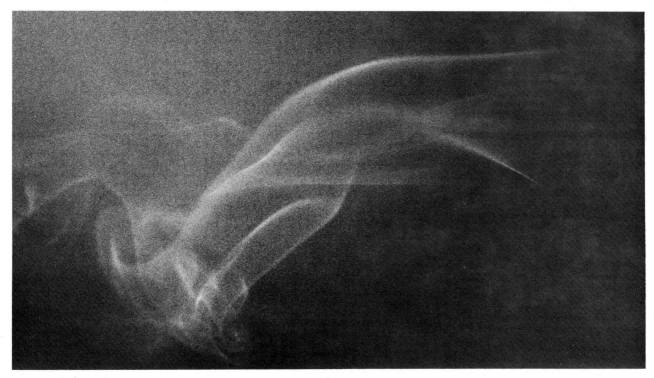

68. (Above) If you study photos such as these, committing smoke patterns to memory, you will find it easier to study the actual event.

69. (Right) Smoke patterns show the spinning wave movement in the atmosphere.

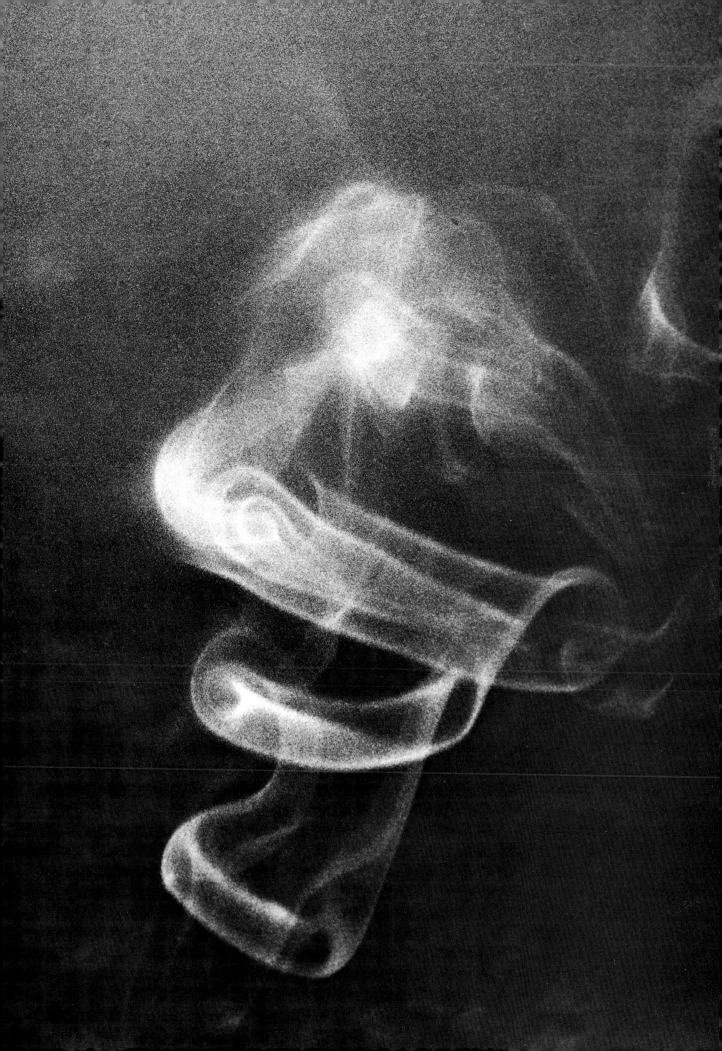

70. There is a double layering of cloud formations in this picture.

waves until it eventually dissipates and loses all form. You can observe form changes in smoke in a matter of seconds while it is necessary to watch a cloud for at least fifteen minutes if you are to see any major alterations in shape.

No two clouds have quite the same shape, but there are some general patterns that do apply to them all. Weather scientists and artists have classified clouds into four basic categories. These are four forms that are distinctly different from one another, but also interpenetrate to create secondary forms.

The high feathery and fibrous clouds are called *cirrus* clouds (Fig. 70). The fluffy clumps of clouds that grow upward from a more or less flat base are called *cumulus* clouds (Fig. 71). The clouds that form in shapes of flat sheets or layers are called *stratus* clouds. The big towering rain clouds are called *nimbus* clouds. When these forms combine they are called cumulo-nimbus or cirro-stratus, etc. (Figs. 72 and 73).

Ordinarily when we think of the cloud form we think of the cumulus. This shape is built up of the typical puffy curves that move slowly inward in spinning waves to create interlocking invaginated shapes. In the huge cumulo-nimbus rain clouds, the whole internal movement of the cloud is in the form of a magnetic field with its axis pointing straight upward along the line of levitation (Fig. 74). Stratus clouds relate to the magnetic field too in that they are thin layers above the earth like one of the layers in a Bermuda onion. But all of the cloud forms, when examined very closely, are somewhat fibrous in their structure and similar to anastomotic lines.

In recent times, there has been a tendency for artists to ignore the atmospheric forms, but there are a number of abstract painters whose forms do stem from atmospheric feelings and insights. Chinese painting in the greatest periods touched these forms most beautifully. The French Impressionists dealt with them too, although the academicians of the time could not understand their doing so.

Project: Since you cannot order clouds to appear on demand, this project is one that you will have to work on over a long period. The observation is every bit as important as the drawing. So you must grasp the opportunity to look at clouds when you have the chance. First, study the cloud from the over-all view, deciding what its general form category is. Next, you must see the pattern of the whole sky, its big direction lines and its structure lines. These lines will converge in the distance just like the two rails on a train track. You must see these things before you begin to draw.

At this stage, it will be better for you to draw one cloud at a time. Do this drawing in an outline of the shapes and masses. We will deal with cloud groupings later. At this point, it is more important for you to watch than it is for you to turn out a finished drawing of a sky full of clouds.

WATER AND LIQUID FORMS

The atmospheric forms we have discussed relate very closely to the water forms, a fact that is easily understood since water has an atmospheric origin. Yet it is difficult to think of water as having any shape at all. Like the atmosphere, we accept water so completely that it is an unconscious part of our daily lives. We have to think a little to realize that we are delighted by the splashing

71. Cumulus clouds on a stormy day show a strong contrast in light and dark tones.

72. These cumulo-nimbus clouds over Sanibel Island, Florida, are typical of rain clouds in semitropical areas.

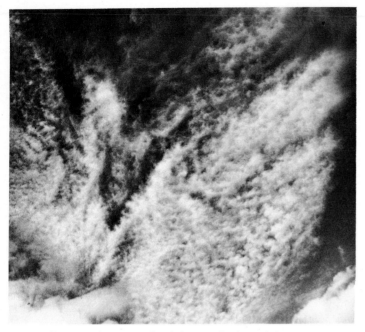

73. Cumulo-stratus clouds have a feathery, light texture.

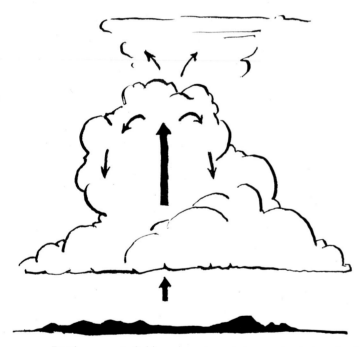

74. The magnetic field movement occurs in cumulo-nimbus cloud formations.

shapes that are created by a simple act as filling a glass with water. We watch the swirling clouds of cream in our coffee with a similar unconscious pleasure. In bathing or swimming, we appreciate the feel and look of the flowing shapes of water just as thoughtlessly. Children are more aware of water, however, and take great pleasure in playing and splashing in it. This is true particularly of the act of urinating; in this function, young children feel a natural delight, not only with the feeling of release but with the bubbling and splashing forms.

There is certainly nothing odd or unnatural in this because we are, as organisms, a highly refined system of circulating fluids. In fact, we are composed of 72% fluids and of only 28% solid matter. The percentage of fluids is certainly large enough to make it quite evident that our form and the forms of all living things follow the patterns and ways of water.

We have spoken of the streaming, branching, and anastomotic lines, along with the galactic form, vortex, radiating lines and circles, and the wave and spinning wave lines. We have found all of these to be rooted in energy expressions and have followed them further into the realm of the atmosphere. You can find similar forms in water and fluids once you overcome the difficulty of observation because water is so changeable. Water forms are difficult to observe in the same way that smoke and steam forms are difficult; these forms arise and dissipate in seconds, almost faster than the eye can follow them.

With patience, we can observe water forms. Leonardo da Vinci, who was a very careful observer of nature, was able to understand many of these forms (Figs. 75, 76, and 77). Today, we are aided by the photograph and motion picture which can slow down or freeze the movement. But remember that these aids are only for temporary help in our primary goal of observing these things directly as Leonardo did.

We begin our observations with the fact that water responds to the force of gravity and seeks the lowest level. When water reaches the level it seeks, its top surface forms a flat plane as on a still lake or a lagoon, in a basin or a tub. In this still state, the edges of the flat plane follow the contours of the shore line, perfectly marking the water level. In drawing still water, we want to establish this water level line in relation to all of the land masses. Another important characteristic of still water is its ability to reflect a mirror image of all that is above. Even in wavy and moving water there is a certain amount of reflected image. We will discuss this in more detail later.

Maybe you have seen a mountain lake at dawn that was as still and as flat as a mirror. As the sun rises on such a lake, the surface changes to ripples which move gently across the surface. Gradually, these ripples change into waves so that the entire surface is covered with a complex texture. You look at such a surface and ask how the artist can possibly understand such complexity. There is too much there to deal with the waves one by one! So the answer is that the artist must find a broad pattern which will explain *all* of the smaller variations. Actually there are two patterns—a series of wave lines that run parallel to one another and the network of anastomotic lines.

Occasionally, waves do run in parallel wave lines when current and wind run in the same direction and when the wind is not too brisk. In most instances though, the water surface is broken and irregular; in this case, the pattern is *anastomotic* (Fig. 78). We can draw all degrees of wave and

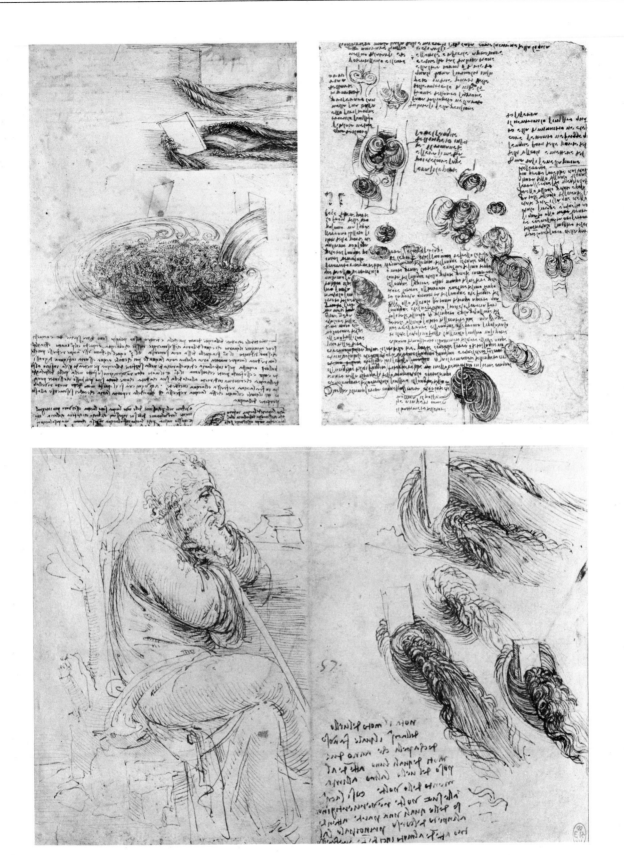

75. *Study of Eddies of Water* (Above left), Leonardo da Vinci, pen and ink. The Royal Library, Windsor Castle. Leonardo's studies of water demonstrate keen and careful observations.

76. *Study of the Human Blood Stream* (Above right), Leonardo da Vinci, pen and ink. The Royal Library, Windsor Castle. Leonardo made studies such as this one of currents, eddies, and jets which occur in the human blood stream as well as in nature outside of man.

77. *Study of Eddies and Falls* (Above), Leonardo da Vinci, pen and ink. The Royal Library, Windsor Castle. These studies are the results of actual experiments with streaming water.

chop by seeing the entire water surface as an anastomotic network enclosing irregular diamond shapes (Figs. 79 and 80). Regarding the surface this way works well for water with both small and large surface waves. We can treat the larger waves as triangular shapes that are pulled up here and there from the network surface. In a situation with storm waves or waves created by high winds, the surface tends to be directional. The waves group in series that are closer to wavy lines generally at right angles to the wind source, or the line that comes from the point of origin of the storm.

Shore waves begin near the shore where the bottom of the ocean or lake begins to rise up toward the land. These waves form in lines parallel to the shore (Fig. 81). One individual wave can be longer than a city block or as short as fifty feet. On one area of the shore, a wave may be just breaking, while at the adjacent strip the water will be receding. There is always variation all along a shore line (Fig. 82).

The patterns of shore waves have always been attractive to artists and the surf is generally appealing to people. But the pattern is difficult to grasp because there are many things going on at the same time; all of them begin slowly and increase in velocity. So the problem is to see the wave's life, its growth, development, and decline. You can do this if you examine the wave from three viewpoints. First, get a bird's-eye view from above for the spacing and frequency of the waves and their growth point (Fig. 83). Next, get the view from the shore as described above. Finally, you must see the waves from the side as though you were separated from them by a big sheet of plate glass that would allow you to see them all the way to the bottom (Fig. 84).

When you see the wave develop from the side view, it seems to emerge from the rounded shape of the surface swell (Fig. 85). This form is created because the water at and near the surface is moving in spinning waves. As the water reaches the shallower areas of the shore line, there is less space for these spinning waves to revolve and so the wave thrusts upward into the air. As the water becomes shallower the wave reaches a stage where the body of the spinning wave is almost completely above the trough level. At this point, the spinning wave turns over in the air before it changes its shape in the process so that it is like one arm of the galactic form while the air in front of it is the other arm. The water and air spin and mix and rush over the water at trough level, creating splashes and foam and forward-moving swirls. Then the water is thrust up onto the beach as a linear, forward-moving, curved stream or sheet.

As this water comes to rest at the final rise, it seems to pause. Here it may be covered by a swiftly moving sheet that emerges from a new wave, or the sheet may be overlapped on one or both sides. As it rushes back it may pull an incoming sheet up short and then back with it. Finally, as it gains body, the water will move in an undertow of spinning waves that run counter to the surface movement. This is like a great symphony with major and minor themes, the great pulsing rhythms of the spinning waves, the superimposition of the two elements—water and air—that give birth to swirl and foam.

Water is a most responsive and sensitive medium as its forms are generated by the movements from the air that borders above it, by the shapes of its earthly bed below, and by the shapes of its own internal movements. All of the water forms are variations on the spinning wave form, from

78. Anastomotic lines in water occur where the form breaks and changes directions.

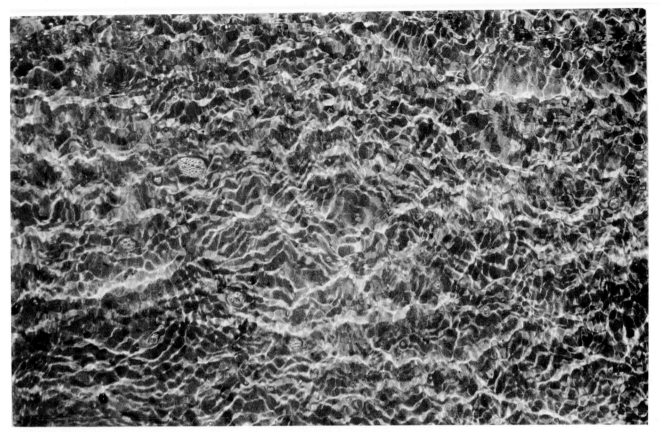

79. Water, atmosphere, and light create these forms; the atmosphere moves the water, causing swellings which act like lenses focusing light patterns on the sand below.

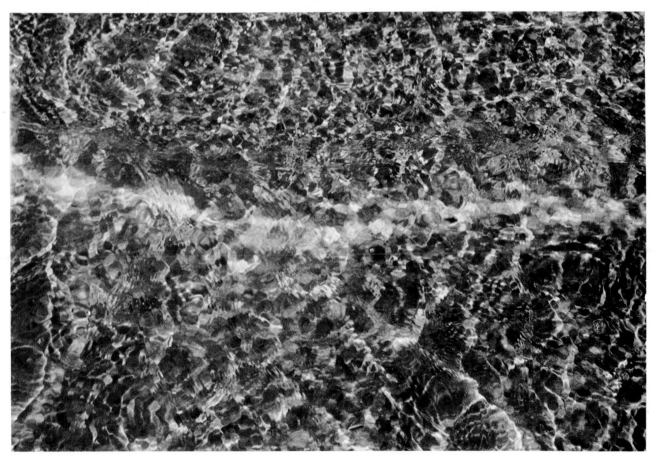

80. The streak of light along the center of this anastomotic pattern was caused by a ripple or wavelet.

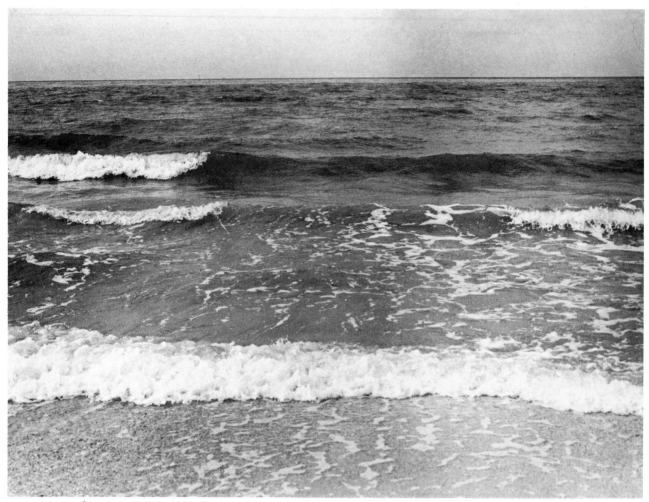

81. An example of waves paralleling the shore shows the anastomotic texture which can be seen toward the horizon.

82. *Long Island Sound from Fish Island,* John Frederick Kensett, oil on canvas, 15 1/2″ x 30 1/2″. The Metropolitan Museum of Art, Gift of Thomas Kensett. This painting has the simple structural pattern of receding horizontal lines that is characteristic of ocean waves.

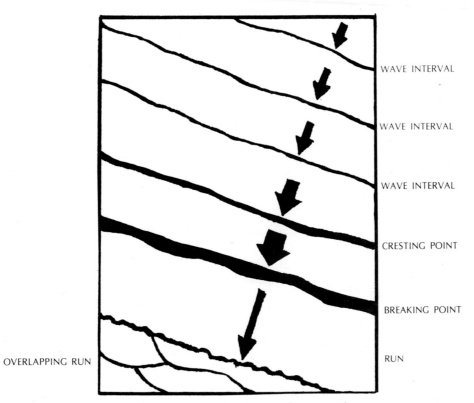

WAVE INTERVAL

WAVE INTERVAL

WAVE INTERVAL

CRESTING POINT

BREAKING POINT

OVERLAPPING RUN

RUN

83. A bird's-eye view of shore waves shows the spacing and frequency of waves as they grow.

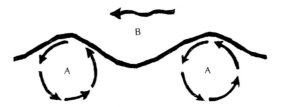

84. This cross section of waves shows the internal movement of wave systems. (A) represents the internal movement of the wave and (B) shows the movement of the wave toward the shore.

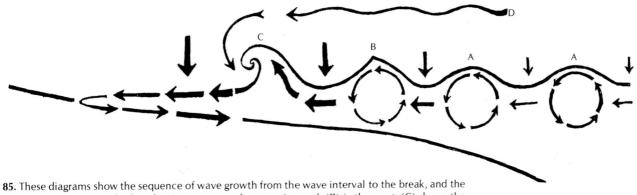

85. These diagrams show the sequence of wave growth from the wave interval to the break, and the final surge of water on the beach. (A) represents the wave interval, (B) is the crest, (C) shows the break of the wave, and (D) is the surface wind.

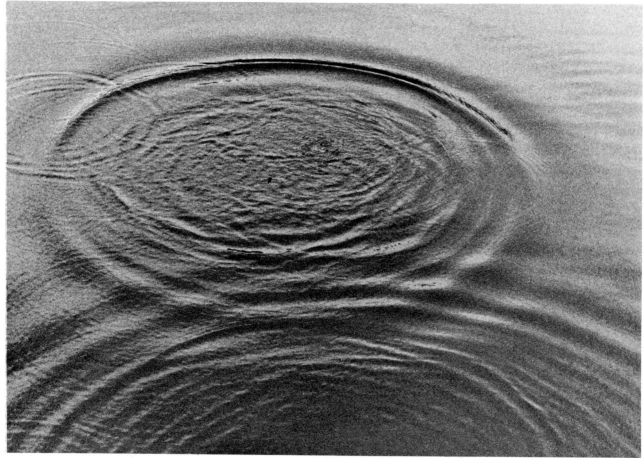

86. Here are two large overlapping radiations. The smaller forms illustrate that there is always an irregularity of form in nature.

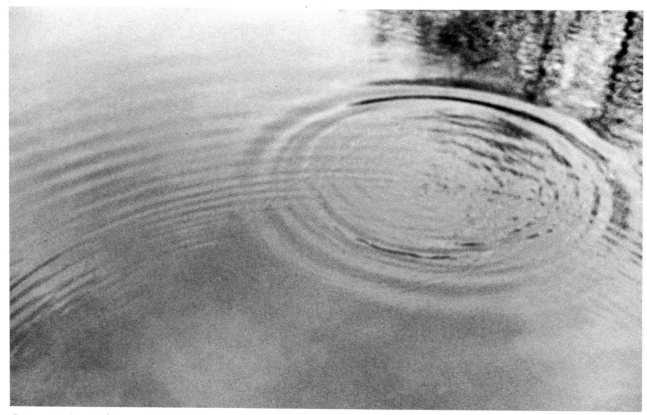

87. A new wave overlaps an old one.

the smallest splash to the largest ocean current. Let us take a look at the forms that occur in moving water.

Well known to everyone, because they occur so commonly in water, are circular radiating waves and the wake radiation (Figs. 86, 87, 88, and 89). The circular radiating waves come about when some object—such as a raindrop, a stone, or a boulder—falls into a body of water. The circular waves are generated by the stone displacing some water and creating a splash hole into which the water rushes back toward the center and then rebounds in spinning waves which move outward in series across the surface of the water. Their size and the distance they travel depend upon the size of the object, its weight, and its velocity plus the surface conditions of the water. The larger the stone and the smoother the surface, the larger and further the pattern will extend. The wake radiation is merely a variation on the same theme; it is caused by the forward movement of the vessel plus the displacement of water by its mass. The angle of the wake pattern is approximately 60°

The forms of splashes and bubbles also have very interesting shapes (Fig. 90). The combination of the air passage and the water displacement in a splash creates a sequence of forms (Fig. 91), which begins with a cone form with slightly curved sides and grows into a tubular form with wavelike sides as the stone falls deeper into the water. While this sequence develops, the water around the opening on the surface rushes inward to form a ring of splashes that rises up and outward. As this occurs, the opening is closed by a spout of water that comes up from the center of the hole.

Patterns similar to the splash are created in water when colloidal liquids of a heavier body than water are poured into water. The swirls of cream in your coffee can create cloudlike forms, or the drop of India ink in water swirls like smoke (Figs. 92 and 93). Many other shapes are formed by mixing two liquids of different density. These range from a simple teardrop to a lens form (Figs. 94 and 95), to forms so complex that they almost defy words.

The forms of bubbles and foam are significant water forms too. The single bubble of sea water and air is as close to being a perfect globe as any form found in nature. But the bubble form is capable of a number of interesting changes. When bubbles are packed together in a single film, the formerly round bubbles become hexagon shaped (Figs. 96, 97, and 98). When these spheres are piled in masses, they assume a fourteen-sided shape called a *tetrakaidahedron* (Fig. 99).

The forms of running water are even more varied because they include all the foregoing forms as well as forms created by streaming and flowing. There are several factors that create the forms of flowing water. The first is the energy structure of water and its tendency to freely form itself in spinning waves (Figs. 100, 101, and 102). Also important is the water's response to the movement and attraction of the air and atmosphere. Air and water dance together; they mix and mate; they are sympathetic. On the other hand, water and matter are not on such good terms; matter tries to stop the movement of water to make water still and inert like itself, but water swirls and moves all the more for this restraint and eventually wears matter down to the point where it will express the movement and characteristics of fluid as much as it does mass.

Streaming water will shape the sand and mud of stream bottoms in rippling wave patterns that duplicate water's

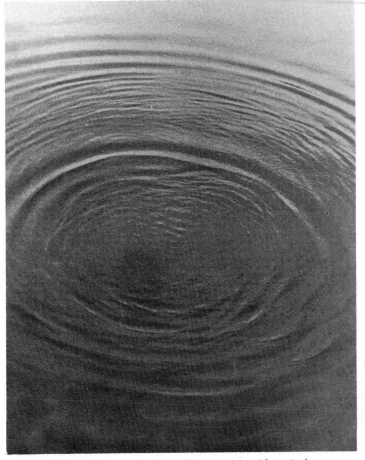

88. This is an example of circular radiating waves with a single source radiation.

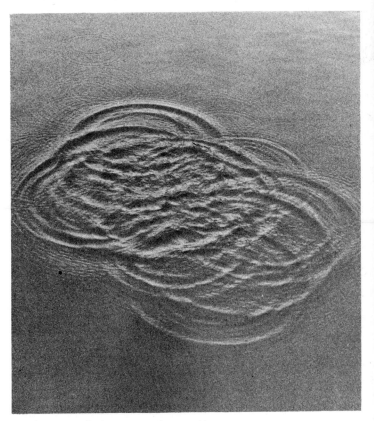

89. About six radiations start at the same time.

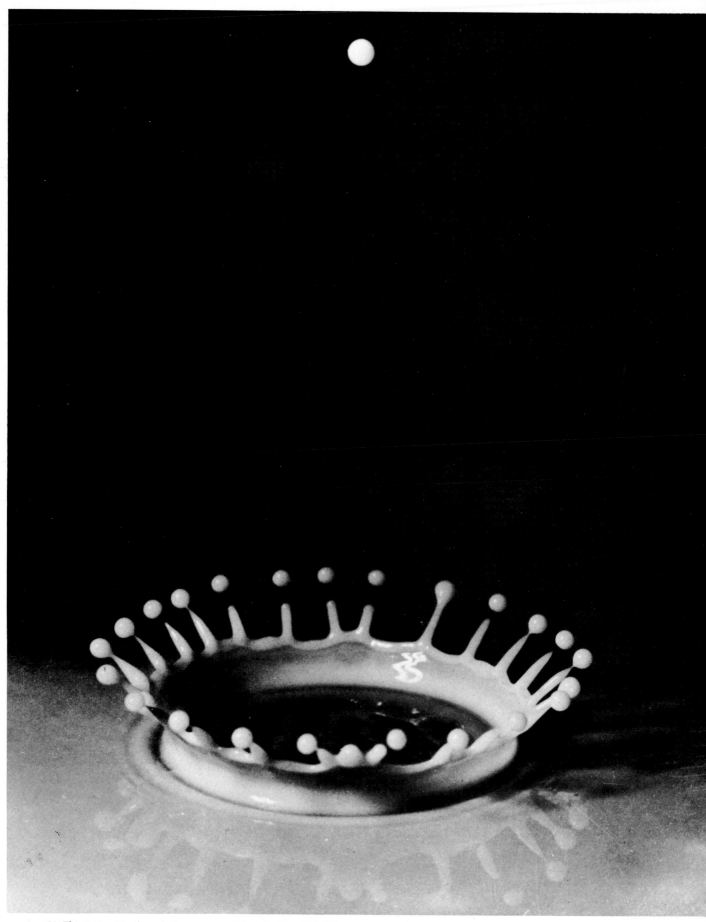

90. This is No. 3 in the splash sequence. (Photo by Harold E. Edgerton, Massachusetts Institute of Technology)

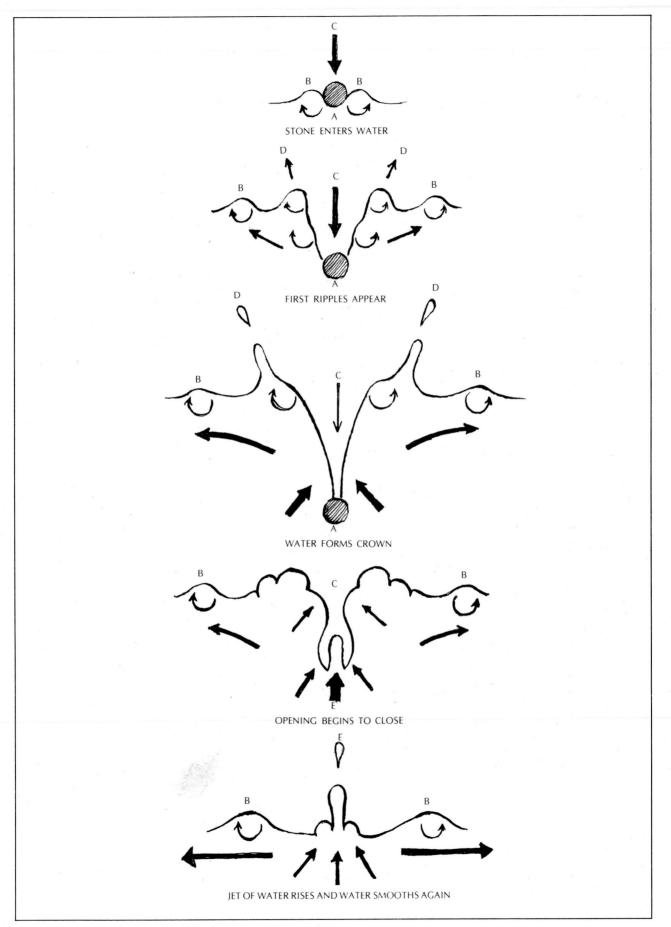

STONE ENTERS WATER

FIRST RIPPLES APPEAR

WATER FORMS CROWN

OPENING BEGINS TO CLOSE

JET OF WATER RISES AND WATER SMOOTHS AGAIN

91. These five diagrams illustrate the splash sequence.

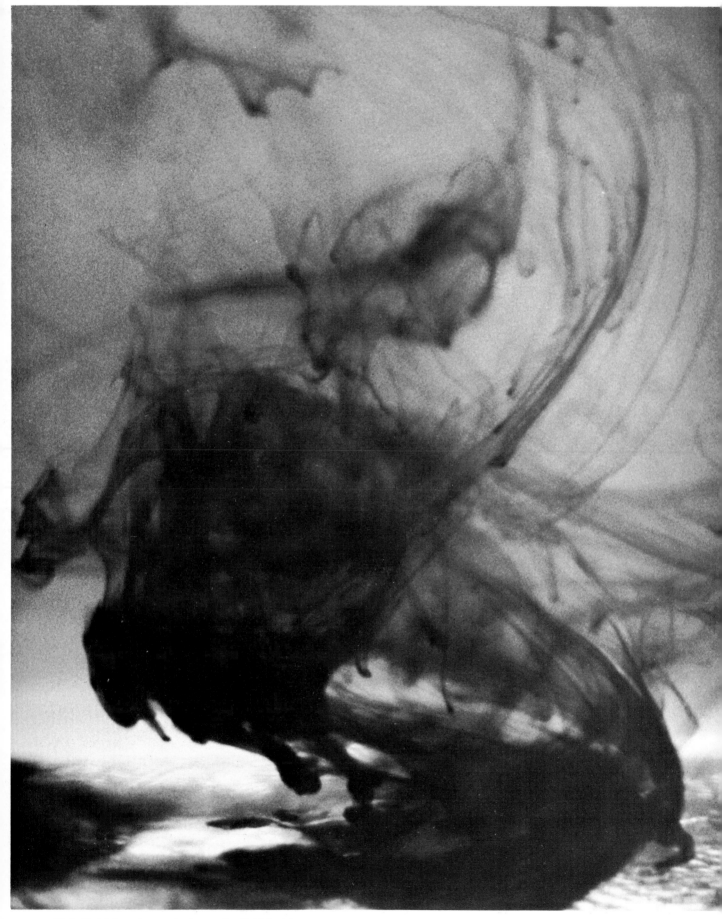

92. India ink in water creates forms of colloidal mixture.

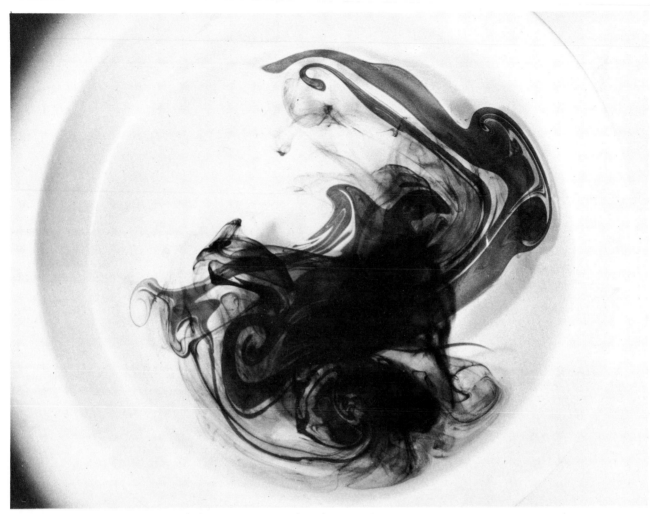

93. Compare these colloidal forms with the spinning wave and smoke patterns..

94. This diagram demonstrates the sequence of a drop of India ink in water. (From *On Growth and Form*)

95. The lens form is created by two fluids—one denser than the other—and the atmosphere. (From *On Growth and Form*)

96. Sea foam appears to be white because the layers of bubbles, like the foam on a glass of beer, create almost total reflection of light.

97. Bubbles pressed together form hexagonal boundaries.

98. The phenomenon of compression which happens in foam or soap bubbles also accounts for the hexagonal shape in the honeycomb cells.

99. A tetrakaidehedron—or fourteen-sided shape— is formed when groups of round forms are compressed. (From *On Growth and Form*)

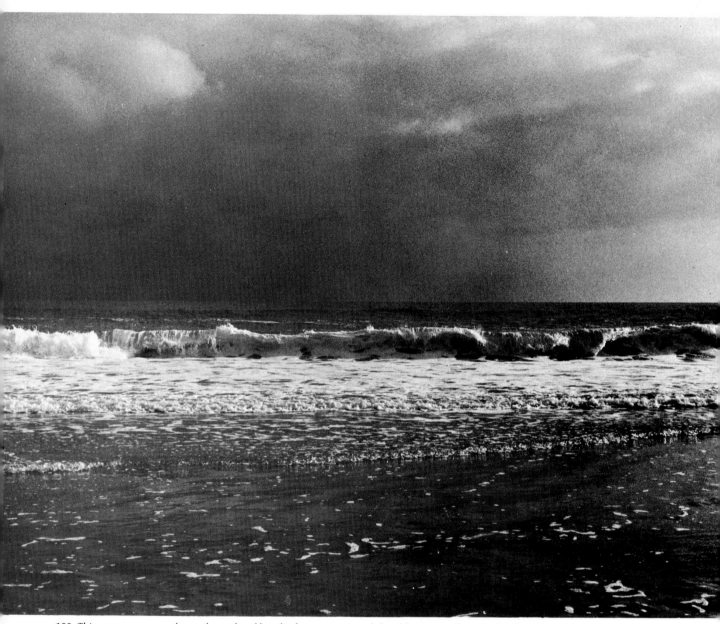

100. This wave sequence shows the curl and break of a new wave and the older waves closer to the shore.

101. These overlapping sheets show the final shoreward movement of the wave.

102. The patterns formed by the foam of the surf are very much like some cloud formations.

movement (Figs. 103, 104, and 105). These patterns in turn offer resistance to the water's flow and increase the movement of the water, causing surface ripples.

Rivers and streams run in sinuous, meandering curves and the branching anastomotic network is the form of the entire stream and river system. Streams and rivers also tend to run in planes and to level out. Where the land slopes rapidly, the water will rush downward to achieve a level or gradually erode the stream bed so that it becomes level. In other situations, a stream's course is a series of levels that are divided by rapids or falls. Within the stream itself the water will form eddies, waves, vortices, jets, falls, and spirals, which are all forms of the spinning wave (Figs. 106, 107, 108, 109, and 110).

Water is closely related to the atmosphere and at times a part of the atmosphere, but it is also a part of the realm of solid matter. Many mineral substances are partly composed of water. Water in the frozen state is, in fact, solid matter. Ice in rivers forms in sheets which, upon breaking, have many of the characteristics of rocks and stones. Ice has fracture lines that are similar to the fracture lines of stone because both possess a crystalline structure.

The realm of the crystalline snowflake is vast and varied, but the snowflake form is basically very simple (Fig. 111). All snowflakes have three axis lines. These form six arms or radii that are separated by 60° angles. No two snowflakes are alike, but they fall into seven basic categories.

Project: This project will teach you the methods of observation for studying water forms. Do not attempt to master all of these forms in one project as there are just too many variations.

So the problem is not only how to do but *how to look* and *what* to look for. Patience and pencil and paper are all the tools you need.

You can observe ocean waves best in the manner described before. In drawing the surf, first observe the entire sequence of wave development. Then, re-create the sequence on your paper: the outer swells, the growing shoreward wave, the breaking wave, and the rushing surf. Estimate the space divisions of each occurrence. Once you have plotted this on paper, you may use the actual waves as models, referring to them as you need them.

Study eddies, vortices, jets, and falls at home by using the bathtub; you can also make circular radiations and wakes. You can create eddies by moving your hand an inch or two beneath the water surface in one direction. By moving a stick through the water, you can create wake patterns. You can create falls by pouring water from vessels of various sizes into the water in the tub. A small stone dropped in the water will give the circular radiation pattern. Try objects of various sizes, so you can also observe the splash patterns. You can watch jets by filling a syringe or meat baster with water colored with a little India ink and then ejecting the stream into clear water at various speeds. Be sure to eject it beneath the water and parallel to the surface. Of course, the vortex appears when you pull the plug.

By observing these shapes again and again, you will see them well enough to draw their subtleties. So you cannot expect to gain anything at all from doing this just once. Play!

103. (Right) Blowing sand forms wave patterns which are comparable to water and cloud forms.

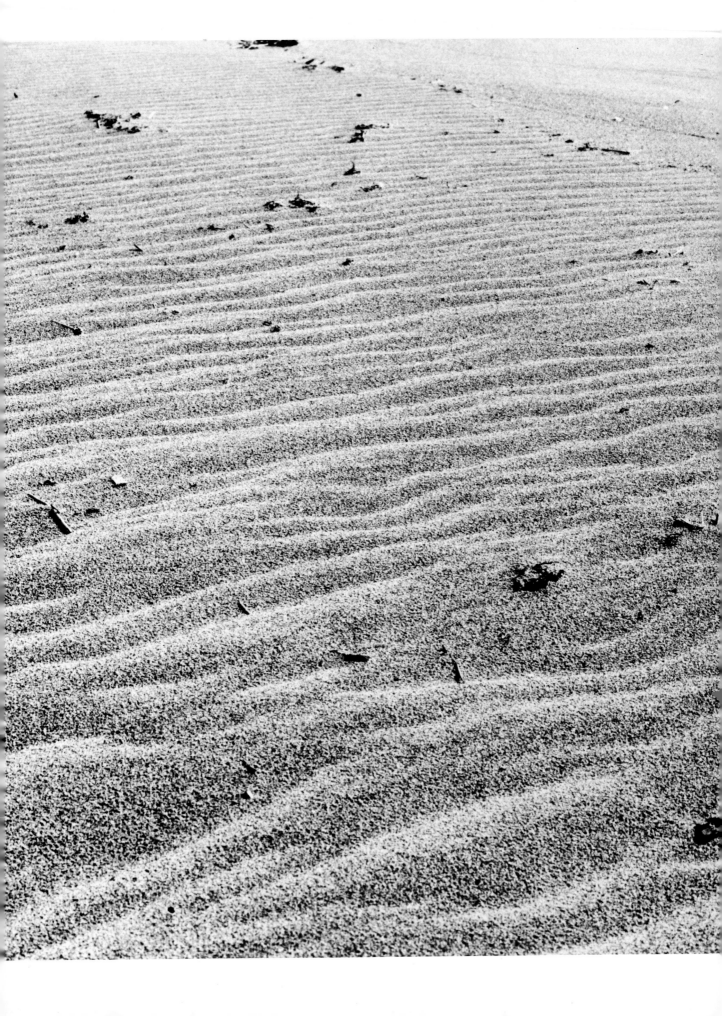

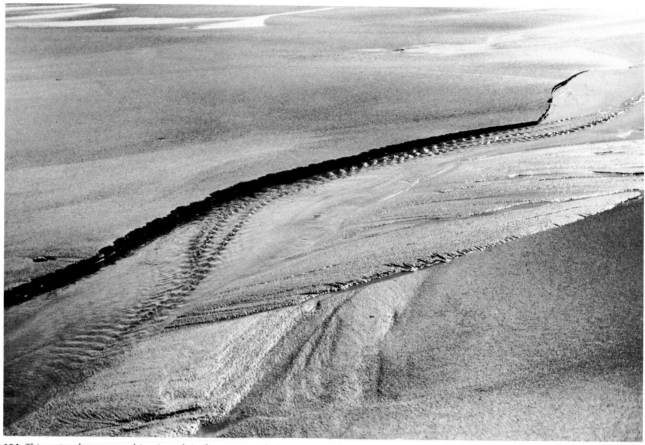

104. This water shows a combination of rippling, a meandering curve, and anastomotic lines.

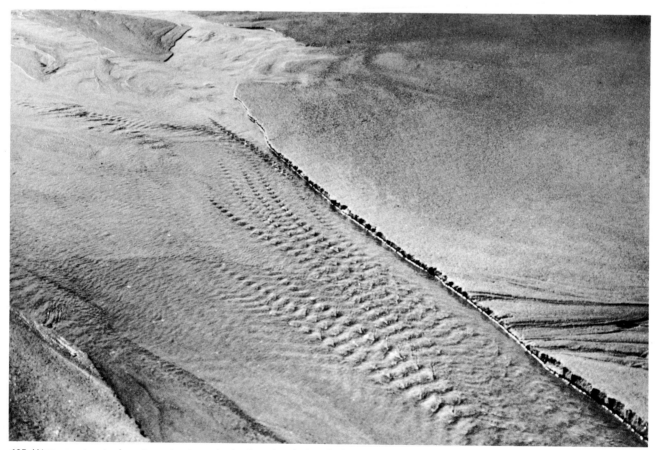

105. Water creates ripple patterns in stream beds of sand and silt, which increase in complexity the patterns of flow in the water.

106. Water falls in waves and spirals, which are forms of the spinning wave.

107. Vortices and eddies occur in a swiftly moving stream flowing around a rock. Both forms are variations of the spinning wave.

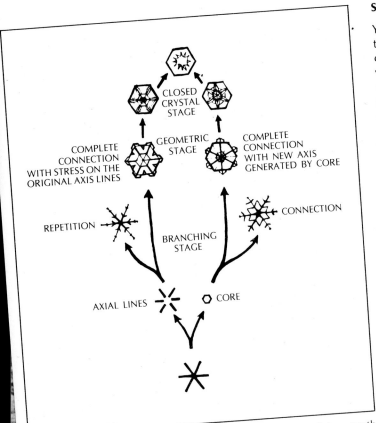

111. This diagram demonstrates the stages of snowflake growth and shows the causes of the variations in form.

112. These are the seven rings of attention. (Comparable to The Limaçon of Pascal)

SOLIDS AND EARTH FORMS

You can miss the whole meaning of nature if you speed through the landscape like the motorist in an air-conditioned car with his radio turned up to maximum volume on a superhighway. When contact with nature is attempted at machine speed and is insulated behind steel and glass, most of the meaning, much of the feeling, and all of nature's time sense disappears. To study nature's forms properly, you must be patient and close, and attune your sense of time to the rhythms of the things you are attempting to understand.

In discussing energy, atmospheric, and water forms, we have dealt with forms that are at times invisible and are always elusive and transient. Energy penetrates and gives substance to all of the realms of form, but there are boundary lines between air, water, and earth that are visible to us and are important to our lives. These three great realms are the environment of our lives; they make up the earth's biosphere, the place where life grows. Of the three realms in this biosphere, the earth's form provides the surface on which we live and the boundary that reminds us every waking and sleeping moment of the weight and impact of gravity. We are creatures living between earth and sky.

When we consider our basic feelings about these three realms, there is a deep feeling that water and air are young and fresh and alive. They are constantly being restored in the changing cycles of weather and season. We even use the qualities of air and water to describe youthfulness with such words as sparkling, bubbling, light, and breezy. The earth forms, on the other hand, give the feeling of being old beyond measure, beyond any comprehension of time as we know it. In fact, a child learns the very concept of age itself from the hardness, coldness, and imponderability of the earth forms.

Consider how much a child learns from air, water, and earth in the first three years of life. He progresses from lying in one place and making rolling and swimming movements, to sitting and crawling, to standing and taking a step, and finally to walking, running, and climbing. This is a period of exploration and learning such basic things as over-under, up-down, in-out, here-around, high-low, which are all coupled with the feelings of joy involved with hide, seek, and find. To a child, piled boxes can be mountains, blankets over chairs, caves.

It is these same experiences that the artist seeks to make conscious again on a higher level. All of these early learnings are part of the age-old mystery of our relationship with the earth. The dirt, sand, gravel, pebbles, rocks, mountains, canyons, valleys, and plains that we learn to navigate in our first years of life are the rooting place of our lives and of our knowledge and feeling of form.

HOW WE SEE THE EARTH

Emanating from and surrounding each person is what can be called his field of attention. The person's organism is the center of it and the field radiates outward in rings that have radii of varying lengths (Fig. 112). This field is like a series of circular radiating waves on the surface of a pond. Each ring has its own meaning, but the more distant ones superimpose and interpenetrate the nearer rings as they move from the outer reaches toward the center.

This morning glory is a beautiful example of the luminosity of transparent flower petals.

Yellow emerges from white with a suggestion of orange at the center of this wildflower relative of the snapdragon.

The shape and color of the dandelion suggest the sun's radiation from the core outward.

As in the after-image progression sequence in Color Chart 2, green induces red as these red berries emerge from the parent green of this plant.

These two photographs, taken at an altitude of over six miles over
the Atlantic Ocean, show atmospheric movements similar to
smoke patterns and a delicate mingling of the white light and
pure blue of the atmosphere.

(Right) The Dumb-Bell Nebula of Vulpecula shows an advanced
development, a growth into an almost circular form. (Courtesy of
the Hale Observatories, California Institute of Technology and
Carnegie Institution of Washington)

A breaking wave shows a luminous line of transparency in the center.

(Above) Water patterns in sand are defined by shadow.

(Right) The turbulent water forms of a ship's wake mixes frothy white with a green sea.

These cliffs in the Sierra Nevada, Spain, show several color tones of subtle quality as well as rugged masses.

A stream bed near Epidaurus, Greece, and the color of the sky echo the tones of the earth masses on a moody and stormy day.

The colors are as startling and dramatic as the eroded forms in this scene of Bryce Canyon, Utah. (Photo by Albert Boothby, Sr.)

The ring closest to us is the area of our closest feeling, contact, and perception, and this extends from our body to about a foot away from us. In this area is also our closest focus of vision. The second ring extends outward in a radius of about four feet from the center. This is the area of our reach, of intimate association, and of intimate study and observation. This area is where we study and work, and there is a large sense of personal privacy about it. The third ring is the area of shelter and of secure, home environment. This radius expands to room size, with a measurement of about ten feet in all directions. Outdoors, this third ring is also a ring of close visual attention because within this ring we find the footholds, pathways, and resting places that are secure and comfortable. The fourth ring is the ring where the external world begins, but it is still an area of close attention which extends outward from the center for several hundred feet. We are naturally interested and wary of anything within this circle and examine all objects to find out if they are useful or harmful, and we look to see if people or animals within this range are friend or foe. The fifth ring extends from the center for about a mile. This is the ring of observable visual clarity; up to this point, details are reasonably clear and objects identifiable. The sixth ring extends from the center to the earth's horizon, which extends for about eight miles at sea level. Objects can be seen at this range but all forms tend to flatten out. The seventh ring extends from the center into deep cosmic space.

Of course, these rings may expand or contract somewhat, and each has different values and functions at various stages of human development. The first ring for the infant is exceedingly large, as it is based on his physical limitations and his vital need for contact and security. But he soon progresses into the second ring, and by the first year or so it is all that the mother can do to keep him within the safe boundaries of the third ring. From the age of five onward, a child can venture out as far as the fifth ring (at least in the country where the land is clear and not mountainous). At the age of about seven, a person just naturally rambles through the first six rings with ease. When we are awake, we see and sense all seven of these superimposed rings of attention. The artist develops the ability to stay in one spot and focus his perception of these rings in the most sensitive way.

Ordinarily, our attention fluctuates among the first three rings. The first two rings involve close detailed thinking and involvement, but these two can be shifted in space within the boundaries of the third ring which we regard as a room or a work area. We are particularly skilled at judging sizes and shapes within the confines of the third ring because in it we can compare things ranging in size from a mustard seed to an elephant. Our ability to analyze and compare shapes within this ring is so highly developed that it has become an unconscious skill for most people. But as an artist you must attempt to make all of these stages of perception conscious again because they are the tools of understanding form and space.

CRYSTALS: A CLOSE VIEW

The earth's surface is made up of minerals and rock. These are formed in sheets which may be either a few feet thick or miles in thickness. The earth forms with which we are familiar are the outcroppings or large boulders, and the rock, stones, pebbles, sand, dirt, silt, and clay that we walk

113. The crystal shape is built of triangular sides.

114. This is an example of a square crystalline form.

115. This piece of quartz shows six-sided crystalline forms.

116. The sides of this crystal form a parallelogram.

on. Rock and minerals are composed of crystal shapes that are fused together, and even the broken bits and pieces that we call earth have tiny crystalline structures. It is the crystal structure that determines how a rock splits, how a mountain breaks, or how a rock fractures. Water erodes these shapes and softens them into more fluid forms.

Pure crystal shapes are the simplest shapes to draw since they are the forms of nature that come closest to our geometry (Figs. 113, 114, and 115). These shapes are cubes, tetrahedrons, prisms, and other many-sided shapes that are constructed of symmetrical planes. Many gems and minerals can be found as single beautifully shaped crystals (Figs. 116, 117, 118, and 119). But the crystals of rocks and minerals that we ordinarily encounter are much smaller and are tightly packed into the mass of rock and ore. Even though they are small, they still influence the over-all shape of the rock or boulder.

Crystals assume many forms as they grow. Some can be found in branching formations, others in radiating lines; some crystals found in geodes have undulating and in-vaginated shapes (Fig. 120). You can find crystals of gypsum that follow the spinning wave form, and there are some mineral crystals that grow in round shapes.

All crystals emerge from the liquid state, so it is not unusual that the progression of forms we have discovered in energy, atmosphere, and water should show up in the realm of solid matter also. Science has shown us that matter is frozen energy, so it is logical that we can find some transformed energy expressions in forms of solid matter. Yet it is difficult to see clearly how the movements of energy are frozen into crystal form. Many of these forms are produced under great pressure and beneath the surface of the earth. It is not uncommon that crystal forms superimpose and interpenetrate so that one form actually grows through another. This pressure may account for some of the rigidity of crystalline forms. In contrast to this, the crystalline forms of calcite stalactites (Fig. 121) and stalagmites form a great variety of liquid moving forms that are still microscopically crystalline, and other minerals can be found in rounded, organismlike shapes.

As I mentioned before, snowflakes are one of the most fascinating and unique crystal formations. The principle that they all share is their six-sidedness which is divided by the three axis lines. There are 60° divisions between each radius. No two snowflakes are alike, but each arm of a snowflake is a duplicate of the other arms of the same flake. For thousands of years these forms have been used as symbols of the symmetry of nature. They have been used as design motifs for fabrics and decorations. By laying out the basic pattern of three axis lines, you can invent your own snowflake patterns. Or you can borrow the patterns suggested in a kaleidoscope which makes illusionary snowflakes.

Project: You have already worked with geometrical shapes and have acquired the necessary reasoning to draw individual crystal shapes. This project will show you that there is always a difference between man's concepts of geometry and the actual crystalline shapes found in nature. You need pencil, paper, and some crystal samples.

117. (Right) A platinum hemispherical crystal is magnified 700,000 times. (Photo by Prof. Erwin W. Mueller, Pennsylvania State University)

118. This tungsten tip was magnified 1,000,000 times by an electron microscope. (Photo by Prof. Erwin W. Mueller, Pennsylvania State University)

119. An iridium crystal, magnified 2,500,000 times by an electron microscope, shows each dot as a single iridium atom. (Photo by Prof. Erwin W. Mueller, Pennsylvania State University)

You can find crystals of all sorts in your local natural history museum or you can buy them in lapidary shops. You will need only about three or four different shapes. If you really want some fun though, you can go out and find some crystals in their natural haunts. The book on minerals that I recommend will tell you many places where they can be found. (See the Bibliography at the back of this book.)

In drawing crystals, you should analyze the shape of each crystal first to find the geometrical concept which fits it best. Draw this geometrical shape as perfectly as you can. *Then* draw the actual shapes as they occur in the real crystals and compare the difference.

ROCKS AND BOULDERS

The crystalline structure of rocks determines lines of grain and fracture that create the rocks and boulders of our environment. The most basic rock formations that are found were originally created under the earth's surface in areas that extended over many square miles. Sometimes this underlying rock may cover an area equal to several states or European countries. But as the earth has grown and moved, these large areas of rock have cracked or have buckled and then been thrust upward to become mountains, cliffs, and crags. Rocks and boulders have broken from these large masses.

When rock is split along its grain, the break follows a fairly even line, but crossgrain breaks tend to be more jagged and irregular. The kind of line depends on the type of rock and its structure. Fracture lines across the grain are a lot like the edges of broken peanut brittle (Fig. 122). But denser rocks will break with smoother surfaces, like hard candy (Fig. 123). The very dense rock formations that seem to be amorphous and have no grain at all break like glass in a wavelike pattern that is called a conchoidal break (Fig. 124). Volcanic glass or obsidian, bituminous coal, and some gems break in this fashion.

The shapes of rocks and boulders created by breaks are fairly simple to comprehend. You should look for how many sides the rock has, the shapes of these sides, and then decide the *over-all* shape of the top view, the side view, and the front view. When you have done all this, draw from one angle or viewpoint, but walk around your subject if you have to check the form. Once you see the form clearly, you can alter the actual forms to suit the purposes of drawing and your compositional needs.

Weathering adds other features to rocks. Most of the rocks that we ordinarily see in the fields or in streams are weathered rocks. Freshly broken rock is always a little forbidding because it has a sharp and dangerous look (we always recognize subconsciously things that will hurt us). Weathering rounds and softens these forms until they become actually appealing. But different kinds of rock weather in different ways. Very hard rock will remain angular for a very long time while softer rock will round off more quickly. Some rocks decompose and crumble very readily. All of this has a great deal of expressive meaning for the artist as these things suggest time, weather, and weight.

In the first three rings of our attention, the meaning and feeling of earth forms is the strongest as we see and feel the hardness, the weight, and the weathering of rock. Freshly broken rock suggests either the activity of man or the recent activity of nature. On the other hand, weathering indicates the ponderous and ancient origin of the earth

120. (Left) This is a geode showing an invaginated crystal formation. Compare with cloud and water forms.

121. (Below) These stalactites in the Luray Caverns, Virginia, can be compared to the patterns of falling water.

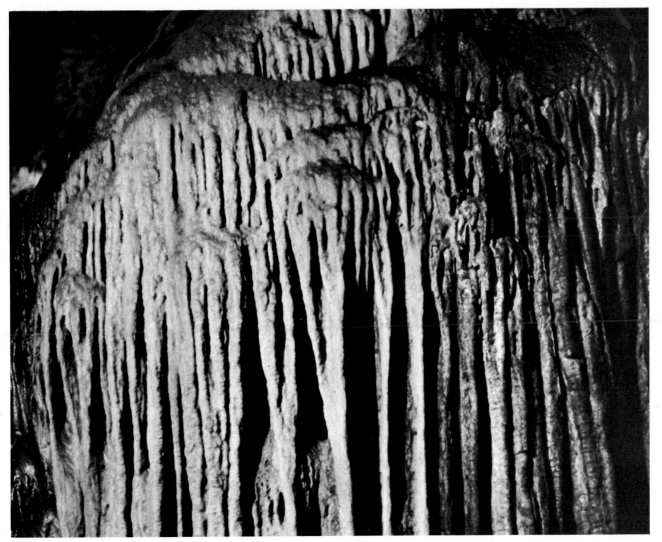

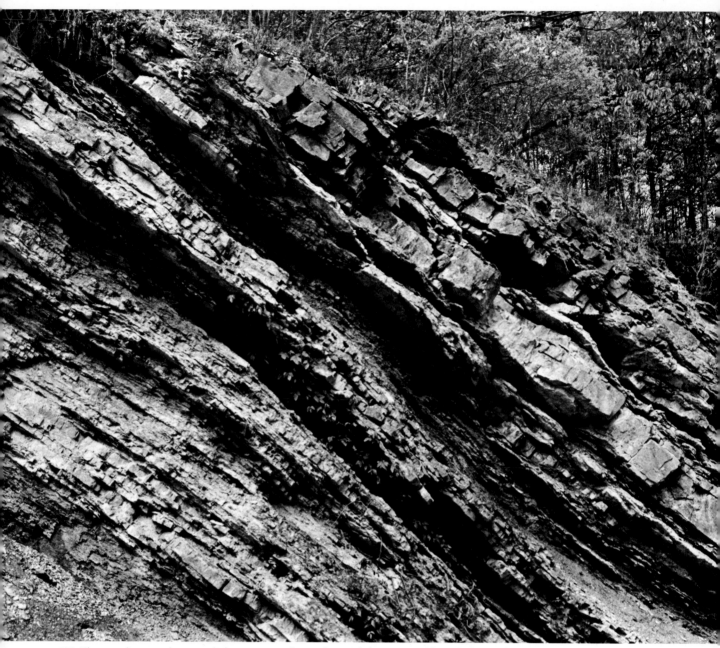

122. These rock strata show rough fracture as well as a diagonal thrust caused by a break in the earth's surface.

and the incalculable passage of time. The forms that we draw beyond our third ring of attention must be drawn by the transpositions and conjectures that are based upon the close observations we make within the first three rings of our attention.

Project: Go out and get some rocks. Get some freshly broken ones and some nice rounded and weathered ones. When you return to your workroom, I want you to set these rocks before you and compare them in the light of the things I have said and in the light of your feeling. Try to imagine the age of these things; try to imagine them forming beneath the earth under pressure and heat. See them as part of a great thrusting break of the earth's crust. Look at them as bits broken long ago, rounded by streams that no longer exist. See them brought over time to your own place. Look at the jagged shapes which are less worn by time and at the older, rounded shapes, weathered by erosion, and let the age and untold history become a feeling, a deep feeling inside of you. Take your time doing this, and if you cannot feel these things right away—wait. When you have the feeling of the rocks, draw them with charcoal and sketch paper.

LARGER AND FARTHER EARTH FORMS

When you endeavor to understand the landscape beyond the third ring of attention, it is important for you to imagine the events that have created the landscape, as well as observing it in its present state. An artist must look for the clues of the origin of landscape forms (Fig. 125).

The most theatrical earth forms are the ones that expose the work of the great earth-making forces—the rocky, mountainous landscape strata of rock that are thrust up at jagged angles and counter-angles. We can see these angles of rock in relation to the plane of gravitation and the right-angle thrust of levitation which gives anything that occurs at an acute angle a sense of being out of balance. The largeness of these rock forms, plus their angular thrust, demonstrates events of great energy and magnitude that are almost beyond our ability to imagine as well as being beyond our ability to live through. Though landscape appears to be at rest, it is always a matter of the balance of these forces that makes the drawing have meaning.

The wind and water in the landscape contrast with these powerful shapes. Although they are naturally soft and seemingly gentle, wind and water eventually affect the form of rocks and leave their marks upon them. As the rock erodes from the action of the wind, or the water of rain and stream, the mountain begins to show the rounding off and veining with which we are familiar. Branching lines begin near the top of the mountain and grow large and interconnect as they approach the lower levels where they form ravines and canyons. The sides of the mountains are generally worn down to almost 45° angles. These are the angles of the great Egyptian pyramids and the middle angle that matter seems to find as it progresses from the vertical to the horizontal plane of gravity. Eventually all mountains are reduced to rolling hills and finally to plains.

Small rolling hills in flat areas are often structured or grouped in an anastomotic network similar to the network of ocean waves. Water forms are found in the plains areas in the form of branching networks of stream, creek, and river. So water is always the clue to follow in looking for the correct forms in the larger landscape. Water is the clue

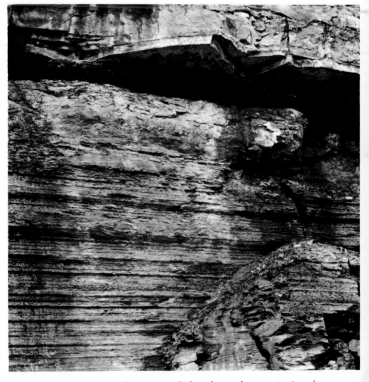

123. These rock strata show smooth breaks and even grain of stratification.

124. This Indian arrowhead is a good example of conchoidal breaks.

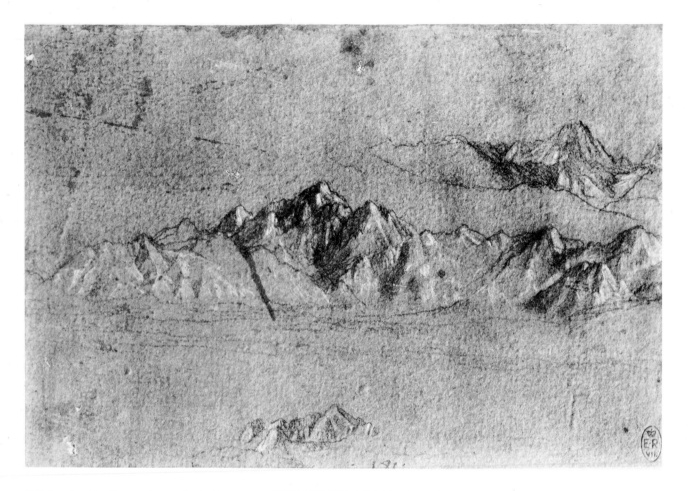

125. *Landscape* (Above), Leonardo da Vinci, chalk on paper. The Royal Library, Windsor Castle. This study defines the shape of earth masses which show vein formations caused by water erosion.

126. These seeds blow in the wind and also catch in the fur of animals.

to the rounding of rock formations; it is the carrier and leveler of soil which provides the foundation or rooting place for most of the plant forms.

Project: The purpose of this project is·to return you to the days of innocence when you played with mud pies. There was more learning in such play than you might have imagined. If you have your own yard, you will have no trouble finding material to play with. But if you are a city dweller, you will need a large tray or piece of plywood about 18″ x 20″. You will also need a nice, large bag of dirt. You can also use your collection of rocks.

I want you to create some miniature landscapes. Start with mountains and gradually work them down to rolling hills and plains by figuring out water erosion patterns. At the beginning, try to imagine the forces that thrust up your mountains; do not just pile your dirt haphazardly. You can use some water for your erosion. If you use a relief map of a mountainous area, you will have an excellent guide for this project.

PLANT FORMS

We have traveled through four realms of nature that are commonly regarded as having none of the qualities of life. But through all of these realms, we have seen the movements and functioning principles of energy, even in the frozen forms of mass and matter. Now the cycle turns upward again as soil, water, and atmosphere release their energy to the plant world, and the plants—defying gravity—reach upward again.

The realm of living forms is quite different from all of the previous realms. Plants embody a little of the realms of nonliving nature. Their forms resemble some of the patterns of solid matter. In growth they flow and move like water, and as they blossom they scent the air with their perfume and laden it with their pollen, and finally like energy they re-create themselves in their seed. The plant's chief characteristic is a deep responsiveness to all other realms. Plants take unto themselves the sum of their environment and create expressions that reflect the other realms of nature. In color, form, and movement the plant is a mirror of its environment in countless variations. Energy, atmospheric heat and cold, dark and light, seasonal pulsation, earth and water help to form the plant which responds to these things from within *and* without.

The nature of plants is that they root in one place and are limited to one area; though some plants, such as ivy, can grow for remarkable distances, the plant is tied to its rooting place. The only way that the plant can overcome this limitation is in devising seeds that can travel. Plant life has devised some remarkable methods of hitching rides on the wind, the water, on the fur or the insides of animals (Figs. 126, 127, and 128). Some seeds are shaped like airplane propellers, some like parachutes, and others have barbs that catch on the fur of animals or on humans.

Though the plant is ingenious in form, it lacks the kind of individuality and character that is a product of the higher forms of organic life. But there is still great variation in shape and form between two plants of the same type. Variation is the rule of nature, but differences between two plants of the same type are based more on outer events than inner motives. It is as though the plant itself is a skeletal form, a core, whose complete self includes the air and earth around it. There is an exposed helplessness in

127. A milkweed plant spreads its seeds with the help of the wind.

128. These are three types of wind-borne seed forms.

129. *Study of Rush with Seed Clusters* (Top left), Leonardo da Vinci, chalk and pen and ink on paper. The Royal Library, Windsor Castle.

130. *Study of Acorn with Oak Leaves* (Top right), Leonardo da Vinci, pen and ink on paper. The Royal Library, Windsor Castle.

131. *Study of Caltha Palustris* (Above), Leonardo da Vinci, pen and ink over chalk on paper. The Royal Library, Windsor Castle.

132. *Study of the Star of Bethlehem, Crow's Foot, and Anemone* (Right), Leonardo da Vinci, chalk and pen and ink on paper. The Royal Library, Windsor Castle. Leonardo's study shows the variations in shape and form that are found in plants.

GRASS

VINES

IRIS

PALM

133. These examples of monocotyledon plants show the spiral or segmented form.

plants, a naked faith, a submission to the environment that must be understood in any attempt to draw them. But even though the plant may fall to the extremes in the environment, a living plant is the ultimate expression of joyous faith in the continuity of life. These qualities can be seen in Leonardo's studies (Figs. 129, 130, 131, and 132).

When you draw living things it is not merely a matter of putting parts together in a mechanical way like assembling parts in a factory; this is the surest way to kill the life that is there. The plant may not talk to you in words, but it expresses the dignity, patience, vulnerability, and pure creative beauty of plant life. Drawing plants well is not a matter of imposing manmade ideas on the outer appearance of these forms; it is a matter of understanding plants on their own terms.

Plant forms follow a number of general growth patterns such as grasses, vegetables, trees, shrubs, vines, herbs, and flowers (Fig. 133). All of these plants bear flowers and seeds. There are also ferns, moss lichens, and fungi which do not flower or produce seeds. Botanists classify plants in a much more complex fashion, but for the artist these categories work very well.

In order to draw plants well, it is necessary to find the general patterns that show the sequence of growth from the seed to the mature plant. We must also look for the general form that has qualities shared by all of one group. This is important because our eleven groups can be further divided into over 335,000 species of plants in the entire world, and no one could possibly cope with them all. So again, we must look for the basic lines and basic forms that will serve us.

The plants that we are familiar with begin their lives as seeds which are generally shaped like teardrops. The seed finds a rooting place on, or slightly under, the earth's surface or gravity plane. Growth occurs above and below the soil. Below the soil the growth is downward and outward, while above the soil the growth is upward and outward. Branching forms occur off the central axis both above and below.

Though plants use the whole range of line and wave forms, only one of our energy forms can be adapted to the over-all plant outline. The form of the magnetic field superimposes very well with the plant pattern and abstractly gives the feeling of energy and movement of plant life (Fig. 134). Many plants duplicate this form perfectly in their over-all shape above and below ground and also in the shape of their fruit which encloses their teardrop-shape seeds. The plants that do not fit this abstraction perfectly modify the form by stressing a wave line in their central core—like the vine—or a spiral-like vortex around the core as do the coniferous trees and artichokes (Figs. 135, 136, 137, and 138).

When we see plants as over-all branching and rooting systems, the trunk corresponds to the center of the magnetic field, the branches and roots reflect the outgoing curves. We must see most plants as only part of this form, the rest is completed by the atmosphere that surrounds the plant. The plant is a system that uses its close environment to complete its form; each plant *needs* the space around it to reach full form. When plants are crowded their shapes become distorted. A plant is a *spatially aware* form of life and the plant's external space is as important in drawing the plant as the actual visible parts of the plant. You must consider that the plant possesses an energy field which is as much a part of its form as its stem, leaves, and roots.

PLANT PATTERN

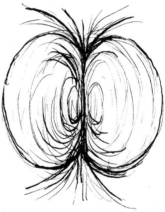

MAGNETIC FIELD

134. The plant pattern of dicotyledons relates closely to the magnetic field.

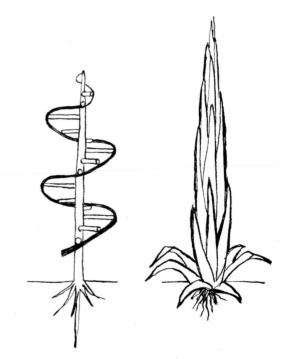

135. This diagram is a simplification of the spiral principle which can be found in plant growth.

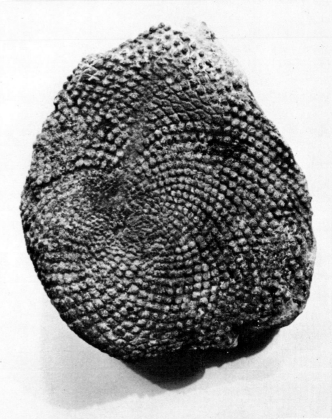

137. A pine cone is formed of seeds growing in two spiral directions around an axial stem.

138. A petrified seed pod from prehistoric times found in Kentucky shows the same interpenetrating spiral pattern as the daisy or a spiral galaxy.

136. (Left) This cross section of the artichoke shows how the leaves spiral around the heart.

139. This apple, halved along its axis, can be compared with the side view of the magnetic field.

140. An orange, cut along its equatorial plane, shows a relationship to the radiating lines seen at the poles of the magnetic field.

141. The onion could have been the inspiration of the geographer who invented the concept of longitudinal lines.

The form of the magnetic field is reproduced beautifully in such fruits as the apple and the orange (Figs. 139 and 140). Both fruits stress a slightly different aspect of the form. In the apple, the over-all shape as well as the swirling inner loops and the axis is stressed to perfection. In the orange, the longitudinal lines are stressed, dividing the segments down the core. In the vegetable realm, onions, beets, and turnips show this over-all shape and the spatial layering (Fig. 141). The pumpkin is a perfect example of this magnetic field principle in nature (Fig. 143). The basket slime mold produces little frameworks of this form. This meaningful form is found throughout nature.

A major movement of the plant world is the upward growth in spiraling waves (Fig. 144). Many tree branches and the leaves of flower stems (and even the long blades of grasses) spiral around a central axis. Of course, climbing vines like the bindweed, the honeysuckle, and the sweet pea grow and move in this fashion.

Many flowers follow the pattern of radiating lines (Fig. 145); the daisy is a common example of this (Fig. 146). Other flowers like the morning glory's vortex (Fig. 147) have water forms. Still other flowers cluster like a bubble (Fig. 148); the knotweed flower is an example of this, as are clusters of grapes (Fig. 149). Flowers like lupines, snapdragons, irises, and dayflowers, and even certain vegetables have invaginated forms that resemble cumulus clouds (Fig. 150). There are many flowers that beautifully duplicate the form of the water splash, bluebells, gentians, Penstemons, and jonquils (Figs. 152 and 153), to name only a few. And of course that strange little fungus flower, the mushroom, is a perfect reflection of the water jet (Fig. 154).

It is not unusual that the plant world duplicates the forms of water to such a great degree. Water is the very basis of plant life. The rhythm of plant life is a pulsation in all directions like the circular radiations on a pond. Think of the plant stem and the annual rings of a tree trunk cut across the axis. Grains of many woods are like the patterns of flowing streams (Fig. 155). The more you look, the more you will find that water forms recur in plant forms.

Project: This project will give you confidence to move with greater ease through the plant world in your drawing. So in the beginning it is best that you examine one thing at a time and study the best examples of the basic form principles. The best way to do this is to grow some plants from seeds so that you can observe the whole cycle of development.

Choose a simple flower such as a daisy, or a vegetable such as a beet or a radish, or a simple tree such as an avocado for your study. All of these plants are easy to grow. The flower and vegetable can be grown in pots if you follow the simple directions on the seed packet. You will have to purchase the avocado from the vegetable market. You do the following to grow it.

After you have eaten the avocado and have wiped off the seed, place the bottom of the seed in water so that it will sprout. Use a wide-mouthed quart jar for the water and sharpen four wooden match sticks to insert into the seed. Push the sharpened sticks into the seed so that half of it will stand above the water. Begin by inserting one stick at the equator line so that the stick protrudes straight out from the side. Put the next stick in the opposite side and the following two at right angles to the first two, so that when you look at the seed from the top, the sticks make a

142. The tangerine's form duplicates the magnetic field.

143. The pumpkin's form also duplicates the magnetic field.

144. In these two plants, we see examples of the spinning wave.

cross. The flat end of the seed goes into the water and the pointed end in the air.

It may take a week or two for the seed to sprout. The first growth that you will observe is a white shoot which is the beginning of the root system. Thereafter, roots will branch off from the shoot. Next, the beginning of the trunk will shoot upward; it will be red at the start and then gradually become green. When this sprout becomes about seven inches high the leaves will come out. The leaves grow in a spiral surge, in a series of six which altogether make a complete circle around the trunk. In some varieties, the leaf growth goes in a clockwise direction and in others counterclockwise. In time, as the tree grows, you can observe the beginning of branching. If you do not prop up the tree when it becomes large enough to lean, the tree will grow branches to balance itself.

In growing vegetables and flowers it is important that you plant enough seeds so that you will be able to uproot a plant each week to study as the other plants grow to maturity. In this way, you can observe the underground development. As all of this occurs, draw the plants, making sure to get the feeling of each stage of development.

FORMS OF ORGANISMS

Though we are organic forms that pulsate with life as we move about in the activities of living, we have no absolute necessity to understand why or how we live. We live for the sake of living. We accept the life within us and the life around us. Only occasionally do we ask the question "What is life?"

However, when we do ask this question and we think about life seriously and deeply, we find that we have some mysterious and intuitive way of knowing what goes on in other living creatures. All of us have some of this insight, but some people are incredibly sensitive to life and we call them seers or geniuses. But almost all human beings have the innate quality of deeper understanding because the forms and movements in the world outside of man are duplicated within the human organism and its internal movements. When you understand a thing outside of yourself, you are actually recognizing something that is felt within you.

This has to do with not only the energy forms, atmospheric forms, liquid forms, and the forms of solid matter; it has to do also with the forms of other living creatures. Man has, or has had, within him all the stages of evolution from a one-celled organism to the fish, reptile, and other levels of animal development. You might say that we are a specialized organism that has evolved to know and feel all of these realms.

When artists and talented children begin to draw something, they do not just copy its lines, contours, and shapes, but while drawing they *become* the thing that they wish to draw. Whether it is a living creature, a stone, or a cloud, the artist and the child always seek the feeling of that thing within themselves. They find the feeling of weight or lightness, movement or stillness, pattern and direction from the storehouse of movement and processes within themselves. The children's game of pretend is an important feature of human learning and this game is a worldwide phenomenon. When an adult seeks to understand a thing he still plays this game.

In our discussion of line in Chapter 2, we found that the stick figure originates from man's awareness of his own

145. These are examples of different radiating lines which can be found in plants.

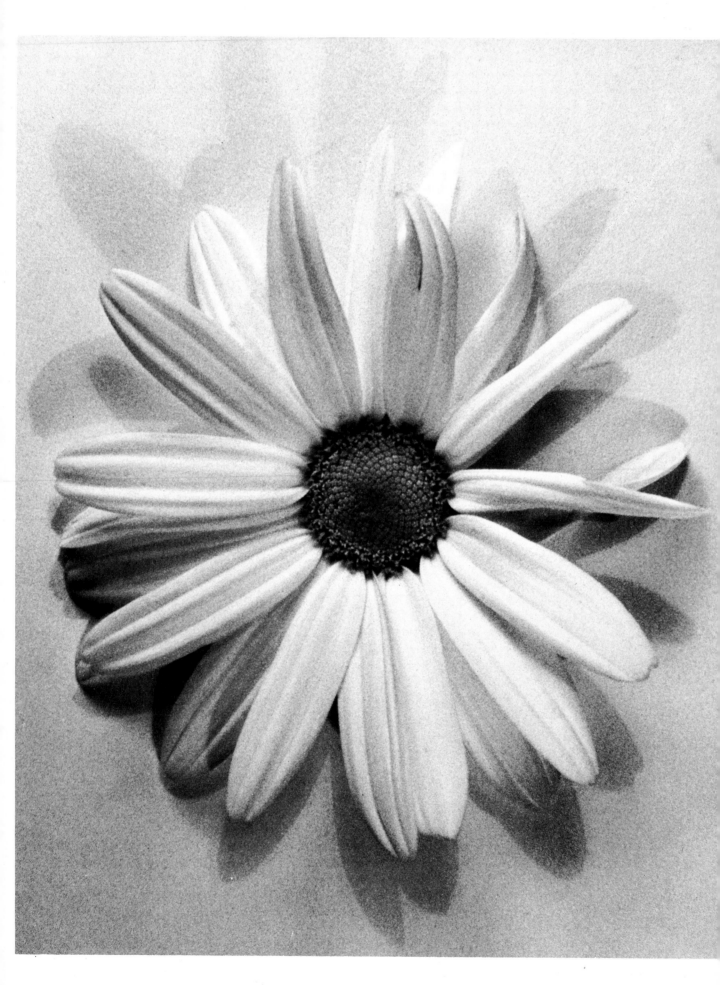

skeleton through his inner feeling of it. By placing the stick figure on all fours, we apply the same concept to animal forms, just as children do when they go on all fours, playing "doggy" or "horsey." But this is only part of how man has learned to draw; he had to learn to fill in the volume of the creatures that he wanted to represent. The stick figure has a certain amount of life and animation, but man feels more than this. He feels volume, weight, and the pulsation of life. The question remains, "Where does the concept of roundness and fullness come from?"

When talented children begin to draw they not only have an instinctive grasp of the stick figure, but often use rounded forms to duplicate the rounded segments of the body (Fig. 156). The segments that they duplicate all the time are the trunk and head. Some children then use lines for arms, legs, hands, and feet, but others will use rounded forms for every part of the body. This is a result of their internal feeling—the feeling of fullness in each segmented part of their bodies. These children have intense feelings within themselves and these are feelings of shape as well as life. The mature artist is one who has kept the awareness of these same feelings in himself, and therefore draws not only what he sees but what he knows by his inner feeling.

As I said earlier, geometrical forms do not correspond to the actual forms of nature. Geometrical forms have no feeling because they are arrived at by a dry, mechanical formula that does not take into consideration the state of energy or the feeling within the subject. Furthermore, geometrical forms can be constructed by people who have little or no feeling for life and growth at all. The talented child does not use geometry as a source of his feeling of form, nor does the talented artist. When they make full shapes they are not trying to make circles or ovals. Instead, they are drawing out the shape of the flowing feeling within themselves, and the shape of the flowing forms found in nature. In our search for natural form principles we have found some of these forms, forms rich with content and feeling. We have found these forms in all of the other realms of nature and it is a possibility that they may give us some clues that will lead us to the abstract forms of living creatures.

When we examine living creatures—ranging from the one-celled swimmers, found in every pond all over the world, to those higher up the scale of life—two forms emerge that blend together and fit the shape of life. The teardrop shape that so well describes the seeds of plants is the *orgonome* (the form of energy in living systems described by Wilhelm Reich) of water creatures. This form has great similarity to the bodies of animals, if we overlook the heads and legs. Since animals have evolved from the swimming creatures it is logical that they have kept some aspects of their form. But animals have added new capabilities that enable them to move over the earth and reach outward. Did the creatures of the land actually *add* these new ways? It is possible that we have overlooked something about the form of the swimmers and if we look more deeply we will find an additional meaningful form within the orgonome or the teardrop shape, another form that is fused with it (Fig. 157).

The other natural form that shows the greatest over-all

147. These two plants are examples of the vortex form.

146. (Left) A daisy shows both radiating lines, as in the magnetic pole, and a spiraling movement, as in the galactic form.

148. Grapes consist almost wholly of water, so that the form of the grape should follow a basic water form such as the bubble cluster.

149. The bubble cluster can be found in many plants.

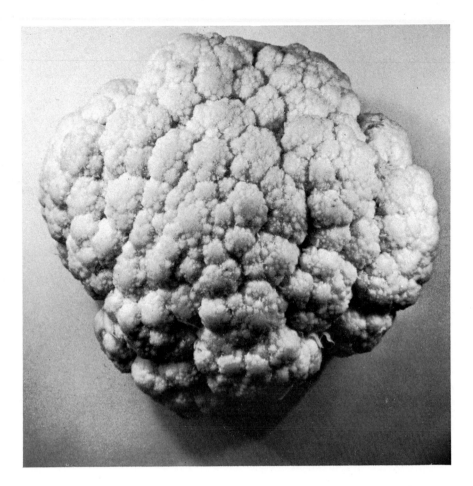

150. We can see the cloud form in a cauliflower.

151. A parallel of the cloud form is found in the convolutions to the human brain.

152. Both the outside and the inside forms of the jonquil show its relationship to the splash form.

153. Here are additional examples of various splash forms which can be found in flowers.

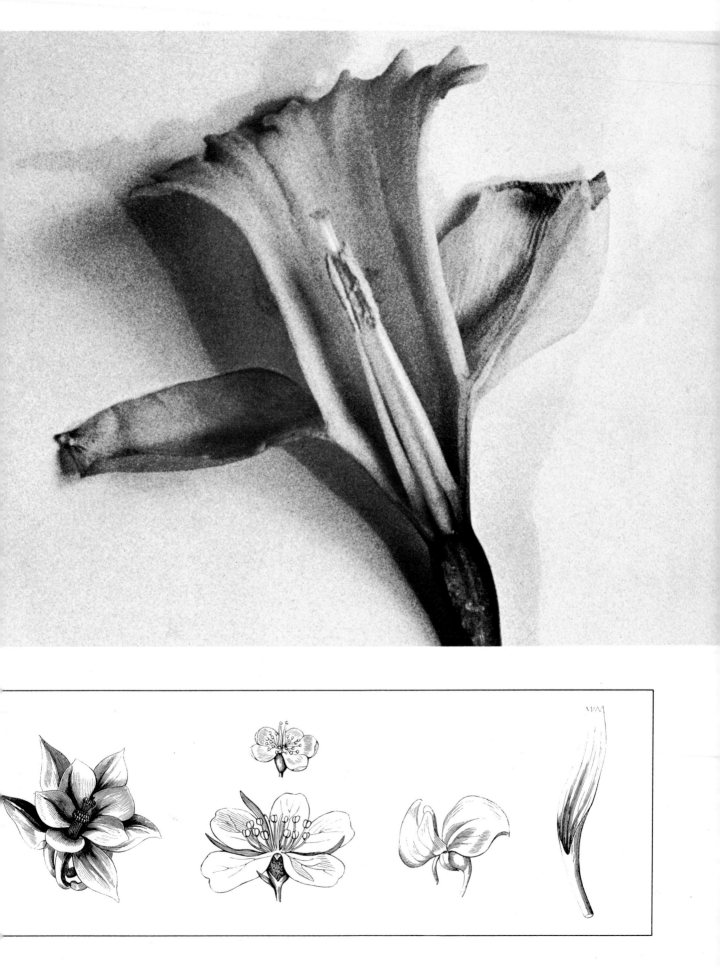

154. This cross section of a mushroom shows its relationship to the jet form of water.

resemblance to walking and crawling creatures is the *magnetic field*. This form possesses a fullness, a mouth-to-anus direction in its internal parts as well as the internal shapes and forms of organs. In addition, the two forms merge so beautifully that the two together resemble a single-celled creature, or a fish, and with a little more emphasis on the magnetic form the arms and legs begin to fill out the form of a land creature. When you realize that the magnetic field of the earth surrounds and contains everything we know of life and nature, you will understand that its basic form should be echoed in all forms.

The abstract forms we have found throughout all of the other realms of nature are also in many variations and combinations in living creatures. The form of the orgonome and the magnetic field are the basic forms and they tend to dominate or produce the rest. For example, the form of the embryo or the form of the male and female sexual organs follows the form of the jet of water (Fig. 158). The bronchial tubes of humans and animals reproduce the branching form. The veins, arteries, and nerves are anastomotic networks. A kidney or an intestinal tract bears great resemblance to the invaginated form of the cumulus cloud, etc. (Fig. 159). But all of these forms are produced within the orgonome and the magnetic field.

It is important for the artist to understand that all of these shapes and forms are variations of the spinning wave line. This line expression seems to be basic to all growth and movement. It is also important to consider how the forms that are hidden within organisms help to create the outer form. In drawing organic forms, you should realize that the inner movements and shapes create the most important aspects of the form, which is not the outline or surface roundness, but the pulsation of the life within and the flow of energy. The inner movements express the process of life—the rhythmic heartbeats and breathing, etc.—while the flow of energy in the muscles or at the skin expresses the emotional feeling and the reaction of a creature to the environment (Fig. 160).

In other words, knowing the movement within the form, —seeing it and feeling it—is the key to drawing it well. It is the key to understanding what a living creature is—what makes it different from the plant, the mineral, the inert form. Knowing this about life means that you recognize that male and female living creatures are drawn together in the sexual embrace, that in this the creatures express the creativity that fills the universe. Not only are the forms of the animals designed for this union but in the actual union itself the male and female together create a pattern that is found throughout nature—the galactic form. In the lower animals this convulsive movement follows the galactic pattern alone, but in humans the male and female complete the pattern of the magnetic field in their embrace as well as the general form of the swirling galaxy. These forms, these feelings, and these purposes are all subjects for the artist's deeper understanding.

To attempt a description of the forms of all animal life is more than a lifetime task because there are over a million known species. The fish family alone has so many variations in form, shape, and coloration that it would fill a large volume. The creatures above water are just as varied, and this is why we have to think in terms of the principles of form that are common to all living things. The human form, even though we see it all our lives, is the most complex of all because the range of expressions is so very

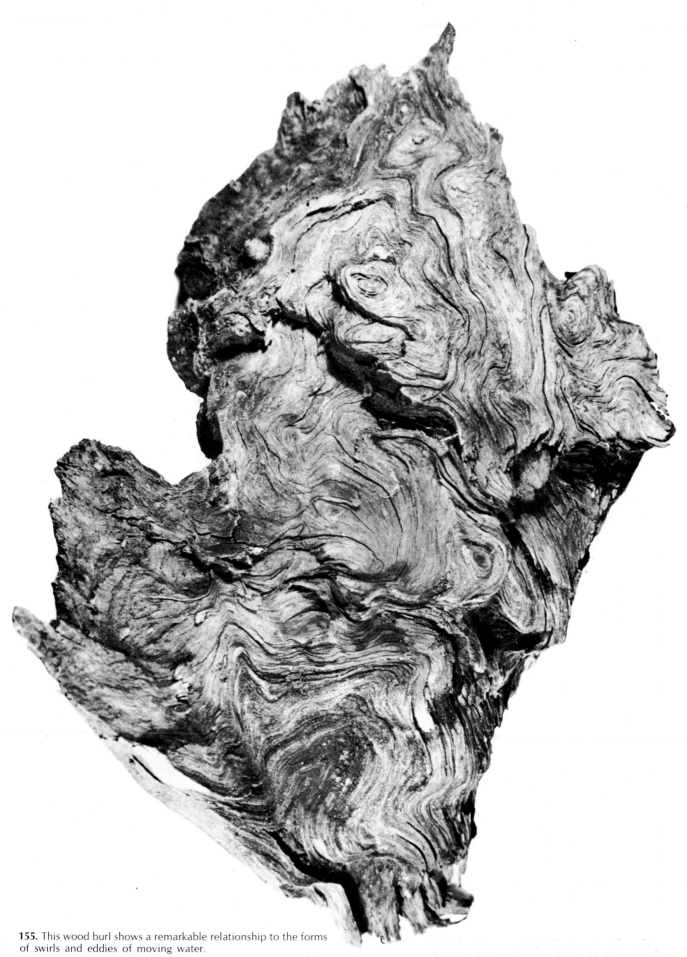

155. This wood burl shows a remarkable relationship to the forms of swirls and eddies of moving water.

156. Children draw rounded forms as though they have the same qualities of pulsation as organisms. The arrows outside the diagram show the sense of an outside force (atmosphere) and those inside (the inner life). (Drawing by Lisa Hale).

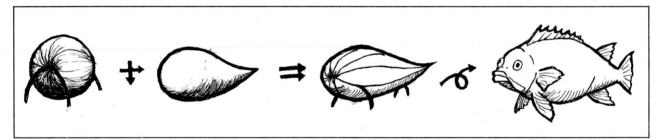

157. The magnetic field and the orgonome merge in the form of a fish.

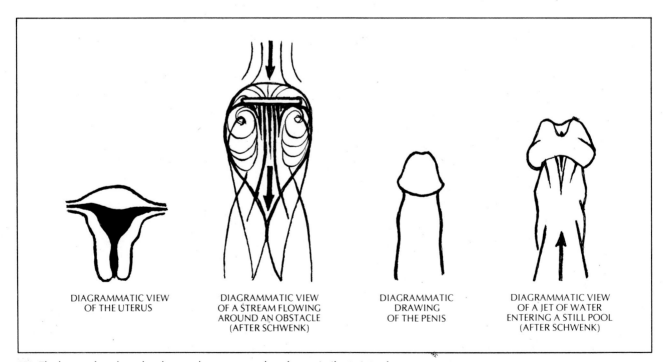

DIAGRAMMATIC VIEW
OF THE UTERUS

DIAGRAMMATIC VIEW
OF A STREAM FLOWING
AROUND AN OBSTACLE
(AFTER SCHWENK)

DIAGRAMMATIC
DRAWING
OF THE PENIS

DIAGRAMMATIC VIEW
OF A JET OF WATER
ENTERING A STILL POOL
(AFTER SCHWENK)

158. The human female and male sexual organs reproduce forms similar to jets of water.

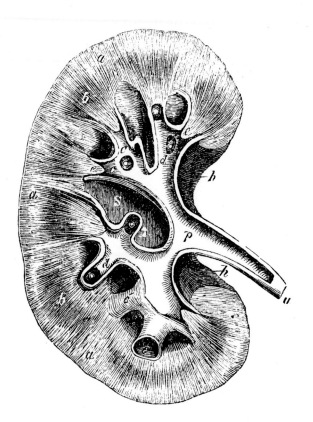

159. Some human organs follow the jet form: the kidney follows the shape of the inward flow of the fluids that it purifies.

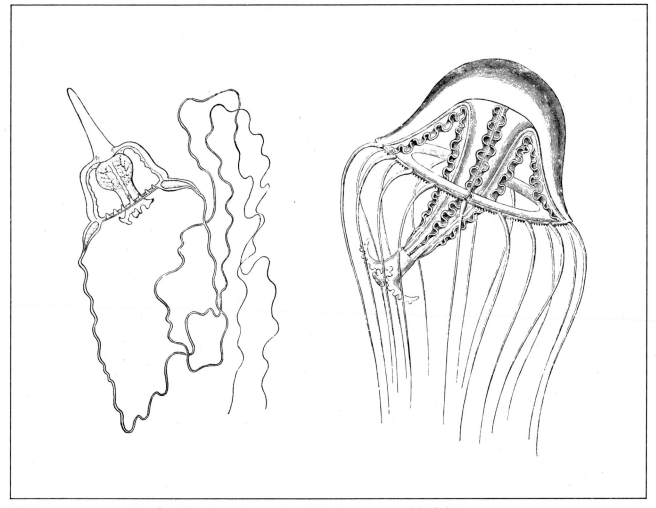

160. Some marine organisms also follow the jet form: the jellyfish is a structure of fluids living in a fluid medium, and so it follows the movement of its surroundings.

wide. Yet the human figure is the very center of the artist's interest. It is his standard and what he learns from the simpler organisms, he applies to the study of the human form. This is called comparative anatomy and it is very much like the game that children play of being "doggy" or "horsey." Organisms can be compared because their cells all function in the same way and their organs are similar. In the vertebrates, there is an astounding similarity in skeletal structure and musculature because all vertebrates are constructed on the same principles. So it is these principles of form that are important to the draftsman. The basic organic shapes of the orgonome and the magnetic field are the foundation forms of life.

However, the artist must follow the development of the actual growth and forming patterns of the creatures that he wishes to understand. Each living thing should be seen not just as a form of the present but as a history of growing movements which started in the parents' creative embrace and continued in the embryonic growth, birth, and development to maturity. No creature is young forever; all creatures are a part of the great cycle of life. Each stage within this cycle has its own specific tale to tell in form as well as in content.

Project: This is a twofold project in the basic organic forms and movements. You need your pencil and paper. You will have to do some collecting along the seashore or spend some time in the natural history museum, aquarium, and zoo.

It simplifies things to study living forms that have kept a record of their shape and development in the forms of their shells. Shellfish are excellent study material because they specialize in one or two basic forms and movements (Figs. 161-177).

It is a simple matter to collect models of all of the basic forms in shellfish. In coral forms you will find branching, radiating lines, and invaginations (Figs. 179-186). Horn shells show the vortex form, whereas the conch and the whelk show the vortex *and* the equiangular spiral. Many shells show variations of the wave form including the cockle, the oyster, and the murex. Limpet shells show circular radiating waves. Sea urchins are beautiful examples of radiating lines. There are many others.

Among other sea creatures the radiolarians, foraminifers, diatoms, and other tiny creatures produce the entire range of structure in their skeletal formations (Figs. 187-194). Among larger water creatures the starfish (Fig. 22) shows the well-known forms of radiating lines, while the octopus' body is a combination of the orgonome and the radiating lines of his tentacles. Jellyfish are shaped in the splash or droplet form (Fig. 195), but the rainbow comb jellyfish (Fig. 196) is a perfect example of the magnetic field form. As we said earlier, the fish forms show the orgonome form most strongly although they sometimes distort it in incredible ways. You must draw as many of these forms as you can find, but first fix the universal principles of form in your mind.

For the study of basic life movements there is nothing better than looking with a microscope at the little creatures that are found in ordinary pond water. In these creatures, you see pure pulsation and streaming movement in the simplest and most beautiful expressions. If you can get to the local high school or college biology laboratory, you will be able to see these little creatures. Or you might buy one of the inexpensive microscopes that are made

today, as I have. One way or the other, this is an experience you should not miss. Look for a while and then try to draw what you have seen. Do not worry about the detail of the creature, but work for the over-all movement and feeling of life.

Goldfish or aquarium fish are also excellent subjects to work from as they move fairly slowly and often hold still long enough for a quick drawing to be made. Kittens, puppies, or infants are fine to draw also, but you will quickly find that their form is more complex. Be sure to look for the basic forms that the simple and complex creatures have in common.

There is one very interesting basic exercise that is marvelous for beginners who cannot seem to get the hang of drawing living forms. Take a toy balloon and fill it with water and tie the top. The filled balloon represents the animal membrane with the plasmatic fluid inside. The balloon can be drawn as it sits on a table or it can be squeezed into different shapes. The total effect is very lifelike and quite easy to draw. There is a fascinating responsiveness in this form that will open a beginner up and enable him to make the transition from hard shapes to the soft yielding ones.

FORMS OF DISINTEGRATION, DECAY, AND DEATH

As all forms come into being they also disintegrate and fade away, a fact that may seem depressing and beyond the scope of art. Decay is not a joyous subject. On the other hand, nature is in a constant state of change and as some forms die others come into existence. For mankind this thought creates the urgency and poignancy of time.

You will notice that I have used three words to describe the ways that vitality leaves form. There are three conditions in which death occurs in nature, aside from accident. But before we discuss these conditions we will first consider some natural aspects of disintegration that we do not ordinarily regard as death.

In energy forms there is no real death as energy emerges from and returns to the universal ocean of vitality. Energy forms in space—such as the galactic form—come and go, taking countless billions of years in the process of their existence. Other energy forms, ones with which we are more familiar, take only a few years for their existence. Still nothing is lost, and the energy that has animated one form today will animate another tomorrow.

Weather forms show this constant fading away and rebirth very clearly. When clouds disintegrate, these atmospheric forms gradually lose their form by first becoming ragged at the edges; their energy dissipates from their edges to the center until finally the mass disintegrates into a mist. We are so used to seeing weather changes that we do not regard the death of a cloud with fear or dread. We know that clouds will always re-form, that weather constantly changes.

Water can command life and death—becoming and fading away. We are seldom aware of its disappearance as it evaporates. Only when water boils are we able to perceive its disintegration. Just as mysteriously, water reappears again in the form of dew, rain, or snow. Even

161. (Right) This shell is an example of an equiangular spiral that does not move along its axis.

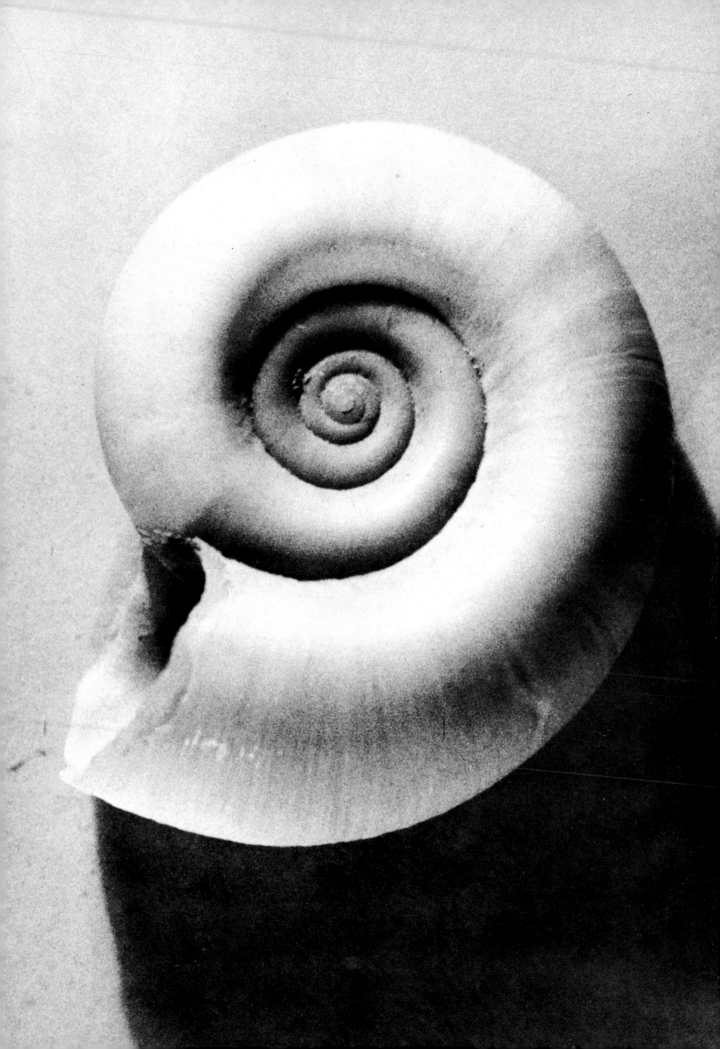

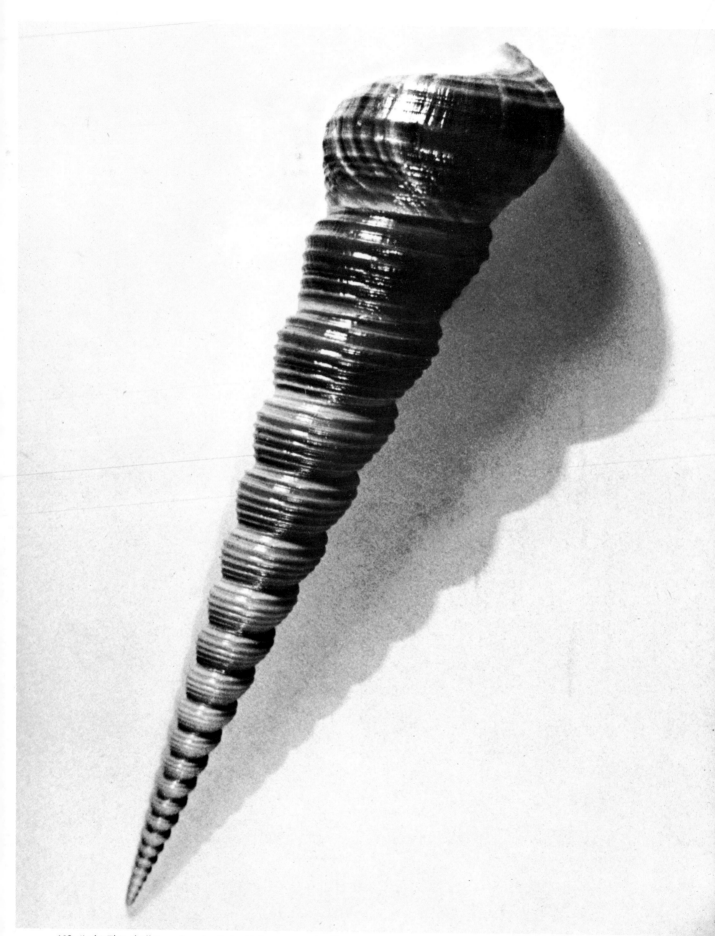

162. (Left) This shell is a closed spiral which connects itself as it grows along its long axis, creating a solid form.

163. The top of the skeletal form of the sea urchin shows a relationship to the polar end of the magnetic field.

164. The bottom of the sea urchin shows radiating lines as well as a relationship to the polar end of the magnetic field.

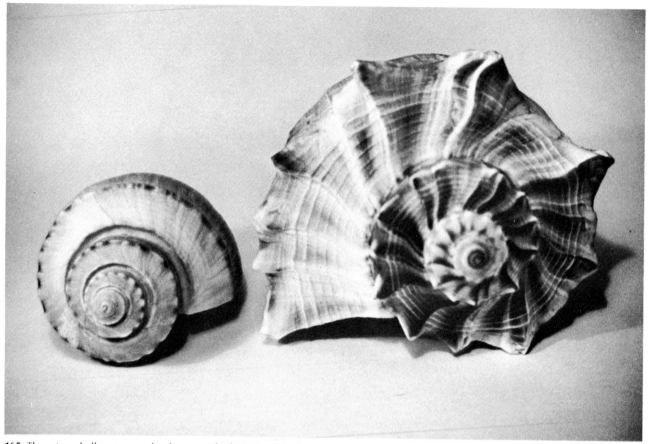

165. These two shells are example of counterclockwise and clockwise directions of growth.

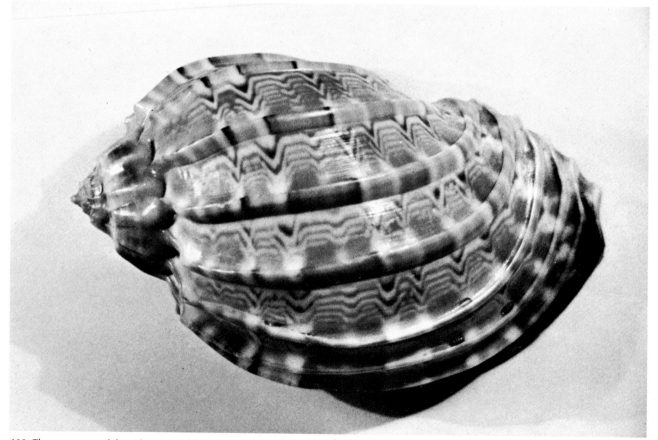

166. The symmetry of the ridges resembles waves pulses, while the shell's pattern resembles the sine wave of electronic pulse.

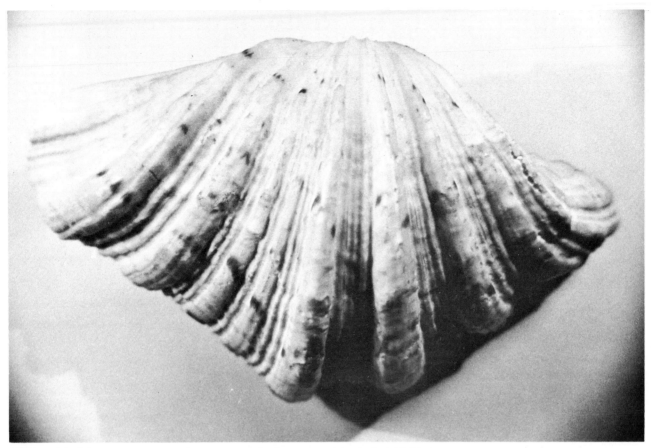

167. An echo of the wave movement of water appears in the pattern of the shell of this bivalve.

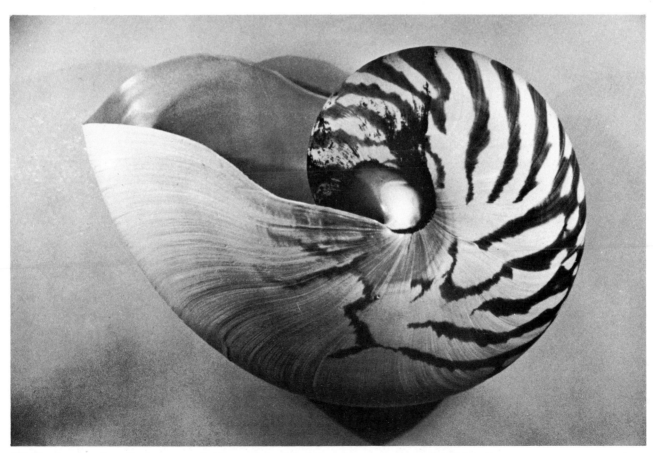

168. The chambered nautilus is an example of an equiangular spiral, moving around one point of its axis.

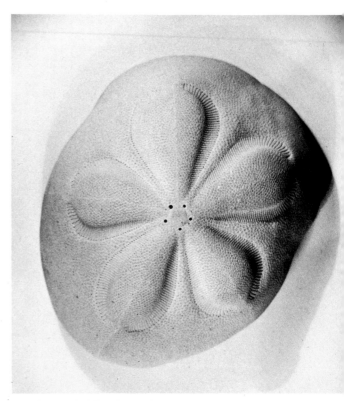

169. This sand dollar shows an example of radiation within the form of the radiation of flower petals.

170. This sand dollar shows the variation of form in relation to radiating lines.

171. The wavelike serrations within the cowrie shell make it an unusual form.

172. Two cone-shaped shells: the one at left grows tightly around its axis; the larger one at right extends its form along the axial line.

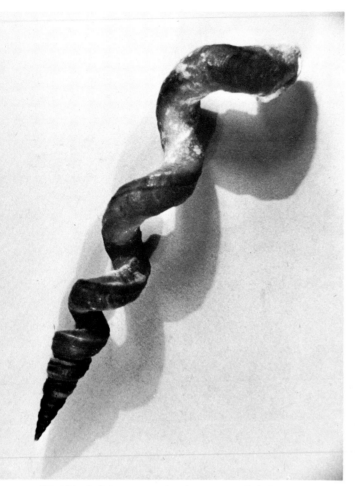

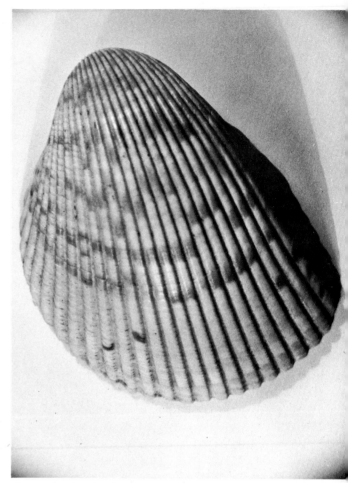

173. This shell is an example of an open spiral that grows more along its axis than along the plane of rotation.

174. Another bivalve shows a strong linear pattern in its direction of growth.

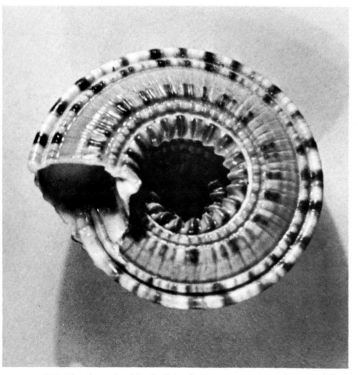

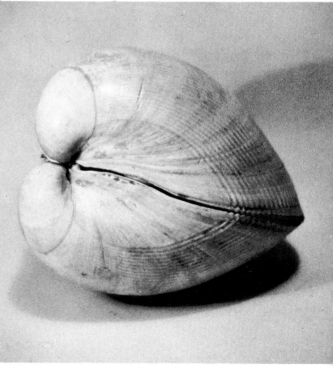

175. The form in this shell is close to an equiangular spiral, but there is a slight growth along its axis of rotation.

176. This bivalve shows double spiraling—the ends of which meet along the center line.

177. This shell spirals tightly on its axis but has enough movement along it to extend the form. Note the resemblance at the squared end to a Babylonian ziggurat (a many-storied tower, giving the appearance of a series of terraces).

VENTRICLES OF THE HUMAN HEART

VORTEX FORM IN THE CROSS VIEW OF A SHEEP'S HEART

EXTERIOR OF RIGHT BONY LABYRINTH

INTERIOR OF THE LEFT LABYRINTH OF THE HUMAN EAR

LEFT COCHLEA OF A YOUNG CHILD'S EAR

COCHLEA OF A FETAL CALF

OSSEOUS COCHLEA OF THE HUMAN EAR

OSSEOUS COCHLEA IN CROSS SECTION

178. Examples of shell-like spiral forms can be found in the human body and in animals.

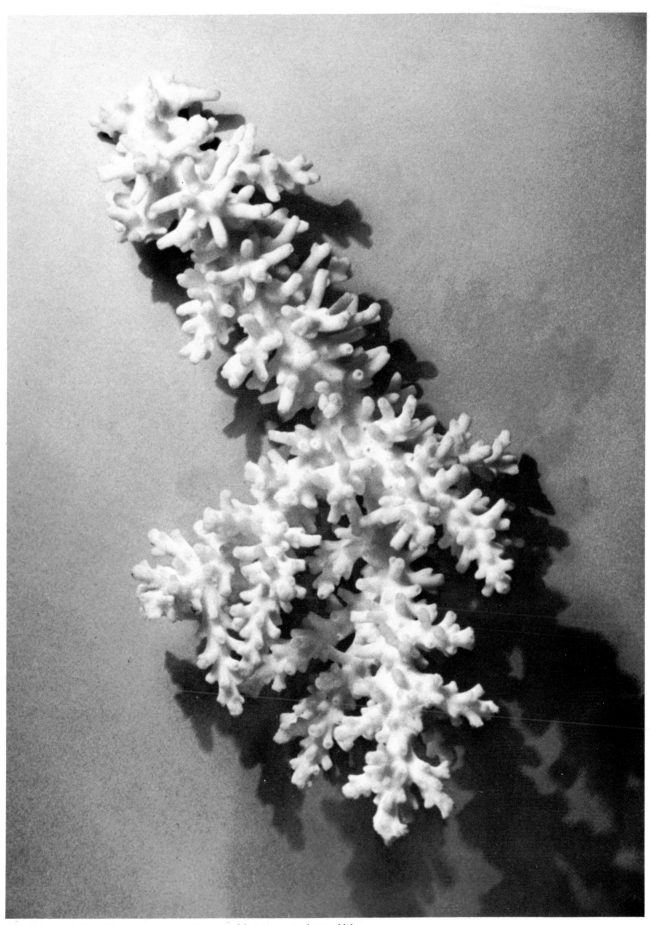

179. This coral shows the immense variation possible in just one form of life.

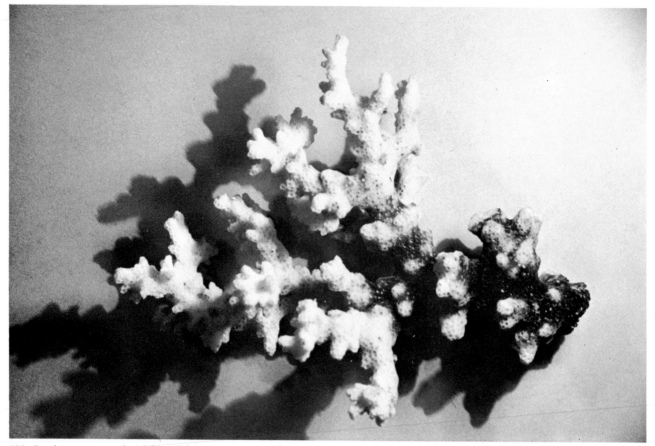

180. Coral is one example of the solidification of animal matter that creates the earth masses of coral reefs and islands.

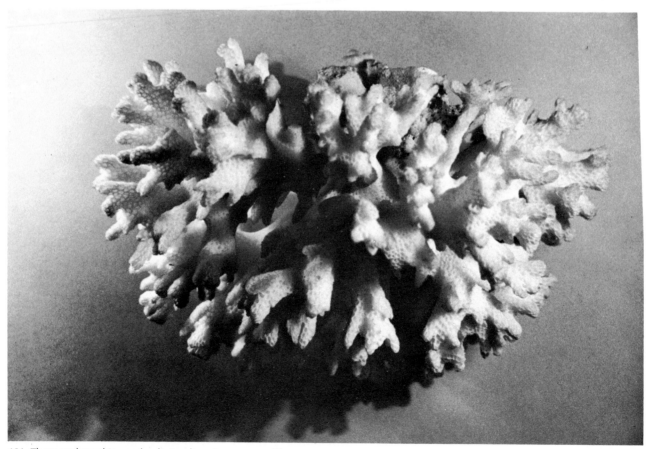

181. There are branching and radiating lines in some coral forms.

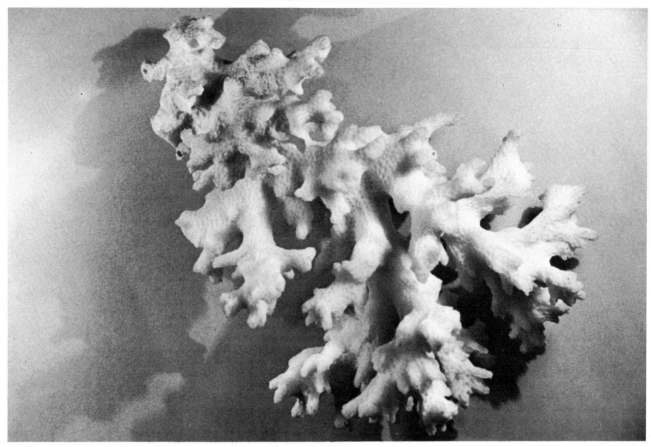

182. There is great similarity in this coral to a cluster of juniper leaves.

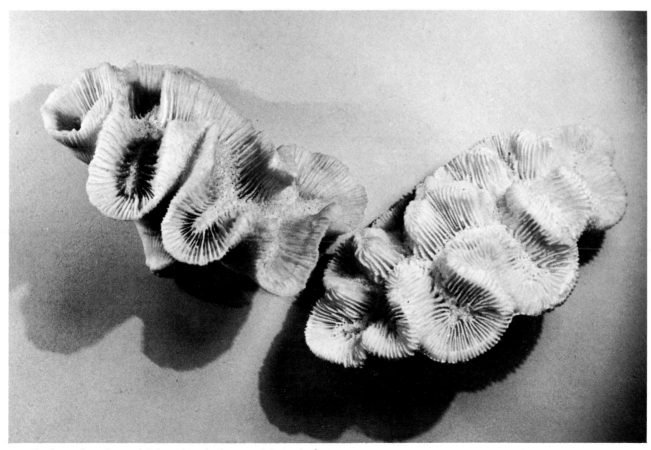

183. The form of coral growth is based on the long, undulating curve.

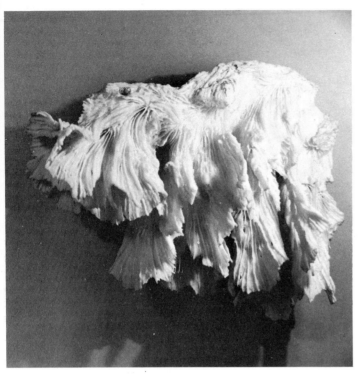

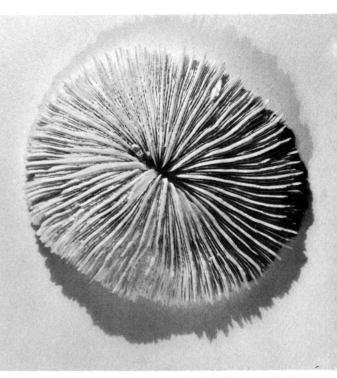

184. This is called lettuce coral because of its wavy, leaflike form.

185. This coral is a beautiful example of radiation, which is comparable to the polar end of a magnetic field.

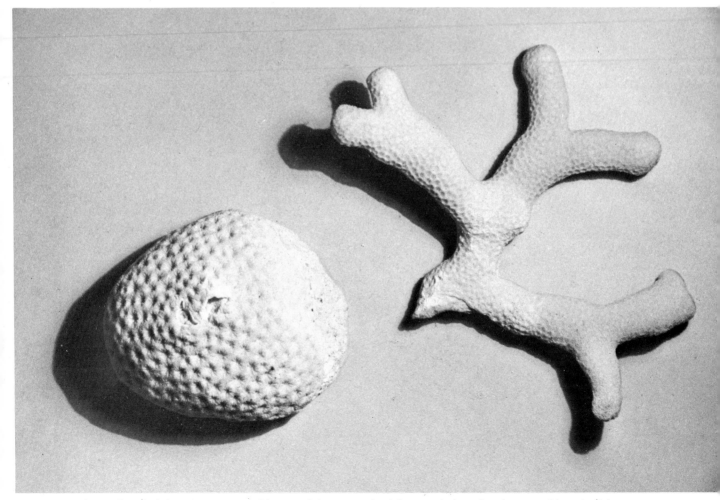

186. The coral on the left grows in a rounded form, and the one on the right grows in branches that resemble animal bones.

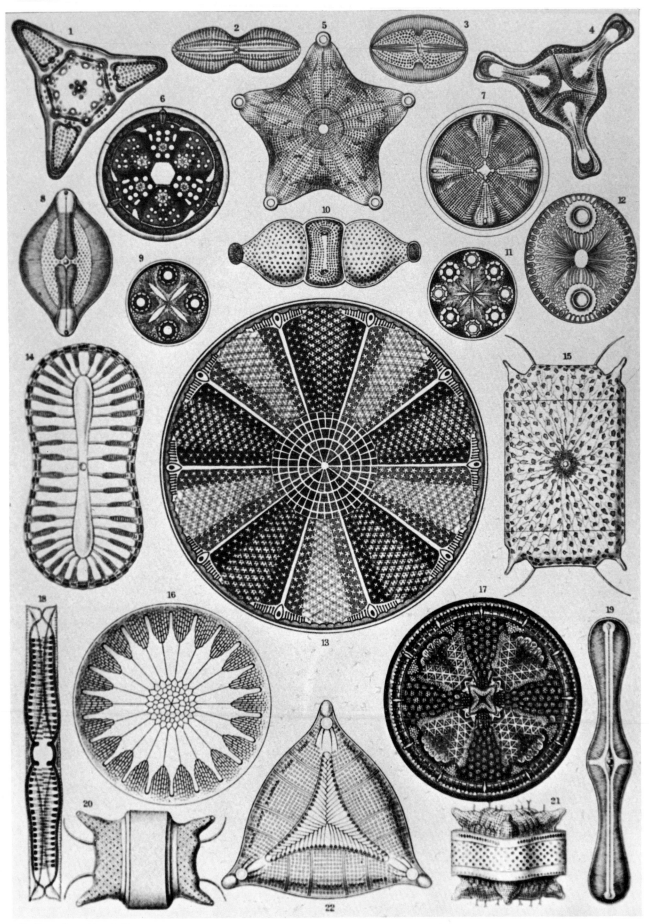

187. (From Ernst Haeckel)

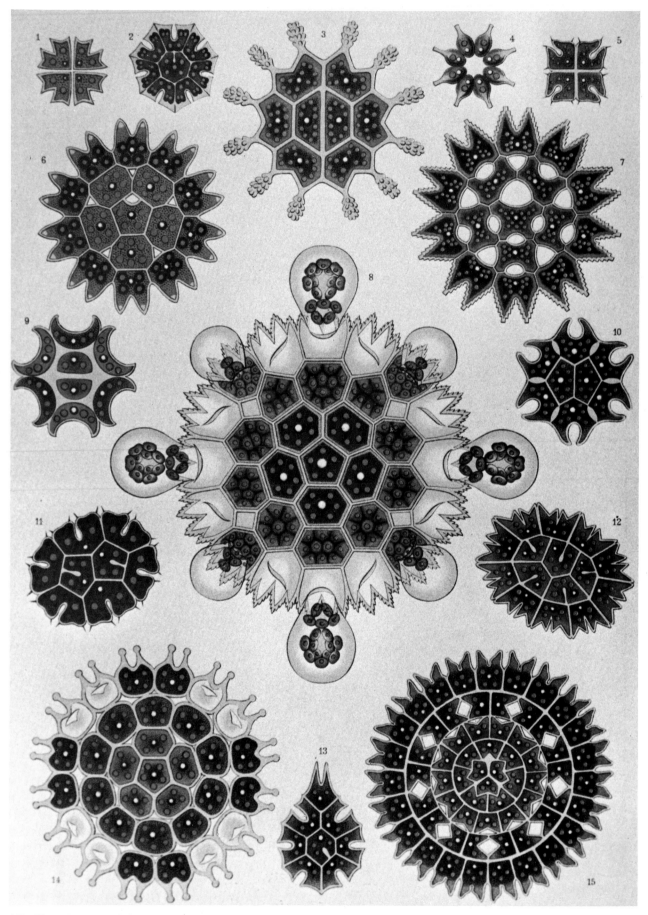

188. (From Ernst Haeckel)

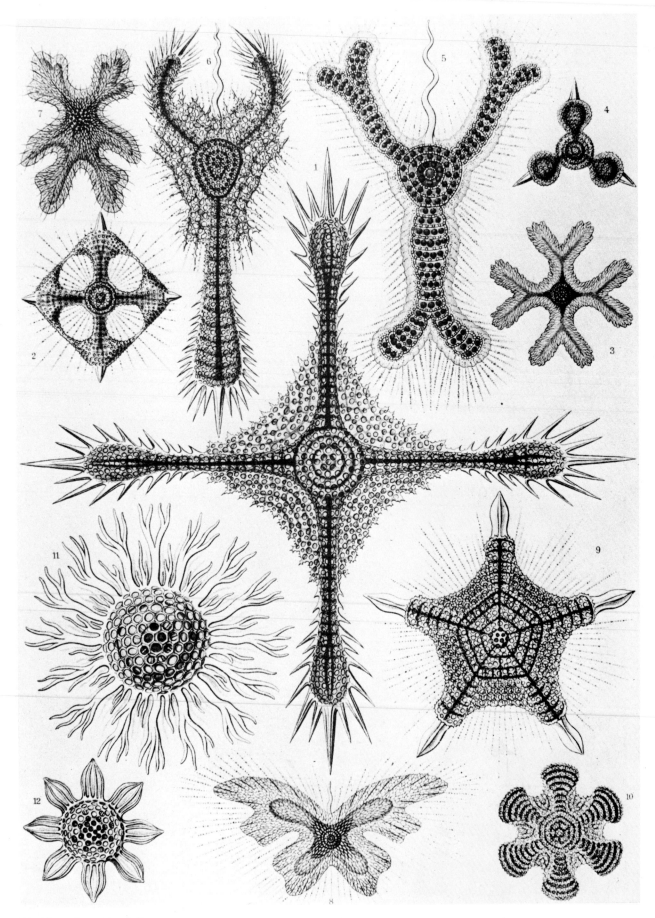

189. (From Ernst Haeckel)

194. (From Ernst Haeckel)

195. Minute organisms follow many forms, both those whose substance is composed mostly of fluid follow the forms made by water, such as the splash form. (From *On Growth and Form*)

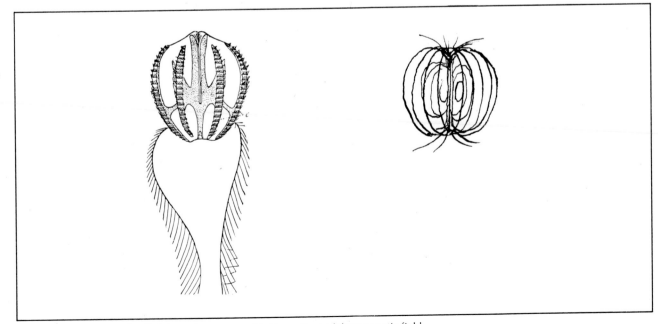

196. The pattern of comb jellyfish can be compared to the pattern of the magnetic field.

though we can sometimes read signs of coming rain, it is a miraculous thing to see water come from the sky. But water in the form of clouds or in the form of liquid is very close to the magic of pure energy, so this changeability is understandable.

It is the earth forms that really make us aware of disintegration since they take such a long time in their forming and in their dissolution. We never see the emergence of the earth forms as they occurred before the beginning of life. We only see their venerable age. We do occasionally see the re-forming of earth masses though, through erosion or in the disaster of an earthquake.

Atmosphere, water, and earth, however, do not exist independently of one another. They interact to create an environment where life can occur. This relationship is always a balance of their forces. As a system of balanced forces, the scale of the environment can be tipped to two extremes that are on either side of the middle area where life flourishes. So there are three general kinds of environment that do exist on earth and each one has a marked effect on forms that live and on the nonliving.

On one side of this scale of environment is a condition that tends to disintegrate atmosphere, water, earth forms, and the forms of living things. This is the desert. In this condition the earth forms dry up and crumble as the earth can no longer hold water, and the atmosphere can no longer produce rain or hold moisture. This condition can go so deeply into matter that rocks and minerals, which ordinarily do contain a certain amount of water, lose their water content and undergo a chemical change. As this happens the old forms corrode and crumble, creating some of the strange rock formations for which deserts are well noted.

Being an environment that does not nourish or encourage life, the desert can kill living things that are not adapted to its ways. The life forms that do appear in deserts are all strangely distorted. Some of them are very stunted; others are like skeletons or fleshless frameworks; many are spiny and repellent. It is not uncommon for human tribes that have adapted to desert conditions to have some of these same characteristics in their behavior.

Some deserts have occurred naturally and for reasons that are not fully understood, but in the last five thousand years of civilization man himself has created vast deserts with his sheer ignorance. He has done this by overgrazing the land with his flocks of sheep and goats. He has done it by cutting off timber and destroying the natural plant life that attracts and holds moisture.

If you have wondered why areas of landscape surrounding human settlements are often ugly and repellent, it is because man has created a desert with his trash, industrial fumes, and careless destruction of all the natural arrangements of the landscapes. These desert conditions mar the forms of nature and give the impression that the landscape has been starved, burned, or killed. This is very close to what does actually happen in the desert condition. As the atmosphere loses its moisture, the heat of the sun and the cold of the night become more intense— all of which hastens the corrosion of the earth forms and the death of plant and animal life.

Why is this important to the artist? Does it have anything to do with learning to draw? It is important because both healthy and sick forms exist in nature and we already have an unconscious awareness of these differences. But to draw form well, it is necessary to understand the expression of the form. You must be able to evaluate form's shape, mass, and the condition that the form is in. There is a considerable *emotional* difference as well as a *difference in forms* between a landscape where life flourishes and one that is oriented toward death.

Before I discuss the other environments, let us consider briefly the forms of fire since they bear some relation to the desert condition. Fire is an agent of disintegration and energy transformation that reduces forms to simpler states. Fire is a release of energy which we can observe in watching the dance of the shapes and movements of flame (Fig. 198). All flames move in a beautiful combination of anastomotic lines that move upward along the line of levitation in spiraling and spinning waves. The fascination that fire holds for us comes from the repeated rhythmic movements. These movements are very similar to the feelings and sensations within our bodies. But fire has a dual nature: it can take life as well as warm it, and so part of our enjoyment of fire is tinged with fear.

Decay is the opposite of the drying and burning disintegration of form. Decay is a product of water which is, in fact, the very opposite of fire. In the environment of decay there is too much water. In this condition, forms become swollen and waterlogged and lose their natural elasticity or crispness. If in the desert things are reduced to skeletal forms, in the overwet environment of swamp, marsh, or tropic rain forest, forms tend to be overblown and weak in structure.

In damp, rainy, and swampy conditions there is too much growth and a stagnation of the atmosphere. In the desert there is a quickness and nervousness of movement, but in the overwet environment there is sluggishness and torpor. Forms that fall prey to this environment easily harbor parasites within themselves. Rocks and minerals will soften and swell and nourish mosses, algae, and bacteria. Plants that thrive under these conditions are soft and spongy. There is an abundance of insect life and other more primitive life forms. This environment seems to turn time backward. Decaying forms are swollen, and fetid.

Balanced between these two extremes is an environmental state that fluctuates between fire and water. In this environment a natural aging and decline can occur for both plants and animals. The forms that we regard as natural, pleasing, and healthy are products of this environment. These forms are enabled, because of this environment, to go through the stages of their life cycle and develop all of their potentials. Since this environment is a life-positive one, living forms expand to the full capacities because their energy is not sapped and distorted in adapting to adverse conditions. Which is not to say that adversity does not occur here. It does, but only as part of the movement and contrast of the lively environment.

Variations in this environment do not disturb the balance because the balance is based on a changing state of weather and season. The forms of a healthy environment are never stagnant, never fixed in one attitude; they have the ability to respond. It is important for the artist to acquire a feeling for this liveliness and variation. This can be done by studying and making drawings of the

197. (Left) The flame is basically an atmospheric form that results from the upward flow of burning gases. Compare this form with smoke patterns, cloud forms, and flowing water.

extremes of environment in the two anti-life environments, seeing how they are stopped and fixed, and then studying and drawing the moving and changing forms in the healthy environment.

A natural form of aging occurs in this environment for both plant and animal. After the period of maturity there is a gradual decline in the strength and structure of the form which does not diminish the inner liveliness, but allows it to exist to the very end with an alertness and a sparkle. Even the inert forms of rocks and minerals, though they are rounded off by weather and wear until they are tiny pebbles, will retain their density and cohesion. The leaves and stems of plants remain erect and springy until the cold weather diminishes or ends the flow of their sap.

Under the conditions of this environment, the decline and death of living creatures has a feeling of dignity. Though there is an increasing leanness and fragility there is neither decay nor disintegration; it is as though the form *fades* away, keeping the spark within. When this form of death occurs to humans there is nothing repellent about it, as they have simply lived out the cycle of life, the allotted time, and the energy that has animated them in life has returned to the reaches of space.

Artists have been interested in the forms of death, decay, and disintegration from the beginning of time. Some excellent drawings have been made of creatures in death by such masters as Dürer, Rembrandt, and Leonardo. I might add that today some artists find themselves attracted to these subjects in a singular way. Among these, in our own times, is Ivan Albright. Though the attraction may be difficult to understand, you should remember that death and disintegration eventually touch all things.

Project: The important thing here is that you study these processes of disintegration objectively. This project shows you how to do it.

Disintegration is an occurrence in time, and so you must space your drawing observations in separate sequences. For example, take a crisp lettuce leaf and place it in the sun so that it will wilt. Space your drawings one half hour apart. In each drawing observe the *movement* of the form change until the form has dried out. Try this same process with an inexpensive potted plant which you should allow to dry out. In this case, you should make observations twice a day. Depending on the type of plant, the project may take a week or as much as a month.

Decay can be observed and drawn by placing vegetable matter in water. The softer the substance, the quicker the results. It might be advisable to keep your specimens outdoors to avoid the odors of decay. The death of an animal is an entirely different matter since no one can easily allow an animal to die. But if you live in the country on a farm the situation is quite different. People on farms frequently see life being born and life dying, as it is part of farm life. If this is the case with you, the observations and drawings that you make should be spaced according to the condition of your subject. One point to note in animal death is the stiffening of the body that occurs after the body heat disappears. This is called *rigor mortis,* and it gives the form the inert qualities of stone or mineral.

If you would like to make a study of fire forms you will have to observe quickly and draw what you remember. Look for the anastomotic pattern, the over-all shape, and find the details after you have established them. There are great similarities in drawing fire and water.

198. (Left) Compare this example of flame with the flowing forms of surf and foam.

4. Pattern

The concept of pattern in art is an extension of the idea of form. Pattern deals with the relationships between forms in nature. In Chapter 3, we discussed basic forms and reduced these forms to their simplest shapes and movements. But as we did this, we realized that nature is not always as simple as we wish. Forms relate to their environment in complex ways. A single entity might be composed of several interconnected forms, and this entity relates to others of its kind. And finally it changes as time passes on.

For example, rather than having only one shape, a plant begins life as a seed, progresses into a shoot, then develops its leaf and root systems until it reaches its full growth when its flowers and seeds finish the cycle. Animals, on the other hand, have distinctive arrangements of organs and structures that are actually a whole series of forms that work together as a unified pattern. Animal forms grow in an ordered sequence so that the *over-all* system of change and growth is part of the pattern that is repeated with every new generation.

Each form lives in a complex world where it is surrounded by other forms of its own kind, as well as by forms of similar type and forms of different or opposite character. An example of this is the bug on a frog on a bump on a log by the lily pool at sunset in the summertime, where each form relates to other forms in the environment and becomes part of an over-all pattern. This pattern is like several different songs that are sung at once and end up sounding better than one song by itself. No form stands alone: a plant depends on its family traditions (its genetic customs), other plants that are living and dead, the soil, insects, the geography, the seasons, and the weather changes. A human depends upon his genetic forebears, his intellectual forebears, other living humans, animals, plants, earth, air, water, and the laws and functions of the galaxy that keep the earth moving on its yearly trip around the sun. So pattern in drawing also shows a series of relationships within a unit and/or that unit in relation to forms in its environment.

Some of the things that can be drawn in patterned relationships are the arrangements of forms like the fruit and flowers in a still life, the grouping of rocks and plants in a landscape, or the rhythmic forms of a human figure that focus into an expressive action like a kiss or the drawing of a picture.

Some of the qualities that pattern shows in drawings are arrangements of similar shapes, grouping of dissimilar shapes, symmetry, balance, sequence of movement, contrasting movements, and rhythmic movements. Also, there is variation within forms such as male-female or adult-child. Pattern can also show asymmetry or distortion of the natural shape; it can show the emotionally rational and the irrational. We can say then that pattern shows the forms within a single system or the relationships of various forms to the different realms of nature.

In drawing the patterns of things in nature, we automatically discover the laws of composition and design. Composition and design in art are not separated from the laws of nature. At the same time, artists are free to choose the patterns and meanings that appeal to them or suit their expressive purpose. In drawing pattern, you also encounter story, content and history, and the abstract meanings of nature that connect one realm to another. This sounds pretty impressive and may lead you to think that there are hidden and secret laws about art known to only a few artists, but in actuality all of these things are before our eyes. The problem is not that they are secret but that they are overlooked or seen only on the surface by most people.

COSMIC PATTERNS

We are all part of the universe; the movements and forms that occur in outer space—in our galaxy and others—can also be found in our earthly environment and within all living creatures. The galactic swirls and the anastomotic formations of star clusters are all echoed within the artist and his fellow humans (Figs. 199, 200, and 201). So it is important for you to realize, even when you are drawing the smallest and simplest forms, that these things have a cosmic origin and that you are a traveler through space. And further, that no one person can lay claim to these forms or their laws; they are all ours for the seeing.

Yet we understand very little about the universe and the cosmic patterns, and it has taken us thousands of years to understand the little that we do know. Even though we do not comprehend the whole scheme, the universe and its laws are the foundations of our activities and existence. The artist accepts these laws on faith, pretty much in the same manner that each newborn child accepts its creation and the function of its life. Even though we might see a reflection of the galactic swirl and superimposition in the swirl of a daisy or a vortex in the water in the kitchen sink, the life in us accepts far more things that we will *never* know because life is an automatic acceptance of all complex forces of nature. The idea of man controlling nature to any large degree is rather vain because nature is larger than our comprehension.

The realm of the known in art is not as vast as the area of the unknown. This idea is important to recognize in drawing because the blank page of paper represents open space—not emptiness, but the unknown and the unknowable. It also represents the space and the laws that

199. (Left) Compare the form of this cloud of cosmic energy to the smaller kinds of clouds in our atmosphere. (Courtesy of Mount Wilson and Palomar Observatories)

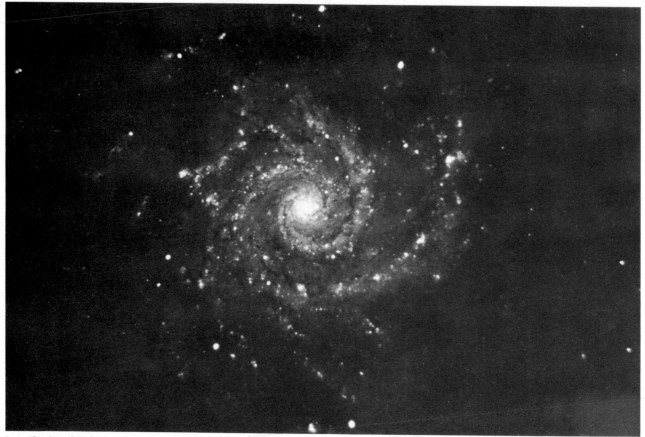

200. The Spiral Galaxy in Pisces is typical of the spiral form of the galaxies found throughout the universe. (Courtesy of Mount Wilson and Palomar Observatories)

201. The Star Cluster in Libra is a more developed stage of creation that occurs after the spiral and cloud formation. (Courtesy of Mount Wilson and Palomar Observatories)

govern the things that we *do* understand. We *draw things out* of the mysteries hidden on the page.

You must recognize that the page itself represents cosmic space. Even though it is flat and bounded by four edges, for the artist it is a kind of crystal ball where images of unknown things appear.

Project: In teaching students to draw, I have found it very useful to ask the student to first imagine the simple form of an egg and then concentrate on the page with great intensity as though he might actually bring the form of an egg to reality with the power of his mind. Then I ask the student to make drawing movements over the paper with his fingertips without making any marks. The student then draws the egg as though it were emerging from the page itself. I want you to repeat this experiment and then do some variations. You need pencil and paper for the first part and charcoal, a kneaded eraser, and fixative for the next one.

I want you to do some stargazing at night and some spacegazing during the day. Allow yourself enough time so that you can sit down or lie back and look up at the sky in a relaxed way. Do not look for particular objects, but let your eyes concentrate on open space and let your mind be free. You will notice waves, points, and zigzag motions in the air; pay particular attention to these motions as well as to the stars. Observe how light emerges from the space and that the space itself is full of movement and liveliness. When you have finished your observations, darken a piece of paper all over with charcoal. Draw out with the kneaded eraser the light forms you have seen. Draw out the light of stars and the points and movements in free space. This is also a good way to draw a spiraling galaxy or the anastomotic clouds of star clusters.

For your drawing with white paper, I would like you to create dots of various sizes so that they appear to be set at different depths in space. When you have done this, look at a sheet of blank paper and try to see it as depth and infinite space.

WEATHER AND ATMOSPHERIC PATTERNS

The patterns in the atmosphere that concern the artist are the cloud formations that stretch from horizon to horizon. In order to understand these patterns, it is necessary to show that the direction of weather movement is generally from west to east. You should also know the positions of the sun at different times of day. The sun appears to move from east to west, though it is the earth that actually revolves in a west-to-east movement, making the sun appear to cross the sky (Fig. 202). You should also have a good sense of the north-south lines of the earth's magnetic field.

The drawing of atmospheric patterns is governed by the movements of the earth's rotation on its north-south axis. The lines of the earth's magnetic field and the lines of the energy that causes the earth's rotation to cross each other at right angles create an invisible gridwork in the sky. The artist must visualize this gridwork pattern in order to place cloud forms and the weather movements in their proper relationship. If you take a large glass bowl and use a grease pencil to mark a series of parallel lines an equal distance apart in one direction and then another series of equally spaced lines at 90° to the first series, you will have

DIRECTION OF THE ROTATION OF THE EARTH

PRINCIPAL DIRECTION OF WEATHER MOVEMENT

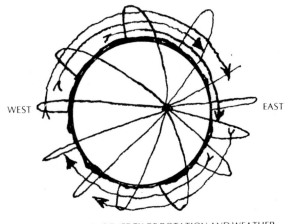

INTERSECTION OF THE ENERGY OF ROTATION AND WEATHER WITH THE TRANSVERSE LINES OF THE MAGNETIC FIELD

202. These diagrams show the invisible energy grid of the atmosphere from different compass positions. The broken lines indicate rotation and weather movement, and the solid lines indicate the magnetic forces.

ATMOSPHERIC GRID FROM A VIEWPOINT
LOOKING EITHER NORTH OR SOUTH

ATMOSPHERIC GRID SEEN LOOKING
SOUTHEAST OR NORTHWEST

ATMOSPHERIC GRID SEEN LOOKING
SOUTHWEST OR NORTHEAST

203. These diagrams show the grid of the atmosphere from different compass positions. The broken lines indicate rotation and weather movement and the solid lines indicate the magnetic forces.

an example of the lines that you must visualize in the sky. Hold the bowl above eye level and imagine similar lines crossing the bowl of the sky.

How do you duplicate this grid on the drawing paper? Since you can draw only one portion of the sky from the point where you stand, you must determine how these invisible east-west and north-south lines cross above your horizon line. The key to this problem is the direction that you face. This pattern is the same if you face north, east, south, or west; lines coming from the horizon radiate from a point below the horizon with a center line going to the top of the page and the other lines coming out at angles on either side of it. The other lines are curves from side to side that grow in distance as they approach the top of the page. In cases where you face a position that is between south and east, south and west, north and east, or north and west, one set of curved lines comes from the left horizon while the other set crosses from the right (Fig. 203).

Some cloud formations correspond almost exactly to the invisible gridwork, and they form in a series of long lines and move toward the east from the western horizon. In this case, the clouds in the distance parallel the horizon and are close together, while those coming nearer are more separated, though still parallel with the horizon. The same clouds you see when you face north or south will follow the radiating lines right into the horizon. From the southwest, north-west, north-east, and south-east positions the clouds will be arranged so that they cross from the top of one side of the paper to the horizon at the opposite side. This applies only to linear formations.

Scattered and puffy cumulus formations tend to flatten out and create a linear pattern along the horizon line regardless of which direction they come from and which direction you face. But cumulus patterns also tend to radiate out at angles from a point at the horizon when there are only a few scattered clouds.

Once you have gained some experience in using the invisible grid patterns, you will find that it is a simple matter to draw cloud formations that exist in one stratum above the earth. But if you observe different weather formations, you will notice that at times clouds exist at *two* different levels (Fig. 204). When two such formations appear, it is necessary to visualize *two* gridworks, one above the other. This would be as though there were two glass bowls with lines, one inside the other.

Though at first visualizing this gridwork may seem difficult, you will find that it is also something with which you are familiar. We are all subconsciously aware of this atmospheric geometry. Our sense of direction comes largely from the unconscious observance of the great atmospheric lines and angles. Remember that we live within a giant magnetic field that runs in great curving north-south lines and that this is crossed at right angles by the stream of energy that moves the weather and the planet.

Project: This project will help you draw and understand large cloud patterns. You need pencil and paper. To begin, I want you to make four pages of structural gridworks like the preceding figures. Find a position outdoors where you will have an unobstructed view of the horizon and the whole sky. The top of a hill or the roof of a tall building is a good vantage point.

First, determine the north-south and the east-west directions. Select the structural diagram that most closely

approximates these directions in relation to the direction that you have chosen for your picture. Next, quickly plot the position and direction of the clouds by making light outlines of their shapes. Then change your position and select another structural gridwork accordingly; then plot out the clouds again. Do the same thing from at least four positions. Finally, repeat the drawings from the same positions without using a diagrammed grid structure. Try to imagine the invisible structure that exists.

Take your diagrams back to your workroom and try to shade the clouds and draw in the landscape. Once you have grasped the basic principles, you can invent skies and your own weather formations.

Be sure to understand that clouds mean weather. A very fine drawing project is to work from the diagrams you have made and to use light and dark tones to create a feeling of weather movement. You can create a whole series of different kinds of weather in your landscapes.

WATER PATTERNS

The patterns of form created by flowing water are determined by the volume of water flowing, its rate of flow, and the structure and composition of the channel in which the flow occurs. You must first visualize the stream bed *without* the water in it. Draw the features of rocks and soil that are the stream boundaries before you attempt to draw the water pattern.

The first drawing concept to consider is the plane of gravity and the shape of the land in the picture area. If the stream bed allows the water to flow down an inclined slope, the streaming will produce turbulent rapids. But if the stream bed is a series of steps, there will be ponds in the level places that break into falls or rapids where the levels change, falls where there are abrupt breaks, and rapids where the levels are divided by inclines (Fig. 205). In this type of stream are all water forms: the eddies, the waves, the vortex, and the spirals. In drawing streams, look for the earth structures and from these you can predict what the water will do. Remember that the water is seeking the sea or a lake where it will finally come to rest. The patterns that water assumes are the expressions that it makes when it encounters obstacles along its journey.

When drawing large areas of water like lakes or the sea, remember the water's tendency to respond to the great energetic forces. The principal force is gravity which constantly urges the water to become still and form a level plane of surface. The forces of the atmosphere urge the water upward into movement. So the great drawing contrasts are the flatness of the plane of gravity and the water's response to the atmospheric directional movements above it. These are the major forces in the patterns of large bodies of water where the structure lines of current and wave movements oppose the flattening pull of the gravitational force.

In Chapter 3, we discussed the major wave and current movements, but the structure lines of weather movement that we have just discussed are important too.

The wave lines move at right angles to the weather's direction until they reach the shallows of the shore where again the earth structure interacts with the water to create shore waves.

The key to drawing water is to realize that water is always involved in a *sequence* of movements in response to the earth and the atmosphere.

Project: In this project, you can draw some water patterns. I will show you the steps in planning an imaginery stream, using the water forms that you have already studied. You can also draw an imaginary seascape. You need pencil and paper.

In order to draw a stream correctly, you must know its direction of flow. Plot out its turns from side to side and its levels from the highest point to the lowest point. Start by making a plan of the stream in a bird's-eye view, showing all its levels and turns. Next draw a profile view, showing the places where there are level pools and the separations between the pools where there are falls or rapids. To make the drawing more natural, place rocks and boulders along the stream course in the bird's-eye view and then place these properly in your eye-level view. The object is to use the bird's-eye view as a guide in drawing the eye-level picture; it will help you to foreshorten the stream in the areas where it comes toward you. Once you have plotted out the course of the stream, you can think out how to draw the water.

Think out the rate of flow. It is slow in the pools, but it begins to show current at the openings where it changes levels. If there are rocks in the pools, there are eddies around the rocks where the current is strong. There are only ripples around rocks where there is little current. These ripples are also at the edges of the pool. Where the slow currents and faster currents meet, a large or small vortex forms. At the falls there is some spiraling as the water pours over the edge and splash forms at the bottom. The rapids show intertwined currents, splash forms, and falls.

If at all possible, try this same drawing procedure with a real stream. This will reinforce what you have learned and demonstrate that you have learned how to understand a stream.

In your drawing of an imaginary ocean, start by drawing the horizon line a little above the bottom third of your paper. The shore line should begin at the bottom right-hand edge of the paper and move up to the horizon line at the left, but before it reaches the horizon let it curve back toward the right and up to the horizon. Then make a bird's-eye view on another sheet of paper, showing the shore line and the wave lines with an arrow showing the wind direction coming into the shore. The bird's-eye view should also show where the water becomes shallow—the point at which the shore waves begin to form. You will find that in your eye-level drawing, you are not facing directly into the wind and waves, but that they are coming in from your right toward your left, so the lines of the waves recede toward the horizon on the left. At the shore line there are overlapping sheets of water where the waves have swept up on the shore and these sheets diminish in size along the shore line as they move up to the horizon.

When you do a seascape that faces the shore and sea directly, it will give mostly horizontal lines. The only relief possible in such a head-on seascape will come from the way you handle the sky where there is a possibility of radiating or oblique lines.

It is very useful in the seascape project to use the drawings that you have made in your weather project to determine the pattern of your sky and weather. But be sure that the movement of the waves and the cloud direction coincide. When you have finished the project try to do a seascape from nature (Fig. 206).

204. Two layers of clouds show gridworks at two levels.

205. A level pond breaks into a downward flow at the pool's edge.

PATTERNS OF EARTH FORMS

In working with atmospheric and water patterns, we have already touched upon the earth patterns. Earth, air, and water are contrasting elements of nature, but at the same time they cannot really be separated from one another. This makes it difficult for the artist sometimes because he must separate them before he can understand them well enough to put them back together in a way that makes visual sense. You can see that the process of abstraction is like picking out the ingredients in a bowl of stew. You try to look for the parts, but it is the fact that the "juices are all swapped around" (to quote Huck Finn) that really interests us. The artist is always moving between contrast and unity in a fluid world of impressions.

One way of analyzing earth forms is to mentally remove all of the plants, atmosphere, and water in order to get down to the structure of the area you are drawing. In doing this, decide the heights of the earth and rocks, the contrasting angles of slopes and level ground and the direction of rock strata, all in relation to the plane of gravity, the horizon line, and your own position. Estimate the size and distance of objects in relation to your own height and your sense of the right angle of the plane of gravity and the line of levitation. In doing all this, you operate within the framework of your seven rings of attention, which we discussed previously. The nearer things are clearer and more interesting while the farther vague, indistinct, and mysterious.

This does not mean that there are always seven rings of depth in a picture. Our angle of vision takes in about 120° and large forms in the foreground can obscure portions of the distant landscape; a picture may have only three rings of depth. This is all a matter of the view you choose. But for learning purposes, it is best to use at least five rings of depth: close, nearby, within vision, distant, and atmospheric. Mentally remove plants and water to get down to the structural lines and directions. Draw these with simple lines that show the size and directions of masses. As you do this, take into consideration some aspects of earth formation that you may never actually draw. Think about how these forms came into being and how they are gradually changing.

In drawing, do not just copy the lines of the landscape, because ignorant, rote copying is not art. Lines as lines have no value and no meaning; your lines must reveal your thought and feeling, your contact with the forces in the landscape that you draw. You must look into the depth of things to find the inner causes, the movements and direction of growth and change. For example, in outlining a rock, ask yourself if the rock is freshly broken or old and worn, hard or soft. Is it of local origin, or thrust up out of the earth, or has it been brought there by flood or glacier? Perhaps this rock was once only a layer of silt at the bottom of a long-gone sea. If you ask such questions your lines will show not just shape, but also the deeper pattern of things.

And that patch of soil that you have represented with a line—is it filled with roots and little living creatures? How have plants and water helped to make and preserve the landscape that you see? What is the meaning hidden beneath your lines? Lines alone will not make a drawing profound. You can do this only by making your lines the expression of your vision and understanding.

Though you began your drawing by removing the plants, the water, and the atmosphere, you must give the structure meaning by bringing these things back. You know how to draw the atmospheric pattern and the water patterns that might be a part of the view. What other problems are to be solved? What more can lines express? What about weathering? Has the soil eroded in the rains or wind? Or is the soil of the landscape held together by the roots of trees, plants, and grasses? People tend to think of erosion or earthquakes as the great forces in earth formation because these forces are very theatrical. Yet the plant and animal world are even greater in forming the landscape by the slow and gentle accumulation of their remains. This is the source of the soft landscape forms; this is the great invisible forming pattern of richness and fertility.

Pattern in landscape does not mean just the heights, the angles, and the shapes. These are very simple things for anyone to draw. Barren structural lines might apply more closely to a desert landscape or to the surface of the moon, which are lifeless places of rocks and minerals—dead matter. So remember that abstraction does not mean find the skeleton; it means find the essence—the *life*!

Project: This project will help you make the transition to drawing earth masses as environments that interact with plant life. You need pencil and paper.

Take a field trip to an area that has no plant life at all. This might be a building site that has been cleared with a bulldozer, or if you live near a desert, do your drawing there. Make a drawing of a barren ground area to show the ground levels and slopes and how the ground is changed by wind and water erosion.

For your next drawing, pick a spot that has a ground covering of grasses and shrubs. As you draw, pay special attention to the way the plants and grasses hold the soil and soften the forms. Note the difference between the two terrains so that you understand the contrasts between a lifeless area and living ground.

Make some closeup drawings of the soil at the bases of trees. In contrast to this, draw the soil at the bases of rocks.

When you have finished with your field trip drawings, make some imaginary drawings starting with a basic structure of lines that indicate different levels of ground, rocks, and at least four rings of distance. In one drawing use this basic structure as a landscape covered with grasses and shrubs. In another one, draw the same structure with stands of trees. Next, draw this landscape after a forest fire and show how the land eroded when the plants were destroyed.

PATTERNS IN PLANTS

Pattern in plants begins with the basic linear forms that we have discussed in Chapter 3. Different plants use the basic forms in distinctive ways. Each plant has its own pattern of growth and change which affects its height, the growth of leaves, the shape of flowers, and the shape of its fruit and seeds.

Plants grow in a rhythmic sequence. There are pauses and changes of form in plant growth as each new period of growth proceeds. In drawing plant patterns, it helps a great deal if you are aware of the sequence of growth (Fig. 207). Just as the seed begins germination by sending up the axial shoot, begin by drawing the central axis of the plant. Next

are its first leaves, a pause, and then the formation of branches. Draw the plant from the central axis to the branching pattern. Then draw the leaves themselves if the plant is a simple one. But if the plant has large clusters of leaves draw the patterns made by the whole group before proceeding with the individual leaves. You can see that the drawing sequence comes close to repeating the growth sequence.

Rhythm in the drawing of plants is very similar to the actual rhythm of growth. Drawing a tree or a plant is not just a matter of drawing shapes; it is drawing what the tree or plant is doing. In the fruit trees there is a seasonal rhythm of growth that begins with the budding in springtime followed by the blossoms; then the leaves are established and the blossoms disappear. After pollination, the fruit develops and matures during the summer so that it becomes ripe by the fall. Without understanding this yearly cycle, an artist draws only meaningless shapes with no real knowledge of the tree inherent in them.

The movements of growth come from within the plant in response to the seasonal changes. Develop your drawing of the tree or plant so that your drawing expresses the period of development of the plant at the time the drawing is made. You must also learn to draw plants with some knowledge of what the plant is *striving* for. *This* is the abstract pattern of the plant. You can see that this approach has much greater meaning than a drawing that treats the plant like an inanimate object.

PATTERNS OF BRANCHING

In the United States alone there are 1,035 classified trees. Though they fall into just major four categories—the deciduous trees, the conifers, the broad-leafed evergreens, and the palms—each one of these trees has a branching system and silhouette that is distinctively and recognizably its own. This seems to make the problem terribly complex, but the artist does not have to memorize isolated facts; instead he uses a few *drawing principles* that apply to many things. The artist is trained to draw movements and to comprehend shapes. So when you encounter a new form, you should be able to re-create it from direct observations.

Understanding branching patterns requires two things— seeing the over-all silhouette of the tree and seeing how the branches divide. Tree silhouettes are all variations on the form of the magnetic field. They range from rounded tops to fan shapes, the cone, the tear-shaped orgonome clusters, and finally, random clusters. Within these silhouettes, it is important to observe the central trunk. In some cases, it grows straight to the top with branches spiraling off its axis as in the case of the cone-shaped white spruce or the orgonome-shaped cedar, the fan-shaped sugar maple, the cluster-shaped shagbark hickory, or the round-shaped sycamore. In other trees, the main trunk divides into secondary branches and loses itself in a veinous pattern throughout the tree as in the rounded white oak, the fan-shaped ash, and the cluster-shaped black locust.

206. Here is a seascape you can study for the exercise. A few simple, structured lines can suggest deep space and far horizons.

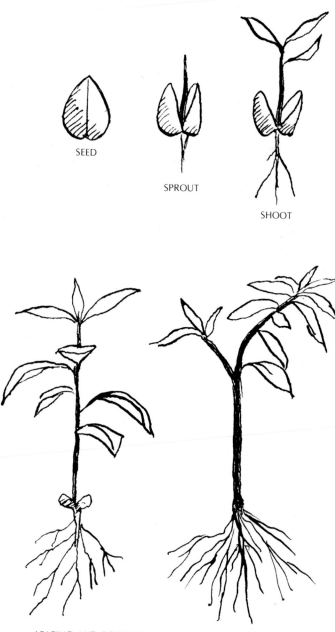

SEED

SPROUT

SHOOT

LEAFING AND ROOTING

BRANCHING

207. These diagrams show the stages of growth of an avocado tree.

Most branches from the main trunks follow the veinous branching pattern. You can watch for the angle at which the branches divide from the stem. Ask yourself if the branches come off in random places or follow an ordered sequence.

PATTERNS OF LEAVES

Besides flower patterns, the patterns of leaves have been used as decorative elements in art and architecture more frequently than any other decorative motif since the beginning of civilization. Because they are symbols of the earth's fertility, they will probably continue as long as man survives. So let us consider the various kinds of leaves and the drawing problems of their patterns.

The cone-bearing trees have three kinds of simple leaves (Figs. 208 and 209). The pine trees have needlelike leaves that grow in clusters which you can draw with simple pencil lines. The firs and spruces also have needlelike leaves, but these grow directly off the branches, if you remember from your last Christmas tree. You can draw these with a pencil also, but from a distance the branches have a furry and indistinct look. Other conifers like the juniper and cedar have long clusters of scalelike leaves that grow in soft, thick bunches. You should draw these leaves as masses.

The other evergreen trees are of the broad-leafed variety like the magnolia, the holly, or the eucalyptus. They are not cone bearers but are much like the deciduous trees since they lose some leaves while new ones begin and others remain green and growing. The problems in drawing these leaves are the same as those encountered in the deciduous trees.

Just as there are too many types of trees for you to remember, there are also many different leaf shapes (Fig. 210). Drawing leaves of any of these trees can be reduced to just nine features, which have to do with the characteristics of shape and how the leaf grows on its stem. These are the features you should look for in drawing: (1) whether the leaves grow in a group off a single stem, (2) the general outline of the leaf, (3) the shape of the leaf tip, (4) the shape of the base of the leaf, (5) the type of margin or edge that the leaf has, (6) the pattern of its veining, (7) the lobation of the leaf (whether there are hollowed-out indentations in its pattern), (8) how it is attached to the stem, and (9) whether the leaf is curled or flat.

The pattern of entire leaf groupings is also important in drawing trees. Observe the over-all shape made by the clusters of leaves. Some groups form thick fan-shaped clusters. Others form flat, hand-shaped planes that seem to float in the air. Still others form the tree into a solid mass of leaves that gives the tree a shape like a cumulus cloud. Some leaf clusters point upward, while others have a downward direction.

Project: This project will help you use the principles that we have discussed in making drawings of the trees in your locality. You need pencil and paper.

208. (Right) These conifer leaves are linear forms that cluster in groups on branches.

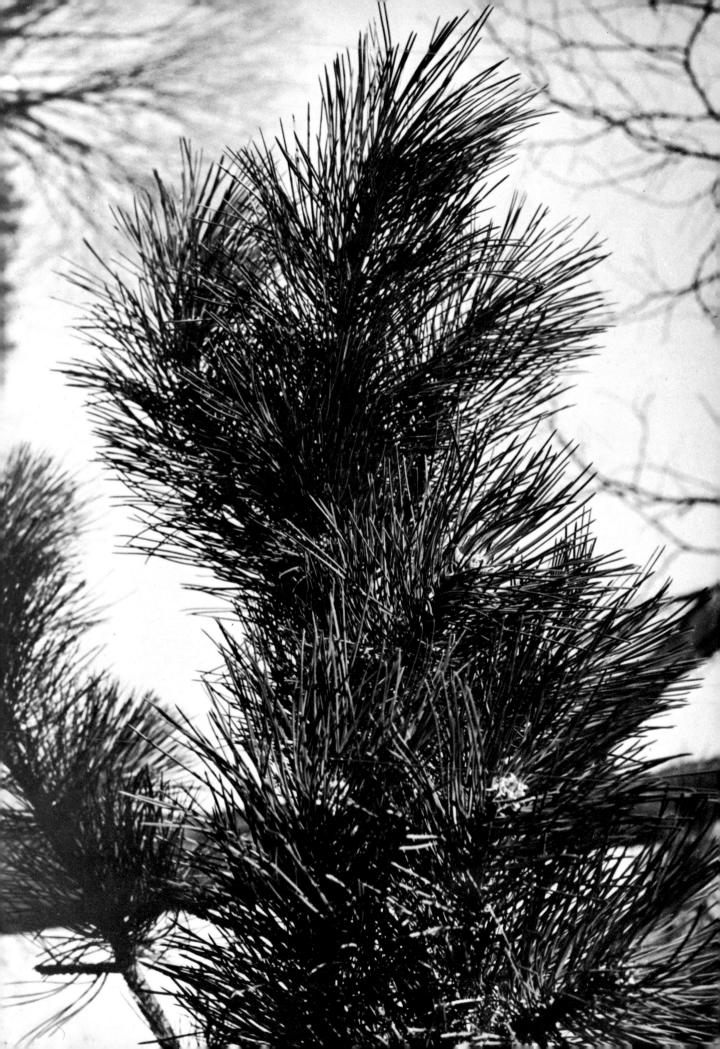

209. These are different varieties of conifer leaves that cluster in groups.

SIMPLE AND COMPOUND LEAVES

PINNATE **PALMATE**

SIMPLE LEAF ODD-PINNATE ABRUPTLY PINNATE BIPINNATE TRIFOLIOLATE PALMATELY DECOMPOUND QUINQUEFOLIOLATE

GENERAL OUTLINE

ACEROSE LINEAR LANCEOLATE LINEAR-LANCEOLATE ELLIPTIC ENSIFORM OBLONG OBLONG-LANCEOLATE OBLANCEOLATE OVATE OBOVATE

SPATULATE ORBICULATE RENIFORM DELTOID PANDURIFORM CUNEATE CORDATE

TIPS

ACUMINATE ACUTE OBTUSE TRUNCATE RETUSE EMARGINATE OBCORDATE APICULATE MUCRONATE CUSPIDATE CIRROSE

BASES

ACUMINATE ACUTE OBTUSE TRUNCATE CORDATE AURICULATE HASTATE SAGITTATE CUCULLATE

MARGINS VENATION

Reticulate Parallel

ENTIRE DENTATE SINUATE REPAND SERRATE CRENATE INCISED PINNATELY VEINED PALMATELY VEINED FROM BASE TO TIP FROM BASE TO MIDRIB FROM MIDRIB TO MARGIN

LOBATION

LOBED CLEFT PARTED DIVIDED PALMATE RUNCINATE LYRATE PEDATE PECTINATE

ATTACHMENT

SESSILE AMPLEXICAUL DECURRENT PERFOLIATE CONNATE-PERFOLIATE PELTATE

210. Here is a key to simple and compound leaves. (From Webster's *New International Dictionary*, 2nd Edition)

Walk through your neighborhood and select five types of trees that you like well enough to draw. Begin the drawing of each tree by lightly drawing the trunk and the outline of the branches. Pay attention to the order in which the limbs branch out from the trunk as your drawing grows upward. You control the scale of the drawing of the branches by outlining the shape of the entire tree and making sure that the drawing of the branches does not go outside the limits you set. Begin by first drawing the line of the branches rather than their volume. Once you have done this, draw the volumes of the branches closest to you, followed by those at the sides of the tree, and finally those on the side opposite. Take special care to draw the diminishing size of the branches as they extend outward and upward.

When you have drawn the skeleton of the tree, draw the leaf clusters in outline. When you have done this, strengthen the lines of the trunk and visible branches. Finally, draw the texture of the leaves closest to you in detail, using pencil texture for those that are not distinct. Use the heaviest texture at the bottom and the undersides of the clusters since the upper parts reflect more light.

You will find it very useful to collect leaves to draw. Collect many different kinds and draw them while they are still crisp and green. You can trace the outlines of each one and you can make studies of the veining.

If you have house plants, make some careful drawings of leaf clusters to practice leaf foreshortening and the groupings of leaves.

PATTERNS OF PLANT GROWTH

Up to this point, we have considered plants as isolated objects, but now let us consider plants as groupings and as a part of the environment. Patterns of plant groupings vary in different geographical locations and in different climates. Plants become so much a part of their environment that many of them do not live in a place where the climate or altitude is not the same. Plants and earth together give the character and feeling to locales, countries, and continents. No two places in the world are quite alike.

Plants, like people, require the proper food and conditions of weather and climate in order to survive. And like the people of different regions, their character reflects their background. A tree growing on a rocky, windswept coast will have the same tough resiliency as the coastal fisherman whose lined, determined face reflects his arduous way of life. A tree growing in a fertile meadow by a stream in a mild climate will have the same fullness and grace as does a person who lives an easy and well-regulated existence in a temperate climate. Part of drawing plants in a landscape is to give them character. Is the plant rich or poor, sick or well; what is its personality? Use your feelings and responses to *draw out* what is in the plant.

Some plants thrive in rocky soil, others in sand, and still others only in the richest meadowland. Each kind of terrain has its characteristic trees, shrubs, and grasses. Plants and their terrain always harmonize in some way that can be drawn because the form of one will accent the form of the other (Fig. 211).

Grasses blanket and soften the earth forms (Fig. 212). The term *ground cover* is very apt for the grasses when, in drawing, you consider how the grasses affect the raw earth forms. A growth of grass converts a field textured with rocky shapes to one that appears to have a soft tone on a drawing. In areas of flat or rolling land the grass covering may so dominate the surface that it is converted into an area of the most responsive movement by the smallest breeze. Such grass-covered land is turned into a sea of moving waves as air currents and the grasses interact (Fig. 213). Other variations in this landscape pattern are occasional clusters of low shrubs and occasional stands of trees that grow along water courses. The drawing structure of this sort of landscape deals with rounded and flowing forms. Big contrasts do not occur in the shapes of this type of landscape, but are a result of the seasonal changes, weather changes, or the time of day.

In the northeast portion of the United States, where the great deciduous forests grow, something similar occurs in the landscape. The land is structured with low, rolling mountains that are covered with trees which make the earth appear a solid, rolling billow of green in the summer months. But in the fall the trees are denuded of green and a rocky, sometimes angular landscape is exposed. When the snow comes, the earth forms again disappear and all that remains are the verticals of the treetrunks and the veining of the branches that are intermingled above. So the drawing contrasts here depend both upon the point of view of the picture and the season; for even in the summer when the long view of the forest is billowy, a drawing done *inside* the forest will have all of the contrasts of terrain and growth imaginable.

There are geographical environments where plant and earth forms are both always visible and always in contrast. High, rocky mountains provide footholds for only the hardiest plants and the patches of growth are randomly spaced. In this kind of locale, the vegetation and trees also change higher up the mountain until finally at the *timber line* the trees can no longer grow. Again, this is an example of how the plants and the terrain *contrast* to give meaning and content to the landscape drawing.

In deserts, the amount of growth varies a great deal, but it is always separated and stunted. When you draw a desert landscape, keep in mind the dominating earth structures. The only other environment that comes close to this is the modern city.

Project: To study the environments that affect plant growth, take advantage of any trips that you make to do drawings of plant patterns in different localities such as the seashore, farm land, forest, and unforested mountains. Use pencil and paper and make quick sketches of what you see so that you can later rework and develop your drawings at home. Your object is to understand the climate, terrain, and type of plant so that you can re-create drawings from imagination.

As you draw, try to see the underlying earth structure by *seeing through* the growth. Next, draw the major tree forms with their vertical lines. Treat clumps of shrubs as rounded forms. In all localities, pay particular attention to the bordering areas that divide earth and grasses, shrubs and trees. Let the details of leaves and textures come last.

EFFECTS OF PLANTS ON ONE ANOTHER

One big factor in the patterns of plants is the relationship of plants to one another. Plants are by no means passive;

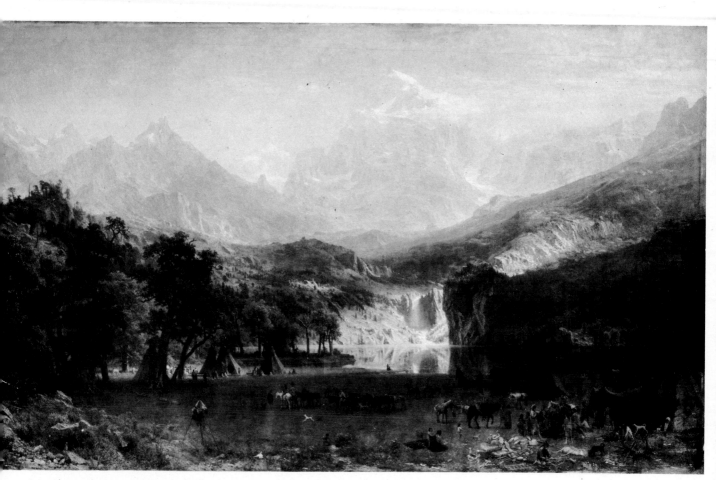

211. *The Rocky Mountains,* Albert Bierstadt, oil on canvas, 73 1/4" x 120 3/4". The Metropolitan Museum of Art, Rogers Fund. The different plant growth patterns of the plains, the mountains around the lake, and the land beyond the timber line create contrast in this painting.

212. *Sunrise,* George Inness, oil on canvas, 30″ x 45 1/2″. The Metropolitan Museum of Art. The subtly diminishing scale of the trees in this landscape gives depth to the scene, and the range of soft tones sets the mood of sunrise.

213. *Christina's World,* Andrew Wyeth, tempera on gesso, 32 1/2" x 47 3/4". Museum of Modern Art. The grass and Christina's hair give movement to this stark composition. The grass also gives depth to the painting as the many lines which form it grow smaller in size as they move toward the background.

214. The patterns of plant leaves found in a very small area show the incredible variations in nature.

they strive and compete with each other for sunlight, soil, and air (Fig. 214). A thicket of shrubs often consists of more than one type of plant and these various plants compete with one another for space. Some plants even kill other plants in their attempt to take over a patch of ground, while others will attempt to live peaceably with their fellow plants. Within forests there is only so much space available and the air overhead may be covered with a tangle of leaves and branches. A new tree has difficulty surviving unless another tree loses some branches or an old tree dies to give it room. Even if this does happen, the larger trees might send out more branches to take the space before the small tree can grow big enough to hold its own.

So in drawing plants, your lines will take on more meaning if you look for the dominant plant forms which tower over the lesser, or subdominant, forms. In drawing, consider the age and strength of the trees and plants, and contrast their youth and age. You can accent these features by the strength or lightness of your lines. The contrast in height between tall trees and the low shrubs accents the different kinds of life in the plant community and stresses the upward striving of plant life. A good landscape drawing should have as much character differentiation as an old-time family album.

Project: In this project, make drawings of plants, stressing their different characters and the competitive relationships in the thicket or forest. Use pencil and paper to make simple line drawings.

For your first drawing, find a plot of ground where there are very small plants, no more than a few inches high. Make your drawing from a sitting position on the ground that enables you to examine the plants very closely and peer in among them as though they were part of a tiny forest. Draw these plants just as you would a larger land-scape, but put something like a button or a bottle cap in your drawing to give the scale.

Repeat this procedure with a thicket or a clump of shrubs. Be sure to draw wild plants and not neat garden arrangements. The plants are probably snarled and tangled, so as you draw, plot out the positions of the trunks and stems of the main plants on your ground plane. This helps you to draw the lines of each plant and not lose the lines in a tangle. When you have done the main plants, you can easily draw the lesser ones and not become confused. The mistake beginners make when drawing complex things is to begin drawing the first thing they see rather than plotting out the bases and space of the plants.

You can repeat the procedure in a forest if you go in among a stand of trees. First, find the lines of the ground structure. Next, plot the bases of the trees. Then draw the trunks and branches, working from the nearest trees first, and finally the leaf clusters and textures.

PATTERNS OF LIVING CREATURES

The varieties of living creatures that exist are almost beyond comprehension. No man could describe them all. The fact that living creatures can be grouped into species makes it possible for us to understand them. Even so, it is difficult for us to discuss all of the species in this book. We will concentrate on the species that are most familiar to us:

the birds, the fish, and the vertebrate animals. And though we will not venture into the realms of insects, microbes, or reptiles, I believe this chapter and Chapter 2 will give you some principles that will enable you to draw them on your own.

First, however, a discussion about surface pattern is in order. To many people the word *pattern* means the decorative designs of dress material, wallpaper, or the carved flowers and leaves that were once used to decorate buildings. This group consists of manmade imitations of nature's patterns. Pattern also brings to mind the zebra's stripes, the leopard's spots, and the peacock's tailfeathers. This group consists of imitations of nature's patterns made by biological processes. These surface patterns help some animals to blend into the background and *hide* their form and pattern. Because of this we must get beyond surface deception and concentrate on the forms beneath. Only after we do this can we start to draw the camouflage.

PATTERNS OF FISH FORMS

We have already talked about the basic fish forms stemming from the orgonome. The remarkable thing about this basic form is that the fish family has developed a startling number of variations. There are an estimated thirty thousand kinds of fish—all different in size and shape—but creating their variations from the same original orgonome shape. This is the main feature of the fish pattern and the structure of its body and the part that must be drawn first.

The fin pattern of the fish is of next importance (Fig. 215). For many fish, the fin pattern is basically the same. The dorsal fin runs along the backbone. The tail fins may be divided or the tail may have a square or rounded shape. The pectoral fins are located at each side of the fish behind the gills on the lower half of the fish's body. The two arm-like ventral fins are below the pectorals and project from the underside of the fish. Depending on the length of the fish, there may be one or two anal fins. The fin pattern is followed by fish as small as the guppy all the way to the large fish like the warsaw grouper that reaches six feet in length and weighs as much as five hundred pounds. In drawing the fins, remember that they are built a lot like Japanese fans with a series of needlelike bones that reinforce the thin membrane. They are flexible, but not completely so. The long fins tend to move in rhythmic waves while the short fins like the pectorals and the ventrals are used for armlike power strokes and as maneuvering devices.

Fish are unwitting cartoonists of people. The instructive thing in drawing fish is in playfully altering one simple shape and creating marine personalities that parody human character types. At the same time, drawing fish can instill the lesson that all living forms are modeled by the movements that creatures make. The pattern varies from the long sleek lines that are characteristic of the fast swimmers to the short and powerful lines of the fish that dart and maneuver, but there are also forms that are so grotesque as to appear dragonlike and hideous (Figs. 216A and 216B). Fish can distort their basic form in incredible ways, exaggerating one or two characteristics: some become a mass of spiny bones; others become almost all skin and inflate themselves into balloon shapes at the

approach of danger. Fish can make their bodies as flat as a flounder or as narrow as a grunt.

The science of forms—called morphology—uses the grid pattern of coordinate lines and points as a basis for analyzing form and comparing form changes in related types of fish (Fig. 217). Albrecht Dürer, the great German painter of the Renaissance, was perhaps the first one to use this method of analysis in a systematic way, preceding the science of morphology by several hundred years. This method can be adapted to the analysis of human types and animal species as well (Fig. 218). The American sculptor and anatomist William Rimmer used a modified form of this grid to demonstrate different human body types.

When you first examine these figures, the change of form appears to be the result of a pulling from the outside as though the fish were being pulled and stretched by a vertical and horizontal force outside their bodies. You must remember that these drawings have been made by man and that the forces of change come from inside the fish. The atmosphere of the earth *does* have a gridlike structure of forces, but how this affects the form of animals has never been determined. Your drawing should take into account both the internal forming of the fish and the horizontal of gravity and the vertical of levitation as these are all part of the drawing problem.

In drawing fish, remember that you are drawing them in their living, moving world of water. Their movements are similar to the movements that water makes: the wave, the ripple, the spiral of the vortex, the eddy, the jet, and the splash can be found in the different forms of *swimming* that fish employ as well as in various fish bodies.

Project: Here is your chance to make creative use of the grid patterns in the drawing of imaginary fish. You need pencil and paper.

You can use either photographs or real fish as reference to make drawings. Make these drawings within a grid pattern. When you have completed your original drawings, draw some new gridworks that distort the original shapes. You do this by expanding the center or the head or tail sections. Next transfer the lines of your originals to the new gridwork by placing the lines in the proper squares. Once you have practiced transferring the lines, you can easily invent new fish forms. The use of the grid helps you get an idea of how proportions actually evolve. Once you grasp this idea, it is not very difficult to draw your inventions freehand.

Make some drawings of aquarium fish. Looking at the fish will give you a fine opportunity to observe their living movements. The major line to capture is the curve of the spine. The fish's body moves from side to side in wavelike movements. The motion of the body in swimming is echoed in the fin movements, the pectoral and ventral fins being held close to the body, as the fish darts forward. The ancient Japanese were the world's best draftsmen of fish in movement and form. Go to your local library and look at books of Japanese paintings and drawings and notice how they capture the forms with the fewest simple lines.

PATTERNS OF BIRDS

Birds and fish are very similar in form because both glide through the media in which they live. Their streamlike

SALMON

SEA TROUT
OR SALMON TROUT

COMMON CARP

GOLDFISH

BARBEL

MIRROR CARP

215. Here are some examples of fin patterns of fish.

BARRACUDA

ANGLER FISH

"PERIECU"

216A. Here are examples of fish body types.

FLATFISH

SUCKFISH

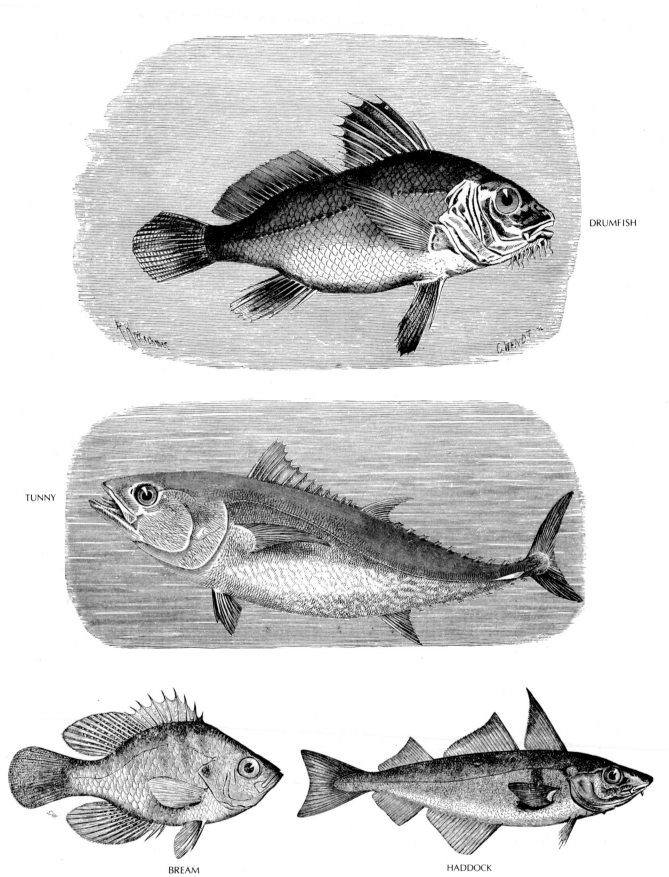

216B. Here are some examples of fin patterns of fish.

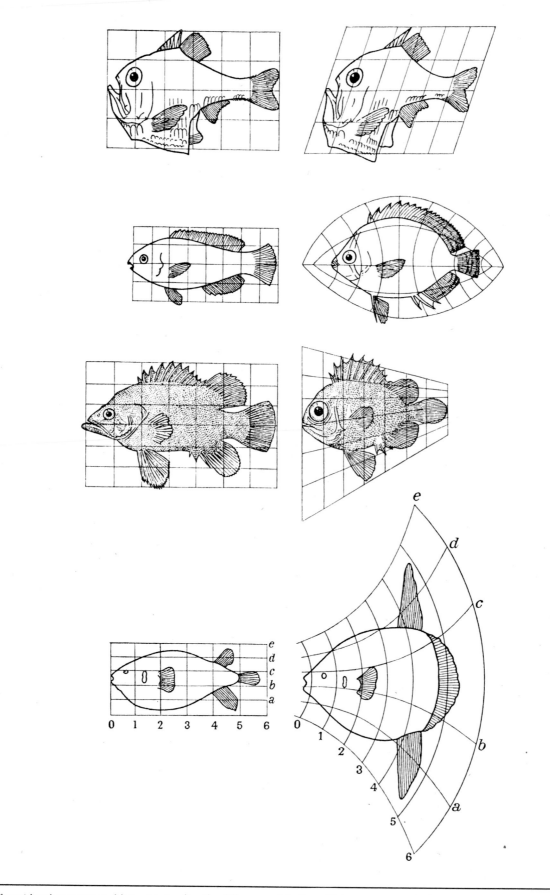

217. The gridwork concept enables us to visualize the difference of feeling within creatures caused by a variation from a basic pattern. (From *On Growth and Form*)

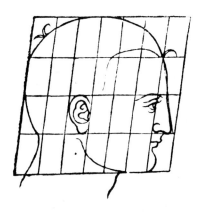
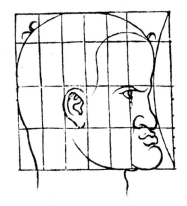
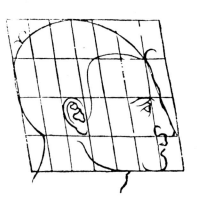

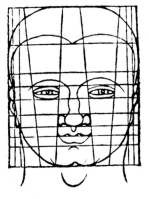

218. Dürer's system of morphological coordinates provides a method of analysis for form variation in the human body. Where the form varies from the normal, there seems to be a fixation of a certain expression, such as fear, aggressiveness, petulance, etc.

lines emerge from the laws of movement in water and air. Although there is wide variation in the shape of birds, their general form does not undergo the changes that occur in the fish family. Water supports and encourages more extreme variations than air. This is understandable when we realize that flight requires simplicity of form. Nevertheless, the bird family has some pretty gaudy members.

The smallest known bird is the bee hummingbird of the Caribbean. Its wingspread is only two inches. The largest bird that is capable of flight is the condor. And, of course, the largest bird of all is the ostrich, which cannot fly. But regardless of the size difference among these birds, the general form of their bodies resembles the orgonome.

Several factors determine the variations that do occur in birds' shapes. Variations occur in size, type of beak, length of neck, type of foot, length of leg, type of wing, and in the type of feathering (Figs. 220, 221, and 222). The variations depend on the way the bird gets its food: wading birds have long necks and legs, swimming birds have webbed feet, predatory birds have talons, etc.

One of the main characteristics is the type of flight that the bird has adopted, and this alone determines the wing structure. Wing structure is gauged by length and shape in relation to the body and the tail. There are four essential wing types. The short wings are used by the maneuvering birds like the hummingbird, the swift, and the swallow. Birds of speed like the pheasant or the duck use broad wings for quick takeoff. Gliding birds like the tern or the gull use long narrow wings. And the great soaring birds such as the eagle and the condor use long, wide wings. And, of course, there are birds that have combination type wings.

It's almost impossible to draw birds without drawing their markings. These patterned markings vary from the ultraconservative markings of the blackbirds and sparrows to the exhibitionistic and theatrical garb of the peacock and cockatoo. It is always the males who wear the finery. The markings always obscure the actual structure of the feather groupings so I can give you no particular drawing advice except to say that in the cases where there are lines in feathers, the lines will help reveal the over-all form. The camouflage of tropical birds seems extreme to us because we do not take into account the colorful surroundings in which these birds live.

Project: This is a birdwatching and drawing project. I am suggesting things for you to observe and draw. All you need is pencil and paper.

The best way to become familiar with bird forms is to visit the aviary at the local zoo. Take your pad and pencil along and make some sketches. In the beginning, try to draw the over-all shapes of the birds as they sit on their perches. Make several simple drawings and compare them with one another to see how closely they duplicate the basic form. Next redraw the same birds with closer attention to the way the folded wings modify the form. Observe the leg forms as they emerge from beneath the folded wings. If you have trouble visualizing how the wings fold over the thighs, I suggest that you buy an uncut chicken at your local meat market and draw the legs and wings in various positions. You will find that the feathers disguise the underlying form.

After you have drawn perching birds and understand how the wing and leg forms fit compactly into the bird's body, draw birds on the wing and also as they hop about on the ground or run along the seashore in search of food. You can see the relationships of the wings and legs in movement and balance.

You will find that sea gulls in flight are easy to draw. They are gliding birds that keep their wings extended much of the time. You can see and draw the three segments of the wing which are very much like our own upper arm, forearm, wrist, and hand. Most important, as you draw these birds in flight, try to visualize the air currents that they glide on. This is important because it is this *unseen* factor of atmospheric currents that the bird is touching and feeling while in flight.

PATTERNS OF VERTEBRATE ANIMALS

All vertebrate animals are structurally similar to man as well as to one another in their musculature and bony framework. Their internal organs are all much the same too. Our own bodies are very reliable standards of comparison that help us to understand the forms and patterns of animals. This is why it is easy to use a modification of the stick figure as a framework for drawing animals.

The most important parts of the animal form are the body, neck, and head that are all part of the central axis of the spine. This spinal unit is capable of wavelike movement from side to side and from back to front. In general, the forms of animals can be abstracted into a superimposition of the orgonome form and the magnetic field form. We can consider the legs, neck, and head as the servants of the torso and so in drawing it is important to begin with the shape of this central form.

The torsos of all four-footed animals may vary greatly in size, but the similarity in shape among them all is pronounced. The segmented spinal column with its rib cage and pelvic structure is the common denominator. The forms that really make the difference are the legs, the neck, and the head (Fig. 223). Some animals like horses, deer, cows, and pigs stand upon the ends of their toes, their feet having become extensions to the length of the leg. This extended leg adds to the speed in running or adds extra height for grazing. Other animals like cats, dogs, and bears walk on the fingers (or toes) and the pads of the hands and feet. Their shorter legs and more powerful muscles give them the capability for the short bursts of speed needed to gratify their carnivorous ways. Just like the fishes and birds, their way of life molds their body form.

In drawing animals, it helps to first study the animal's character by acting out the role of the animal. I mentioned before that children play such roles and learn a great deal in their play by finding the common characteristic that we humans share with the other vertebrates. So in order to draw animals well, we must compare them with ourselves, both in form and attitude.

Just like the other creatures of the vertebrate persuasion, we carry our air and water supply within us as we move about. Some of the animals—the camel as a water carrier and the whale as a breather of air—are far superior to us in both functions. All animals superimpose in the mating process. The young are carried within the female until the young develop their forms and functions well enough to survive independently. After infancy they continue as a part of a multistaged life cycle. So it is clear that we must

MARABOU SECRETARY BIRD

BLUE JAY PRAIRIE CHICKEN

219. Examples of bird body types are shown above.

MAGPIE

STARLINGS

220. The shape of birds' beaks, their wingspan, and the type of legs they have are all adaptations to their environment. These two pages show examples of the variations in bird body types.

RUFFED GROUSE

CAROLINA RAILS

SECRETARY BIRD

GEANT (EXTINCT)
AS RESTORED BY SCHLEGEL

GUIANA EAGLE

RED-BILLED
TROPIC BIRD

CASPIAN TERN

SWALLOW-TAILED
KITES

MISSISSIPPI
KITE

221. Variations in the structure of birds' bodies depend on the way they obtain their food, as shown on these two pages.

CALIFORNIA
QUAIL

LADY AMHERST
PHEASANT

222. Part of the study of the variations of bird body types is the study of their markings.

MACAWS

CANVAS BACK

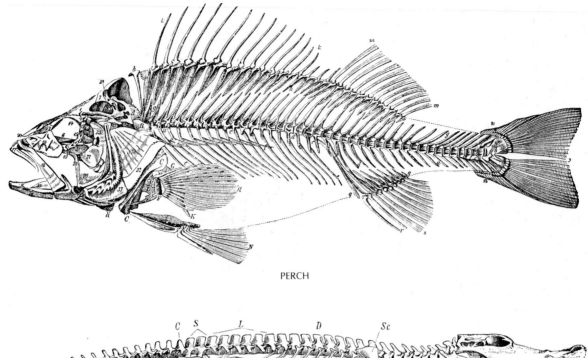

PERCH

CROCODILE

RIGHT LATERAL ASPECT OF A HORSE

HESPERORNIS

IGUANODON

223. This group of skeletal diagrams shows the common forms shared by all creatures possessing a bony structure.

draw out our own natural understanding of these same processes when we draw animals.

Of the living vertebrates there are seven classes and three thousand species, all of which share forms in common as well as all being different in some ways. The patterns of animals vary because of the ways of life from which they have evolved and also because of their sizes and life span. For example: a mouse is tiny, has a rapid metabolism, and is easily startled (Fig. 224). The gestation period of a mouse is about twenty-one days and the mother bears from one to eighteen young. Its length of life, barring accident, is three years. The mouse is a creature for whom fright is a way of life since it is eaten as food by many other creatures. But it defends against extinction by becoming mature in forty-five days and bearing up to twelve litters of young per year. On the other hand, the elephant is a great and complex creature that moves slowly and ponderously (Fig. 225). The embryo takes twenty months to develop. The elephant may live to be eighty or ninety years old. The only real enemy that an elephant has is man. So the elephants move with a dignity and unconcern that is both powerful and gentle. You can easily see that the qualities of these two animal patterns should be quite familiar to human feelings.

Once you have grasped the character of animals, the more complicated aspects of their anatomy will make sense to you because you will know the reasons for the form patterns. We draw fish by becoming aware that their forms are modeled by the laws of water movement. And so we must draw animals by understanding that their form is modeled by their life on land (Figs. 226, 227, and 228).

The grid pattern that you worked with when drawing fish also has it use in drawing animals. Fig. 229 shows how the form of the skull changes and modifies with different uses of the jaw. This kind of grid analysis can also be used for the other forms of the body. Some people object almost automatically to the use of the grid because it seems too precise to them and not artistic and free. Art students often object to the idea of measuring anything. I dislike rigidity and restraint as much as the next person, but to make an effective drawing, we must use every tool at our disposal to develop our skill.

Surface patterns in animals are less a part of their defenses than they are in the fish, birds, and insects. Animals rely much more on their character traits, their speed, and their instinctive knowledge of the type of environment to which they have adapted.

Project: This project will teach you a method of understanding the character patterns of animals so that your drawings will express more than just the outer forms of the creatures you see. You need pencil and paper.

Try to become familiar with the basic animal structure. In this case, you can use the family cat or dog as a model. Draw the basic shape of the body indicating the spine, the rib cage, the belly, and the pelvis. Be sure to draw the joints of the forelegs and back legs correctly. If you have some doubt about how long these are and how they bend, feel these segments on your pet and bend them gently until you see how they work. If you are still in doubt, buy a skinned rabbit from your butcher and make drawings of the exposed structure in various positions.

Next, make some drawings at the local zoo, following the same forms as described above. Note the similarities at first but do not concentrate on the differences. Simply look

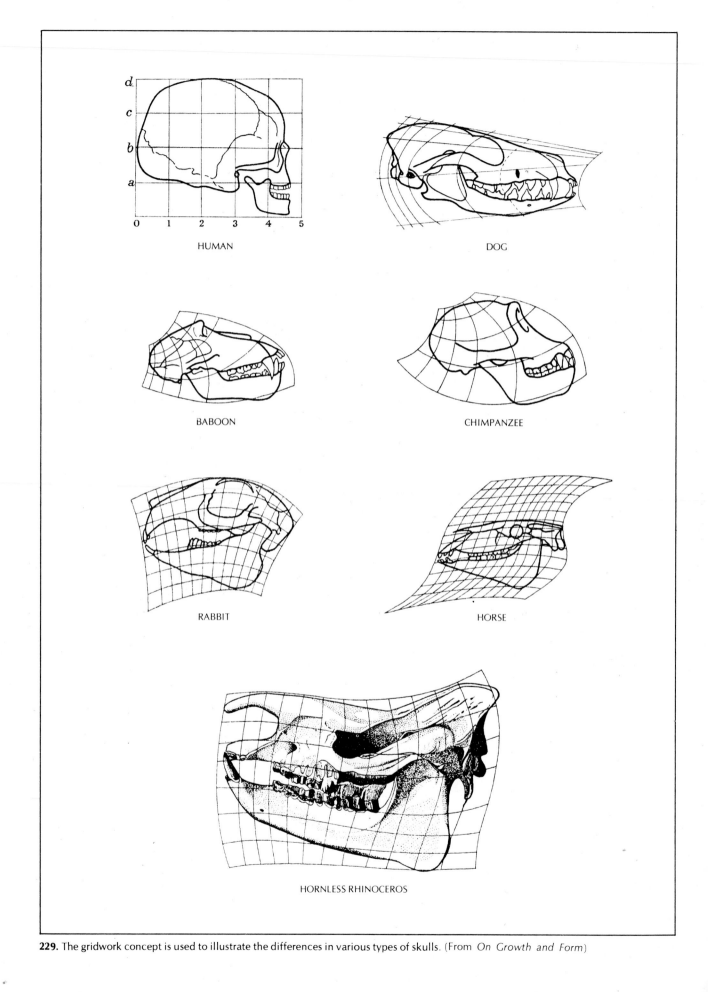

HUMAN

DOG

BABOON

CHIMPANZEE

RABBIT

HORSE

HORNLESS RHINOCEROS

229. The gridwork concept is used to illustrate the differences in various types of skulls. (From *On Growth and Form*)

for the spine, the rib cage, the belly, the pelvis, the neck, the head, and the joints of the legs. You will find that the differences are not as great as you imagined. When you have done this, *then* make drawings that bring out the individual variations. See these variations as exaggerations of the basic form: the longer neck of the giraffe, the deeper chest of the buffalo, the larger masses of the elephant's whole body, etc.

Finally, in the privacy of your workroom—or in the classroom—act out the parts of the creatures that you have drawn. Be a timid rabbit, a friendly sniffing dog, an angry bull, a gentle deer, a fierce tiger, a sly and tricky fox, etc. When you have acted out each part, redraw the animals using your own feelings as a model of their characters.

PATTERNS OF HUMAN FORM

We begin the study of patterns of human form by looking for the characteristics that humans share with animals, and then looking at the ways that the human form is distinctively different. In form the human torso, head, neck, arms, and legs are very similar to those found in all of the animals, both in construction and function (Fig. 230). But in man all of these members form a closer unity. In animals, the forms are basically oriented to the ground plane. The animals are earthbound, their spinal columns parallel to the plane of gravity, and their attention is directed toward the earth. The exception to this is the ape family.

Man's stance is organized along the line of levitation. This posture allows the entire human body to achieve more versatile and thoughtful movements. This great capacity to move in versatile—but not specialized—ways allows the human a certain freedom of choice, whereas the animals are restricted by their balance which is centered on four legs. They are like stationary tables in their mode of balance where humans are constantly interacting between gravity and levitation. Man has to constantly be aware of his surroundings because of his stance.

Animals generally have only one or two specialties. For example, the giraffe feeds off the tender leaves of trees and is able to reach these leaves because his body is *chronically* reaching; it could not adapt to a different mode if it wanted to. Man, on the other hand, is constructed in such a way that he can reach or climb at will and go on to other things. The mole digs as a way of life and spends his life burrowing. Man is an adaptable creature who will dig only if necessity demands it. Man's structure has specialized in perfecting the anatomical principles that allow the senses and the structure to do as many things as possible.

Man's head is constructed so that the organs of his senses radiate outward from a central point within his skull and they can all focus on the object of his attention (Fig. 231). The ears, eyes, nose, and mouth combine in a series of radiating angles that allow man to compare several sensations at one time and, in so doing, form superimposed impressions of the object of attention. The face of a horse, on the other hand, is a shortsighted, grass-eating appendage; the face of a lion is a killing and flesh-tearing structure. The faces of animals reveal their specialized modes of life. The face of man is, first of all, the face of thought and reflection. A good example of these qualitiees is Leonardo's self-portrait (Fig. 232). Man's head is the crown of his whole structure and, under favorable con-

230. This diagram illustrates the difference between a human stance and an animal stance.

SOUND

SIGHT

VOICE

SUPERIMPOSITION OF THE SENSORY RADIATIONS

231. The form of the human skull follows the radiations of its receptive organs: ears, eyes, nose, mouth.

5. Space, Proportion, Scale, and Perspective

In Chapter 4, we talked about the patterned relationships of things that we encounter in everyday life. Now we will talk about the ways that mankind looks at things and makes judgments about their spatial relationships, and, in the case of artists, how these judgments are translated to the drawing page.

In discussing space, proportion, scale, and perspective, I will demonstrate to you that these things are understood by all people on an unconscious level. Again we will deal with human skills that are so much a part of our lives that we take them for granted, but we will make them conscious and visible here.

Space perceptions in art and in life are based predominantly on the organic visual process. The recognition that the laws of vision apply to all people is important because there has been a great mystification of the subject of space in art education and art criticism. The mystification has led students to feel that space and depth can only be understood by a select few. Or, where this mystification does not exist, the subject of space has been reduced to geometrical concepts that separate vision from human feeling.

So the student has had only the two alternatives in the study of space: either to accept on faith the pronouncements of the pictorial space cult or to memorize dry rules that take all life out of the subject. We can gain much in considering the idea that our basic understanding of space and depth stems from processes within the human body. This approach gives us a simple and direct access to the spatial problem. In addition, it places the problem on a level where it can be understood in very personal terms.

INNER DEPTH

In talking about space, proportion, scale, and depth, we are again talking about functions that have no real separation in nature, and the separation of these things in drawing is necessary only to simplify a complex problem. However, in perceiving things, our eyes attempt to focus temporarily in one-sided ways that enable us to scan different aspects of a single thing in order to see it as completely as possible. In this way a number of aspects of one thing are stored within the memory.

Our visual memories of a gnat or an elephant take up the same amount of space in our minds. On our mental filing cards for each of these creatures, we imprint coded memory impulses that can be connected to feelings and locations in our bodies. When these mental records are played in recall they tell us the details of the feelings and visual facts we have about these creatures. For example, we recall by inner feeling that a gnat can get into our eye and we can sometimes almost feel the discomfort, but we also know by inner feeling that an elephant will never cause us that kind of trouble. The trouble that an elephant might cause us would be on a much grander scale. We can at a moment's notice call up a vision of a gnat or an elephant and both of these creatures can fit into our *inner* eye with no difficulty at all.

Our bodies are structures that are imbued with vast feelings of inner space and depth. Within us there are points, junctions, and centers of feeling. Everything we see and record in our memories is classified according to how it can affect the sensations within our bodies. Though we seldom stop to think of it, our bodies are universes of sensation full of memories of past events and of anticipations of future events. In our inner universe, vision and feeling cannot be separated.

Project: Examine the sensations of perception in the inner universe of your body. This project suggests some methods of drawing the inner perceptions that you will experience. Use charcoal, a kneaded eraser, fixative, and paper for your drawings.

In your workroom, or in a room where you will not be disturbed or distracted by sounds or people, I want you to sit in a comfortable chair and close your eyes. Concentrate on the sensations within your body. Do not think of things or people, but let your mind concentrate on the feelings in your arms, trunk, feet, etc. Try to follow the pure sensations without *trying* to form mental pictures; let the pictures that accompany these feelings emerge by themselves. This may require some practice at first, so you must be patient and allow yourself plenty of time.

If you can do this experiment in a relaxed way and give in to the pure sensations of your organism, you will find an awesome sense of inner space that is quite apart from the space of the outside world. You will experience wavelike feelings that radiate from centers. As you examine these inner feelings, you will find that you can perceive your total self or can concentrate on specific areas of your body. Remember that I am not talking about anything mysterious, but about the sensations of life that everybody experiences.

When you have done this experiment in a sitting position, try examining this inner world while standing or lying down. Finally, try the experiment while you move around the room with your eyes shut. Keep working at these experiments until you can visualize these sensations as an inner picture.

To make your drawing, begin by covering your entire paper with a charcoal tone. After that, use your kneaded eraser to draw the centers and movements of your sen-

(Right) The mountains in Crete show a purplish cast and the vein formations in the earth masses.

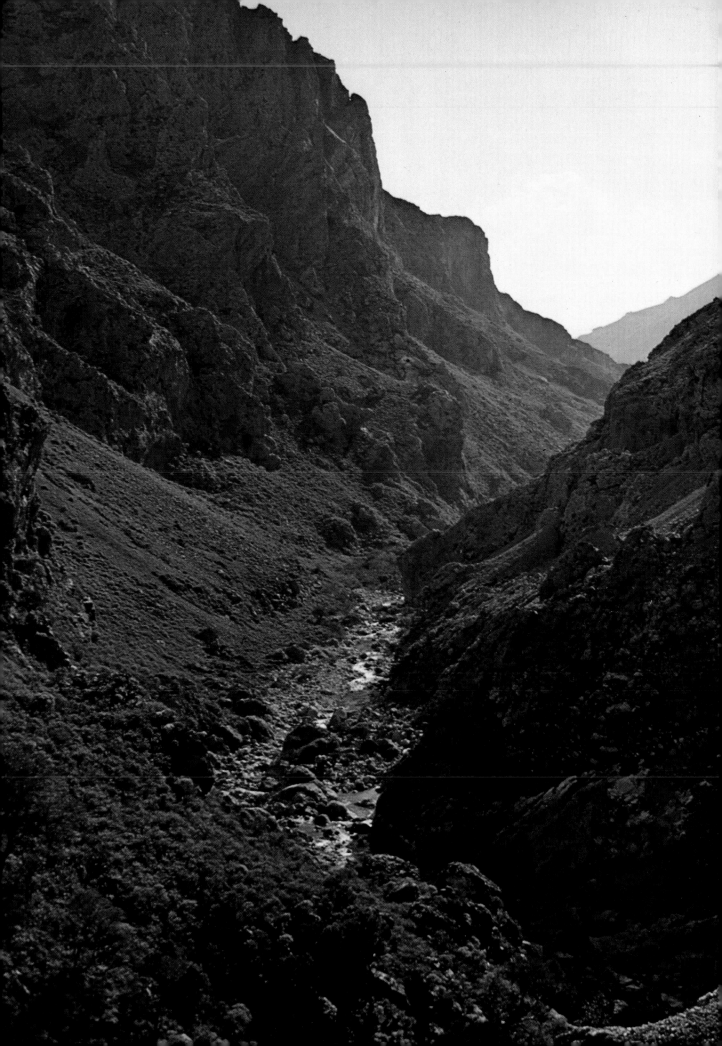

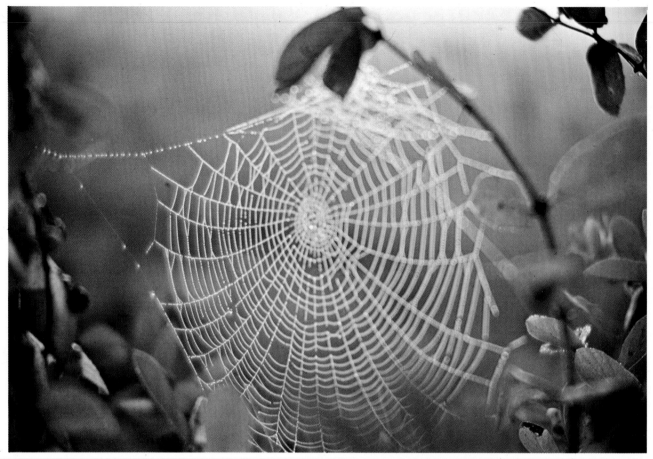

Early morning dew has formed on this spider's web, reflecting a pure white.

The colors of summer green appear vibrant at the Hale's Mill spring in Virginia.

This winter scene at Millbrook, New York, shows the whiteness of snow and the starkness of the bare trees which create a combination of grays with a dense blue reflection.

This is another scene of summer green at Hale's Mill, Virginia.

Fall colors in New England are bright and intense in contrast to the blue sky.

(Right) At the beginning of winter, browns and ochres dominate, as can be seen in this view of Hale's Mill, Virginia.

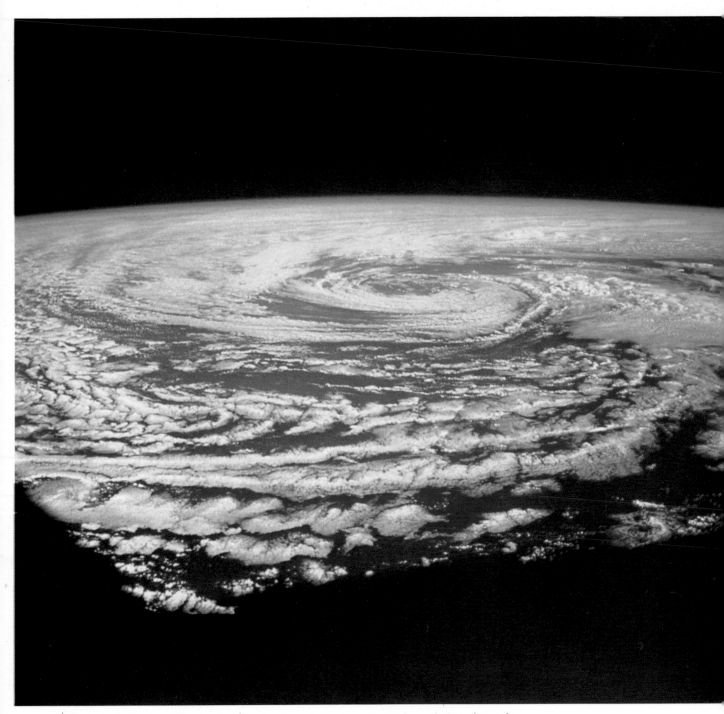

This photo, taken at an altitude of 1,200 miles from Apollo 9, on its 124th revolution, shows the blueness of our atmosphere and the galactic form the weather system moves in. (Courtesy of National Aeronautics and Space Administration)

Here is a fine example of the modeling of a rippled surface in the muted tones of a gray day.

The light source is behind these clouds, but rays of light can be seen which show the linear quality of illumination, although the color range is limited, there is a sense of great brilliance.

sations, their shapes and the distances between them Because the inner world is dark, the eraser will bring the form of the sensation out as streaks or points of light. You may have discovered by now that the forms of these sensations are much like those of water and the atmosphere.

To make it less difficult, start by drawing the sensation of a limited area such as your hand. When you have done this, go on to the whole arm. You will find that you lose your concept very easily. When you do, close your eyes and take the time to regain the image.

INNER PROPORTION

People talk about a "sense of proportion," but quite often they cannot explain how this mysterious sense is developed. The sense of proportion originates in the bodily *feelings* of lengths, distances, shapes, and spaces. In the universe of your inner feeling, you have a sense of size and distance between the centers of feeling in your body. But this inner sense of proportion is different in some ways from the actual, measured proportion of objects outside of your body in the external world. When your eyes are closed you are neither large nor small because you relate your inner centers of feeling to one another and not to the world outside yourself. With your eyes closed, the sense of yourself expands considerably. Your inner space becomes a universe that is the opposite of the universe without. Within this universe, there are centers of feeling at the joints and at anatomical junctions and radiating points. These occur where several anatomical parts meet: the center of the face, the genitals, the shoulders, etc. The inner sense of proportion arises from the feeling that goes back and forth between these centers.

With your eyes closed, these distances seem very great, but there is still a clear awareness that one distance may be longer than another or that two distances might be the same. There are billions of cells within you and they are all alive; there is an immense energy capacity in your entire organism and *this* is what you sense. Of course, when you open your eyes, you immediately relate your body size to what you see, the *feeling* of proportion becomes enclosed in the visual image.

Pressure points, the places where your body touches objects—such as your foot on the floor, buttocks on the chair, elbow on the table—help to give you a further sense of the proportion of objects. Pressure induces feeling at places that are not normally feeling centers, or increases the feeling in places that are (Figs. 236 and 237). This increase of feeling with pressure teaches you how to "handle" things and manipulate objects by weighing them against the pressure that you feel. Your inner sense of proportion works with your sense of the plane of gravity and the line of levitation. All of the major forces are interwoven.

A good illustration of how your inner sense of proportion judges objects in the outer world is your ability to feel pain. An injury or a hurt causes a more than ordinary sense of pressure which focuses all of your senses at the point of pain. In feeling great pain, you can actually lose your bearings or your balance and become disoriented. With a serious injury, all that you feel are the radiations of pain; the pain becomes the largest thing in the world. Pain, however, has its uses too because it teaches you a better

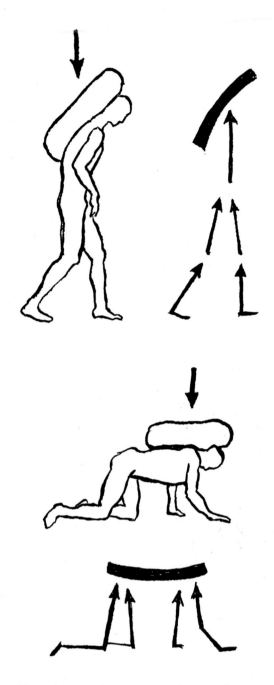

236. These diagrams show pressure acting on a figure carrying a burden. The upward movement of energy counters the pressure of the burden.

sense of proportion by making you a better navigator and a judge of the properties of objects.

The human skeleton is constructed so that the segments of the arms and legs decrease in length as they grow from the torso to the end of the limb. This factor of anatomy gives us a proportional system which we can use to measure objects or use to manipulate them. We can determine instantly the proportions of most things by comparing them with a part of our body. Actually, we do not see things in terms of inches; we see them in relation to fingers, hands, feet, or other body lengths. Underlying this skeletal measuring stick is always our *feeling* which measures things by relating them to the life within.

Generally, we are so bent on the chores and interests of life that we use our proportional measuring system without giving it any conscious thought. We react automatically later to a thing which we have experienced once. We grow up comparing the sizes and shapes of things, recording them in our memory, relating them to the feelings within our bodies, and never giving much thought to how we do all this.

Infants start life with very powerful inner feelings; the interior universe is their first and largest reality. As a child develops, he begins to relate these inner feelings to the realities outside. The child begins life by storing memories about the qualities of things and also the differences among them. These memories serve the child like the navigational charts used on a ship, and they remain with him through his lifetime. When a child re-examines an experience, it is relived and repictured, and acted out within the inner space of the person. Each re-creation of an experience imprints it still further on the mind. So when we see a clumsy movement in an infant or a child, we should realize that he is trying to adjust his inner universe to the unfamiliar obstacles of the outside world. And, when *you* run into some difficulty with proportion in your drawing, you must think the problem out clearly so that you will imprint the right answer on your memory.

Human life does not start in a vacuum. Healthy infants are born with a very powerful sensation of inner depth and proportion. With each new stage of development, they master a new ring of attention and extend the scope of their movement. Until the age of about three, a child's experience oscillates between a sense of intimacy with his environment and a sense of the vastness of the world. After the age of three when this bony framework has begun to take on the practical measuring functions, the child's sense of proportion can bridge the gap between the two extremes more easily. In physical contact with loved ones, in play, in dance and sports, his sense of proportion grows naturally. If he begins work in drawing it may help this development in becoming a thoughtful process rather than a completely unconscious one. But the worst thing in the world is to force the child to do things for which he is not ready.

In this respect, it is interesting to note that there are no child prodigies in drawing or sculpture even though we do see remarkable talents. The same level of skill does not exist among children in drawing as it does in music. The

reason is that skillful proportional drawing is based on qualities of judgment and dexterity that occur only in the adult. Skillful proportional drawing and an accurate sense of composition develop only after puberty when the physical and emotional capacities have begun to approach adult level. Little children draw with great sweetness and charm, with the freedom of naïveté, but masterful drawing is based on the wisdom that comes from experience in both the inner and the outer space.

Project: Here are some experiences that will accentuate your natural sense of inner and outer space. After you have tried the following experiments, make some drawings with pencil and paper.

Try to pick up something very heavy with just your fingertips. Pick up something very light like a ping-pong ball or a feather, using both hands. Jump as high as you can over a low object. Jump as low as you can over a high object. Try to remember how it feels to step down another step after you have reached the floor level, or step another step higher than necessary at the top of the stairs. Pretend that you have never seen any of the objects in your room, whether they are hard or soft, and that you are just learning to walk. Spend an hour walking around on your knees. Imagine yourself walking across a highway full of speeding cars. As you do or imagine all of these things, examine your inner feelings to see how much you depend upon decisions reach automatically.

Draw pictures of yourself doing all of the above activities. The object is to show graphically that there is logic or illogic in the arrangements of the elements in a drawing. You can make some drawings that contradict your sense of space and proportion.

PROPORTION

Proportion in drawing means judging and estimating the sizes and relationships of shapes within a single form, of several independent forms, and of the spaces between and around them. The estimate and measurement are done by drawing all shapes in their positions in relation to the plane of gravity and the line of levitation. This does not mean that an artist must take a measuring tape to the shapes with which he works, like a carpenter or a tailor might, but it does mean that an artist must think in terms of units and must make numerical comparisons. You must ask yourself such questions as: What is the proportion of the width to the length? Where is the middle? What length shall I use as a unit to compare with the other lengths?, etc.

In drawing—just as in life—proportion is determined by the sensations and feelings of the artist. The artist compares all things with his own body and its functions. The artist asks, "How high is this compared to my own height?" or "How large is it compared to my torso?" or "How wide is it compared to my body width or to my extended arms?" The artist answers these questions by making marks on his drawing paper that show these relationships. With any object that is drawn, there is always an invisible measuring stick—the human figure. A human being will read the tilt of a line in relation to his line of levitation, the position of a form in relation to his sense of the plane of gravity, and the form in relation to his own form.

How big should a drawing be and how do you determine the size of what you draw? The rings of attention deter-

237. *Beggar Holding a Stick in His Left Hand*, Francisco Goya, wash in sepia, 8 1/16" x 8 5/8". The Metropolitan Museum of Art, Harris Brisbane Dick Fund. The sense of weight and pressure is apparent in this figure—his own body weight, the weight of his place in life, and the weight of his personal history.

238. The great depth and atmosphere of this Thomas Bewick engraving are a result of the artist's correct use of scale in composition. (From *Eighteen Hundred Woodcuts by Thomas Bewick and His School*)

239. This stairstep arrangement of a large family shows the triangle of growth that occurs from infancy to adulthood. The composition resembles a curve on a graph.

240. The same family is shown here in a random arrangement of heights on a frontal plane. It is a more interesting composition because it shows a greater variety of relationships.

mine the size of works of art. The most natural size for anything is something that fits within the second ring of attention—something that can be held conveniently in the hands. Most drawings and books are such intimate, handheld objects because this size relates to the human body and to the convenience of study. Most works of art originate with ideas in the head of the artist which are then translated to drawings that are within the scale of the second ring. Then, once the original idea has been worked out, the drawing can be enlarged so that it will fit into the scope of the third ring. Most paintings and much sculpture are made to fit into the room-size third ring of attention. Beyond that a work would have to be further enlarged to mural size or to the size of heroic sculpture, which are the kinds of art works that fit into the fourth ring. Anything larger than this—fitting in the fifth or sixth ring—would be something on the order of a pyramid. In short, works of art of any complexity must go through a *series* of size changes in order to arrive at a large scale.

In the average drawing or book-size picture the scale of the human figure ranges from about one-tenth of life size (7") down to about one-seventieth (1"). Most of the drawings of Leonardo da Vinci are very small and he often did little studies with crowds of figures that were all less than an inch high. Greatness in art has nothing to do with great size.

If you choose, you can draw anything to its actual size, but this is seldom done in drawing unless the subject is on the scale of an apple. You can readily see that it would be very inconvenient to carry horse-size tablets of drawing paper, or for that matter, even man-size would create a great deal of bother and difficulty.

The first goal in drawing, then, is to learn size relationships as they appear in nature and to translate them to a functional size in drawing. For example: if you draw a man so that his figure is about 2" high, how high would a horse and a tree be in the same plane of space? They would have exactly the same proportional relationship as the full-size things! In other words, size can be changed but proportion cannot. At whatever size a thing is drawn, the proportions remain the same. The only exception to this rule is when proportion is altered for specific purposes (and even then the alteration is made from the basis of the known proportions). Examine the reproduction of one of the wood engravings of Thomas Bewick (Fig. 238) and you will see that it is possible to create great work in small spaces when there is a correct understanding of proportion.

And the reason that such small drawings or engravings can suggest vast spaces and accurate landscapes is that whatever the scene, object, or figure that we look at, the image occurs *within our heads*. Regardless of the size of anything that we see, it is reduced to fit within our eye. We then re-examine the image within our mind and it is then enlarged to its proper proportions of feeling so that it can fit into our inner universe. The mind rejects images that do not correspond to previous experience and the inner sense of proportion.

The distortion of size and proportion has some interesting effects on the viewer and there are some kinds of drawing that utilize these effects. Very small things that we are accustomed to thinking of as almost invisible can be enlarged in drawing. Very large things can be reduced. By themselves, such drawings can be very useful, but if the

gnat and the elephant are drawn to the same scale and placed in the same plane of space, our inner sense of the rightness of things is challenged. Distorted proportions and space relationships create an imaginary world of unreality that upsets the viewer's sense of equilibrium and creates an image like that of a bad dream or an hallucination. There may be very important reasons why this kind of drawing should be made; I am not arguing against such a possibility. In order to distort space or proportion, though, it is essential to begin from an understanding of normal proportion.

How do you begin to master space and proportion? You have already made a beginning in your study of form and pattern. In working with form you cannot help thinking about the proportional relationships *within* a shape. In working with pattern, you begin to draw the proportional relationships *between* forms and spaces. It is important to remember that the act of drawing is a coordination of many different perceptions and many different movements. To begin a drawing on any level of ability means that the artist must plunge into the torrent of his perceptions and swim. With practice, you gradually learn to handle the different problems.

First, a student begins by learning to draw shapes and then goes on to draw patterns. Once he has developed some skill in drawing patterns, the student begins to adjust the size of objects so that they relate more naturally to one another. After developing skill in proportion, he attempts to put objects deeper into the space of the picture.

Project: Here are a few simple exercises in proportion. You need pencil and paper.

Select several small objects such as some coins, a pencil, a paper clip, a nail file, a pebble, or anything similar. Place these objects at random on a sheet of drawing paper. Trace the outlines of the objects on the paper. Remove the objects when you have finished. The result shows a transference of the natural proportions of the objects.

Next, replace the objects on their outlines and on another piece of paper try to draw them to one half their size. Keep the proportion of the objects in relation to one another and the spaces between them in the same relationship. After you have done this, take the objects off the first sheet of paper and compare the two drawings. If your half-size drawing is not very accurate, put the objects back on the first tracing and keep at it until your drawing is accurate. When you have a half-size drawing that you think is good, hide the objects and the first tracing and draw the objects in the original sizes and position, using the half-size drawing as a model.

When you try this a few times you will find that it is absolutely essential for you to think in terms of the over-all measurement of the objects on the page rather than of the objects as isolated shapes. Visualize the objects as if they were resting on a gridwork, dividing the paper in halves, quarters, and eighths squares. Also think of the placement of objects in terms of angles that are created. You can find these angles by looking for a center point or an axial line in the individual object and by connecting them with imaginary lines to the center points or axial lines of objects nearby. Within any random placement of objects there will be three-, four-, or five-point angular shapes that can be easily seen.

It is also a wonderful exercise to make size estimates and to assess angular relationships when you go for walks. As you walk along, pick out several objects ahead of you that are grouped fairly close together. Quickly judge their proportional relationship to one another as you approach them and also estimate the approximate geometrical shape of the objects as a group.

Estimating the proportions of a series of randomly placed objects is a good exercise in composition. Take some coins or matchsticks and let them fall on a piece of paper. On a second paper, draw the shape of the over-all pattern that they make; try to see it as a simple shape such as a triangle, square, arc, etc. Try to see the whole group as a mass (or two masses). Once you have drawn the simple shape you can organize the smaller units within the larger shape. You will find that sometimes the centers of some shapes are the strongest guide, whereas in other shapes, the edges or corners will dominate.

SCALE AND SPACE

You have seen family snapshots of parents with their children lined up in a row, all facing frontward with the tallest at one end and the youngest and shortest at the other end of the stairsteps that are in between. Before the advent of birth control, such snapshots were not at all unusual. These photographs were wonderful illustrations of the human scale. They illustrated that when such a group of figures are placed in the order of birth in a symmetrical line facing the picture surface a triangle of growth and time is created that goes back to almost the sperm and the ovum. Such a line-up shows the *scale* of human growth and development at different ages.

Scale is a numerical concept of unit measurement. It tells the size of things, but does not tell anything else about them. Drawing scale—the scale used in art—is somewhat different from the kind of measurement used in science, engineering, or economics. An artistic drawing of scale must take into account the expressive qualities of the shapes as well as their sizes. Since we have already talked about these expressive qualities, you know that when we talk about the scale of objects now it is in the light of the expressive qualities we have discussed.

Picture scale is the comparison of sizes of objects on the picture surface, *and in the receding planes of space within the picture.* In order to compare scale difference between objects we generally place them on the same plane facing the viewer (Fig. 239). This is like the stairstep family snapshot and it is the simplest kind of scale. Children use this scale approach in their drawings. But scale comparisons can be made when objects are scattered at random places in a line too (Fig. 240), and doing this with our snapshot family would make a picture that was a little more true, since it suggests personal affinities and chance. Finally, scale comparisons can be made between objects that are in different planes of depth in the picture, but this can only be done by a skillful artist who knows how to create picture space (Fig. 241).

The space in the pictures of primitive painters is generally shallow and the sense of scale is very rudimentary. Primitive painters draw all objects in their pictures as though they were on the same front plane. They are not able to construct space through the use of scale because they are unable to *visualize* how things become smaller as they recede in space. The "primitive" painters

241. The stairstep family in different planes of depth, shows not only personal relationships but also activity in space.

242. In man's first attempts to draw, objects were rendered singly without relationship to one another, such as in this diagram after the cave paintings of Altamira.

243. In the beginnings of civilization, man started to organize the forms of his drawings in order to tell stories or give messages, as we can see in Greek friezes and Egyptian art.

try to achieve deep space by placing figures in different areas of the front plane of the picture. Like children, they say, "This man in the lower right-hand corner is in front because he is by the house, while the man in the upper left-hand corner is in back because he is where I put the mountains." But because the figures are the same size and there is only one pictorial plane there is no real use of space in the picture.

The answer, of course, lies in the way the artist handles the scale and placement of the picture objects. The answer is simple—make the figures that are far away small and the near ones large. Or put one figure behind another and another behind that. But this does not explain how the illusion occurs nor the techniques of how to go about making complex pictures. Fig. 242 shows a random placement of individually drawn objects as in the cave paintings of prehistoric man. Primitive man, some children, and beginners in art draw one object at a time without much concern with how several objects will relate in a picture. Though the individually drawn objects may show some space between themselves, they are not drawn in relation to one another and do not really affect one another's spatial position.

Man's talent for drawing objects developed slowly until the drawing of single objects was mastered. At this point there was a desire to relate one shape to another and to tell a story. The simplest way to do this was to line up shapes facing the viewer or have them move to the right or left while they stood on a line that represented the plane of gravity (Fig. 243). This enabled the artist to make figures that could walk in two directions and also confront the viewer. This form of spatial composition eventually gave rise to pictographic writing, calligraphy, the phonetic alphabet, and the concept of cinematic continuity. This basic form of composition could express action, reaction, and time, but generally only one thing could happen within one picture. It was as though everything occurred in a narrow corridor.

The next logical step was to give more movement and space to the pictorial events and objects, and to create an illusion of an environment within the picture world. The first method of approach to this problem was to place objects and figures at random intervals on the picture surface and to connect them by using landscape features (Fig. 244). This is really an extension of the corridor space in which the top of the corridor is taken off to allow the figures to move up or down as well as from side to side. This produced a picture something like a bird's-eye view or an aerial map. But the *actual* illusion is that the ground plane of the picture is at a 45° angle from the plane of gravity and also from the viewer's line of sight. The image this creates is similar to viewing figures on a hillside. It was very hard for man to go beyond this type of spatial composition and scale because it has some strong elements of reality. Figures do not become smaller necessarily in these compositions and they do not in actuality; they only *appear* to do so (Fig. 245).

Artists had been drawing families of shapes for a long time. They drew big and little humans, big and little plants, cows and calves, etc. But these were generally lined up in a row facing the viewer or clumped together on one of the hillsides. During this time man also was able to draw the same object in different sizes. In reality he had at this time all of the elements of spatial drawing, but did not quite

know how to put them all together in such a way that he could draw deep space. Something was lacking.

The realization of the importance of the horizon line was the next big step in art as it established a limit to the plane of gravity, and suggested the earthly curvature and the dome of the atmosphere. But at first, objects were placed within such a composition in the old-fashioned way with no regard for scale changes as objects approached the horizon (Fig. 246).

There were several geniuses of the early Renaissance who decided to use the horizon line and at the same time diminish the sizes of the shapes as they placed them closer to the horizon (Fig. 247). This established a funnel perspective that created a violent movement into the deep space of the picture and an equally violent movement out toward the viewer. Scale in depth had arrived.

Another great spatial discovery that had first occurred in Greek painting and was continued in Roman times came to the rescue. This method involved putting one shape behind another and then another shape in front of the second one to create a gentle in-and-out movement. This method is now called overlapping planes. But at that time it took a genius to realize that through tthe use of overlapping planes the abrupt, violent movement of objects in diminishing sizes receding into space could be softened and slowed down so that there would not be a funnel to the horizon line (Fig. 248).

Once travel into picture space had begun, it was a simple step to go beyond the horizon line (Fig. 249).

The development of technical skill and virtuosity naturally followed the method of space creation. The artistic surge of the Renaissance began. It was not long before artists could move objects behind the horizon line, and farther on to a new horizon beyond, or even reverse the movement and have things come right out of the front plane of the picture (Fig. 250). Artists could make the ground billow and model picture space as though it were air, water, or clay. Finally, artists developed a pictorial freedom that enabled them to examine the external world and bring it into the inner universe.

Of course, the sequence that I have just shown you did not happen quickly or in a mechanical order. There were stops and starts, lulls and regressions, but the result was a towering accomplishment—an evolutionary gain. Think of the untold number of artists who added to this progress of drawing over thousands of years!

Project: I want you to use these different figures as compositional guides for drawing studies. Use shapes of your own choice—fruit, animals, or rocks and plants. Use pencil and paper and make variations of each diagram in sequence. Do not copy the diagrams exactly, but try to understand the principle in each figure. Be sure to check your ideas carefully; just one mistake could change the whole spatial structure. It is important to realize that each figure represents a step in the logic of constructing space.

PLANES INTO SPACE

The steps in learning about proportion, scale, and picture space lead now to deeper understanding of how to visualize forms in space and how to construct a picture with more consistent spatial qualities. The steps that we have just discussed in the preceding section taught artists to visualize invisible planes *within* the picture. These

244. During the medieval period, man began to draw forms going into the picture.

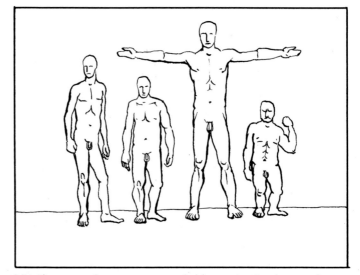

245. The sense of space was expanded by contrasting large and small objects.

246. The use of the horizon line created a differentiation between ground plane and atmosphere.

247. A sense of depth is created by diminishing the sizes of forms moving toward the horizon.

248. By putting one object behind another, a solidity of volume and an increased sense of depth in space is achieved.

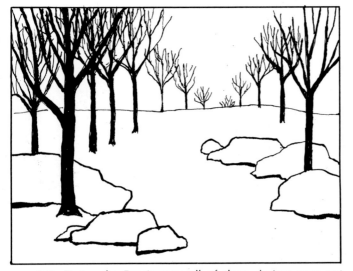

249. During the Renaissance, all of these devices were put together when the laws of vision were discovered so that objects could go beyond the horizon line.

planes were parallel to the picture surface and occurred at various points in the picture depth.

One good way to imagine these planes is to think of them as panes of glass (Fig. 251). On each pane there is a part of the drawing that corresponds to the figures, landscape features, and other objects that are at that depth of the picture composition. On the front pane are all of the things that are nearest the viewer. The next pane has the objects that are immediately behind the first, and so on until the last pane shows the most distant objects. Seen from the side the imaginary planes of space would look like a series of panes of glass with parts of the drawing on each. Numbers 1 through 6 represent what is seen on each plane of depth. Number 7 represents the entire picture.

The concept of dividing space into planes enables the artist to regulate the depth of the picture by controlling the scale of objects and keeping them in the proper relationship to one another in their own particular spatial plane. It also enables the artist to control the tone and intensity of his lines; for as you know, tones are clearer and brighter the closer they are to the viewer, while on the horizon objects are blurred and indistinct (Fig. 252).

It is interesting and important to note that these planes correspond very closely to the rings of attention that we have discussed. The artist's spatial planes are divided into the number that he can handle technically, but this also corresponds to his visual capacities and his organic-emotional structure. The artist does not select his planes mechanically, but he does so with the instincts that originate within his inner universe, the structure of the eye, and the nature of light.

In theory, the artist can choose as many planes to work with as he wants, but only as many as he can cope with. If you examine many paintings, you will find that even the most complex pictures will have a maximum of six or seven planes of depth (Figs. 253 and 254). If the planes of depth become too numerous, the picture becomes unreadable and forms are reduced to mere textures. Even a triptych as complex as *The Garden of Earthly Delights* by Hieronymus Bosch can be reduced to six planes in the center and right-hand panels and three in the left-hand panel. To avoid the complexity of too many planes, the forms can be more carefully thought out and more spatial effects made with overlapping planes. .

Project: One of the best and simplest ways to study planes in space is to analyze paintings. Select color prints from books and make drawings of the spatial divisions. Do not copy all of the detail, but just outline the larger areas of the planes, using a single page for each. If you use tracing paper you can put all of the planes together and check the whole series with a good backlight.

You can also analyze photographs of landscape in this manner, but I suggest that you do this only after you have analyzed the space in painting because photographs are not selectively organized and can be very misleading. Make sketches from landscape and vary your plane concepts in a single scene to see how many different ways there are to construct space.

VISUAL ORGANIZATION

There is a much overworked phrase about "each person having his own point of view." Yet all seeing humans share

the visual functions regardless of age, personality, race, religion, or geographical placement. All human eyes are constructed upon the same principle. The inner universe of each person may vary a great deal, the memory of each person may be unique, but the common denominator of most of the experience coming from the outside world is vision. It is merely that each person selects the things that are most beautiful and meaningful for his inner world that makes all the difference. Philosophy and education can make people see entirely different views of the same thing, but all sensible, unarmed people will run from a charging rhinoceros. The eyes are the true pathway to understanding.

A chief function of vision is as a navigational aid. The eye leads and directs the body's movement. The eye is also a major tool in the seeking of food. Other functions of vision are the seeking of love, pleasure, and comfort. The eye *selects* things that come into the field of vision in order to gratify the living needs of the body. The eye helps the infant and child to grow and the adult to maintain life.

While eyes take all in, the memory stores images of what is seen as well as the moods and sensations that give meaning to the image. By the time a person has matured, the stock of visual memories should have grown enough so that the inner vision will be able to react to the outer vision of things and compare what is actually seen with what has been seen and judged in the past. So with each vision of the actual world a *re-vision* occurs in the inner world, a comparison of experiences. An apple is seen in the light of apples that were experienced in the past—and thus apple-stealing is born, or the urge to draw apples, or maybe to grow apples, and certainly the wisdom not to eat green ones.

The eye is not a dumb mechanical contrivance, but a sensitive organ that is the link between two worlds—the inner and the outer. The eye is never as indifferent as the lens of a camera. The whole purpose of the eye is to search for meaning. For example, in a landscape the eye seeks out the contours and shapes of an object seen in order to determine whether an object is a threat, a useful tool, an obstacle, a navigational aid, a thing of beauty, a thing of edibility, a love object, or finally, an object of indifference. Everything that comes within the visual field is noted and scanned almost instantly. Whether or not the object is given further attention depends upon the needs of the viewer at that time and upon the way that his system of values has been conditioned.

The successful visual organization of a landscape picture, for instance, depends upon the artist's ability to select the things that are most relevant to the depiction of form, space, and mood. These things must be relevant not only to the artist but to those who view the picture. The artist does not have to pander to the prejudices of taste of the viewer but he should create visual experiences that the viewer's eye responds to. A picture is the artist's guiding of the viewer's eye in and out, over and around the things that the artist feels are significant. One viewer may or may not like what the artist has done to his eye—and hence to his inner universe—but the standard of success is whether or not the picture had the results that the artist intended in the judgment of many people. He selects elements that give depth to his picture where it is needed; he reinforces the sense of the plane of gravity and the upward thrust of levitation, the qualities of the plant life, the sense of time, etc.

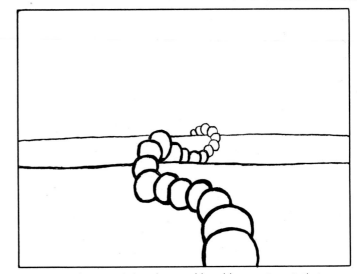

250. Artists discovered that they could mold space to suit their needs by moving objects beyond the horizon line or to a new horizon beyond.

251. The artist thinks of each area of depth in the picture as a separate plane into space.

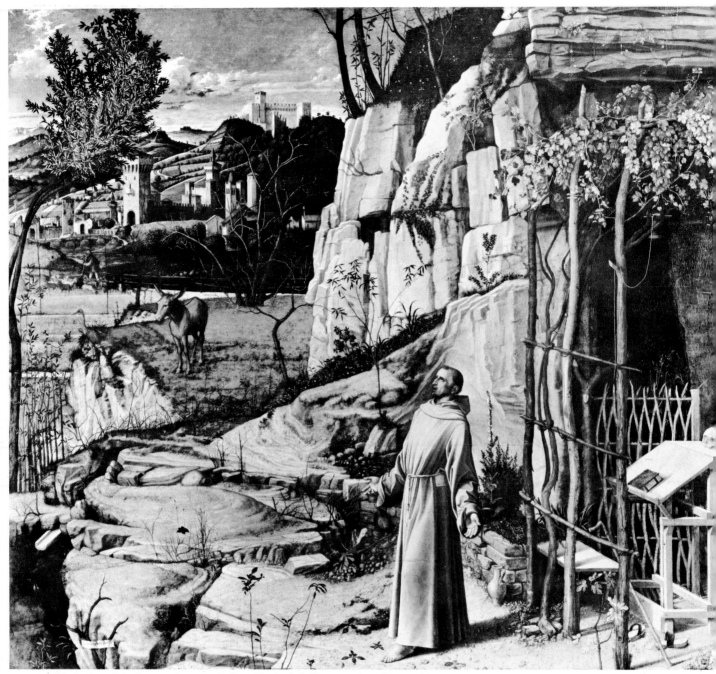

252. *St. Francis in Ecstasy*, Giovanni Bellini. The Frick Collection. This painting shows that the artist studied all the realms of nature, not only in design but in content as well.

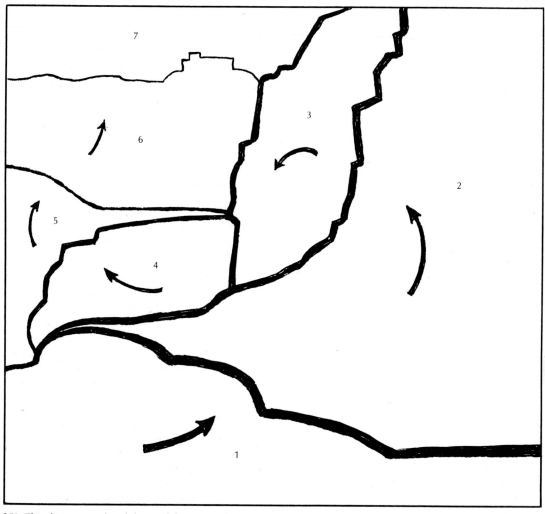

253. This diagram is a breakdown of the seven planes in space as they exist in the painting shown in Fig. 252.

254. In these diagrams, each of the seven planes in the picture is isolated as a shape.

255. This diagram illustrates the seven rings of attention with a visual cone superimposed.

Drawing well is really a matter of selecting and focusing the most basic experiences that are created in you by what you see. Drawing is a way of leading the eye from one experience to another, whether it is in a landscape or the territories of a human torso. The drawing must focus the viewer's eye on what is relevant and either blur or eliminate the irrelevant. In a painting by a skilled artist, you do not see a scene that is viewed arbitrarily. Instead you see a scene that is a re-creation by the artist that balances the meanings he sees in the outer world with the meanings of his own inner world, his visions, and memories. In a fine drawing or painting the mind of the viewer and the artist actually merge with each other.

The artist must select and stress lines in a *vital* way rather than following a rigid formula. If you draw a line to create depth you must feel that depth or the line is not successful.

Project: I would like you to make some observations of landscape features as you take a walk through the countryside. If you live in the city, go to the country for this exercise. Do not walk on a road or a path; walk across country. Once you begin, notice as you walk that you will have to pause from time to time to select your path. You will have to go around certain obstacles—circle the places where there are rocks, holes, or plants. As you pause, I want you to ask yourself questions about why you select your path. Think in terms of the plane of gravity, the scale of objects, your own height, and the direction toward which you are headed. Try to connect your walking with the picture-making process.

After you have walked a while, return by the same route and as you approach the areas where you analyzed the obstacles in drawing terms, I want you to re-examine the same areas—only this time you will be doing it from the opposite direction. When you have returned to your starting point, take your drawing things and select some of these sites to draw. Draw from your original approach, but as you draw see if you can imagine yourself *in* the space of the drawing looking back at yourself. Your idea of a terrain becomes different when you see it from two directions, so see if you can use this knowledge to make a better selection of forms and spatial meanings.

NATURAL PERSPECTIVE—THE VISUAL CONE

The eye is a visual center, and the act of seeing has shape. This shape extends from the center of the eye and goes outward in the cone-shape field that we use to scan the space of our environment. When we move our eyes, we move the entire cone-shape field of vision. The primary cone of vision which can include objects seen out of the corners of the eye and to the sides of our bodies sweeps an area of 120° or more. At the edges of this cone, objects are indistinct, but become clearer as they approach the center of the cone where the sight is clear. This central part of the cone can be focused to a very fine point.

In discussing the rings of attention, we regarded different distances of the object from the viewer as a factor of the emotional qualities and visual clarity of objects. Using the cone of vision *and* the rings of attention in a diagrammatic way, we get a very realistic view of how vision works (Fig. 255).

This figure coincides very well with the concept of planes of space, the shape of the visual field, and the rings of the individual's attentive abilities.

There are some peculiarities about seeing which have a great effect on picture-making. Very fine detail can only be seen in the first three rings, and there is even a great deal of variation of clarity in these distances. But with very large objects it is necessary to increase the distance of viewing in order to see the over-all shape, or to fit them into the cone of vision. Our gnat will fit easily into the second ring of attention, but our elephant will not. If we are close to a tall tree or building, we must move the cone of vision in order to see the top of it. In order to see anything completely, it must fit within the cone of vision and the larger the object, the remoter the ring of attention that it will fit into, until we reach sizes that we cannot in any way compare to our own body. Very small objects, on the other hand, will disappear from view as they recede in the distance; our gnat disappears in the third ring but an elephant disappears in the sixth.

Within the functions of the cone of vision there are three contradictions to the sense of everyday reality. It is because these contradictions existed that artists took so many centuries to develop the concept of planes in space, but these contradictions when fully understood also became the foundation upon which natural perspective was built. One contradiction to reality is that things appear to grow smaller as they recede in the distance (Fig. 256). Our every experience tells us that things cannot grow smaller just because a viewer or object moves away from a certain position. The second contradiction is that parallel lines seem to converge toward a point on the horizon. Yet we can walk down a road or along a railroad track and *never* reach that point of convergence. The final puzzler is that *more space* and *more objects* are contained in a square inch focused on the distance than in a square inch focused on the foreground (Fig. 257). We can appreciate why it took so long for artists to develop deep pictorial space. The shallow space of pre-Renaissance art, of Indian paintings, of Chinese and Japanese art do not hold these contradictions, though they do hold others. The important point is that the development of natural perspective did not destroy earlier concepts; it merely added to the knowledge and skill of the art field and gave a new approach to old problems.

Why do things seem to become smaller and why do parallel lines seem to converge in the distance? The answer is that we do not see *things*, but rather *reflected images* in triangulated relationships. The focal point of the human eye is the vertex of the cone of vision which in diagrammatic form we slice down the middle so that it appears to be a triangle. This triangle extends from the eye in two lines, one to the point where the object seen meets the line of gravity, and the other extending from the eye to the top of the object. The third line of the triangle extends from the top of the object to the bottom point. No matter what object we look upon, what we really see is this triangular relationship that is made by the light rays from the object which are caught and focused by the lens of our eyes.

We do not see the object itself, but rather an *image* focused by the lens. Our eyes are able to catch reflections and focus light rays in triangular form within the cone of vision. When the distance of the observer's eye and the object increase, the shape of the triangle of vision changes.

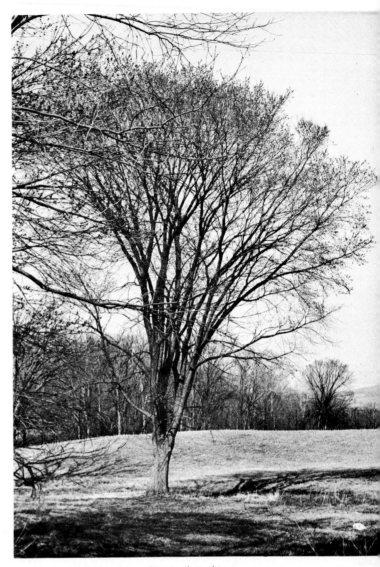

256. A contradiction to reality is that things appear to grow smaller as they recede in the distance.

The length of the two sides increases, but the third line of the triangle remains the same. In other words, as we add distance, we add the quantity of space to the two sides but add nothing to the third line which alters the shape of the triangle. The only way an object can stay the same size to the eye is if it grows in height as it recedes in space. Fig 258 shows how the triangular relationship changes in space. Also notice that when the viewer and the three subjects that he is viewing are seen by *us* from the side they are all the same size. The reason for this is that our eye sees these objects all on the same plane.

The big mistake that we all make is in believing that the image we see in our eye is *the thing itself!* Our eyes are such marvelous organs that they have us believing more than we have a right to believe. If you just shut your eyes for a minute you can prove this to yourself. With your eyes shut, the whole illusion of sight disappears. When your eyes are shut, your relationships to the objects of vision become completely changed. The coordinates of space of the blind person are different from those of a person with sight because he relies only on the sense of the plane of gravity and line of levitation and on physical contact. A blind person must walk through the space to confirm the distance that we see, or he relies on his more conscious use of the triangulation of sound.

When things appear to grow smaller as they recede in space and when parallel lines appear to converge, both images are a result of the eye seeing triangular relationships in depth, and seeing the objects crossing the cone of vision in planes. Fig. 259 illustrates how the eye makes the lines of the road converge.

Natural perspective in drawing is based on an understanding of the triangular relationships in the cone of vision, on the artist's ability to estimate the scale of objects, their position in the receding planes of space, and finally on his ability to transfer all of these facts to the picture surface. Leonardo da Vinci stated, "Perspective is nothing other than seeing a scene behind a flat and very transparent pane of glass on the surface of which one marks all the objects that are on the other side; these things are connected to the eye by pyramids [our cone of vision]; and the pyramids are intercepted by the 'pane of glass.' "

When you are drawing in perspective and trying for accuracy in judging diminishing sizes in depth—and scale in planes of depth—it is necessary to keep one position and point of view toward the scene you are drawing. The reason is that any shift in viewpoint changes all other angular relationships to those that you have already drawn on your picture surface. On the other hand, it is not at all natural to look at objects from one frozen position. Ordinarily we do not do this because we are moving and alive creatures and the reality of vision comes from the movement of the viewer in the field of observation. In normal seeing, we move our eyes and walk around objects and change focus from point to point. This is the way we create inner images that have vitality; our inner visions are montages of many views.

257. Forms converge toward the horizon so that there is more space and more objects in an inch of background space than in an inch of foreground space.

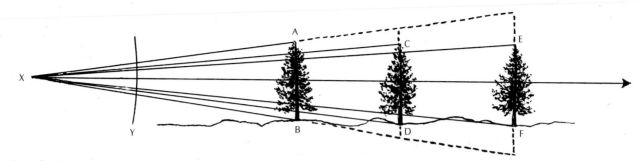

258. This diagram illustrates the triangle of vision. The broken lines show how much larger the second and third trees would have to be in order to appear as tall as the first tree on the lens plane. (X) is the focal point and the horizon line. (Y) is the lens (or picture) plane. ABX represents the visual triangle of the nearest tree. CDX represents the visual triangle of the second tree. EFX represents the visual triangle of the third tree.

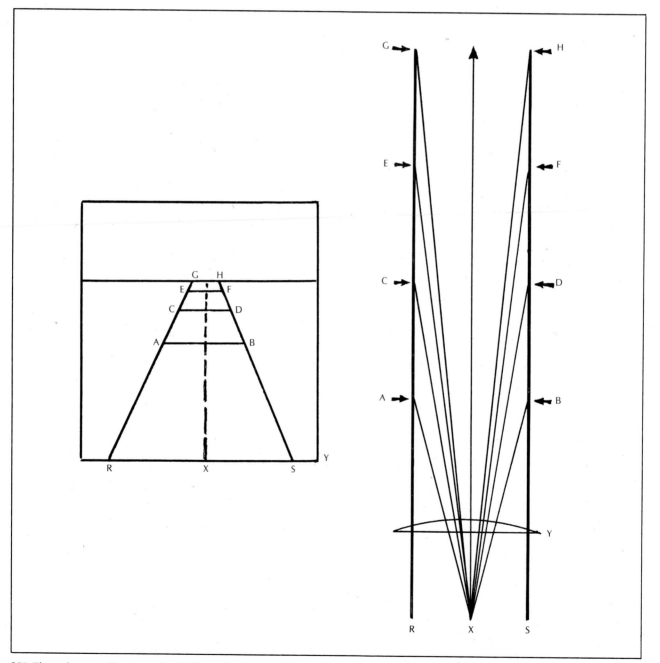

259. These diagrams illustrate why the lines of roads appear to converge. (R) and (S) represent the sides of the road. (X) is the focal point and center line of the road. (Y) is the lens (or picture) plane. The widths of the road at different distances are represented by AB, CD, EF, and GH.

Project: This project illustrates Leonardo's statement about the pane of glass and my comments on the fixed viewpoint. You need a pane of glass and a china marking (grease) pencil. For your pane of glass you can use the framed glass from an old picture. This gives you a safe way of handling the glass. (I fasten the glass to the frame with masking tape.)

Place your glass in a fixed position on an easel in front of a still life of simple objects. Start drawing the objects as you see them through the glass. You will immediately discover why you cannot move your viewpoint.

NATURAL PERSPECTIVE—THE VIEWPOINT

One of the first books ever written on perspective, and perhaps the first scientific one, was written by the painter-architect Leon Battista Alberti in the fifteenth century. Another one was written about the same time by the great painter Piero della Francesca. Since that time it has always been considered important for artists to learn the rules of perspective. However, artists have always taken liberties with these rules once they have learned them and in the nineteenth century, Cézanne found some new approaches to the perspective problem. Actually, Cézanne did not find new principles, but he reapplied the old ones by using several different viewpoints in his pictures. He created a great sense of internal movement in his pictures by allowing the viewer to "see" several different sides of the same objects—it created shifts in the image.

You should understand that this was not a breaking of the laws of perspective; instead it was an extension of the same reasoning that had developed in the Renaissance. Cézanne attempted to re-form these laws on a higher level. This means that Cézanne did not eliminate the necessity for you to learn something about perspective, but he did make it more important for you to learn how the eye sees.

In essence the *theory* of perspective is based on a few simple scientific facts about the refraction of light and the images that are created by the lens. The *logic* of perspective shows how geometrically ideal shapes are changed when they are seen through a pane of glass from one viewpoint. For example, if we look through our pane of glass at a cube, the front side of which parallels our pane of glass across our eye level, we will see a square shape and not see the sides or the top at all. But if we view the cube from a little to the side and a little above, the front is still relatively square but the side appears to be a parallelogram and the top appears to be a quadrilateral (Fig. 260). All shapes are altered by the perspective of vision with the one exception of the globe whose contour from any viewpoint is always round. The real trick behind perspective drawing is in understanding how shapes change from their geometric ideal when they are seen from one point of view. The person with natural drawing ability always has a good subconscious understanding of this aspect of shapes.

In order to draw in perspective, you must learn to *see through* objects as though they were transparent. Probably you have seen shapes drawn as those in Fig. 261 in which dotted lines represent the contour lines of the shapes on the unseen side, away from the viewer. This is exactly what you must learn to do in order to draw ny shape in perspective. You will notice that most of the lines are actually parallel to lines that are naturally visible on the viewer's side. In other words, the invisible lines are

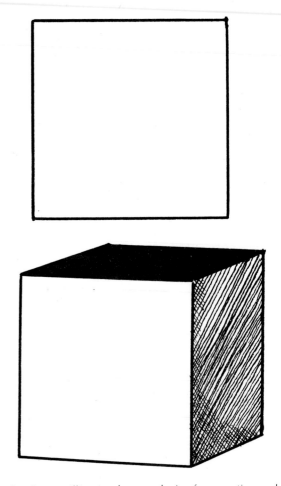

260. This diagram illustrates how our logic of perspective works.

261. Here are perspectives of common geometrical shapes with dotted lines showing the line behind the forms or within them.

267. Several gestalt closure forms are illustrated here. The eye is such an eager unifier that it will accept the barest indications of identity and then integrate the rest of the picture through imagination.

268. Another example of pictorial form is the "Urn Phenomenon," in which two images alternate in our perception.

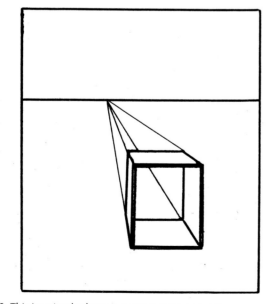

269. This is a simple shape in a one-point perspective.

mind equates the contraction of intervals with receding distance. The interesting thing is that this is a completely two-dimensional device.

An extension of the parallel-line phenomenon is the optical box-pyramid illusion (Fig. 265). The addition to the concept is the uniform shortening in the length of the lines. The basic box-pyramid appears to converge toward one point at the horizon or to rise above the picture surface. This is not only because the eye sees the diminishing scale of the lines that indicates a recession in space but also because the eye sees the spaces between the lines as *white lines!* This in turn gives the effect that the spaces *between* the four groups of lines actually do converge. Finally, the center of the whole composition corresponds to the optical viewpoint, the center of the cone of vision where there is the deepest focus into space (Fig. 266).

The optical box-pyramid is the first cousin to the diminishing line of telephone poles. The converging lines of the road or railroad tracks are also of the same family. The optical box-pyramid is an *almost* two-dimensional figure, but the black-white shift and the phenomenon of closure put it halfway between a two-dimensional flat image and the perspective image of space.

The phenomenon of closure simply means that the eye sees what it is led to see even if a part of the image is left out (Fig. 267). In life we do not stop to check the rhinoceros to see if he has all of his parts when he is charging us; we make the assumption that he does on pure faith and instantly get under way. So it is with most of the things that we see with which we have great familiarity; because we know objects we often give them an incomplete scanning, just enough to identify them. This means quite a bit to the artist as it enables him to deal with only those elements that describe his subject. This is the basis for the artistic simplification of form.

Another phenomenon that is important is called the *Urn Phenomenon* (Fig. 268). It is actually an *attention shift* or an oscillation between *spatial form* and *atmospheric form*. (I do not like the terms positive and negative space because they imply that space and atmosphere are formless and that, as we have seen, is incorrect.) The reason for this shift is that the intention of the drawing is to deceive. The drawing is neither an urn nor is it of two heads; it is a montage of profiles that makes use of the fact that the eye always examines the spatial *intervals* between forms. These spatial intervals are as meaningful as the forms, particularly in living shapes because the space around these forms is an extended part of the field of awareness of the shape. In drawing, this shift between the form and the space around it is important. A too heavily drawn form seems enclosed and dead to the atmosphere and creates a stopping place in a drawing, too insistent an emphasis.

Project: Set up your glass again in front of a landscape where there are plenty of trees and draw only the vertical lines with your grease pencil. When you have finished, put

270. *The Adoration of the Magi* (Right), Albrecht Dürer, woodcut, 11 1/2" x 8 5/8". The Metropolitan Museum of Art. The composition of this engraving is built around a one-point perspective. There is also a galactic swirl in the picture.

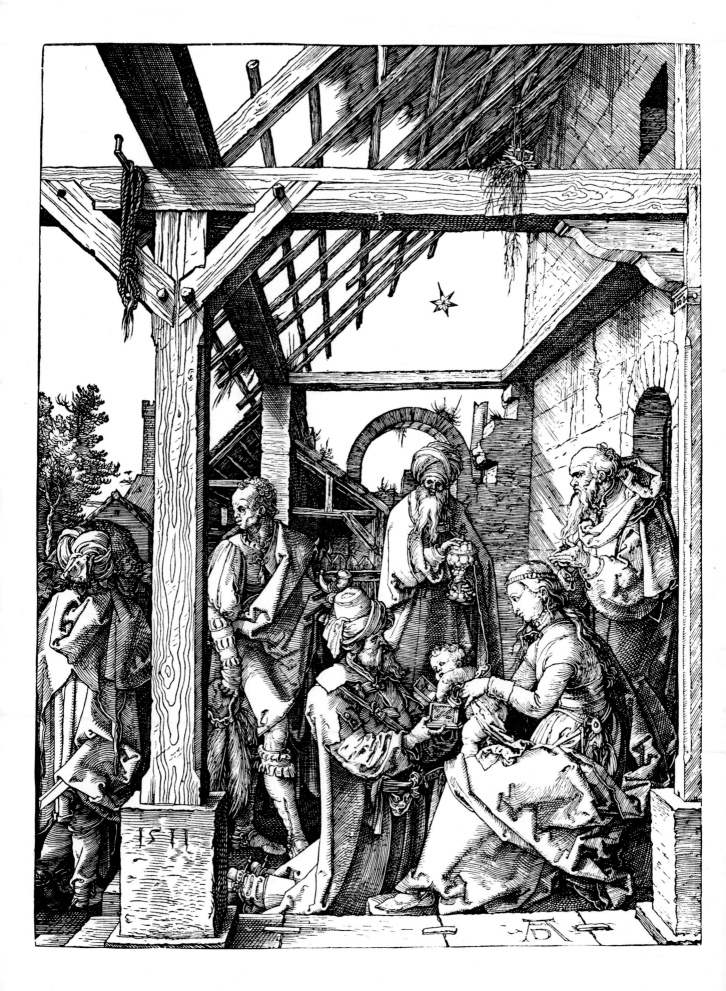

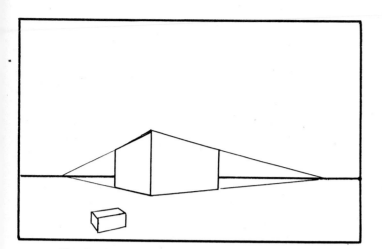

271. This is a simple shape with two vanishing points.

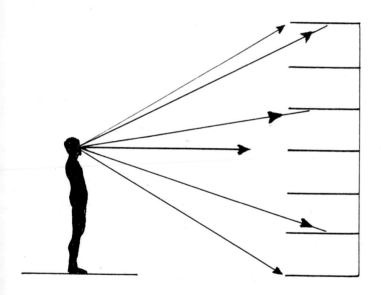

272. These diagrams show a series of planes above and below the horizon line seen in perspective.

a piece of white paper behind the pane of glass and study the spatial effect of the lines by themselves.

Another exercise that you can do with the glass is to study horizontal lines in the same manner. Both exercises will help you to see how *line groups* add to the structure of a picture and give it solidity.

NATURAL PERSPECTIVE—VANISHING POINTS

You have heard the terms *one-point perspective, two-point perspective,* and *vanishing point.* All of these terms relate to the way that parallel lines that do not parallel the picture plane recede into space toward the horizon.

In one-point perspective, the point at which these lines meet the horizon and disappear is identical with the artist's viewpoint (Figs. 269 and 270). This viewpoint is also called the *central vanishing point* of one-point perspective. You encounter it while walking down city streets, while driving on highways, or while walking in groves of regularly spaced trees.

Two-point perspective is a little more complex because it includes two vanishing points, one at either side of the artist's viewpoint. Just how far to the right or left they are depends upon how close the artist is to the principal objects he is drawing.

As you can see in Fig. 271 the factor that determines the decision to use two-point perspective is that the object has no plane that is parallel to the viewer. Instead, the foremost part of the object is the edge where two planes meet at either side of which the parallel lines converge to right and left. The factor that determines where the vanishing point is established on the horizon line is the angle of the lines receding into the distance. The more angled the object is to the artist the shorter the vanishing points are, while the more parallel the object is to the horizon the longer the lines and the farther the vanishing points.

A very important factor in perspective is the shape and angular relationship of the ground-plane of objects. There are three things that determine this: the distance of the object from the artist, the distance of the artist's eye level from the ground, and the position of the object between the bottom of the page and the horizon line. The more you look down on a form, the more its ground-plane shape corresponds to its own true geometrical shape. The more the object approaches the horizon line, the more its ground-plane shape recedes into a straight line, until finally at the eye level it becomes a straight line. A good way to visualize this is to imagine an accordion that has been pulled open on one side; if you see the center of the bellows as being on the horizon line, you can see exactly what happens to planes below *and above* the horizon line. With forms above the horizon, the only difference in drawing is that the converging lines are drawn downward instead of upward to the vanishing point.

There is some difference in the drawing of ground-planes in one-point and two-point perspectives. In one-point perspective, square or rectangular ground planes have one side paralleling the picture plane which produces a blunt, heavy feeling. In two-point perspective, the ground planes form triangles which lead the eye around the object into the atmosphere (Fig. 272).

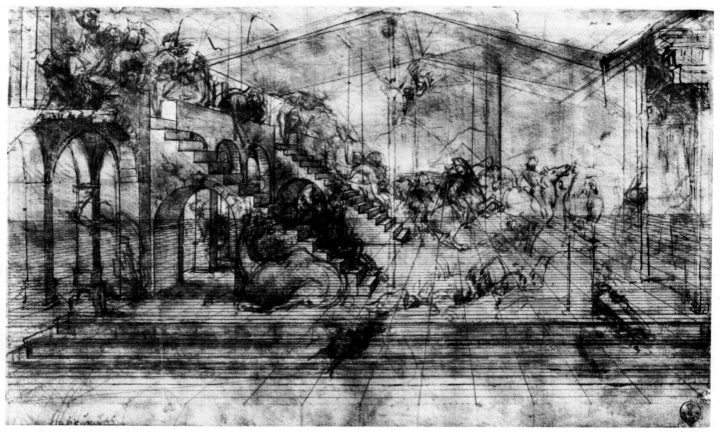

273. A compositional study in perspective for *The Adoration of the Magi,* Leonardo da Vinci. Uffizi, Florence, Italy.

FORESHORTENING

Objects can be foreshortened in a very technical way by squaring off the surface on which they lie in a perspective checkerboard and then transferring the measuring points of the object's ground plane to the corresponding points on the checkerboard as shown in the reproduction of the Leonardo drawing (Fig. 273). There is an easier way to foreshorten objects based on very careful observation and the use of planes in space. This is useful for drawing figures and more complex shapes. The method is to mentally slice the shape up as though it were a bologna sausage. Try to see the various shapes of the form as planes that fit one behind another just like the apples in a still life are drawn in overlapping planes (Fig. 274).

Project: Using your pane of glass and your grease pencil, you can practice foreshortening. The object is to train yourself to see foreshortened shapes. Begin with simple shapes like the cardboard cylinder from a roll of paper towels. Draw this and similar simple geometrical shapes in several positions, but try to see *through* each shape that you draw. When you have done the simple shapes, get a friend to pose for you and try to draw the foreshortened arm or leg. When you understand the thinking involved in foreshortening, put away the glass and try to draw the same shapes by your eye alone.

SOME FINAL REMARKS ON PERSPECTIVE

This has by no means been a thorough exposition of the laws of perspective, but is intended to acquaint you with the characteristics of vision and human feeling upon which the laws of perspective have been built. When you go into a deeper study of perspective, it will be important to remember that the eye does not see mechanically and that good pictures are not painted from prearranged rigid plans that exclude chance and the feelings and observations that occur during work. At its best, a perspective structure provides your work with a firm groundwork for your expressiveness; at its worst, perspective can be used to erect an empty shell of appearances. This part is up to you.

If you can pursue it, the further study of mathematical perspective is both fascinating and rewarding. This subject is called projective geometry and it has had far-reaching effects in science. And when very accurate drawings of buildings in perspective are required in architecture the method used to draw them is geometrical projection. However, in my opinion, projective geometry is much too rigid an approach to be useful to the artist in everyday drawing.

274. These drawings show how the perspective plane concept works with the human figure. A figure clothed in strips encircles the body in lines transverse to the axes of the forms.

6. Light and Darkness, Black and White

Wakefulness and sleep are functions of life from which we derive our basic understanding of light and darkness. When we go to sleep, we change our whole relationship to the world and return to a primitive state of being—the state we call the unconscious. In sleep, our relationship to gravity and levitation is changed; instead of fighting against the force of gravity we give in to it and rest in darkness. When day comes we rise up again and seek the light. Our lives alternate between light and darkness.

In Chapter 4, I pointed out that the structures of human heads and animal heads are determined by the body stance in relation to the dark earth surface and the light of the sun overhead. Our brows, eyelashes, and eyelids are placed as they are to aid our eyes in their adjustments between light and darkness.

Though mankind has altered the natural relationship of night and day, the physiological aspects of our relationship to light and darkness still mold the human organism. We are constructed according to the phenomenon of earth rotation—the consequence of which is night and day. For a certain amount of time in each twenty-four-hour rotation we must rest in unconscious darkness and during another part we rise to the light. No organism in the animal world can long survive the disruption of the natural alternation between light and darkness, wakefulness and sleep. Light and darkness are a part of our being as well as our structure.

Consciousness is a phenomenon of light and darkness. We speak of the *illumination* of understanding emerging out of the *darkness* of the unknown. We speak of the *light* of loving another person. In knowing and in revelation, we *see the light*. When we speak of *stark reality*, we mean that there is a sharp contrast in the mentally visible image. Our conscious mind fluctuates between mental illumination and the soft state of darkness and unconsciousness wherein the functions of our bodies automatically continue the processes of life.

There is an inner light and darkness that is visible in our brains for we can *picture* things that we do not see when our eyes are closed. We create inner visions and dreams out of this inner light and darkness. We literally draw pictures with our mind.

At this point, we are not going to talk about color. I do not want you to stop seeing color or thinking about it, but I want you to translate all of the color effects into gradations of black and white (Fig. 275). In reality color, light, and darkness cannot be completely separated any more than the other elements of drawing can be separated from the interrelationships of nature.

To begin with, there are different kinds of light within the cycle of day and night. There is a tendency in some older artists as well as beginners to draw pictures as though all subjects existed under one kind of harsh and unvarying

light. This is probably due to the fact that most people use artificial light without realizing that it is a fairly recent invention. Artificial light has made its appearance only in the last hundred years since Thomas A. Edison developed the incandescent bulb. Painting or drawing pictures within the limitations of the artificial light range is similar to a musician who confines himself to only one or two notes of the scale. Light in nature has an immense range, and it is on this variety and depth that art is built.

DAYLIGHT

Sunlight is literally the "light of life" because it is an integral part of the whole life process on our planet—and most likely the major factor. Sunlight has an incredible emotional significance to all people since most of the hopes and yearnings of humans are connected with the light of place and time. If you search your mind for your most cherished memories and the images of your future hopes, you will find that sunlight plays a very important part in these mental images. Sunlight is one of the more expressive forces in art.

Light changes occur as the sun's rays filter through the lens of the great magnetic field that shapes the earth's atmosphere. The brightest light is at noon, when the rays are perpendicular to the plane of gravity. The dimmest sunlight occurs before dawn and at dusk when the sun's rays reach the earth indirectly by reflection from beyond the horizon.

Project: Set up a simple still life on a table outdoors and make some time sequence drawings of it during the day. Use charcoal, kneaded eraser, paper, and fixative.

Set your clock to get up at sunrise and set the alarm to go off at three-hour intervals after that for the whole day. Make line drawings of the objects and table surface and use a charcoal tone to show the light change and the direction of the sun's rays.

SEASONAL ALTERATIONS OF DAYLIGHT

The daily pattern of light changes is also altered by the changes in the seasons. These occur, as you know, in a sequence of four periods during the earth's yearly orbit around the sun. This seasonal change is the result of a chronic 23 1/2° slant in the earth's axis (Fig. 276). This makes the sun's direct rays reach the northern part of the globe during the summer part of the orbit and reach the Southern Hemisphere during the winter months. This changing relationship to the angle of the sun's rays does not alter the seeming daily east-west path of the sun through the heavens, but it does alter it from north to south. This means that instead of the sun being directly

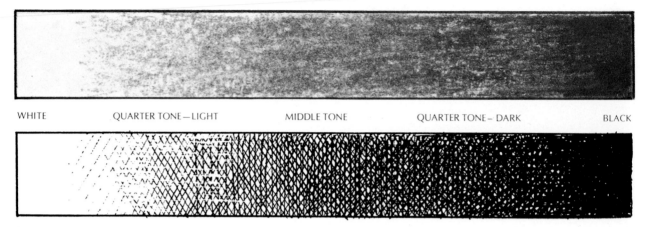

WHITE QUARTER TONE—LIGHT MIDDLE TONE QUARTER TONE— DARK BLACK

275. The two bars above represent two scales of black to white gradations. The top one was done with charcoal, the bottom one with pen and ink.

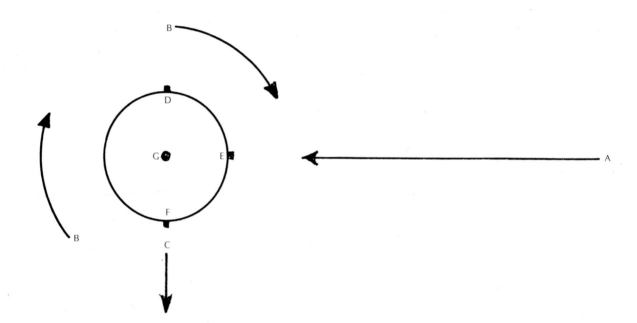

276. The earth's position is shown here in relation to the sun, showing the time of day as visualized from a point above the North Pole. (A) is the direction of the sun's rays, (B) is the direction of the earth's rotation, (C) is the direction of the orbital path around the sun. (D) represents dawn, (E) noon, (F) sunset, and (G) is the North Pole.

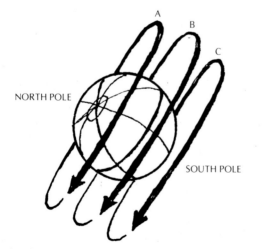

277. This diagram shows the angles of the sun's path in summer, winter, spring, and fall. (A) shows the position of the sun's path in summer, (B) shows the position of the sun's path in spring and fall, and (C) shows the sun's path in winter.

278. Clouds alter daylight by casting large shadows.

overhead at noon, as it is in the summer, it will be toward the south during the wintertime. This also means that there are *two* angular relationships to look for in finding the sun's position: the angle of the daily arcing path, and the angle of the seasonal slant of the entire path (Fig. 277).

The visual and emotional feelings of the seasons stem from the different qualities of the weather and light which result from the angle of the light and radiant heat of the sun. This in turn affects the growth and decline of plants and the mating and migration cycles of animals. Actually, all of these things go together to give us a sense of the quality of daylight. We should remember that we are not just casual observers of these changes but we respond organically to them.

Project: Make a drawing of a tree outside your window at the same time of day—once each month—for a year. If you do not have a tree, find one in the neighborhood and always draw it from the same position. Use charcoal, kneaded eraser, fixative, and paper. Try to keep your drawing in the same style and size so that the only thing that changes is the light.

HOW WEATHER ALTERS DAYLIGHT

A daily factor that alters the quality of the sunlight is the weather. Cloud formations alter light conditions constantly to a degree depending upon the thickness of the clouds and the wind speed (Fig. 278). Weather moves at fairly regular planes of altitude above the earth's surface and this allows cloud patches to act like a hand moving in front of a flashlight's rays in obscuring the sunlight from vision. As clouds move across the landscape, one area is lit by the sun while another is in shadow. And so the light rays that reach the earth may create a great variety of light effects in a patchy sky.

On the other hand, the entire sky might be completely covered with clouds which will filter much of the sunlight and decrease considerably the brilliance of the day. In this case, the time of year has a great bearing on the quality of light. The direct rays of the summertime sun create a very luminous filtered light while the sun of. winter gives an overcast sky a gray and leaden quality.

NIGHTLIGHT

If sunlight has the qualities of openness and wakefulness—giving us contact with the earth and all of the life upon it—then nightlight brings us in contact with the mysteries of space beyond the earth and the farther reaches of the universe. Nightlight reduces the inner feeling of the size of human beings and of our conception of the size of the world because we can actually see other worlds and other solar systems. Usually, the whole sense of human scale is oriented to the visible daytime earth. The darkness of night opens up the *sense of space* within us to the space beyond the earth.

Our principal source of nightlight is the moon. Like the sunlight, the light of the moon is directional and follows the same kind of angular relationships. When the moon appears at night, it seems to travel an arcing pathway from east to west across the heavens; and again this is a result of the earth's rotation. Of course, the moon's position in the sky is not fixed, but it follows an irregular orbit around the earth. The moon's path varies between 5° north and 5° south of the ecliptic orbit of the earth around the sun. The seasonal change of the moonlight to the earth is somewhat similar to that of the earth and sun; the moon appears farther south in the wintertime.

The brightness of moonlight varies with the phases of the moon and the clearness of the atmosphere. In a clear, dry atmosphere, bright moonlight can make objects and landscape amazingly sharp. In a painting, moonlight can be very beautiful as all forms emerge from the darkness or blend into it. Because moonlight can alter the feeling of scale within us, it can also evoke strong feelings of yearning and loneliness at times. In extreme situations it can also arouse feelings of fear, dread, and terror. When one is safe, moonlight is very beautiful and calm; but when there is danger about, one is never quite sure what lurks in the shadows.

Project: Moonlight is not very easy to draw by, so to make moonlight drawings, you will have to make careful observations and then transfer these to the drawing paper from memory. Again you will find that charcoal is the best medium to use.

Set up a simple still life on a table similar to the one you used in the sunlight study, but use a white cloth on the table and light objects. Avoid making the composition too complex. Do only one or two drawings unless you feel like staying up all night and following the path of the moon. You can make the general outline of the composition during the daytime and then make the tonal part of the drawing at night. Spend some time observing, and then come inside and work on the drawing. When you need more information, return outside and observe again. You can follow the same technique with moonlight landscape by drawing in the daytime and doing the tonal part from direct observation at night.

FIRELIGHT

Mankind has made use of fire for a number of purposes—the main ones are for heat, cooking, and to frighten away savage beasts. But an extra dividend of fire is the charm and delight of the dancing flames. Perhaps in past times this was some reward for the labor of wood gathering and cutting. At night, when primitive man was warm, fed, and protected from fear, his social instincts expanded into storytelling, dance, and lovemaking in the moving beauty of the firelight.

The qualities of firelight are utterly enchanting to us because flame light is changeable and flickering, and there is some added mystery connected with the flame emerging from the wood and dissolving its form. The emotions created by firelight are warm and comforting or joyous and merry. Firelight changes our whole perspective of things because our vision is geared to the light coming from above; firelight alters all accustomed patterns since its flickering rays come from ground level. For this reason, fire has always been associated with the earth and with earthy emotions.

Project: If you have a room in your house with a fireplace, make a drawing with charcoal and sketch paper of the room in regular light. Then, when you have a fire going,

279. *The Education of the Virgin,* Georges de La Tour, oil on canvas, 33″ x 39 1/2″. The Frick Collection. The light in this picture radiates outward in all directions from the center of the flame.

turn out the lights and observe the firelight on the objects of the room. Pay attention to the tonal range; there will be many dark tones and few middletones and light tones will be bright. When you have absorbed the general idea of the pattern, turn the lights on and draw. You can do the same with a campfire if you make your drawing in the daytime and use a flashlight to see by when you put in the tones.

CANDLELIGHT

Once the usefulness of firelight as illumination was implanted, a natural chain of events led to the invention of the oil lamp and, later on, to the candle.

The quality of candlelight is very soft and charming. Like the light from burning wood, the light of a candle seems to play with darkness and shadow. But unlike the light of a wood fire, candlelight is generally kept near eye level and gives an illumination that is more accommodating to the eye. The evenness of the candle flame adds another important quality, that of steady illumination. The French painter Georges de La Tour specialized in scenes using the illumination of the candle as shown in *The Education of the Virgin* (Fig. 279).

The study of forms by candlelight is excellent for the artist because it defines the most delicate aspects of the forms. The quality of the candlelight itself is warm and not glaring, and the shadows from the forms blend quickly into the darkness.

Project: Take some simple objects—a vase, a plate, an apple, a white tablecloth—and place them on a table illuminated by a candle. On sketch paper, draw the outlines of the forms before you turn the light off. Then observe the quality of the light of the candle. You should be able to retain the quality of the light if you use a low-keyed electric worklight to draw by. Charcoal is the best medium to use for the initial study.

ELECTRIC LIGHT VS. NATURAL LIGHT

In these days people spend a great deal of their lives under artificial light. Technological man has in some respects abolished the order of night and day through the mass production and distribution of electric current and the incandescent light bulb.

With all due respect to this invention, the esthetic qualities of electrical lighting are in no way as charming or meaningful as natural light. Artificial light has no time of day, no season, and no great effect on the processes of life and growth. Artificial light is not connected with the heavens, or to the great movements of the stars, planets, and galaxies. It is a by-product of the destruction of matter and is akin to the fires of the interior of the earth.

To the artist there are qualitative differences between artificial light and natural light which are very subtle, yet very important. These differences are the contrasts between true and false light. We say this—knowing how important to us artificial light is—because the total acceptance of artificial light by the artist spells death to the deeper expressions of light in drawing and painting.

The human eye was created to function in natural light. To the eye, natural light is rich in quality and meaning and it is connected with many profound functions of nature. The study of it can enrich the whole fiber of the artist.

Natural light is intermeshed with the meaning of the whole human organism as well as its structure. Mankind is a creature of light, not of the incandescent bulb.

By understanding natural light and regarding it as our basic point of reference, we can use and study incandescent light with the proper perspective. The incandescent light can be a useful and welcome tool. It is very adaptable because of its portability, ease in focus, and the control of brilliance. The fluorescent light, on the other hand, is destructive to color, is clumsy and not easily adjustable, and also has unpleasant physiological effects on sensitive people. So what is said here about artificial light always refers to *incandescent* lighting.

Artificial light can be used to duplicate sunlight in drawing objects. It is an excellent means for studying shadows. Its best qualities are its mobility and its unvarying intensity which enable you to study one light effect until you understand it.

DARKNESS

Ordinarily, we do not think much about darkness because as organisms we are light seekers. In addition, there is a residue of fear about darkness which is the heritage of earlier, more superstitious times. Today, however, we know that in space there is no total darkness because space is filled with flickering and luminosity. Space is the medium of energy and energy can be either light or dark.

The only examples of total darkness that exist are where space is enclosed by matter as in caves or mines. The interior of a stone may be completely dark too, but since we cannot penetrate stone without letting in light, the closest we can come to total darkness is to be in a closet or a cave. But you do have visible darkness at your command in the form of your pencil, charcoal, or ink—all of these represent the blackest of blacks and darkest of darks.

In the human, there is light and darkness within the brain, even though his eyes are closed or the person is at the bottom of a mine. Our inner universe has its suns, moons, and galaxies that intermingle with darkness. With our eyes closed we can still see points of light, patterns, and colors in our mind. The inner darkness we see is a field on which the lights and patterns play and the light *seems to emerge from the darkness!* And the most interesting thing is that the inner light and darkness are very much like the light and darkness that we see in outer space.

Project: Though you cannot draw total darkness, it will do you no harm to sit in a dark closet and observe it for five or ten minutes. If you do observe any light phenomenon, try to draw it later; it makes no difference whether you think it is in the room or in your head. As a matter of fact, I would find it hard to believe if you can tell me that you see nothing at all.

LUMINOSITY IN PLANTS AND ANIMALS

There is a kind of light that we see emerging from darkness in a very subtle way which is called luminosity. It is the kind of light in nature that does not stem from heat as does the light from fire, from the sun, or from the reflection of incandescent light. A luminous object seems to have light as a part of its substance and/or metabolism. This light glows in the darkness enough to make the form visible, but

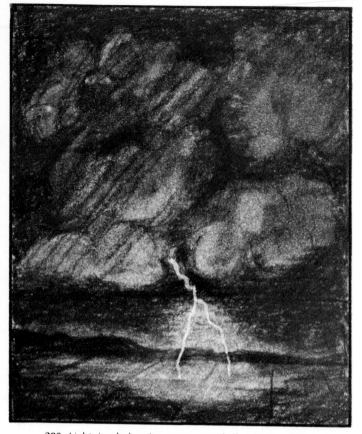

280. Lightning bolts give a very rapid illumination that is faster than the reflex action of the lens of the eye so that the eye is "blinded" by not being able to accommodate the rapid change from dark to light.

not enough to illuminate the surrounding atmosphere. Many fish and marine organisms are luminous, also many insects (such as the firefly) and there are luminous fungi in the plant world. Certain kinds of wood and some marine creatures give off a luminous light during the decay process.

Plant and animal luminosity is low-keyed light. It emerges from the darkness in pulses that alternate between dim and bright. It is a genuine "light of life."

Project: A good way to draw luminosity is to catch some fireflies and to keep them in a bottle for a while. Turn them loose after a half hour or so, as their life is short. If you cannot find any fireflies, there are small tropical fish (Tetras for one) that can be purchased for drawing. Work with charcoal and a kneaded eraser in your drawing and try to draw the luminosity out of a darkened surface, using your eraser.

ATMOSPHERIC LUMINOSITY

There are different kinds of atmospheric luminosity. The largest luminous effect in the atmosphere is the aurora borealis in the Northern Hemisphere and the aurora australis in the Southern Hemisphere. These phenomena occur when the magnetic field of the earth is disturbed and they often occur simultaneously. These lights appear in several different forms—principally in an arc, but also with streamers and curved serpentine bands.

Saint Elmo's fire is a blue glow that appears on the masts and rigging of ships at sea and on almost any object on land under the right conditions. This glow is also associated with atmospheric electricity and it occurs mostly during the wintertime—before, during, and after snowstorms.

At certain times of the year in the northern latitudes, there is luminosity in dark rooms—pinpoints of light and light patterns that are similar to those seen when the eyes are shut. I have seen this only in Norway and it is a phenomenon that the Norwegian painter Edvard Munch noted in several of his paintings.

Project: For anyone situated far enough to the north or south, a study in black and white of the auroras would be a marvelous experience. Use charcoal as a medium to make your sketches. Darken the paper with charcoal to a middle tone and use a kneaded eraser to define the lights and darks.

LIGHTNING

The quality of lightning is not luminosity, but is a quick, brilliant discharge of great energies. The energy builds up in the storm cloud and is quickly discharged when the electrical current streaks to earth and alternates for a fraction of a second between the earth and the storm cloud. The illumination is in the form of a quivering flash of light so brilliant that it can stun the faculty of eye adjustment (Fig. 280).

Project: Because lightning is instantaneous, a photograph would give the best fixed view for drawing. Use charcoal to tone the sketch paper and try to create a flash quality with very sharp light and dark contrasts. Draw out the luminous quality of the lightning with your kneaded eraser, but keep the contrasts sharp between light and dark.

MEASURABLE CHARACTERISTICS OF LIGHT AND SHADOW

We have talked about the kind of light that exists in nature and in the experience of most people. With the possible exception of the auroras and Saint Elmo's fire these different kinds of light are experienced constantly. At the same time light is an *invisible* medium that enables us to see *other things* rather than drawing attention to itself. Unless we actually make an effort to isolate light and consider its qualities by themselves, we tend to concentrate on the objects that the light illuminates. The art student (and the artist) must learn to look at light by itself just as the scientist does; he must isolate it in order to understand its properties.

BRILLIANCE

The first approach to understanding light in drawing is to identify the kind of light that illuminates the subject you wish to draw. Then look at the light and the tones around the light and ask yourself this question: How broad is the area of light and how dark are the tones that surround the light? You will find that most lights are safe enough to look at for a moment or two except the light from the carbon arc (searchlight) and the light from electrical welding, a sun lamp, or a laser.

It is the contrast of light and dark that enables you to give the effect of light and darkness in a drawing. Fig. 281 shows how varying degrees of brilliance are achieved with the contrast of the white of the paper and various tones from gray to black.

You will understand brilliance if you compare the light from a 100-watt electric bulb with different backgrounds. In a darkened room the light from the bulb is brilliant, but shrouded in darkness as in Fig. 282C. If the light bulb is held against a background of reflected light on a light surface the contrast will be less as in Figs. 282B and 282C. Finally, if you take the light out in the noontime sun and look at it against the background of the sky you will find that the atmospheric illumination from the sun will further lessen the contrast of light and background as in Fig. 282D.

Whether the light you draw is from a candle, a light bulb, or the sun, the white paper is the basic light source of drawing. But however limiting this might seem, the effect of light can be greatly enhanced by drawing the images of light sources. Fig. 283 shows how form can heighten the illusion of light.

Once the form of light and contrast is accepted by the viewer, variation in tonality can be used to express dim illumination and illumination from farther sources.

INTENSITY OF LIGHT

Intensity of light is the result of the amount of energy that is released by the light source. Though the heat of a light—or lack of it—cannot be shown directly in a drawing, the reaction of forms to heat and light can be shown (Fig. 284).

Another factor to keep in mind is that different substances have different melting and burning points so that what might affect one thing will not affect another.

On the other hand, different types of reaction can be mixed to show an *incongruous* or *irrational* situation (Fig. 285).

SOLID

70% LINE SCREEN

40% LINE SCREEN

10% LINE SCREEN

281. These light to dark combinations—using the same forms—create wide variations in effect.

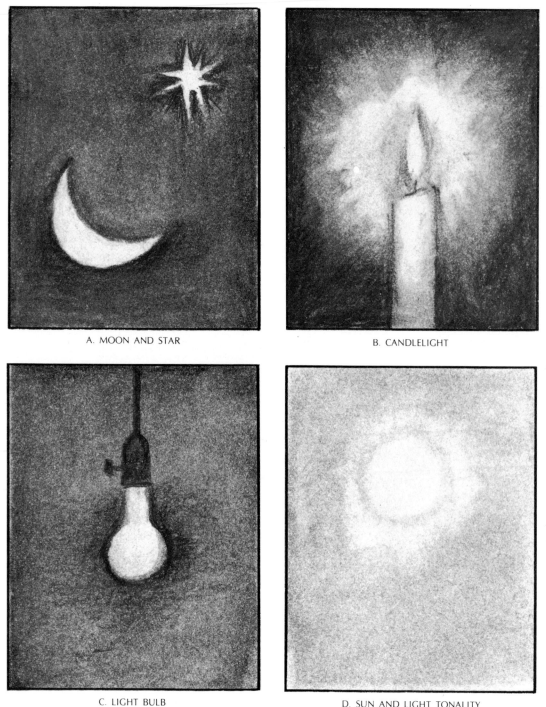

A. MOON AND STAR

B. CANDLELIGHT

C. LIGHT BULB

D. SUN AND LIGHT TONALITY

282. A crescent and a radiation suggest the moon and a star. Candlelight is suggested by a column, a flame shape, and a radiation halo. A light bulb glows by light and dark contrast. The sun shines through a haze of light tonality.

A. LIGHT FROM BEHIND VIEWER AND TO RIGHT

B. LIGHT FROM PICTURE DEPTH

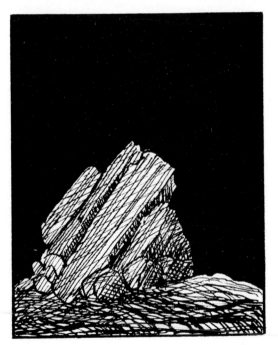

C. SILHOUETTE AGAINST BLACK BACKGROUND

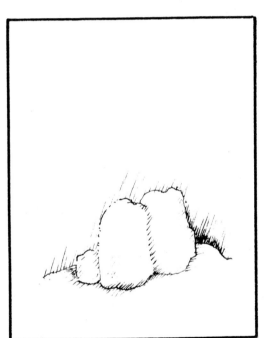

D. FORMS LIGHTED BRIGHTLY

283. These four illustrations represent different lighting situations: (A) the light comes from behind the viewer and to the right in a slightly illuminated atmosphere; (B) the light comes from the picture depth, silhouetting the trees and shrubs; (C) the light silhouettes the forms against the totally dark atmosphere; and (D) the forms are lighted by bright light from above in a light atmosphere.

284. Forms react to heat in different ways.

285. These are two examples of irrational imagery.

Project: For this project, you can draw in one composition several objects of varying light intensity in order to compare their different light qualities. Use a searchlight, a light shining from a window at night, a light from a match, and possibly a neon sign hanging in front of your local store as models. Draw these objects with charcoal on sketch paper.

DIRECTION OF LIGHT RAYS

Do you remember a line form that we called *radiating lines* which we discussed in Chapter 2? Light travels in straight rays that *radiate* in all directions from the source. This radiation allows light to be directed to an object or surface. The straightness of light rays is also responsible for the form-enhancing qualities of light.

You have noticed that the beams from a flashlight or from the projector in a moving picture theater move in a straight line and are sharply separated from the surrounding darkness. Light does not dissipate like smoke or like steam coming out of a pipe. Light travels straight, and when it meets a surface it illuminates that part which is in its path, and where it is not obstructed it continues onward. Fig. 286 shows how the straightness of light rays determines the shading of form. You can see from this why it is important for you to determine the source of the light in a drawing.

Determining the light source in your drawing is reasonably simple. But *only you* can decide the position of the light source and the light direction in *your* picture. You must make the decision as to the line of light in relation to your picture surface (Fig. 287A). You must further determine the direction of light in relation to the *depth* of your picture (Fig. 287B). The dark arrow in Fig. 287A indicates that the light comes from the left-hand side and is slanting toward the center of the picture. The dark arrow in Fig. 287B indicates that the light is coming from behind the picture plane and is slanting toward the viewer.

The major point to remember is that *any* picture that uses the elements of natural light *must show the source of light!* This is the first thing you decide upon when you use light in a drawing. This decision determines the modeling of all forms. But if you make the mistake of copying the light in nature as it appears to you, you will be led astray because the light in nature changes from moment to moment, and copying a changing light sequence leads to irrational light patterns that destroy form, time, season, and mood. Of course, if you copy changing light with the intention of studying such destruction, it is another matter; learning how to change or destroy form can be part of learning how to build it.

Also determine the size and proximity of your light source. Is it the sun, the moon, a candle, or an electric light? If your light source is the sun and you are outdoors, things will be illuminated from a very definite direction. But if you are indoors, the light will come from the direction of the windows, the interior lights, and reflections from the walls. (The light may even have some of the secondary qualities that are suggested by the sun's rays such as time of day, weather, and season.) Candlelight or firelight is self-explanatory if the light source is in the picture; the rays will radiate outward in all directions. Artificial light sources are also simple because they are generally in fixed positions and their light is unvarying.

Determine the brilliance of the light sources as this will guide you in balancing the amount of white paper you leave in illuminated areas with the amount of dark you put in the shadows. In direct sunlight there is much light, few halftones, and very strong dark accents. On a gray day there are few bright highlights, many middletones, and very softened, dark accents. In candlelight there is a small circle of soft illumination that is quickly submerged in darkness.

Project: Make a study with charcoal and paper of each lighting situation we have discussed. Study the difference in the brillance of light on a sunny day and on a gray day. In candlelight, draw out the soft illumination.

REFLECTED LIGHT

Reflected light is light that bounces off surfaces that have been illuminated by the direct rays of natural or artificial light as shown in de Chirico's painting (Fig. 288). Reflected light is deflected at angles that depend on the direction of the main source and the angle of the surface. The light behaves like a cue ball does in a bank shot in the game of pool. The ground, walls, floors—almost any surface—reflect light. In bright sunlight, there is light reflected in all directions. In candlelight, there is hardly any reflection at all. Reflected light is most obvious when objects are seen in the darkness of a large cast shadow; the objects outside the shadow are illuminated in bright tones whereas those in the shadow are illuminated in different and lower-keyed tonal relationships through reflection. And, of course, objects in bright, direct illumination show reflected light on their undersides, *away* from the light source.

Reflected light is very tricky to use in drawing, and artists prefer to use a single direct light source or the filtered light of a gray day such as that Cézanne loved so well. These lights clarify form, whereas broken light will confuse and destroy pictorial form. If lighting becomes too complicated with crossed light rays and crossed shadows, it cuts up the picture form and makes it less readable and clear. I believe that the fractured picture surfaces of Cubism, as in Picasso's painting, owe something to the development of artificial light and its confusion of light patterns (Fig. 289). So it is necessary for you to control the amount of reflected light in your picture and to eliminate any aspects of the existing light that conflict with the form of your picture. On the other hand, if you want to create a broken surface or indistinct form, using many light sources and cast shadows will do it for you.

Project: Set up two lamps with 200-watt bulbs from two different directions for cross illumination, then set up a still life and draw the light on the forms. Use charcoal, paper, and a kneaded eraser for your drawing.

Look for the cast shadows and the broken forms of the object you are lighting.

CAST SHADOWS

Cast shadows can be something of a problem to the artist. When the light source is very bright, the shadows cast by forms that are in the path of the light are very dark. When these cast shadows fall across other forms they often completely obscure the form's qualities and create areas of dark on surfaces that look like holes when you draw them.

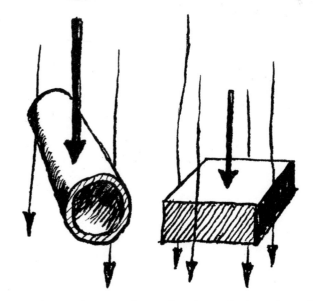

286. Light rays illuminate objects when they strike the surfaces of objects.

FRONTAL PLANE

DEPTH OF PICTURE

287. The artist must establish the line and angle of the light source on the frontal plane and in the depth of the picture.

288. *The Nostalgia of the Infinite* (Left), Giorgio de Chirico, oil on canvas, 53 1/4" x 25 1/2". Museum of Modern Art. This painting achieves a brilliance of light by contrasting the large area of the tower in light to areas in shade and in the long cast shadows. It also shows horizon illuminations.

289. *Ma Jolie* (Right), Pablo Picasso, oil on canvas, 39 3/8" x 25 3/4". Museum of Modern Art. Cubism developed after the advent of the electric light. Many light sources will break form and the surface of the picture plane.

290. Cast shadows, if they are not softened in tone, generally obscure form.

The cast shadow creates an effect just like a splotch of ink that is dropped on a subtly modeled drawing done in delicate halftones. For this reason artists generally eliminate, or soften, cast shadows by toning them down, so that the form beneath can be read.

There are instances when cast shadows are very useful in adding form to the picture (Fig. 290). This is often true when the shadows of trees, figures, or buildings fall on the ground plane parallel to the picture surface. In this case, they add contrast to verticals and provide parallel steps into space (Fig. 291).

To gain an understanding of cast shadows is simple since shadows always follow the contour of the object that is outlined by the light rays. Thus, the cast shadow is always a perfect silhouette when it is cast on a plane that is perpendicular to the light rays. The size of the shadow will vary according to the distance of the object from the surface the shadow is projected on and the distance of the object from the light source.

If the surface on which the shadow is cast is not at right angles to the light rays the shadow will be either elongated or contracted (Fig. 292).

A cast shadow—having width and length—is subject to perspective in a picture just like a three-dimensional form. The only time that a cast shadow retains the same shape as the object is when it is projected on a wall that is parallel to the viewer and behind the object. But if the shadow falls on the ground plane it will contract or grow in width or length, depending upon the position of the sun overhead in relation to the object and to the angle of the earth's surface. If the light comes from behind the object in the depth of the picture the shadow will expand toward the viewer and the front plane of the picture. Drawing shadows correctly depends upon the deciding on a definite light source and light direction.

Project: Set a simple shape like a ball or a bottle on a tabletop and use a movable light to cast shadows from different directions. Make observations, noting the angular relationships of light, object, and table surface. When you have made your observations draw the same positions using the light. Finally, make drawings of all of the cast shadow relationships from memory. Use charcoal and sketch paper.

LIGHT EFFECTS ON OBJECTS WITH PLANE SIDES

You see now that light can be very geometrical. Light-illuminating forms that consist of sharp planes will double the sense of sharp geometry since different planes have different tonal values. You can see this effect in cubes, extended hexagons, pentagons, and any free forms composed of planes. The plane that is perpendicular to the light rays will be the closest in tone to white, and as the angle of each plane turns farther away from the direct rays of light, its tonal darkness increases. The plane farthest away from the light will more closely approach the black end of the tonal scale if there is no reflective surface under it. Fig. 293 shows several lighting effects on planes.

Project: There is a marvelous way to study the effect of

291. (Right) Cast shadows, when handled properly, can enhance form and space, giving them direction and depth.

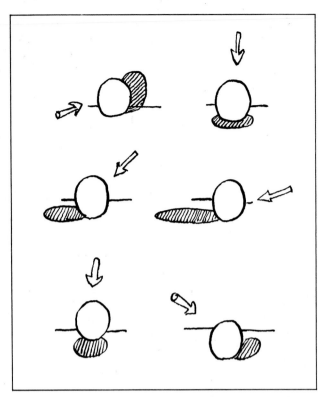

292. The direction of the light source determines the length, shape, and position of the shadow on the picture surface.

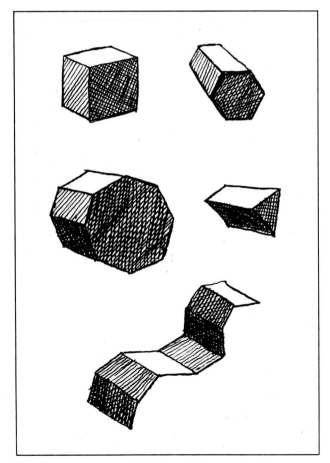

293. Light rays on geometric forms made up of plane surfaces show uniform tonalities on each plane, the planes close to the light being lighter and those away being darker.

light on plane forms. Simply fold paper into various shapes and place these under a light source in different positions to observe the light changes from plane to plane. Then draw them, using charcoal, kneaded eraser, paper, and fixative.

I suggest you begin by making simple shapes: an angle with two planes, then an angle with three, drawing these with different light variations. Then make more complicated forms. You can vary the light further by bouncing it off a wall so that it lights the forms indirectly.

LIGHT EFFECTS ON CURVED SURFACES

Probably one of the biggest stumbling blocks for beginners in the use of light and dark is in achieving the effects of light gradations on curved surfaces. It is not that the solution to the problem is complex, but it is that the student just loves to blur his dark lines with his thumb to achieve tones rather than to think them out. He slurs his tonal values so that they are lost and have no definition at all. Though it is true that these chance effects are sometimes charming in a portion of the picture, they are never enough to sustain the needs of light in the whole drawing. A smearing thumb is no substitute for the sensitive perception of tonal gradations!

Once you understand the pitfalls, you are ready to learn the few simple devices that artists use to solve the shading of curved surfaces. Afterwards comes practice in observation and drawing that enable you to cope with changing light situations.

A curved surface is a continually changing surface so there is never an actual break in the tonality of its lighting. But due to the straightness of light rays, curved surfaces almost always *appear* to be divided into areas of tonality. This enables the artist to simplify the areas of tone into tonal bands. Fortunately, artists have found that these tonal areas on curved surfaces can be reduced to three to six tones of light to dark. But there is no hard-and-fast rule as to the ex*act* number of tones an artist can use because lights vary and tastes vary. The exact number of tones is a decision that you will have to make for yourself.

At first you will think that there are more tones than five or six, but you must remember that your task is to simplify so that you can keep control of the light in your drawing. Always simplify. It may help you if you understand that the eye examines forms with a quick back and forth scanning movement which tends to eliminate small differences and accentuate larger contrasts. So, though an area of form may have many minute tonal differences, the eye will accept a simplified version without a backward glance. Leonardo da Vinci found that only five tones were necessary for his drawing needs (Fig. 294) and since *he* is regarded as the great master of tonal drawing, *we* can safely assume that it is possible to get along with that number. But if you have doubts, by all means try as many as you think *you* can handle.

Project: There are four simple forms that make excellent

294. *Head of the Virgin* (Right), Leonardo da Vinci, black and red chalk on paper, 8″ x 6 1/8″. The Metropolitan Museum of Art. This drawing show the same knowledge of tonal bands as can be seen in Leonardo's *Study of Hands* on p. 206.

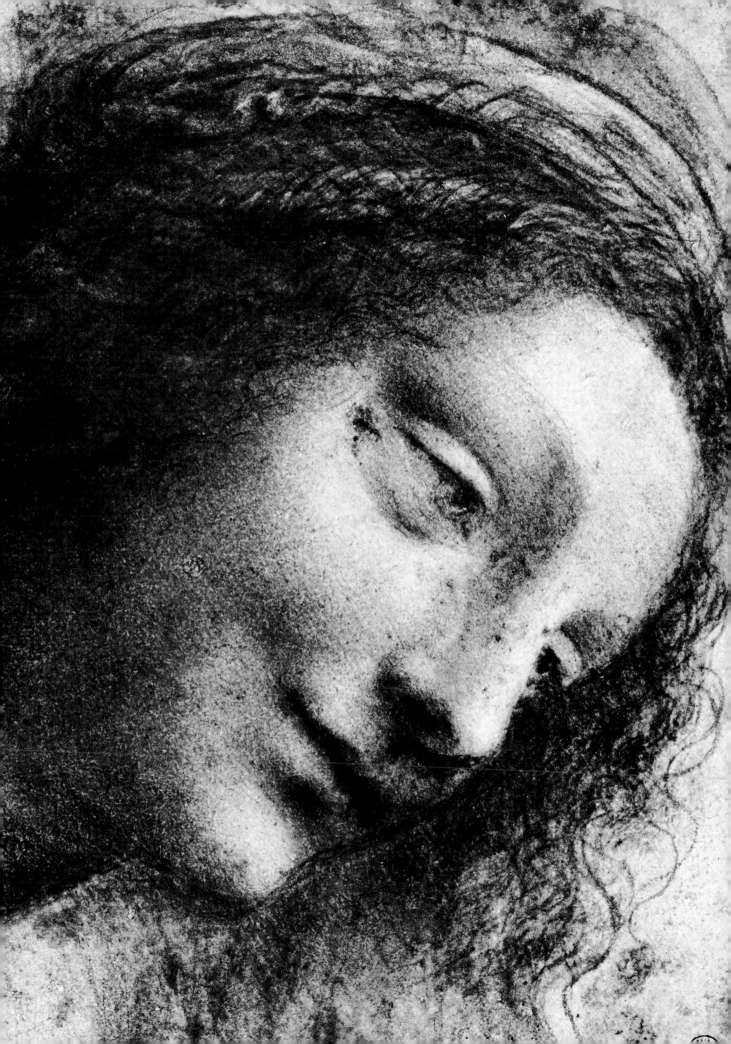

subjects for tonal study. These are the *globe suspended in space,* the *cylinder,* the *egg,* and the *rippled surface.* Draw all of these shapes under different lighting conditions—direct and reflected light. Use charcoal, kneaded eraser, fixative, and paper.

In these drawings, determine *your position* in relation to the *object* and the *light.* Between the light, your eye, and the object there is a triangular relationship that can be a wide or narrow angle, depending upon the position of these three elements. You must notice the shape of this angle and how this angle is changed by perspective when it is transferred to the picture surface. In other words, there is as much a perspective with light as there is with solid forms.

The reproduction of Leonardo's *Globe in Space* (Fig. 295) demonstrates the importance of your understanding the triangular relationship between the eye, the light, and the object. Suspend a *ball* by a string and try to duplicate the tonal effects of this drawing.

The methods for drawing the tones of the *cylinder* (Fig. 296) are similar to those used for the globe. The difference is that this form is an extension of the globe form. It has the same tonal qualities except the tones are extended in long strips. For your drawing, you can easily make a cylinder from a piece of paper.

An egg, placed upon a tablecloth, is a fine form to draw (Fig. 297). Not only does it show the effects of light beautifully, but its form can be related to most of the shapes in the organic world. In this study, cast shadow and reflected light work together and mutually influence each other. On the globe suspended in space the tones form a progression from light to dark; there is no reflected light, but on the egg resting on the table surface that is lighted from above there is an interrupted progression as the reflected light from the table surface illuminates the underside of the egg. This adds contrast to the cast shadow's darkness. Fig. 295 shows this lighting situation analyzed in six tonal areas. This can be reduced to five tones, if the reflected light is given the same value as Tone 2.

So, using a single artificial light source with a 100-watt bulb, draw the egg lighted from as many different positions as you can arrange: from in front, from behind, from the ends, and from the positions above.

When you have completed the first set of drawings, do a second series using a 40-watt bulb from the same distance above the egg as in the previous series. When these drawings are completed, do a series using a 200-watt bulb. Your object is to master the ways that tonal areas change under different light conditions—the brilliance and position of light. When you understand these two aspects of lighting, you should be able to apply the same reasoning to the lighting of almost any curved surface.

Rippled surfaces under most conditions of lighting show a pulsing gradation between light and dark that continues as a repeated sequence (Fig. 298). The tonal sequence moves from the light at the top of the curve into darker tones, which again move toward light tones at the bottom of the trough; these in turn move into dark tones on the

296. The tonality of the cylinder is closely related to that of the egg.

297. This drawing shows the tonal bands on an egg form under a single light source.

LIGHTED FROM ABOVE

LIGHTED FROM AN ANGLE

295. *Study of Shadows on the Globe in Space,* Leonardo da Vinci. Bibliotheque Nationale de Paris.

298. These sketches show tonal bands on a rippled surface.

299. The folds of drapery in this diagram are formed from two suspension points. (From *Modelling and Sculpture*)

next side which blend into the light of the top of the next curve. This sequence varies somewhat when the light source is low and the rays are at right angles to the direction of the ripples. This light source puts that part of the ripples away from the light into the shadow so that the back part of each ripple is dark but possibly slightly illuminated by reflected light. The rippled surface that is lighted from above can be drawn in three tones while the one just mentioned requires five or six.

For your own drawing, make a rippled surface by using a damp piece of cotton sheeting material, placing pencils underneath the material and arranging the troughs by pressing the material down between the pencils. You can make large ripples by using dowels with large diameters. In drawing the setup, use different lighting positions.

The rippled surface is the basic form of all draped material. Once you have drawn the above, you can apply what you have learned to the drawing of drapery. The key to drawing drapery is understanding the suspension points. These are the places where the drapery is fastened, or tacked to the wall, or any place from which it hangs in an accidental way. The looped connections at the bottom of two suspended folds are also important. Fig. 299 shows both suspension points and the looped folds. Set up a draped cloth in the manner shown in the figure and draw it under various lights.

Water ripples are a simple repetition of a single pattern of tones in each trough and rise. The difference is that the ripples are broken on the surface by patterns of smaller depressions and rises which show reflections from direct sources or reflections from indirect sources. Draw the largest aspect of the water movement first, which is the trough and rise. Then show the smaller aspects of the form. It will help you to understand these forms if you can observe their reflections on the underside of a flat surface that overhangs the water like a pier or bridge.

COMPOSITIONAL USES OF BLACK AND WHITE

Everything that the eye sees is a *reproduction* in the brain of the impulses of light and darkness. So in drawing objects in black and white, remember that you are not just drawing objects and you are not using just the black marks of your pen or pencil on the white paper, but you are also using the light impulses in the atmosphere and the light and dark impulses in the viewer's brain. These invisible mediums of luminosity are a part of each drawing. If an artist is unaware of this, his drawings will be dull, heavy, and lifeless. It is his ability to illuminate the atmosphere by his drawing, and to stimulate the inner light and darkness in the viewer that marks the artist as a master.

SILHOUETTES

The simplest use of dark and light contrast in drawing is the silhouette. It can be either a dark form on a light ground or a light form on a dark ground. The use of these two opposites creates a simple day or night composition in which there is a visual shift or oscillation between two elements—the form and the space around it. This shifting back and forth between the two poles of the contrast gives a sense of time and mood to the drawing. In Fig. 300A the

A. SILHOUETTE

B. FRONTAL LIGHT

C. SILHOUETTE WITH WHITE LINE

D. FRONTAL LIGHT WITH BLACK LINE

E. SILHOUETTE IN TONE

F. FRONTAL LIGHT IN TONE

300. These six illustrations represent the possible combinations of lighting a single figure.

A. LINE DRAWING

B. TONAL DRAWING

301. These two drawings show the difference in dark lines in a line drawing and dark lines in a tonal drawing.

light comes from behind the figure. In Fig. 300B the subject is lighted from the front.

The silhouette form can be extended by drawing features with line and also using line to indicate shape and direction within the form. Fig. 300C shows the use of white line on the dark silhouette form. Fig. 300D shows the use of dark line on the white form. These extensions create a shift amond *three* contrasting elements: background, form, and features.

The addition of modeled tones gives the impression of light *within* the drawing which solidifies the form. and makes the space of the picture come alive and the number of optical shifts and oscillations almost limitless. Figs. 300E and 300F demonstrate how the essential qualities of the original silhouette forms of Figs. 300A and 300B are extended by the use of line based on understanding of form and the understanding of the tonal illumination of form.

Project: I want you to make some studies that duplicate Fig. 300. Ask a friend or a member of your family to be a model and do a separate drawing for each figure using charcoal, kneaded eraser, paper, and fixative.

For silhouettes akin to Figs. 300A and 300B, merely outline the form, using backlighting for the first and a light from over your shoulder for the second. For Figs. 300C and 300D, keep the light from over your left shoulder. For Fig. 300E, use a light behind but a little toward the front of your subject. For Fig. 300F, use a light over the subject's head and a little to his front. When you need white line, you can draw this with your kneaded eraser. For the tonal effects in the backgrounds of Figs. 300E and 300F you will have to improvise and experiment, using the knowledge that a *dark area in the background* will accentuate a *light* area on the form, and that a *light area in the background* will solidify a *dark* area on the form.

LIGHT AND DARK LINES

In Chapter 2, we spoke of the dark, heavy lines that appear where forms rest on the earth or where forms are pressed together. These lines suggest not only weight but they also suggest the light from an overhead source when they are contrasted to thinner and lighter lines. An ordinary drawing with no line variation merely defines form, but does not create atmosphere, weight, or mood. But drawings with accenting and contrasting lines can extend the meaning of a line drawing so that it suggests light, light direction, weight, and atmosphere as Fig. 301A demonstrates. The heaviest lines are used for the "down planes," lines away from the light, holes, and indentations, and the places where two forms are pressing together. This use of line can also be extended to tonal drawing as in Fig. 301B.

Project: Make some drawings of simple still lifes, using this method to suggest the effects of light. It will work best if you use all white objects on a white cloth since this will keep your mind on line alone. When you have completed the first study, try a still life with all black objects on a black cloth to see how white lines function.

ENGRAVERS' LINES

When engraving had developed to a high peak in the Renaissance, artists found that the same methods of obtaining form and light could be applied to drawing. The

engravers (and etchers) modeled and shaded form by using a series of lines that followed the internal shapes of the form *and* the light patterns. The simplest expression of this use of line is shown in Fig. 302A which demonstrates how these lines are used to solidify the form. Fig. 302B shows how these lines can serve the double purpose of solidifying and tonally lighting the form. Fig. 302C shows—through an example we are all familiar with—how these lines can show form, tonality, light, and atmosphere.

Project: I want you to draw three forms; a ball, an apple, and a human arm. Use pencil and paper to draw them. Make three drawings of each, using lines in the manner of the figure described. In the darker tones of the engraving in Fig. 302C, you will notice that there is a crosshatching, a controlled use of lines inside and outside the form that gives the sense of shadow and light. You control the tone of these shadows by the thickness of the hatching lines and the distance between them. This applies both to a series of parallel lines and to two series of lines that cross one another.

REVERSES AND SHIFTS OF LIGHT AND DARKNESS

Ordinarily you think of drawing as the black outline used for the delineation of form, and thinking in this manner leads you to the conclusion that you cannot delineate form in the shadowy parts of the picture. But this is not true at all. The engravers and etchers of the Renaissance found a way to go beyond this limitation.

The Renaissance artists realized that the *white paper* could be used to make lines in the darkness of shadows. This was a revolutionary discovery for drawing because it multiplied the effectiveness of the blackness of ink and the whiteness of paper. It extended the scope of the artist so that he could draw in darkness. A portion of a Rembrandt etching shows the use of white line on a dark ground (Fig. 303). A Bewick wood engraving demonstrates that an entire scene can be given a sense of atmosphere, light, shadow, time of day, and weather through the use of line reversal (Fig. 304).

Project: Line reversal is not altogether a duplication of visual elements found in nature, but it is more an invented technique of artists. In order to study it, look at the work of artists who were most skilled in its use. I recommend that you copy some of these artists' works, using pen and ink to duplicate the works line for line. You can begin by copying the works here. You can also take the books out of the library that are recommended in the Bibliography on Rembrandt and Bewick, and copy a few of their works.

PLANES AND GRADATIONS OF ATMOSPHERIC LIGHT AND DARK

You can use pencil, ink, or charcoal to produce light and dark tones in your drawings. The quality of the tones in these mediums may be somewhat different, but they are all based on the gradations from white to black. So, as different as they might be, use the same logic with all of them in drawing. Your skill in handling the gradations of these mediums will grow as you practice modeling the light and dark tones of the objects in your drawings. There is another aspect of tonality in a picture of which you must also be aware.

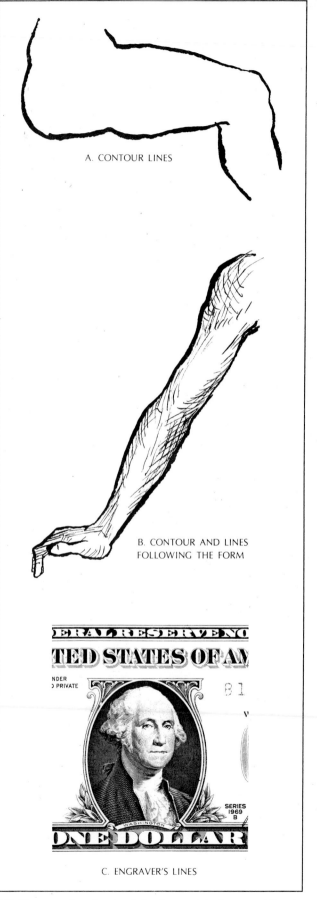

A. CONTOUR LINES

B. CONTOUR AND LINES FOLLOWING THE FORM

C. ENGRAVER'S LINES

302. There are three levels of development in the use of line in drawing.

303. *Christ Crucified Between the Two Thieves* (*The Three Crosses*). (Above) Rembrandt van Rijn, etching, 15-3/16″ x 17-15/16″. The Metropolitan Museum of Art. This etching shows a variety of tonal areas in a single picture.

304. (Right) This Thomas Bewick engraving is reproduced actual size. With an incredible economy of lines, the artist has drawn a variety of light, atmosphere, weather, time, movement, etc., in the composition. (From *Eighteen Hundred Woodcuts by Thomas Bewick and His School*)

Drawing in light and shadow is not merely a matter of shading the tones of objects but it is also a matter of controlling the tonal quality of the *entire picture*. To begin doing this, you must think in a new way about your picture. Start by deciding at the beginning of your drawing what the tonal range of the whole picture will be in relation to the tonal scale from white to black. A tonal range may take in the entire scale, but more frequently it will use one or two segments of the scale while eliminating the others.

The simplest example of this is a picture that used the tones in the first quarter of the scale which were reinforced then with a few black accents and a few white highlights (Fig. 305A). A more complex conception is one that uses two or three segments of the scale (Fig. 305B).

It is virtually impossible to make one picture that suggests all of the tones of the scale because the eye tends to add up all of the tones of a picture and makes a single tonal evaluation. In Fig. 305C, though all of the tones were used, the eye tends to see only one or two over-all tonal values.

It requires considerably more thought to make a drawing using the concept of over-all tonality than it does to make a simple line drawing. On the other hand, there are several *different* degrees of complexity in tonal drawings. Just as you begin to learn line drawing by making simple shapes and avoiding complex compositions and perspectives, in learning to draw atmospheric tonality you must use a simple approach. Simplify the study of over-all tonality by confining your first drawings to only one or two planes of picture depth (as in a simple still life). The reason for this will become clear.

Project: This project shows you ways of controlling the compositional tonality of the entire picture surface. For material, use charcoal, kneaded eraser, paper, and fixative.

Set up a simple still life that is clearly lighted by artificial light. Your object is to repeat this same composition, using different tonal variations. Begin each drawing in line and then select a tonal range from the white-to-black scale. I suggest that you do five versions: divide the gradation scale into quarters and do a separate composition for each segment. Use both black and white sparingly for accents and highlights, but wait until your drawing is near completion before using either. For the final drawing, select two segments of the tonal scale such as 1 and 3, 2 and 4, or 1 and 4. Divide the composition down the center, using one tonal range for each side of the picture.

Set up another still life that is lighted by natural light. Use a place where the light changes during the day. When you have arranged your still life, do drawings, using light from early morning, midmorning, noon, afternoon, and dusk. For each composition, decide the whole range of light and tone. Put the tonality in broadly, trying to duplicate the quality of the time of day.

You might also do a drawing of this still life on a cloudy day, and one in the shade to work with diffused light and indirect tonality. If you can work any further on this concept, do a drawing of the same setup by candlelight.

LIGHT AND DARKNESS IN PLANES OF SPACE

As you proceeded through the projects in this book, adding what you learned in each new section to what you learned previously, you found that each new project is merely an

A. LIGHT TONAL SCALE

B. SEPARATE TONAL RANGE IN EACH PANEL

C. WIDE TONAL SCALE

305. These are three uses of different tonal ranges.

A. STAGE WITH ROWS OF LIGHT AT EACH PLANE OF DEPTH

B. THE ARTIST'S PLANE IN SPACE

C. DIRECTION OF LIGHT IN DEPTH

D. LIGHT DIRECTION SHOWN FROM LEFT OR RIGHT

306. The lighting concepts used in a painting or drawing are similar to those used in stage lighting.

extension of things that you have already seen and have stored away in your unconscious mind, and that learning to draw involves making these things conscious. Now you are going to adjust and rearrange what you have learned about light and darkness so that you can work with planes in space.

In order to draw light and darkness in depth, you have to use line, shape, mass, pattern, overlapping planes, scale, converging lines, light source, brilliance, tonality of objects, and atmospheric tonal gradation. Seeing it spelled out like this may make the problem seem very imposing and profound; it is, but you can cope with the problem because of the experience you have gained from working on the previous projects.

You actually solved this problem when you drew the different light and dark patterns in the last project. Before, you did the *same* subject under *different* lighting. Now you can compose the light patterns of several planes with *one* picture. The best way you can control the light in a drawing with multiple planes of depth is to use the same lighting concept that is used in a theater. Above the working area of the theater stage are placed rows of light that correspond to a progression of imaginary planes that go from the front of the stage to the back (Fig. 306A). The same concept can apply to lighting the planes in space in your picture(Fig. 306B). The only difference is that, for each plane in your picture, you must be consistent with your major light source in all cases where there is a central light (Fig. 306C).

In daylight landscapes, the brightness of the sky determines the over-all degree of light in the picture and—as the planes progress into space—the tones of objects and the ground gradually approach the light tone of the atmosphere. This is called *aerial perspective*. You control the change of tone in aerial perspective by deciding upon a distinct tonality for each plane in your picture space. The tone of the final plane will be barely darker than the tone of the atmosphere (Fig. 307). There are other sequences for different kinds of light, as you will see in a moment, but in all cases the dark and light contrasts are most intense in the foreground.

When the light comes from a low source in front of the first plane in space as in Fig. 308A, the deeper planes are lost in the darkness of the sky at the horizon. The planes become more light and the objects more defined as they approach the foreground plane.

In the cases where the light source is beyond the horizon—in the deepest planes in space—the light will silhouette the ground plane in the deepest areas of the picture and the reflected light of the sky will gradually illuminate objects in planes approaching the viewer These objects will be dark on the side of the viewer but will show a light contour line (Fig. 308B).

In daylight or moonlight where there is a sky of broken clouds, the light breaks through the open spaces putting light into the planes in space where the openings occur. In a case where the light comes through in the middle planes, the tones of the foreground are deepened but clearly defined, and the tones in the middleground are light, while the tones in the background are darkened within their tonal range and also defined within the limits of that range (Fig. 308C). Broken lighting also occurs under artificial light, but the same rules apply as with natural lighting: the sharpest contrasts are always in the foreground.

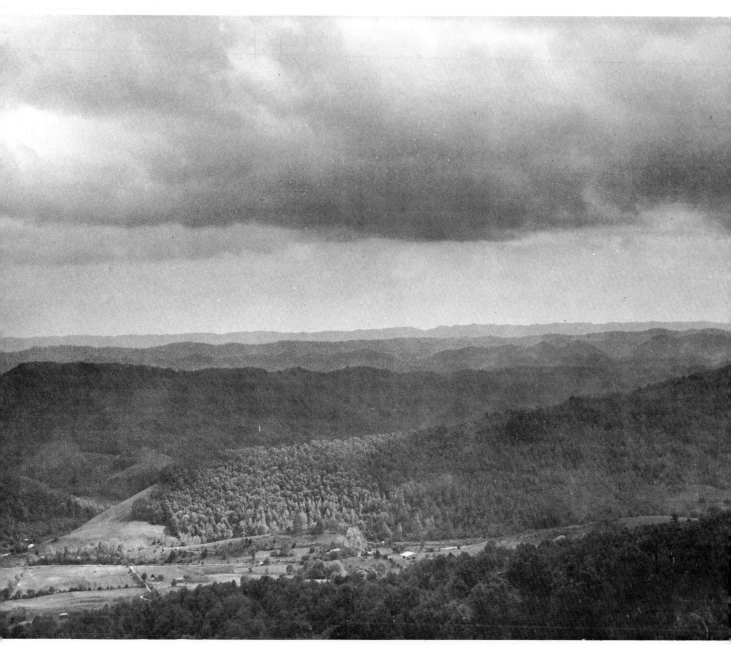

307. The tonal variations in planes of depth (aerial perspective) in natural midmorning light can be seen here. Note also the band of illumination on the thirty-mile-distant horizon.

A. LIGHTING FROM HORIZON BEHIND VIEWER

B. LIGHT COMING FROM HORIZON AT SUNSET OR DAWN

C. LIGHT IN MIDPLANE, FRONT AND REAR PLANES ARE DARK

308. The three drawings show lighting from different planes and the effects that are created.

The lighting of planes in space is the most dramatic element of picture-making. The greatest graphic artists were masters of the subtleties of light changes and of the expressiveness of dramatic light. Daumier, Goya, and Leonardo could literally draw with light and darkness (Figs. 309, 310, 311, and 312).

Beginners in art and poorly trained artists have a general tendency to model the forms of objects very heavily and completely neglect the light patterns in the planes of space. The result is an overmodeling and an overworked drawing that has no atmosphere. The reason is that the artist must make a jump in thinking that takes him past modeling individual objects into a realm where he sees light and darkness in a total way. Instead of focusing on objects, the artist must focus on the entire picture when working with light. There is a tremendous advantage in making this jump that affects your drawing skill.

Once you begin to think in terms of the total atmosphere of light and dark, it only requires a touch or two, or a few tones broadly blocked in, to delineate objects that you painfully drew in detail before. In other words, as your skills and understanding of the elements of drawing become more complex, you are able to simplify your drawings in a selective way that intensifies its expression. When your over-all light and dark patterns are right, a touch of dark accent or of highlight will make a form seem more alive than the most carefully drawn object. When the eye perceives an atmosphere of light and dark that has a convincing tonality it will accept any object within the atmosphere as belonging to that environment.

Project: I want you to make some tonal analyses of the graphic works of Rembrandt and Goya. I suggest that you pick five of the Rembrandt etchings and five of the Goya aquatints from the *Caprichos* series. If you do not have these works, they can be found in almost any library in books that reproduce them in full size.

Copying these works will not be difficult as it is simply a matter of duplicating the large tonal areas and eliminating the detail. I suggest that you make your copies the same size as the reproduction and square off the picture plane in units that will enable you to transfer the shape of each tonal plane to its proper position in the picture plane. Make the dividing lines very light, though! And as you copy, ask yourself *why* the artist used each tone and *how* the individual tones build the space of the picture. Use charcoal, kneaded eraser, paper, and fixative.

You can continue your experiments in lighting planes in space by constructing a miniature stage out of a cardboard carton. A good size is 18″ wide, 12″ high, and 24″ deep, but any size with similar proportions will do. Mark off the floor in a checkerboard of squares. Cut the flaps off so the top is completely open and cut the stage opening out at one end. The opening should be 14″ wide and 10″ high or similar to this in a larger carton. You can use earth, stones, wooden blocks, and twigs for your scenery. Use cut-out figures, lead soldiers, or figures of your own design for your com-

309. *Pobrecitas!* (*Poor Little Things!*) (Right), Francisco Goya, etching and aquatint. The Metropolitan Museum of Art. Goya shows light coming from the horizon behind the figures and also light from the front, leaving the two male figures in a plane of shadow and partially silhouetted in a center plane.

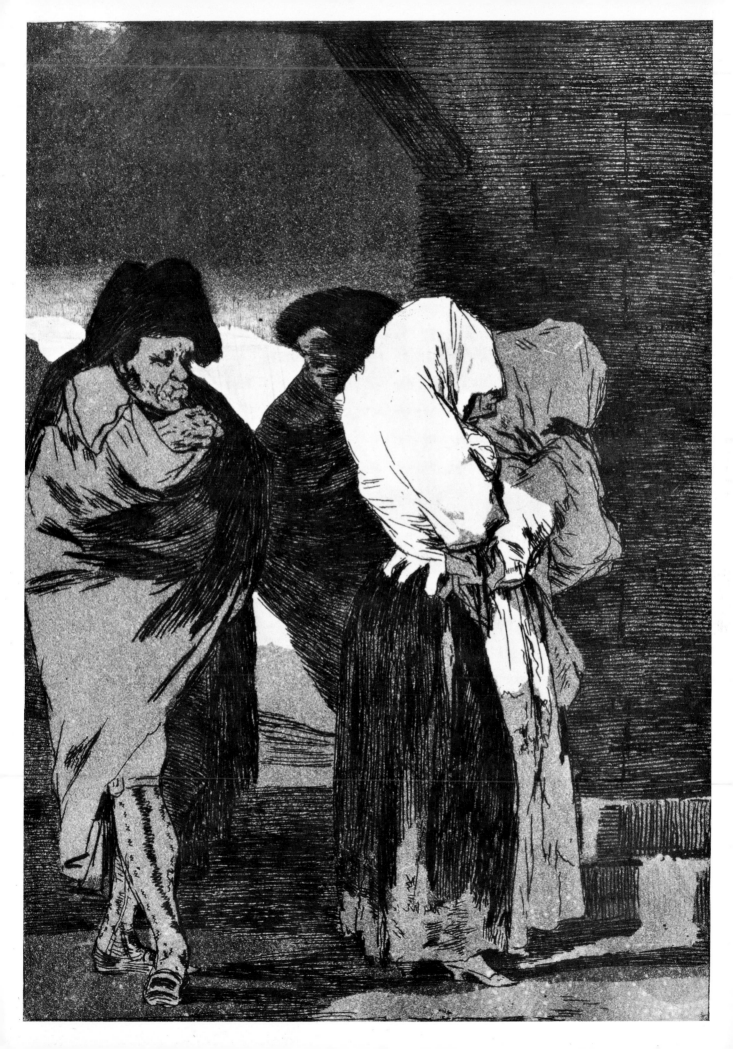

311. *Don Quixote and Sancho Panza* (Above), Honoré Daumier, charcoal washed with India ink, 7 3/8" x 12 1/8". The Metropolitan Museum of Art, Rogers Fund. Daumier juxtaposes Don Quixote and Sancho Panza in two heavily contrasting light tones. The old knight's figure dominates because of the darker accents.

310. *A Clown* (Left), Honoré Daumier, charcoal and watercolor, 14 3/8" x 10". The Metropolitan Museum of Art, Rogers Fund. In this drawing, Daumier defines the front and side planes of the central figure in sharp contrast as though the figure were in a theatrical spotlight.

position. When your set is built the way you want it, light it by placing a sheet of illustration board over the top with holes cut out for the rows of lights. By covering some holes and leaving others open, you can light this miniature theater with an overhead light that is shielded from the audience (you).

By playing with this little theater of light, you can design different effects to draw. Start by making your scenery plan in depths that go according to the number of planes in space your lighting system has. Then simply play with different lighting effects. When you achieve an effect that you like, make a drawing of it to find out why the effect is interesting. See if you can duplicate natural effects of light like dawn or afternoon, etc. The virtue of this method of learning light is that *you* control the entire scene. The next step, of course, is to work with nature which you *cannot* control.

Because nature's light is constantly changing, you will find that you have to decide on your "lighting plan" at the beginning of your drawing and *stick to it*. Light is the most fleeting aspect of nature; it is subtle and difficult to draw. But it is the quality of light in a drawing that moves us most deeply, that illuminates and softens the expressions, giving them a sense of time, mood, and life.

312. *Head of a Man,* Leonardo da Vinci. The Metropolitan Museum of Art, Rogers Fund. Leonardo was such a master of light in his drawings that they seem to radiate a light of their own, as this small study does.

7. The Color Expressions of Nature

There are a number of scientific explanations for color, but none of them can account for *all* of the color phenomena of nature. And the truth is that a scientific explanation is more or less useless to the artist because the artist has a working emotional relationship with the color expressions of nature. To explain color to the artist in terms of waves of energy or corpuscles is much like explaining to a young man in love that his beloved is a collection of cells and chemicals, or to a young mother that her beautiful infant's smile is just gas. Infants do smile, love defies explanation, and color can be explained to the artist only in the visual language of art.

On the other hand, there are some aspects of scientific theories that are interesting to think about, like the explanation given by Isaac Newton three hundred years ago that white light contains all colors and that black is merely absence of light. The poet Goethe, who was also a scientist and originated morphology, the science of forms, believed that color emerged from both light and darkness and that the basic colors were blue and yellow. Newton's theory seems to work best for the scientists and Goethe's seems closer to the artist's way of thinking.

It is not necessary to explain air in order to breathe, water in order to drink, or the origin of the planets in order to walk on the earth; all these things are part of the functioning of life before thought begins. The artist's discovery of color is not an explanation, but is the artist's interaction with the colors of his palette and the colors that constantly emerge and change in nature. What is necessary to the artist is that he sees and sensitively responds to the colors of nature. There is very little theory that can help the growth of sensitivity; only openness, practice, and persistence can develop vision.

When color is taught solely from the standpoint of theory, the student is asked to work with the color wheel (see Color Chart 1) that shows the six pure colors or hues composed of the three primary colors and the three secondary colors, and the intermediate mixtures of them placed in a continuous relationship. Students are taught to mix each color with white to obtain a series of *tints* in gradation that range from the pure color to white. They are taught to form the *shades* by mixing gradation from the pure color to black. And finally they are taught to mix colors opposite each other—the *complementaries*—to obtain gray tonalities. All of this is very useful because it helps you to understand your colors and what they do when they are mixed in different ways. This method of teaching color can also be boring to the student because it bears no direct relationship to the phenomenon of color in nature.

The basic color pigments that the artist uses in oils or watercolors are manmade products that are derived from inert mineral substances which are products of *one* area of nature's realms. The color in the other realms of nature, on the other hand, emerges from energy phenomena that are complex and vast, existing on many levels. So you can see that if the artist depends too heavily on the color theories that stem from mixing manmade mineral pigments, he will be closed to color events that happen on a far grander scale. The proper approach is to harmonize the technical use of palette color with a knowledge of color in nature.

Color in nature is not just a surface expression but is often related to the inner processes of things. So you would be mistaken to think of things only in terms of their colored surfaces and to paint each object as though it were a barn. It is far better to learn how an apple becomes red, or how it ceases to be red, so that you can respond to the full meaning of its color rather than just one phase of it.

The ways in which we naturally perceive color have become obscured in our society. Color is used in our culture to attract attention to commercial products in ways that do not have any bearing on the products' real value or meaning. The manufacturers of products do not consider *all* of our inner needs when they use color, but they compete instead with one another for our attention. The result is that a kind of "color pollution" exists that taxes our ability to respond to the colors of nature. A soap box can be so garish that it can easily win attention from the subtle changing hues of a sunset.

As with all of our very important physical and natural resources, we tend to think that our personal color sensitivity is limitless and inexhaustible. This is not true. Our color sensitivity is an organic capacity, a product of our life process, which can be shocked, overworked, fatigued, and deadened just like any other physical capacity. And, as in other situations, where the fatigue process has set in, larger amounts of stimuli are required to obtain any effect at all. When whole cultures are subjected to such assaults on the senses, art forms can develop that are actually based upon a mass insensitivity.

I encourage you to be protective of your sensitive inner capacities to respond to color. Our study of color in nature will include the study of the color capacities within the artist, as it is upon this aspect of the human organism that the whole craft of painting in color is built.

OUR INNER SENSE OF COLOR

In Chapter 5, we learned that we do not see the *things* in our fields of vision but reflected images that are transmitted to us by light rays. And so the images of our vision are *reproductions* of the effects of form upon the light and the atmosphere. This is also true of the color that we see. We do not actually see the colors of the objects, but light rays stimulate *our inner color sense*. In other words, the colors of the exterior world are not projected into the

human head as a color movie is projected upon a blank screen, but the colors come to us as impulses that stimulate our inner world of light, darkness, and color.

When we dream, the images and scenes that we "see" are a creation of our inner color sense. Though there are a few people who confess to dreaming in black and white, the majority of the people have a colorful dream world. In addition to dreams, there are also the mental images that are created during consciousness—memories of places or people, and the day dreams that we all have which are also in color. We have the mental power to compose completely imaginary scenes and people in our dreams and fantasies, and all of these images are produced and directed from within by our own version of Technicolor.

I do not want to create a complicated theory about this inner color and the reasons that it arises; the important thing is that it exists and is a part of our organic structure. Color is so much a part of our inner sensibility that *all* of the color we see is inner biological color, whether induced by dreams or inner visions or by the light rays from the external world.

AFTER-IMAGE COLOR PROGRESSION

After-image color is an interesting aspect of our inner color sense that demonstrates that color is biologically produced within us, and is different from the mechanical interpretations of the color wheel. We know that when we stare at a spot of color another color is produced as an after-effect. When we stare at a *blue* spot intently for about fifty seconds and then transfer our gaze to a blank page we see a *yellow* after-image. The blue creates the *yellow* within us. We might assume with this that the reverse is true and that we would see a blue spot after staring intently at yellow, but this is *not* the case at all. After staring at yellow, we see violet and my discovery is that this phenomenon continues so that each color suggests another in *progression* until finally all of the spectral colors have been induced. Violet will stimulate us to see an after-image of green, green will stimulate us to see red, red will produce a blue-green, blue-green will produce orange, and orange finally produces a lighter blue than the original to complete the circle (see Color Chart 2). This demonstrates that the inner color sense is not locked in the mechanical series of opposites (the complementaries), but is a moving series, a directional progression. In our inner color world one color suggests all colors; one color leads onward toward the others. This theory also coincides with Goethe's idea that all colors emerge from blue and yellow.

These after-image colors have a very close relationship to the colors seen through a prism or to the rainbow hues. They are atmospheric, but at the same time luminous and brilliant. The significance of this is that our inner visions of the colors of the mineral world, paint pigments, and the world of solid matter are always painted in the same colors as those of the atmosphere and the cosmic energy of the galaxies.

Project: Try to obtain some color sample cards from your art supply store. These are color charts put out by the artist's pigment manufacturers. You can cut these up and place the individual colors on pieces of white paper to produce the after-images. Your object is to begin with a deep pure blue placed in the center of a piece of white paper; using a bright light to illuminate it, stare at it for fifty seconds. Remove the color sample and substitute the blank white page. When you have seen the after-image color, pick from your sample colors the one that most closely resembles the yellow after-image you have seen and repeat the process, picking out the color sample closest to the next after-image color.

When you have finished and have returned from all of the colors back to blue, go through them again and try to duplicate the after-image colors with watercolor washes. You will find that you have to use a very light wash to duplicate these colors.

When you have completed the above experiment, try to obtain the after-image colors for the other colors on your color charts—the earth colors and the off-beat hues. You will find that all colors, tints, and shades produce colored after-images except those closest to black or white. Black and the shades closest to black produce white after-images and white and the tints closest to white produce black after-images.

PERSONAL COLOR SENSE

Each person's reaction to color differs according to sex and period of life. Each person has what might be called his own color-harmonic scale; these are colors that reflect the individual's character and moods. A person may be aware of these colors or they may be a subconscious part of his personality. The more attuned to color the individual is, the more consciously will he use these colors to enhance his person and his environment, or in the case of a painter, his pictures. Since these color choices emerge from the subconscious, the individual may select and arrange perfectly beautiful combinations by pure unconscious instinct if he is sensitive to color.

On the other hand, people who do not use color frequently or who have suffered from big doses of "color fatigue" can be the prey of the color seduction of the manufacturers who use strong and stimulating colors to attract buyers. The result can be a home or a wardrobe that clashes in color and design and does not enhance the qualities of the individual. In an atmosphere of color pollution and vulgar overuse of color, this happens frequently. In an art world based on competition for quick attention rather than quiet long-term meditation, this has resulted in works of little significance.

Project: A very good way to closely examine your personal sense of color is to lie down in a quiet, darkened room, close your eyes, and observe the color images that unfold before your inner vision. Some people see these inner colors more readily than others. Also sometimes the colors may be dark and muted and other times they may be clear and bright. But by making these observations over a period of time, you will find your own color personality. I suggest that you try to reproduce these inner colors with your watercolors.

When you have done the work suggested above, you can extend the exploration of your inner color by visualizing places that you like, times of day, favorite memories, and favorite people. Re-create all of these in your mind's eye and for each memory try to recall and record the predominant colors.

As this kind of personal color is a characteristic of all

great artists, I suggest that you pick three of your favorite painters and select five paintings of each to study their personal color range. If you copy the painters' pictures without attempting much detail, you should be able to abstract the basic color personality of the artist. Generally, you will find that each artist uses several colors in specific combinations in almost every picture.

It is not important if you find, in doing these exercises, that you have a limited sense of color or a very broad one. Color is a growing and changing phenomenon in nature and it is through your continuing experience with nature's color that your own color sense will develop. Whether or not your scale is bright or muted, narrow or large, does not matter so much as finding the color range that is truly your own.

LOGIC OF PAINTS AND PIGMENTS

Now that we have taken a broad look at the territory of color, it is time to clearly define the descriptive terms used for the manufactured artist's pigments and for the ways pigments are mixed by the artist (see Color Chart 3). Colors are also called *hues,* as I have said before. Yellow, orange, red, violet, blue, and green are the basic pure *spectral colors.* Because blue, yellow, and red can be mixed as pigments to form green, orange, and purple, the first three colors are called *primaries* and the others are called *secondaries.* The further mixture of neighboring hues results in colors like blue-green or red-orange, etc., and these are called *intermediate hues.* The terms are very useful in describing the mixtures of paint color, but they do not have very much meaning in relation to nature's color.

All of the colors blend into their neighbors and create colors like blue-green, red-orange, yellow-orange, etc. So between any two of the neighboring six spectral colors there can be a very broad series of *neighboring gradations,* just as each color when mixed with black has its *shaded gradation*, and each color mixed with white has its *tinted gradation.*

A complicating factor in the labeling of manufactured pigments is that there are several kinds of names used to describe pigment colors. Aside from the actual names of the pure colors, there are three other kinds of names given to them. One type of name describes the chemical substance of the pigment such as *chrome* yellow, *cadmium* red, *zinc* white, etc. Other colors are named for the person who formulated them, such as *Hooker's* green or *Payne's* gray. Finally, there are many inaccurate names used by color manufacturers for the purpose of adding chic to the product image, but such names are utterly useless for the purpose of color identification.

For the purpose of purity in manufacture and the correct technical use of paint, the exact hue and chemical name is always best as the chemical reaction of paints and mediums affects the permanency of the picture and color quality. I strongly recommend that you study the basic texts on pigments, mediums, and grounds.

A final problem with manufactured pigments has to do with pigments that are not pure spectrum colors, earth colors—like the umbers, siennas, ochres, and iron oxide reds—are all colors that can be mixed from combinations of the six pure colors with black or white. Because these pigments are very durable and their painting properties are fine, they are very useful to the artist. In addition, they make things easier by saving the artist the time and annoyance of mixing colors that are very frequently found in nature. But you should keep in mind the position of these colors in the hierarchy of color as tints and shades because some of them are very strong and opaque and can easily begin to dominate a painter's palette. It is important for a painter to have full command of his colors rather than have the colors dominate him.

The colors in nature are not labeled and they have no relation to words. They are generally a part of a whole color cycle of changing events. The greenness of a leaf is a temporary state that can start with a greenish white, a yellow, an orange, or even a red that deepens into a yellow-green and then deeper greens and then again into a possible yellow, red, orange, or brown during its lifetime— depending on the kind of tree. This color change is frequent in nature, so it is important to think of color as a thing of changing and mixing states. Painting is a dynamic act where, on the one hand, you are aware of the color progressions of nature and, on the other, you mix similar tones from your own palette colors.

The logic of paint mixture on the palette and the color mixtures and changes in nature bear some relationship to each other. Nature *does* produce pure colors like the paint from the tube at times, and it also produces mixtures of neighboring colors, tints with white or near white, and shades of black.

BLENDS AND GRADATIONS CAUSED BY LIGHT AND SHADOW

An interesting aspect of the movement of colors around the color wheel is that each color has a dark neighbor on one side and a light neighbor on the other. Something like this occurs in nature; when there is a pure color the dark neighbor will appear in the shadowed part and the light neighbor will appear in the areas around the brightest highlight. For example, if an object is a deep green, there may be a blueness in its shadows and a yellowness in its lighted areas. With a red, its shadow may have a purple cast and its light an orange quality.

This kind of neighboring gradation occurs in medium and filtered lights. The "gray days" of Cézanne provide this light and can be most colorful if the gray is not of the stormy, leaden quality.

Yellow is an exception to this because it behaves differently. Yellow is very closely related to white, and it has a very difficult relationship with darkness. In its highlights, yellow shows white, not orange, since both of the colors that neighbor yellow are darker than yellow. But in the shadows of yellow, the blue and green side occur in indirect light while the orange and red side will occur in the shadows of bright light.

Project: The best way to study these neighboring gradations is with colored cloths that are draped in scattered folds and colored paper that is folded to make angles or rolled to make tubes. Whichever you use, be sure to use pure colors. Use both direct sunlight and shaded north light. Do watercolor studies of all of the color variations.

In addition to the above exercise, it is good practice to make graded blendings of a color and its neighbors, but don't forget that yellow does not go by the same rules as the other colors.

TINTING AND SHADING COLORS

Color in nature is also affected by strong contrasts of light and dark. In strongly lighted situations, the colors are modified by white in light areas and with a few very dark accents. These lighted areas correspond to the tinted gradations. The dark shadows in strong light tend to be shades of the base color and black, with very little suggestion of the neighboring darker color.

In deep shadow the color emerges from the shadow's blackness (or darkness). The light area in shadow will correspond more to the basic color and its neighboring light color on the color wheel.

Project: Using your same series of cloths and colored papers from the last project, arrange them in very bright light so that you can make studies of the transition of the color into its tinted light plane. Very bright sunlight is best to work with and, when it illuminates curved surfaces, you will find that the tints appear in the bands of gradation that you are familiar with from your work with the egg. Try to duplicate the bands of tone with washes of different density.

Using the same cloths and papers in a very dark room, you can make studies of the colors as shades emerging from darkness. Again the colors will appear as bands of gradation. Try to control your light by covering it so that you can make studies of several stages of illumination.

As an exercise in mixing pigment, make a graded chart for each of the pure colors in which the pure color is in the center with its tint going off to the right and its shade going off to the left. In doing this, you will begin to see that color is a sort of mid-point between pure light and pure darkness.

COMPLEMENTARY COLOR VS. AFTER-IMAGE COLOR PROGRESSION

The colors of the color wheel that are directly opposite one another are called complementary colors, and much is made of them in the color theories that do not derive from a study of nature and the after-image colors. These complementary colors *do* have a contrasting effect and *can* enhance one another. But since their relationship is only derived from being geometrically opposite one another in a *manmade* arrangement of manufactured colors, they do not have the charged, vibratory effect that the after-image color progressions have on their optical partners. The concept of complementaries is a static one because the color relationship is said to go back and forth between the two colors like an eternal ping-pong game. This does not correspond to the way that colors occur in nature, since nature is never fixed but is always dynamically moving.

This is not to say that complementary colors should not be used or that they do not make useful combinations at times, but their static relationship should not be confused with the after-image optical progression colors (see Color Chart 4). These colors enhance one another in a very powerful way, but only as a progression. Hence, a spot of yellow on a blue field will vibrate intensely because yellow is the after-image color of blue—in a sense blue gives birth to yellow. But a spot of blue does not have the same vibrant quality on a yellow field because yellow strives toward creating magenta as its after-image. Further, a spot

of yellow on a magenta field is again not as colorful as is green—the child of magenta. And so on with green needing a spot of red, red a spot of blue-green, and blue-green a spot of orange.

Only in one case do the after-image colors come close to the complementary or geometrical relationship, and this is in the green to red part of the series. From these observations you can see that the concept of complementary colors has no basis in nature.

Project: I want you to test out the difference between complementary relationships and the after-image progressions. In both cases, the size of the basic color field is the dominating factor. Start with a page of the basic color (8 1/2″ x 11″). Put on this, one at a time, either the complementary color or the after-image color in the shape of a small circle 1-1/2″ in diameter. You can even make a permanent series going through all of the six pure colors and their complementaries. But in making the after-image progression series, you will find that you are making *seven* color pages instead of six, because the after-image series includes all of the pure colors and one *intermediate* color (blue-green). This may indicate that there is some similarity between the color series and the musical scale in which there are seven notes, one of which is a half-note.

You will find additional food for thought in making arrangements on the base color using larger-size circles or squares. Different sizes will have different effects. As the proportional size between any two complementary or after-image color combinations becomes more equal, the two colors will begin to compete with each other for dominance. In this, the colors' quality of lightness or darkness becomes a factor in the balance between the two.

Since your work with color is a very personal matter—one that interacts with your inner senses—there are limitations to theory. Far more happens in the color expressions of nature than we can ever imagine, and it is best to let nature lead rather than to try to make nature conform to theories or formulas that can, at best, be only an approximation of what occurs in reality.

OPACITY AND TRANSPARENCY

When you applied paint to paper or canvas you probably noted that there is quite a difference between a thin wash of color and a solid coat of pigment. When paint is applied as a wash in watercolor or as a glaze in oil painting, some of the underlying surface white of the paper or canvas will shine through and make the color luminous. Watercolors are intended to be used this way although you can use them to create opaque color as in the gouache technique. You can use oil paint opaquely or in glazes of transparent color.

Some colors have greater transparency than others, some are very opaque; alizarin crimson is a very transparent color while Venetian red is a very opaque one. As there are colors in nature that have different light or dark qualities—and different luminosities and densities—your ability to use paint in various ways is very important. This will be more clearly explained later.

TWO OPPOSING GROUPS OF COLOR

The six pure colors are sometimes separated into two groupings that are sometimes referred to as *hot* and *cold*

and at other times as *emerging* and *receding*. There *is* a consistency in these divisions in that the colors on the purple-blue-green side are often regarded as cold, receding, and related to darkness; while the colors on the red-orange-yellow side are generally regarded as warm, emerging, and light. But there are contradictions in the warm and cold—emerging and receding concepts because under certain conditions, red will recede and blue will emerge. As to the hot and cold idea, high-temperature flames are often blue as are some high-temperature energy discharges. The best that can be said of these two concepts is that *sometimes* the two groups of color will react in these ways. When they are used in these ways in conjunction with recognizable forms where they show these characteristics, their expressiveness is reinforced by the memories of the viewer.

As organisms, we have some very basic responses to colors. We are attracted visually *toward* the blue range and we are drawn into it. This probably has its roots in our being creatures of air and water and these are the colors associated with these elements of nature. On the other hand, the colors of the yellow-to-red range are the colors of light and fire radiations, which move toward us as emissions of heat and light. And so our reactions to these two color groupings are on the one side calm attraction and on the other side excited response, such as are our feelings toward water and fire, sky and sun.

Project: I would like you to compose some arrangements of color in the blue range and some in the yellow-to-red range. Use simple shapes such as circles and squares of different sizes. Place them in solid backgrounds of colors in both color ranges. Use colored paper or paint the arrangement.

The object is to see what your own mental associations are with arrangements of the two color groupings. Find the kinds of colors that draw you inward and those that seem to radiate toward you, those that are exciting, those that are calm. Though these reactions to color vary from person to person, your own conclusions are important because they will help you to react to the colors of nature in a personal way.

INTERACTION BETWEEN COLORS

All colors are affected by their neighboring colors, by the base color on which they appear, or by the dominating colors of the environment. Several things can happen in combinations of colors. Neighboring colors that are darkly shaded with black are seen more as gradations of darkness rather than color. In other words, their color effect is *neutralized*. This also occurs when colors are tinted very close to white. Dark shades of colors and light tints are seen more in terms of black and white.

Another way color is canceled out is by the dominance of another color. A sea of green submerges a spot of red unless the red is of a size that is large enough to assert its strength.

There is a certain point at which the size relationship of color areas will interact and the colors will enhance one another. This reaction depends upon the area of color, the purity, degree of shade or tint, whether the colors contrast, neighbor, or are an after-image progression. The area of effectiveness varies with these factors. Pure colors have a vibratory relationship with one another, but a pure color with a tint will overpower the tint unless the area of the tint is expanded greatly. A similar thing happens with the shades, but a shade competes with more strength than a tint because the shade is less diluted.

Project: Experiment with colors by negating or neutralizing the color vibrations to create noncolorful compositions. You can do this by using the color samples and shapes that you used in the previous projects and adding to them whenever it is needed. Begin by trying to cancel out the brightest color you have.

MOMENTARY STATES OF COLOR

Color is seldom static or unvarying. One of its principal characteristics is that it can change under the slightest influence. Color is also very difficult to cancel out, as you have probably learned from the last project. Even objects that have been painted a single hue of opaque color, like a barn or an automobile, undergo color changes as the light varies from moment to moment during the day.

Blues, greens, and purples intensify in shadow and darkness. The colors of the yellow-to-red range intensify in light. Light and darkness are the effects of nature that are responsible for the most frequent and the most transitory color changes.

There are other factors that create color changes in things: heat and cold, the processes of growth, maturity, and decline in living things. Heat and cold over a period of time alter color and form in nonliving things, but they have an immediate effect on the color of living things. Emotional states in living creatures frequently create color differences on the skin surface which we will discuss more specifically later.

Project: Use your color samples or simple colored objects to test how colors are altered by light variations and degrees of darkness. First make observations and then paint a single-colored object under different circumstances.

PRISMATIC COLORS, CORONAS, AND THE RAINBOW

The purest examples of color in nature that are easily accessible to us are the prismatic colors. You can observe them by looking through a glass prism as shown in Fig. 313.

These colors are sometimes created by accidental placement of panes of glass and glass bottles. The prism clearly separates the blue-purple grouping from the yellow-red range (green is only made when the two ranges merge). These colors relate very closely to the after-image colors, and they are so bright that they make pigment colors almost dull in comparison. They are colors of pure light.

The rainbow is the prime example of prismatic color in nature, but there are other examples of the spectrum colors. The child sees them in soap bubbles and in "street rainbows." The latter are caused by drops of oil or gasoline that fall on the rain-wet pavement. Their color sequence runs in the following order: a neutral white, yellow merging into an orange, a red, a beautiful magenta, a metallic blue, and finally a vivid green. The green and the magenta have a very interesting iridescence. In connection with this, it is interesting to note that when a shiny piece of steel or brass is heated, a whole series of colors emerges on the surface

Color Chart 1. The conventional color wheel implies that there are no color relationships except geometrical ones. In nature, color occurs in different and sometimes surprising sequences.

Color Chart 2. The after-image color progression is an organic series of color relationships in which one color (the color swatches to the extreme right) "gives birth" to all the others.

Color Chart 3. These three lines of color show the three major ways that color is mixed in painting to duplicate the colors of nature.

Color Chart 4. These squares show the base color, and the circles show the after-image color each square induces.

This Ring Nebula in Lyra shows the same color sequence as the "street rainbow" we see, which is created on sidewalk from water and oil, and the color we see in heated steel. (Courtesy of the Hale Observatories, California Institute of Technology and Carnegie Institution of Washington)

The Great Nebula in Orion contains a highly charged quality. It is a pure energy form that also appears in clouds and in water movement. (Courtesy of the Hale Observatories, California Institute of Technology and Carnegie Institution of Washington)

This rainbow spectrum was photographed near Knossos, Crete.

This thin band of illumination flashed on the horizon near Avila, Spain.

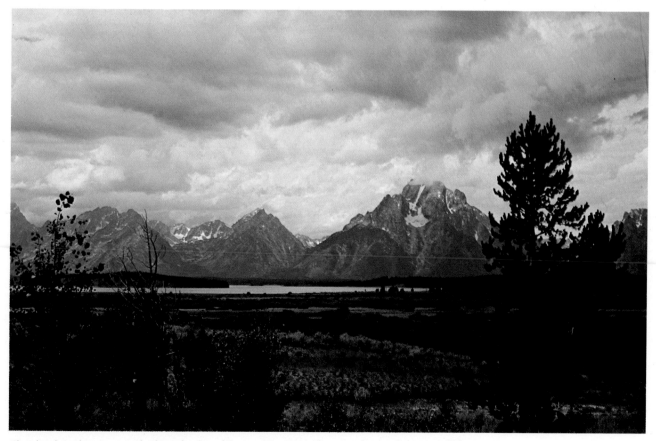

The clouds in this view overlooking the Grand Tetons, Wyoming, show a color combination of blue and black. (Photo by Albert Boothby, Sr.)

The colors in the spectrum of this sunset over the Baltic Sea near Finland have an intensity of depth as though a fullness of color had developed during the day.

These softer sunset hues over Sanibel Island, Florida, harmonize with the deep black-green silhouette of the trees.

(Left) This view of the colors at dawn near Ayia Galini, Crete, has a softness and freshness.

(Above) This view of the Mediterranean Sea near the southern coast of Crete shows the clearest blue and green sea tones.

Here the shallow, underlying sand color mixes with the reflected blue to create green.

(Above) In the colors of this ancient olive grove in Greece, the soil color emerges to harmonize with the color of the grass and trees, creating a base of color.

Flowers show the entire color spectrum in every conceivable variation, as we can see in this flower market in Copenhagen, Denmark.

Quite often, we overlook the color spectrum of things with which we are familiar. This vegetable market on New York City's Lower East Side shows an infinite array of colors.

from the point of heat outward and in the same order of color as the "street rainbow." Steel that is heated to high temperature radiates light from within which begins with a deep red, then orange, yellow, and finally white as the temperature increases.

In a heavy or dense fog, or when cloth or screening is held before light, a corona appears (a circular spectrum of colors). These colors always follow the same order of appearance as those just described.

Project: I would like you to duplicate the prismatic colors, using a watercolor wash. You can do this from direct observation. If you do not have a prism, you can buy one or borrow one from your local high school or college physics department. They can also be purchased from The Cenco Scientific Co., 1700 Irving Park Road, Chicago, Ill. The item is No. 85505-I and its price is about $2.50. You might find a local supplier also.

The colors of a "street rainbow" can be created easily with a little water and a drop of gasoline on an asphalt pavement. Pay particular attention to the magenta and the green since they are very difficult to duplicate with watercolor.

In all of these projects try to create the individual colors in separate bands and then later create the blended sequences by working into a wet surface on your paper.

COSMIC COLOR

The most predominant color in the universe is the blue of space. Its tonal range moves from the lightest blues of our illuminated atmosphere to the darkest tones of the outer reaches. Though blue predominates, it is not the only color of cosmic space. As a matter of fact, all of the colors can be found in the various phenomena of outer space. The most common is the yellowish white of starlight and moonlight, though some stars have a definite orange or red.

The most colorful cosmic phenomena are millions of miles in size. The great Horsehead Nebulae in Orion (see color, p. 282, bottom) is luminous violet. The Ring Nebula in Lyra (see color, p. 282, top) is a corona that has the same color sequence as the heated spot on steel and in the "street rainbow." We can see these cosmic colors through telescopes and through the color photographs taken with the aid of the telescopes. It should not surprise you to learn that color permeates the entire universe.

ATMOSPHERIC COLOR

The purest colors that can be seen with the naked eye are in the atmosphere (see color, p. 283, top left); the rainbow is atmospheric color of the purest sort, and next in purity are the colors of dawn and sunset.

The basic colors of our atmosphere are blue and the yellow-white of light. These colors are often expanded into all of the spectral colors when sunlight is filtered through the great magnetic field of the earth's atmosphere at dawn and sunset. Because the angle of the light rays is greater and travels through more of the atmosphere at dawn and dusk, the atmospheric structure acts like a prism and brings forth an entire range of colors. Before we examine dawn and sunset colors, let us consider the most predominant color—blue.

COLOR SPECTRUM

313. This diagram illustrates that the colors seen through a prism are about the purest colors in nature which are accessible to us.

There are many qualities of daylight blue. The blues of the daylight sky are a gradation of tints from blue to white. In daylight, the deepest blues exist in the areas overhead, but in the areas near the horizon the whiteness increases. When you look at the horizon, there often appears to be a band of illumination (see color, p. 283, top right). This light at the horizon is very intense, and often it can be seen as a band of pulsing light that expands every few seconds and then contracts. Perceptive painters since the Renaissance have painted this band of illumination in their works. It gives a vitality to the color gradations of atmospheric blue. Of course, the blue of the area near the sun again becomes tinted with white, and in the early morning hours or late afternoon the sky will be darker near the horizon opposite the sun.

There is also some variation in the blue of nighttime skies. Night can range from the deep blue-black of dark nights to the clear illuminated blue of moonlight that is tinted with a whitish yellow. The night blues are subtly varied and less obvious than the day blues. In pigment the night blue always requires an addition of black.

Daytime weather adds more variation to the sky with the color of cloud formations (see color, p. 283, bottom). In pure air, the whiteness of clouds and cloud shading is an extension of the white and blue of the sky. The cloud is part of the atmosphere, and so its color emerges from the atmospheric colors. During the main daylight hours, the lightest parts of clouds are pure white and the shadowy areas are a gray that derives from blue and black.

Air pollution is a serious factor in the alteration of cloud color and cloud form. Air pollution gives clouds a dirty yellow color that can approach light brown, and it tends to dissipate clouds and make them ragged at the edges. In addition, this condition affects all colors on the ground, deadening or devitalizing their intensity and vibration.

At dawn and sunset the spectral colors often appear. The colors of dawn are never as intense as the sunset colors except in the range of the yellows and oranges that are in and around the sun and hence reflected on the borders of clouds. Tints of blue are created in the dawn sky (see color, pp. 284-85) and suggestions of green in the sky beyond the brilliant yellow area bordering the sun. At dawn, one can often see pink reflected on clouds. The earth appears to have some red and purple at the horizon. The general effect of dawn is of light emerging into a fresh atmosphere; there is a springlike vivacity in the color.

The colors of sunset are decidedly different. Colors can be very intense with pure red suns, and the red-to-purple range quite deep along the horizon, while in the sky above the horizon there is a progression from yellow to white, green, blue, and violet. (Look at a true prismatic sequence in color, p. 285, bottom).

The parts of the clouds that are away from the light become a dark gray-blue, but the edges are lined with color reflected from the sun or the sky around it. Since the sun's rays shine upward from the horizon the *undersides* of the clouds are illuminated and colorful. Of course, not all sunsets are as spectacular as the one described; colors may be limited to a specific few. The emotional difference between dawn and sunset is striking. Sunset colors are a final autumnlike display of daylight and they may linger quite a while (see color, p. 285, bottom).

Project: It is impossible to describe all of the color combinations that occur in the atmosphere. The artist looks for pattern and the logic of the color progressions. We will examine this logic.

First, I want you to duplicate the daytime sky by painting it with watercolors from observation as though you were lying on your back looking straight up into the bowl of the sky. The gradation of blue will lighten as it progresses from the center of your page outward until you reach the outer circle of the horizon. Follow this up by painting a view of the sky from observation that includes the horizon line in the bottom fourth of the picture, but instead of blending the color, divide it into bands that darken as they move upward.

Next, I want you to do paintings of direct observations of the dawn and sunset colors. The reasoning is basically the same for both, though the direction of movement of light and quality of the color is different. The principal factor in both cases is that the light is most intense at the horizon. Proceeding from this is the horizon dividing two color areas, one of which—the earth—is dark and tends to form the darkest hues, while the other—the air—is the medium of light and contains the lighter color progressions. The ground plane and the objects on it—in both dawns and sunsets—are dark toward the viewer and silhouetted, showing little detail. The sun radiates its color outward in the atmosphere, but this color tends to form a band along the horizon line. The color in the sky above the horizon is formed in progressive bands in the radiation above the sun.

Work with the color gradations of the sky and the earth first before you attempt to paint the forms and colors of cloud formations. Once you understand these gradations, you can go on to the painting of clouds. Sunset or dawn clouds on the horizon are silhouetted, essentially flat shapes that display form through the contrast of diminishing size and by overlapping of their forms. These clouds are colored at their edges by the sun's color. The clouds closer to the zenith are lighted from beneath with the sun's color and are modeled as daytime clouds are with light and dark. The yellow, orange, or red light of the sun on the clouds tends to make the darks of the cloud more colorful and less grayish.

COLOR OF WATER AND LIQUIDS

It is difficult to say for sure whether water has any real color of its own because it is both transparent and reflective. It is, therefore, very susceptible to light, the bearer of color. Water is generally blue or green. But since it mirrors the sky which it faces directly, it absorbs and reflects the blue of the atmosphere. In instances where it is strongly green, there is always a light-colored sand at the shore and under the water which, mixed with blue, no doubt produces green (see color, p. 286, top). Skindivers say that after a depth of thirty or forty feet the color of water disappears and there is a predominant darkness. Recalling my own experience as a seaman, I know that when the sky is heavily overcast, the sea shows many gradations of a colorless neutral gray (see color, p. 284-85).

Water that contains sediment or algae adopts the color of the substance suspended in it. It is transparent or opaque, depending upon the amount of sediment it carries. Water can carry a huge amount of sediment material. Algae gives water a vegetable-green look; soils

can color water tan, yellow, red, and brown that range from light to almost black. Opaquely colored water has little interior light, but its surface is reflective and it mirrors the surrounding colors. But in mirroring these colors, its own color mixes with those it reflects.

Liquids other than water may be either transparent or opaque. These liquids range from biological products like blood (opaque), lymph (transparent), vegetable saps like milkweed (opaque), pine sap (transparent amber), to honey (transparent), to name a few. Of course, there are manmade fluids of various colors like wines, vegetable oils, and all sorts of chemical solutions. Transparent liquids act as light filters and change the colors that are seen through them into tones that harmonize with their own color just as colored glass does. These fluids also reflect and transmit their own colors when light shines on or through them.

Project: Though water reflects perfectly when it is smooth, a surface broken with ripples and waves changes the reflected parts considerably. Some parts will mirror the sky overhead, others the places near the horizon, others the sunlight, while still other parts will be in shadow. The effect is not a gradation, but a mosaic of several different tones.

All of these colors are added by the eye to produce a single deeper color than the sky or a gradation that is also darker. I would like you to work with four tints of blue to paint a water surface. Do not paint reflections, tricky highlights, or objects; simply try to paint the facets of water so that you get a feeling of the surface form and movement.

When you are able to create the quality of a rippled water surface with blue, try the same thing with a muddy color, a tan, or a deep brown. Theoretically, you can produce a waterlike surface with any color. If you are able to do this you should have no difficulty with reflections on water since they are merely a duplicate of the forms on the shore or floating on the water. The reflections are broken with rippled forms and this is the only difference.

You can further extend your skill by painting various sizes of waves and troughs.

EARTH COLORS

All pigments that the artist uses are made from substances taken from the earth. Some of these colors are very close to the pure spectrum while others resemble the different colors of soil and so are called earth colors. Earth colors are essentially shades, but there are those that have a tinted quality too.

When the different soils are dry, they range from light tans to the oranges and reds of the iron oxides to the browns and grays. Artist's pigments are mixed in a medium of oil, plastic, or water-soluble gum, all of which are transparent liquids that give the pigment a deeper quality—a "wet look." The colors of soils also deepen and darken in color when they are wet.

The basic color of earth creates an underlying tone in the landscape that interacts with the colors of the vegetation. The basic earth color is a uniting force for all of the plant colors (see color, p. 287, top). In some areas, the basic earth color is dominantly colorful such as the red iron oxide soils whose bright orange-red interacts strongly with the green of plants. Other soils provide a neutral underlying tone that separates and softens plant colors that might otherwise clash.

The earth color is most intense in the foreground areas of a landscape, the first two or three planes of depth. Beyond this point the colors begin to take on the reflected blue-gray of the atmosphere. Shadows add an additional color and, of course, the darkness of night turns all to blue-black. Where growth is very dense, the earth color may be completely covered over during all seasons by a green mat of grass in spring and summer and by a brown mat of leaves and dried grasses in winter.

Project: It is possible that the different soil colors can be assembled into a spectral series of shades. I would like you to go out and collect as many soil color samples as you can find. You can put them in glass jars. You may have to travel around a bit to get the whole spectrum, but it can be done. Let your samples dry out and put them in the spectrum series. When you have done this, duplicate each color with your watercolors, but use only your pure colors and black and white to tint or shade them.

When you have completed the above, take a part of each sample and dampen it slightly so that it darkens. Then duplicate this color change, using the same method as before.

The difficult colors to obtain are blues or greens, but these can be found in some of the clays. Though their color is very subtle, you can bring them out in the contrast with the red and brown soils.

ROCK AND MINERAL COLORS

The colors of rock formations are different from the colors of soil because their solid surfaces reflect more light and their composition is more unified than soil. You can assemble a fairly recognizable spectrum from rock. Marbles and granites are surprisingly colorful and there are neutral grays, blacks, and whites as well. Sandstone, limestone, and shale also have colorful qualities.

Minerals are absolutely vibrant with color and they provide the array of pigments available to the artist. But there are many unusual mineral colors that are not used for paint pigments for chemical reasons or because of their rarity, such as the yellow of sulphur, the blues and greens of malachite, azurite, etc.

The gem stones represent the purest and most beautiful colors in the mineral world. Their quality of transparency relates to the qualities of liquid as their light comes from within them as well as being reflected on their surfaces. Their color range encompasses all of the spectral colors as well as many color variations.

Project: I would like you to assemble a collection of rock color samples by making field trips in your own area. If you have a stoneworks in your locality, ask whether they can give you some scraps of kinds of stone which they have. When you have assembled a spectrum of rocks, try to duplicate them by using pure colors and the tints and shades.

As for minerals, they are a little more difficult to find and it may be easier to study them in your local natural history museum. One of the nicest collections I have ever seen is at the Smithsonian Institution in Washington, D.C. It is also possible to find samples or small collections in stores that

serve amateur lapidaries or rock collectors.

Few people can afford a spectrum of gem stones, but you can find examples of gems in the exhibitions of minerals in the museums of natural history. Gems are mineral crystals formed under heat and pressure. You can make studies from colored glass or colored liquids in clear glass bottles that will show effects similar to gems.

PLANT WORLD COLORS

The colors of the plant world which cover the earth and outside the cities account for most of the color we see. What do you think of when you see the color green? Ninety-nine times out of a hundred the answer to this question is grass or leaves.

In the temperate regions, the trees that are a neutral gray or brown during the winter come alive with color in springtime. And though it is customary to speak of the colorfulness of the autumn season, in springtime there is a muted display of color in deciduous forests. This display is of gentle and tender colors—light yellow-greens, the orange colors of buds, and even reds and purples in some of the new leaves. The blossoming of some trees adds white, pink, and violet tints.

For some reason we always think of budding leaves as being green, but new leaves can be tints of green that are almost white, tints of yellow, orange, or even bright red— all of which gradually become green. It is as important to recognize a plant's color sequence as it is to recognize the forms of its own growth pattern. The green of leaves intensifies and deepens as the heat of summer develops. This color continues until autumn.

With the first chill, the autumn colors emerge within the green of the leaves. Many leaves make a direct transition from green to yellow, orange, red, and purple. The sassafras turn yellow, the maples turn red with touches of yellow and orange, and the beeches turn a deep purple, while the oaks turn brown. Though I've named just a few, it is far more important for you to see than to name them.

The color quality of spring buds and blossoms tends toward the tints while the autumn colors are pure or shaded. With the coming of winter the tans, grays, and browns return and colorfulness disappears.

The colors of the evergreen trees of the colder climates become deeper and darker during the winter; at times their green is almost black. But in spring and summer when the new leaves begin to form, the darker green is tinged with a tender yellow-green.

The evergreen trees of the southern climates and the tropics show a range between yellow-green and the dark, full greens. There, the color changes are not so much affected by the seasons as by rainfall.

There are tropical tree and plant leaves that are multicolored. Within the basic green of the plant leaf there are yellow, orange, red, pink, purple, and even violet that suggests blue. Sometimes there are several colors within each leaf. In general these colors are pure or tinted and may appear in intricate pattern or they may spread in random flow across the leaf surface.

The colors of the plants of arid regions and deserts tend to follow the color qualities of the rocks and soil. Desert plant colors are always dusty tints and grays, and browns that blend with the soil. The exception to this is after the rains when there is a greening of everything. There are also some very brilliant desert flowers which come out in the springtime.

Project: Two excellent long-range color projects are the study of seasonal color change and the study of the color qualities of arid and tropical regions. For the seasonal study schedule yourself to work at specific times during the year when the colors come out. Both spring and autumn come about rather quickly and at different times in different regions so you must plan ahead to set aside a day or two to study these colors when they occur in your area. You can study summer or winter colors over much longer periods of time. As for your work with tropical and desert colors, these regions are much the same during the year. Set aside time during your vacation trips to make the necessary studies. I suggest in all cases to make color notes that duplicate only the color qualities at first. When you have made your abstract color notations you can then go on to paint the landscape if you wish.

FLOWERS, FRUITS, AND VEGETABLES

The most colorful expressions of the plant world are intertwined with the perpetuation of plant life. The bearers of plant color—their flowers, fruits, and vegetables—are the sexual organs of the plants. The plant uses color to attract attention to where its seeds and pollen are generated. There are additional inducements in the form of perfume, nectar, and edible substances.

In the order of colorfulness, the flowers lead all living things in number. The amount of colored blossoms is tremendous—200,000 known species of flowers and multiple variations within each family. There are hundreds of thousands of tints and shades of colors (see color, p. 287, bottom). The colors of flowers appear opaque for the most part, though there is often a certain amount of transparency of the petals. Some flowers appear pure in tone, while others are graded tints or graded mixtures of color. For the most part the colors radiate outward toward the periphery, yet in some flowers the color may be concentrated at the center. Radiation, though, seems to be the key factor.

Blossoms always precede the fruit, which means that there can be two colorful displays in some plants. The color qualities of many fruits are much like the glazes of the oil painter or the washes of the watercolorist in that there is a glossy transparent skin over a thin layer of pigment beneath which may be a white or transparent flesh. The apple, cherry, plum, and grape are examples of fruit that have transparent and translucent colors. The color range of fruit goes through the entire spectrum of pure colors with a predominance of the bright, noticeable colors—yellow, orange, and red. There can be more than one color at a time on a single fruit. For example, apples can have green, yellow, orange, pink, red, and purple all at one time.

Many of the vegetables with which we are familiar grow aboveground on bushes and vines that live only for a season. Others that we know are the underground root vegetables. The ones that grow aboveground emerge from blossoms and are similar to fruit. The colors of these vegetables range the whole spectrum with the exception of blue (see color, p. 288). The turnip and eggplant's purple

are the only one that approaches blue. There are brilliant transparent colors in such vegetables as tomatoes and peppers that range from yellow to deep reds. Other vegetables, like squashes, have brilliant opaque colors. The root vegetables are white (horseradish), blue-violet (turnip), orange (carrot), yellow (sweet potato), red (beet), etc. The root vegetable colors vary from the pure colors to tints.

Project: I would like you to assemble a spectrum of flower colors and also a series of variations on one single color. Do this with both wild and garden flowers and you can make these projects as complex as you wish. The main thing is to assemble all of the colors before you at one time. With your watercolors, reproduce each color singly and then try the combinations without drawing the flowers themselves. It will be good for you to work with the color gradations you find in a single flower. Once you have worked out the colors abstractly, try to paint a formal still life.

Next, assemble as many varieties of fruit as you can find with the object of creating a complete spectrum. Again, reproduce the color and the blending without trying to draw the shapes. Try to understand the quality of the color and see its purpose. Then when you have completed the abstract study put them all together and try a still life. When you have finished with the painting, you can examine the fruit closely, peel the skins, and look at the color under a magnifying glass to discover the color pigments.

Continue your color study, using vegetables in the same manner, doing the colors first without reference to the shapes. An interesting side experiment is to slice the vegetables very thinly so that you can study the way the light affects the color as it comes through the substance. You will also marvel at the intricate structures that are revealed in this way.

COLOR IN ANIMALS

The colors that occur within the different phyla or groupings of animals are incredibly varied in the quality, design, and function. In some creatures, color is used to attract, in others to camouflage, and still others use color with the creative gusto of a color painter painting for the sheer joy of it.

COLOR IN FISH

The colors of the fish family have an incredible range. When their colors are pure they have an iridescent or opalescent quality that is vibrant. Most fish are covered with a transparent secretion that heightens their color, and their scales give their colors additional reflected metallic highlights. According to ichthyologists, fish color is produced by pigment cells called chromatophores—the cells being black, yellow, red, and white. Combinations of these cells produce colors. However, this information is not sufficient to describe the astounding colors that fish create.

The fish that are not particularly colorful generally have a brownish or bluish camouflage pattern on their backs while their undersides have a silver metallic color that seems to be the most prevalent fish color.

Project: I do not suggest that you catch fish to form a spectrum series as there are far easier ways to study fish color. The best way to study them is in an aquarium, either the small kind you can have in your home or the great public ones. But even fish from the market—fresh or smoked—will make excellent material for you to study. It is the metallic, vibrant quality that you must learn to paint with your watercolors or oils.

COLOR IN INSECTS

Insects are intensely colorful in several ways as they produce opaque, transparent, and iridescent colors that range through the entire spectrum. In addition, there are insects that produce shades and others that produce tints. Since insects are closely united with the earth, they frequently adapt the earth's colors.

There are insects that are gloriously patterned with spots, others with stripes, still others that have adapted designs of flowers and plants. You should realize that these displays of color are expressions of the creative process in nature and that there is a definite link between the art in nature and the creative work of man. The chief difference is that the art of insects is built into their very structure; their art serves their life functions. A butterfly takes on the characteristics and patterns of the flowers it feeds on, and it uses these same patterns in turn to attract and stimulate the mating superimposition.

Again, the technical reproduction of these colors by the artist closely follows the nature of these colors in the creatures' makeup. For example, the lady bug has a shiny colored surface that is opaque and bright, and this is better reproduced with opaque color. In oil paintings a mixture of varnish with the color will give the surface a shiny, brilliant quality. The transparent colors of, say, a dragonfly's wings can be reproduced with washes and glazes that let the light through as the insect's wing does. The tints and shades found in these creatures are either a mixture of spots of pigment or the result of textures that add light and dark grain to the color base.

Project: I want you to collect a spectrum series of insects. They are easy enough to catch in the spring and summer, and they can be found almost anywhere under rocks and dead wood. You can use bottles with air holes in the tops to keep them in while you study their colors. Capture them by placing the jar over them if you are squeamish and reluctant to use your hands. The flying ones have to be caught with nets that you can improvise from cheesecloth and clothes hangers. Duplicate their colors with your watercolors and, when you have finished, release them and let them live out their lives.

COLOR IN REPTILES

The reptile family is not as colorful as the insects or fish, though they do have some striking patterns. For the most part their colors are earth colors which provide camouflage. There are bright greens, reds, oranges, and yellows and even a few types that appear to be blue, but as far as I know there are no purple snakes except in nightmares. The reptile colors are opaque, very rarely pure, and with many shades and tints.

Project: You can study snakes best at the zoo. Paint some

with your watercolors. This form is linear and cylindrical. The tonality is the same as a simple pipelike form with curves in it. Since snakes are scaly, there is a shiny quality in the light areas, showing little facets of reflected light.

COLOR IN BIRDS

Birds are aerial creatures that reach farther into the heavens than all other animals. Their color range is heavenly, gaudy, joyous, and humorous. What could be more heavenly than an iridescent hummingbird that shows the whole spectrum in metallic brilliance, or more humorous than a raucous toucan with a huge improbable beak that shows *all* spectrum colors!

Some birds' colors are shiny and brilliant, some iridescent, many are opaque with no sheen, and there are many that are tints and shades. Think of chickens, roosters, canaries, and parakeets.

There are tropical birds that actually have all six pure colors on their coats. Birds are incredibly colorful!

You will notice I have refrained from naming all of the different kinds of colorful birds. Instead, I want you to take the trouble to go to the zoo to see these colors and not look for names.

COLOR IN MAMMALS

Mammals are the most subdued in color of all the creatures of the earth. The colors of animals tend toward black, white, gray, and the earth colors. The primary motive of animal coloration is concealment, which helps the creature either to hide from its foes or to stalk its game unnoticed. Oddly enough the relatives of man—the primate family—have the only real examples of brilliant coloration: the mandrill. The male mandrill has a fur ruff around his head and another around his buttocks and genitals; both of these ruffs have brilliant spectral hues of blue, red, and purple on a base of white.

The general color of animals is based on the type of fur. Short, glossy fur will catch and reflect more light and seem shinier and more colorful than long animal fur which mixes areas of light and dark in the shaggy places, producing broken color.

Some animal marking is extraordinary; the stripes of the zebra and the tiger are familiar to all, and the spots of the leopard are known to be unchangeable.

Project: Visits to a zoo, a farm, a racetrack, or a dog kennel will provide you with plenty of animal color to paint. Try to duplicate the fur colors that you find. But in your painting I do not want you to use any of the earth colors; instead use the six pure colors and mix the colors you see as shades or tints. If you see many kinds of animals, you should be able to find shades and tints of most of the spectrum colors. The only color you will not find is green.

COLORS OF HUMAN BEINGS

The colors of human beings are subtle and beautiful; the color changes often are barely perceptible in each individual. Human colors are so subtle that it is very misleading to call people red, black, yellow, or white, since none of these colors describes human flesh tones. And there are many variations within each general type of color grouping.

AFRO-INDIAN PEOPLE

The darkest-skinned people originated in the African continent and the area of India. The skin colors of these people range from blue-black and purple-black to very light browns and tans of soft richness. On the skins of the very dark people there are suggestions of very beautiful blues and reds and there are reflected highlights of white light. The lighter, browner people have suggestions of orange and yellow more strongly, but also tints of blue or green. Hair color appears black at first, but may have a blue, brown, or reddish cast. Eye colors range from the deepest brown to light brown and in some instances individuals will have eyes of a most unusual golden color.

ORIENTAL PEOPLE

The skin tones of oriental people range from brownish to a very pale tint of yellow that has an ochre quality. Again there are subtle harmonies of the other colors. In the browner skins there are hints of oranges and reds while the lighter-skinned people may have a greenish or bluish undertone. Hair coloring is blue-black and eyes are in the darker browns.

WESTERN EUROPEANS

The people regarded as white are anything but white. Individuals generally have a characteristic basic tint which can be of any of the six pure colors. This may be only a suggestion of yellow, or green, or pink, or it may be an orange, red, or purple.

Along with the characteristic tint of each individual, one can generally see suggestions of all of the colors as tints. The light skin is translucent and it tends to show the colors underneath more readily than the darker skins which are more opaque. In addition to this the light-skinned human shows more clearly the emotional responsive colors because of this translucency. The surface of *all* people can become red with heat or embarrassment, purple with choked rage or alcoholism, blue with cold, green and yellow with sickness or envy, but the lighter skin color is, the more visible these emotional responsive colors are.

In the Western European group there are all of the hair colors from the lightest blond to black, brown, and red. The eye colors run the gamut of blue, green, yellow, mixed to brown.

My origin is from the Western European light-skinned group and consequently I have had more experience and have made more observations within this group. I believe we tend to idealize the loving family faces that we first see as infants and children and so we all may have something of a natural bias. Because of this I hope you will add your own perceptions to mine and forgive any shortcoming you find here.

Project: If you are as fortunate as I am and have friends of all different shades and hues, you must ask your friends to come and sit so that you can make studies of their colorfulness. If your circle of acquaintance is limited, you will have to make passing observations and unobtrusive notes of your fellow citizens.

Dark-skinned people require the use of more opaque tones of color and so you will have to think out their color variations carefully as too much manipulation of color will

gray out all of the tones. Light-skinned people have to be painted with washes of thin color over their basic tone. In either case, use the six pure colors and try to achieve your color effects and earthier tones with tints and shades.

COLOR RESONANCE AND HARMONY

I want you always to remember that each realm of nature has its own expression of the spectral colors, its color progressions, and color changes. When you paint from nature you may use as many as eight or nine distinct color spectrums. We have just surveyed this vast territory, but I hope that you have grasped clearly the differences between these realms.

Many mistakes are made when these differences are not taken into account. The biggest and worst mistake is to use the color straight from the tube for *all* of the varied spectrums of nature. This mistake produces paintings that look like children's coloring books or those paintings done from the numbered painting kits. Using the color directly from the tube is *not* expressive of your sense of nature's color; it is only an expression of the manufacturer's line of pigments. I am not trying to discourage you from being bold and daring or free in the use of color, I am only saying that you cannot be any of these things unless you first *see* the colors of nature and realize that the color range of pure pigment has greater possibilities when it is guided by a knowledge of nature's colors.

When you translate the colors of the different realms of nature into paint on paper or canvas with keen judgment, they can create a special harmony and resonance because they show the interactions of vast realms of natural functions—life cycles, great atmospheric movements, and seasonal, daily, and momentary meanings. Harmony and resonance exist in nature's colors because they are softened by the shades and tints and grays that always accompany natural color phenomena. This will also occur when you see nature as a guide in painting and the pigments are softened, shaded, or subtly placed. When colors are used with thought to nature's light, modeling, and over-all tonality, they set up a vibration, creating a quality that makes the total picture greater than the parts.

There is no exact formula that can be followed that will lead you to making perfect color pictures. The beauty of art is that there are great open spaces and areas of freedom that allow you to find ways of expression that are distinctively yours. Color is the most difficult area of all for the artist; there is no doubt about this. The best way to approach finding your own spectrum is to depend always on your own eyes, your inner visions, and the colors of nature. Let your palette always be the disciple of these masters.

Finally, I suggest that you study the paintings of the great masters inch by inch. Analyze their color transitions and pigment mixture, but most of all try to see or find the example in nature of the things they were trying to express. The greatest masters were those who learned from nature.

Bibliography

Boon, K. G. *Rembrandt: The Complete Etchings.*
New York: Harry N. Abrams, 1963.

Cirker, Blanche, ed. *Eighteen Hundred Woodcuts by Thomas Bewick and His School.*
New York: Dover Press, 1962.

Cole, Rex V. *The Artistic Anatomy of Trees: Their Structure and Treatment in Painting.*
New York: Dover Press, 1951.

Cole, Rex V. *Perspective: The Practice and Theory of Perspective as Applied to Pictures.*
New York: Dover Press, 1970.

Ferrari, E. L., ed. *Goya: His Complete Etchings, Aquatints, and Lithographs.*
New York: Harry N. Abrams, 1962.

Gudiol, J., ed. *Goya.*
New York: Harry N. Abrams, 1965.

Hale, Robert B. *Drawing Lessons from the Great Masters.*
New York: Watson-Guptill Publications, 1964.

Kepes, Gyorgy. *Language of Vision.*
Chicago, Illinois: Paul Theobald, 1945.

Kepes, Gyorgy, ed. *Vision and Value* (Series)
New York: George Braziller, 1966.

Kurth, Willi. *Complete Woodcuts of Albrecht Dürer.*
New York: Dover Press, 1963.

Lanteri, E. *Modelling and Sculpture: A Guide for Artists and Students.*
New York: Dover Press, 1965.

MacCurdy, Edward, ed. *The Notebooks of Leonardo da Vinci.*
New York: George Braziller, 1955.

Petrides, George A. *Field Guide to Trees and Shrubs.*
Boston, Massachusetts: Houghton Mifflin, 1958

Poppelbaum, Hermann. *Man and Animal.*
London: Anthroposophic Press, 1932

Pough, Frederick H. *Field Guide to Rocks and Minerals.*
Boston, Massachusetts: Houghton Mifflin, 1953.

Reich, Wilhelm. *Character Analysis.*
New York: Farrar, Straus and Giroux, 1949.

Reich, Wilhelm. *Cosmic Superimposition.*
New York: Orgone Institute Press, 1951

Reich, Wilhelm. *Ether, God and Devil.*
New York: Orgone Institute Press, 1949.

Richter, Jean Paul. *The Notebooks of Leonardo da Vinci.*
New York: Dover Press, 1970.

Schindler, Maria. *Goethe's Theory of Color.*
London: New Culture Publications, 1946.

Schwenk, Theodore. *Sensitive Chaos.*
New York: Rudolph Steiner Publications, 1965.

Sullivan, Louis H. *System of Architectural Ornament According with a Philosophy of Man's Powers.*
New York: Eakins Press, 1967.

Thompson, D'Arcy Wentworth. *On Growth and Form.*
Cambridge, Massachusetts: Cambridge University Press, 1961

White, Christopher. *Dürer: The Artist and His Drawings.*
New York: Watson-Guptill Publications, 1971

Index